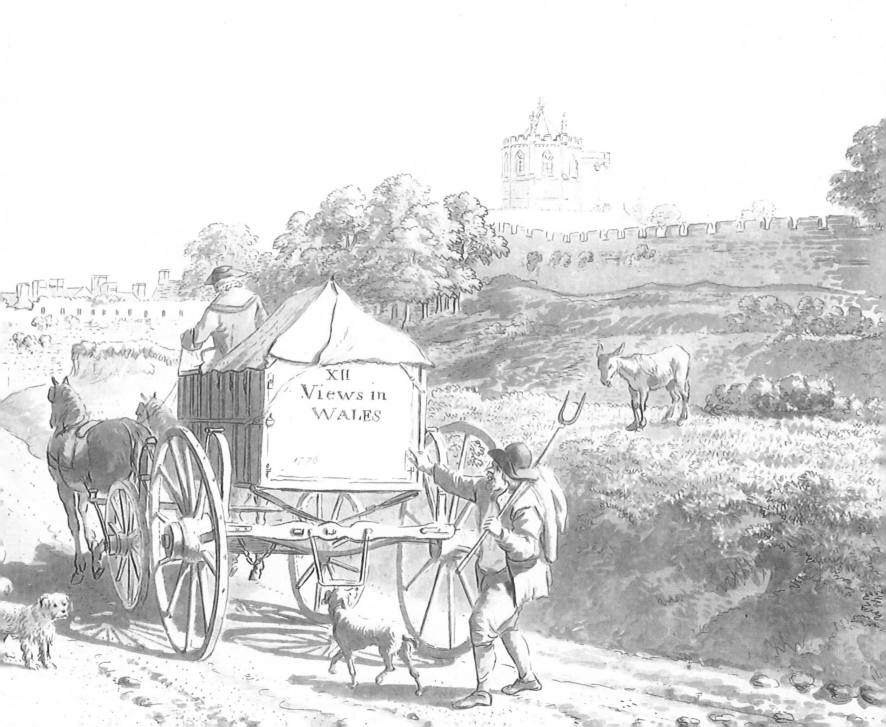

XII
Views in
WALES

1776

THE MOST GLORIOUS PROSPECT

Garden Visiting in Wales 1639–1900
Bettina Harden

For David

The Most Glorious Prospect
Published in Great Britain in 2017 by
Graffeg Limited.

Author Bettina Harden copyright © 2017.
Designed and produced by Graffeg Limited
copyright © 2017.

Graffeg Limited, 24 Stradey Park Business
Centre, Mwrwg Road, Llangennech, Llanelli,
Carmarthenshire SA14 8YP Wales UK
Tel 01554 824000 www.graffeg.com

Bettina Harden is hereby identified as the
author of this work in accordance with
section 77 of the Copyrights, Designs and
Patents Act 1988.

A CIP Catalogue record for this book is
available from the British Library.

ISBN 9781910862629

Front cover: 'The Vale of Maentwrog'.
Hand-coloured aquatint after Edward
Gooodwin, 1814.

Endpapers: The Frontispiece for Paul
Sandby's *Views of Wales* (1777)

1 2 3 4 5 6 7 8 9

THE MOST GLORIOUS PROSPECT

Garden Visiting in Wales 1639–1900
Bettina Harden

GRAFFEG

CONTENTS

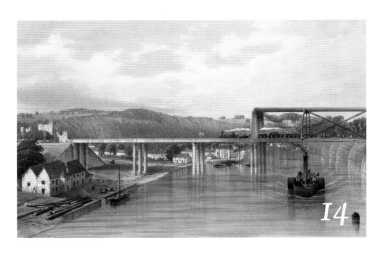

14

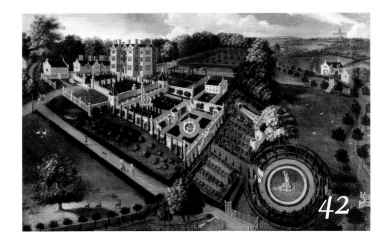

42

ACKNOWLEDGEMENTS

This book would not have been possible without the help and encouragement of a great many people and organisations. I am deeply grateful to the following:

The Librarians and staff at the Bodleian Library, Oxford; the Map Room, British Museum; Cardiff Central Library; the Lindley Library; the London Library; the National Library of Wales; the National Museum of Wales; the Pardoe Collection of The Georgian Group; the Library of the Soane Museum, London; the University Library and Archives at Bangor, for their patience, help and encouragement; Dan Clayton Jones for access to his bookshelves; Michael Freeman for his work on tourist accounts of Wales; Sir Richard Williams-Bulkeley for his time and hospitality at Red Hill; Michael McLaren and Ann Smith at Bodnant Hall; Penelope Currie and Jenna Nugent at the Frick Collection, New York for allowing me to see the portrait of Lady Cecil Rice of Dynevor; Hal Moggridge and Gerald Morgan for sharing their work on Dinefwr; John R.E. Borron and Jennie Macve for giving me access to their research devoted to Hafod; Gary Lovelock and Michael Wynne at Margam Country Park; Marian Gwyn and Richard Davies for sharing their time and research at Penrhyn Castle; Dai Evans and Roddy Milne at Picton Castle; Anne Rainsbury, Curator, Chepstow Museum, for giving me a wealth of information about Piercefield; the staff of Meirionydd Archives, Dolgellau for their help with Plas Tan y Bwlch; Andrew Oughton and Tony Russell at Plas Tan y Bwlch; Janis Davies and the staff at Plas Newydd, Llangollen; Paul O'Byrne for my tour at Plas Newydd, Anglesey and Penrhyn Castle; Tom Till, The Estate Office at Powis Castle; Arabella Friesen for her help and encouragement at Stackpole Court; the staff of Pembrokeshire Archives, Haverfordwest for their assistance with Stackpole Court; Countess Cawdor and Ian Whitaker for their help with pictures of Stackpole now at Cawdor Castle; Elisabeth Whittle and David Lambert, without whose encouragement I would never have embarked on this research; my supervisors at the University of Buckingham, Professor Tim Mowl and Dr Michael Liversidge for their unfailing encouragement throughout this pilgrimage; my tireless readers Jonathan Denby, Gwyneth Hayward, David and Matilda Harden; Philippa Lewis for guidance and advice; Thomas Lloyd, for wonderful pictures and information; Charlie Robinson for his lovely photographs; Helen Williams-Ellis for her advice and good company in the libraries of Wales.

AUTHOR'S NOTE

I have relied on the words from pens other than my own to tell this story of great Welsh gardens and parks. In doing so I have left the spelling and punctuation as it appeared at the time, finding that it gives the descriptions immediacy and charm that I hope my readers will also enjoy. The spelling of Welsh place names baffled many of my writers who tended to write them phonetically as they heard them and in some cases I have corrected them for clarity. My own omission is the spelling of Dynevor, correctly Dinefwr. In order to marry the title with the place I have kept to Dynevor throughout.

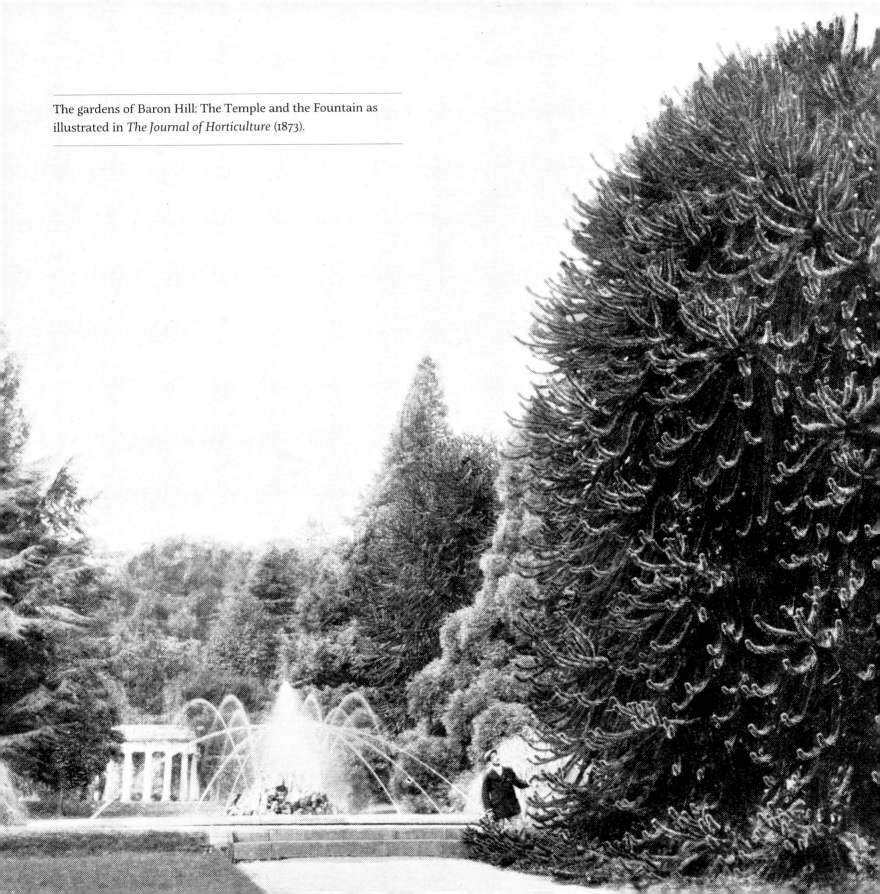

The gardens of Baron Hill: The Temple and the Fountain as illustrated in *The Journal of Horticulture* (1873).

FOREWORD

Books on historic gardens – joyous, beautiful and scholarly – have been rolling hot-foot off the presses for the last decade or two in astonishing numbers, nowhere more rapidly than in Wales. And nowhere more deservedly. Out of the dim perceptions of the post-War generation of a land of mountains, rain and coal mining has emerged a landscape discovered to be filled with the gentle garden and parkland arts, much long forgotten but surprisingly still present, or where sadly not, often inspiringly and just as well documented.

This present volume is all about the well-documented. It is a brilliant new approach to understanding the most famous designed landscapes of Wales, as seen in their heyday through the eyes of beholders and expounded through their diaries and sketchbooks. It brings the past back alive and sets it before us from a whole range of places and spaces – the early Renaissance at Llanerch to equally theatrical Edwardian Bodnant, with more than two centuries of new ideas and endeavours in between.

Many of the sources brought to bear here have never been plundered before. The National Library of Wales and Record Offices hold many unpublished tours of Wales from the later eighteenth century on and plenty even of the published tours are rare and have never been combed for the rewarding material that has been here set before us. Who previously had come across Dr Spiker, Librarian to the King of Prussia, who traversed Great Britain in 1816 and whose account was put into English in 1820? Or the manuscript diary of Jinny Jenks, a lady crossing north Wales in 1772? Or Esther Williams touring Wales in 1836? For the ladies get a very fair and welcome representation here. These are authentic, new voices, speaking to us as they wrote, some with wildly different opinions and judgements about what they saw, and not discarded if they do not suit the thesis of Bettina Harden, the present author and compiler.

The major, long respected authorities, Thomas Pennant, Richard Fenton, Benjamin Malkin, William Bingley and others are usually first allowed to set the way. Their deep grasp of Welsh history and locality of their time (before and after 1800) enable them to set the scenes with authority and with polished literary style. Modern scholars' works have also been widely consulted where their observations are needed to understand the whole picture: Bettina Harden has scoured nearly three hundred years of garden and landscape writing to forge these colourful and comprehensive surveys of the greatest sixteen gardens and parks in Wales which she sets before us here.

Bettina Harden is certainly no newcomer to her subject, having been in immersed in the study of Welsh gardens and a guardian and promoter of them for close on thirty years, since the founding of the Welsh Historic Gardens Trust in 1989, of which she was later chair and champion for nearly a decade. A gifted gardener herself, she has restored and transformed the grounds of the house she married in north Wales into a demesne of great beauty. Subsequently, she started and ran for ten years (1999-2008) The Gateway Gardens Trust, a charity which brought children from inner city schools into the countryside to tour gardens and to open their eyes to scenes and scents and colours that they had never known of before. So she intuitively understands the rapture of eighteenth-century tourists suddenly witnessing a great vista opening before them as they reached a key viewing point in a great north Wales park and saw perhaps a view of Snowdon steeped in a grandeur, which nothing from their home county life had ever prepared them for. This book is a culmination of that desire to share and of half a lifetime's research.

Before we can be let loose into the cast of commentators that Bettina has lined up for us in the sixteen chapters of her chosen great places, we must need to know how they travelled, how they coped with the food and the inns, how they found

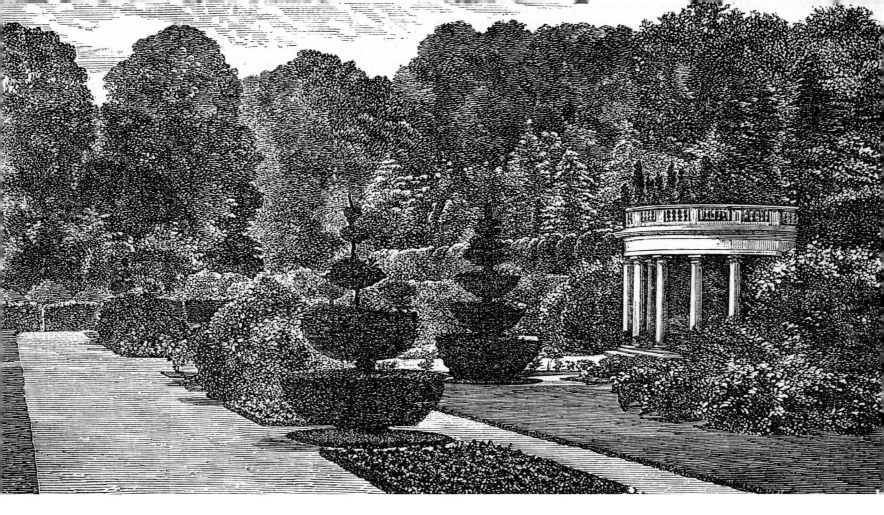

One of the great Victorian additions to the gardens of Baron Hill: The Temple as illustrated in *The Journal of Horticulture* (1873).

their way round on the terrible roads, and in some cases, why they were in Wales at all. These key subjects are covered in the opening chapters, where we meet early scientific explorers like John Ray and Thomas Johnson and famous artists like Richard Wilson and Paul Sandby, and learn of the development of road maps, the building of hotels and in due course the coming of the railway, which opened Wales up to a far wider audience.

It is extraordinary to think of a traveller in the mid-eighteenth-century actually having to use one of Ogilby's minimally detailed strip maps to find his or her way around Wales, when we think of them as mere antique ornaments to hang on our walls. Travelling was hard in every way then, so that the serenity of a landscaped and florally bedecked garden must have been received with a joy many times greater than we can experience today. Such emotions linger deeply across the pages of this book, along with due appreciation of the estate owners whose parks and gardens afforded these pleasures and whose taste and wealth had created them. They stare out at us in the fine portraits illustrated here, starched and clean, well-fed, proud and relaxed, whereas the tired, footsore travellers remain nearly all faceless. But we rejoice in their pens and thank them for coming.

Thomas Lloyd OBE, FSA
Author of *The Lost Houses of Wales* (1986)

INTRODUCTION

This is a story of our love affair with other people's gardens and began as a quest to look at garden visiting in Wales down the centuries. The Garden Museum's exhibition in 2012, 'Garden Open Today! 300 Years of Garden Visiting', explored the centuries-old tradition of opening gardens to the public. However, there was no mention of visiting a garden in Wales. As I am married to a Welshman and have a Welsh garden, I was infuriated and inspired to start researching the history of the discovery of the planned and designed landscape of a beautiful country. The result is this overview of the development of travel and tourism to Wales, focused on its parks and gardens before the advent of the motor car and, as Elisabeth Whittle wrote over twenty years ago, aims to 'counter the popular misconception that Wales has but few historic parks and gardens, and only a handful that are of outstanding interest.'[1]

'Gardens Open Today' was celebrating the National Gardens Scheme and its Yellow Book, that indispensable guide that takes us to wonderful gardens all over the country. It has a charitable purpose in inviting people to pay to see private gardens. In the seventeenth century, welcoming travellers and entertaining them harked back to mediaeval days, when open hospitality was part of the tradition of a great house. This spirit of *noblesse oblige* carried on into the early years of the eighteenth century, when famously hospitable men like Lord Bulkeley of Baron Hill on Anglesey 'dispatched a letter to his Agent, ordering him to entertain Us, & shew Us what was to be seen, if He should not himself be in ye Countrey'. It was common practice to ask the Agent or Steward to offer hospitality in the absence of the owner, as John Loveday found when he arrived at Llanerch, Denbighshire, in 1732, when he was greeted with 'great good Nature & an obliging Temper' by the family steward. Housekeepers and Head Gardeners were expected to have the details of family portraits, treasures and plants at their fingertips to relay to the inquisitive visitor.

The omission of Welsh parks and gardens from the Garden Museum's exhibition and from much of the existing English literature underlines the fact that Wales has long been considered strange and foreign by many Englishmen. The name 'Wales' comes from the Germanic word *wahl*, meaning foreign: the Welsh prefer the word *Cymru*, meaning friend or companion. For English tourists, Wales was considered 'almost as foreign a country as Egypt'.[2] There was a perception of Wales as a country far apart from England and there were huge physical obstacles to its exploration.

In the seventeenth and the first half of the eighteenth century, the wildness of Wales, the height of its mountains and the roughness of its roads, made it difficult to explore the country. Gradually, the history and glories of Wales began to emerge from a Celtic past to delight intrepid travellers. As the eighteenth century progressed, more and more people, having read about them in the increasing avalanche of Tours, Journals and Guidebooks that were published from the 1770s onwards, began to put Wales on their itinerary and set off to discover Britain for themselves. Living and working in Wales has inspired me to take a literary journey through these accounts to offer a fresh view of Welsh gardens. I have spent happy weeks and months reading as many of these books as I could discover. These contemporary reports are an invaluable source of information and exploring them from a Welsh perspective has shown how the travellers' tales reveal changing attitudes in taste, both in the design of gardens and the visitors' appreciation of them. They demonstrate how these places were made accessible, initially to the polite world and, as the nineteenth century progressed, to a wider, well-to-do, middle-class audience. The travellers' diaries, letters and tours of Wales conjure up a lost world of gardens now either vanished or altered beyond measure from their first construction. Their words provide glimpses of important gardens and garden design, particularly

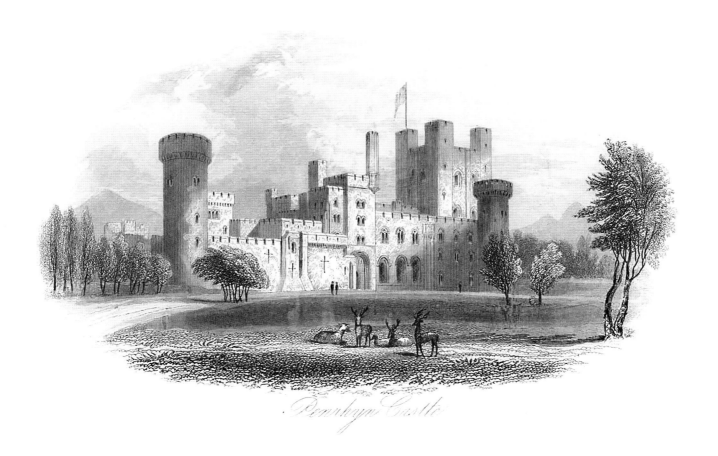

Pennbryn Castle

their buildings, which might otherwise have been lost to history. We catch sight of the great romantic gardens at Piercefield under construction, with Valentine Morris just missing a fall from the 'precipitous rock', of the moment at Chirk when the great Baroque gardens vanished as 'the proprietor, Mr. Middleton' levelled and formed the park 'to the present taste', of Wynnstay, 'where works were carrying on, under the direction of a late servant of Lancelot Brown, who proceeded in a confin'd way with B's great plans'. There are tiny details too, such as J.C. Loudon's note that it was at Wynnstay that 'the banana was fruited, and its fruit used at the dessert for the first time in England'.

The earliest travellers, like Thomas Johnson and John Ray, who wrote about Welsh landscape and the gardens they saw, did so in the course of their scientific exploration of the country, cataloguing its flora and fauna. However, in the seventeenth century there were great and fashionable Welsh gardens waiting to be discovered. These were created by men of fortune and education. They numbered among them Tudor and Jacobean entrepreneurs, some of whom had been on the Grand Tour to Italy: Sir Thomas Myddleton at Chirk Castle, Sir Rice Mansel at Margam Abbey, Mutton Davies at Llanerch Park. Powis Castle was said to exhibit a French style encouraged by the Herberts, a staunchly Jacobite family who followed James II into exile in France.

By the eighteenth century gardens had become a major attraction for travellers throughout Britain. Reflecting the influence of the Grand Tour, gentlemen were bringing back artworks, statuary and ideas from Italy. For the first time, great landscape designers were employed in Wales to provide settings for elegant neo-Palladian houses and villas designed by architects such as James and Samuel Wyatt. Lancelot 'Capability' Brown was employed at Wynnstay near Wrexham, William Emes worked at Baron Hill, Anglesey, Chirk Castle near Wrexham and Powis Castle, just outside Welshpool, and Humphry Repton was commissioned to produce a Red Book for Plas Newydd, Anglesey. These creations showed that their owners were men of taste, and the visitors to their houses and gardens were anxious to demonstrate that they too were possessed of taste and could admire and marvel at what they were welcomed to see. For example, Arthur Young, the great advocate of agricultural improvement, when making his tours of Britain seeking out details of farming practice, cropping patterns and animal husbandry, always took the time to see the great houses of the estates he was visiting and commented in great detail on their architecture, elegant contents and gardens.

The writings quoted in this book take the reader to Wales in the company of, initially, the aristocracy and gentry with the money and time to travel for pleasure: Lord Lyttelton, Sir Christopher Sykes, Sir Richard Colt Hoare and the Hon. John Byng. These men were exploring a Wales that many people did not realise existed and their accounts revealed how much of interest was on offer. Thomas Pennant and other antiquarians fostered a desire among an increasingly educated middle class to come and see the ancient wonders of Wales, catching up parks and gardens as they passed by. The congregation of clerics with an interest in everything from topography to druidical remains also took up their pens: William Gilpin, Nicholas Owen, John Davies, James Plumptre and the hard-walking Richard Warner, leading us into the nineteenth century. The appearance of general guide books and the advent of the railway spread the taste for Welsh beauty to an even wider audience.

From the middle of the eighteenth century, gentlemen of culture and education began coming to Wales to see for themselves the places of interest that were so well described by writers such as Thomas Pennant. In making such journeys: 'a man would be more likely to pride himself on being first and foremost an antiquarian, an authority on the Picturesque, or an expert on gardens'.[3] Travellers like Henry Penruddocke Wyndham wished 'his countrymen to consider Wales as an object of attention'.[4] He noted that, 'while the English roads are crowded with travelling parties of pleasure, the Welsh are so rarely visited, that the author did not meet with a single party of pleasure during his six weeks' journey through Wales.'

With taste and sensibilities opened to concepts of the 'Horrid' and 'Sublime', the 'Romantic' and the 'Picturesque', there was an eighteenth-century artistic rediscovery of Wales and, in the process, its parks and gardens. The change in attitude towards the appreciation of a wilder British landscape, spread by the travel journals and guidebooks, began to create a wider audience for the beauties of Wales beyond the wealthy nobility and gentry who had initially explored the country. With an emergent middle class, intrigued by prints depicting the romantic and dramatic scenery to be found and encouraged by widely available advice, travel to Wales opened up. As the century ended, the outbreak of the French Revolution and the Napoleonic Wars closed much of Europe to British travellers, who increasingly discovered the 'Cambrian Alps' in Wales as opposed to Switzerland or Italy. Great showcase landscape gardens, such as Piercefield in Monmouthshire and Hafod in Ceredigion were developed to demonstrate the new ideal of the Picturesque and were magnets for the traveller and, later, the tourist. The inspiration of the Picturesque filtered down to smaller gardens, such as the Ladies of Llangollen's idyll at Plas Newydd, Llangollen.

The Industrial Revolution in the eighteenth and nineteenth centuries increased both the development of spectacular gardens in Wales as well as the means of exploring the country. Visitors saw not only ruined castles, abbeys and standing stones but also industrial sights such as slate quarries, copper mines and ironworks. The vast wealth generated by industry led to the creation of huge, magnificent houses and gardens like Penrhyn Castle, financed by the slave trade and slate quarries.

Plas Newydd, Anglesey was funded by copper and coal; Margam Castle was built on dockyards and, later, ironworks; Plas Tan y Bwlch was created with slate-generated riches. Today, when the Welsh economy is so fragile, it is hard to realise how copper and slavery, ironworks, coal and steel poured money into Wales. The new industrial barons wanted their houses and gardens to reflect their money and status. There is a snobbish view that they had 'New money; No taste', but these energetic men were fascinated by the latest technology and their great glasshouses and conservatories filled with new, exotic plants were evidence of this. They wanted to make their mark and invest in new ideas and devoted as much energy to their new houses and estates as they had to the enterprises that had made their money in the first place.

Many of these men invested in the railway. By the time railway lines were beginning to criss-cross Wales in the nineteenth century, Bradshaw's *Railway Hand-Book* described the country as 'a continuous recurrence of hill and dale, wood and water, cornfields and meadows; the sublimity of wildly magnificent, and the beauty of mild and cultivated, scenery combine to delight the eye of the beholder at every turn he takes'.[5] The railways carried new visitors, 'excursionists', to discover the country through the energy of men like Thomas Cook, who organised the first excursions by train and steam packet to north Wales. Moving on from elegant eighteenth-century descriptions written by wealthy gentlemen who travelled in their own carriages or on their own horses, accompanied by a manservant, exploring a largely unknown Wales, the appearance of guidebooks such as John Murray's *Handbooks*, whose volumes on Wales first appeared in the 1860s, provided information for a different kind of tourist. They were happy to be given detailed itineraries containing the highlights to be seen en route rather than to discover them for themselves. Handbooks told the tourist where mail and stagecoaches ran, where and when steamers arrived, and recommended Bradshaw as the source of information about train times, as well as places of interest to visit, including gardens. Times had changed, and, as Mrs Piozzi wrote:

Sublimity will soon give Place to Convenience – while Commerce with his levelling Plough breaks down the Warrior's Camp and Druid's Cromlech, into a smooth Way for Waggons Mail Coaches and a long Et Cetera.[6]

This book cannot be encyclopaedic and not every impression will be quoted or every garden in Wales mentioned. There are many wonderful and beautiful gardens to be seen throughout Wales. To contain the great wealth of sources I have allowed the writers to select the gardens here, offering a view of sixteen major gardens that nearly every traveller visited across Wales and down the years. Working from the century in which the gardens first emerged, each one is presented through the eyewitness accounts up to the end of the nineteenth century. The gardens that attracted the attention of visitors, if they have survived, are largely listed as Grade I in the Cadw *Register of Parks and Gardens of Historic Interest in Wales*. This would seem to reflect not just the taste and wealth of their owners and creators, but also the beautiful Welsh landscape within which they are set.

A Gardens Gazetteer completes the tale, relating the story of the gardens cited in the twentieth and twenty-first centuries, noting which are still open for visitors, as well as those that have vanished from view and only survive through the written word, and echoing Repton's view that:

For the honour of the country, let the Parks and Pleasure Grounds be ever open to cheer the hearts and delight the eyes of all, who have taste to enjoy the beauties of nature.[7]

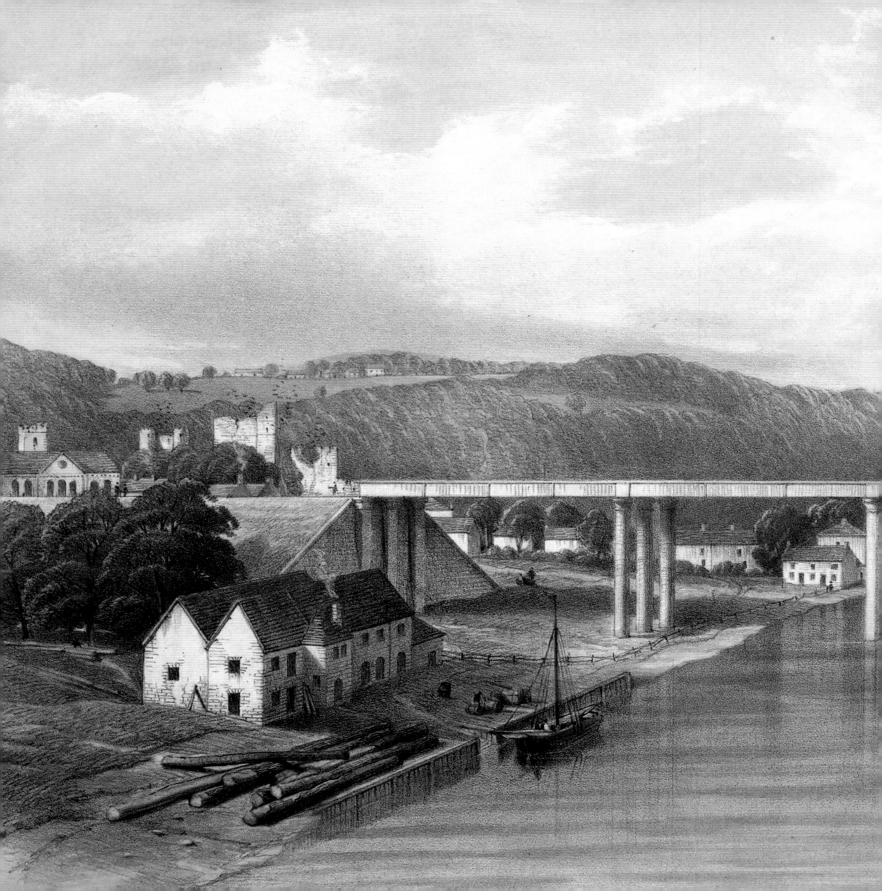

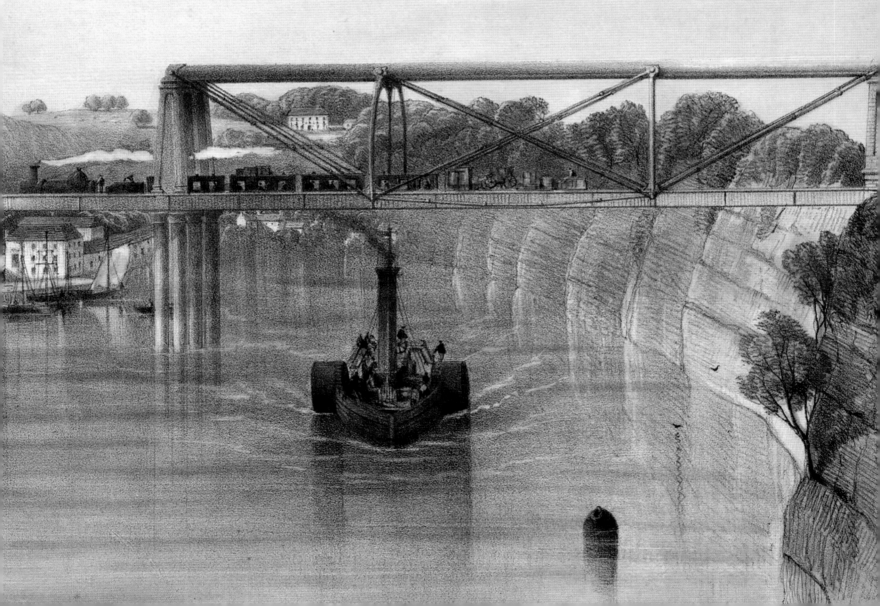

EXPLORING WALES

Chapter 1
TRAVELLING CONDITIONS

In 1684, Henry, 1st Duke of Beaufort, as Lord President of Wales, set out on a remarkable Progress through Wales. Of all the travels related in this book, this tour of Wales was by far the grandest. The Welsh people whom it was designed to impress were amazed at 'the splendour of the great man's equippage'. Thomas Dineley was the chronicler of the tour as the Duke and his retinue, numbering more than fifty people, travelled across Wales from Chirk Castle in the north to Margam in the south. The speed at which the journey was accomplished was remarkable. They started from London on July 14, reaching Powis Castle from Ludlow on July 19, and completed the Progress on August 21, barely five weeks later.[1] This was achieved on horseback. Travelling by coach was a very different matter. Welsh roads in the seventeenth century were primitive. During what would now be considered short journeys, carriage axles and wheels broke, horses became lame, luggage fell off and the jolting could be so rough that travellers were sometimes

Fig. 1 A nineteenth-century view of the terrors of Penmaenmawr with a shipwreck below the now-safely-walled road. A steel engraving by W. Radclyffe after David Cox, 1836.

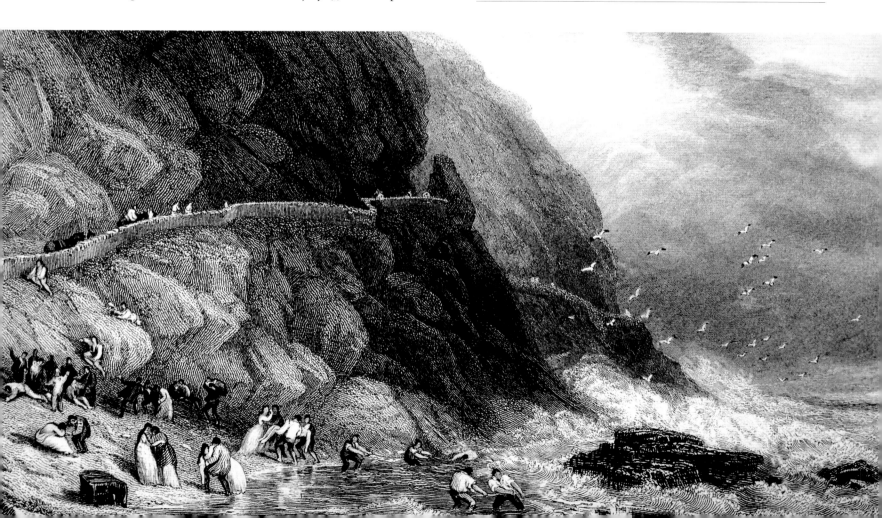

Fig. 2 *A View of Penmaen Mawr in Caernarvon,* published by J. Boydell in 1730. This print demonstrates the sort of peril encountered going across Penmaenmawr before the protective wall was built.

thrown out of their carriages. In foul winter weather, a journey of 40 miles could take up to 14 hours. Horseback was much more practical than a cold, draughty, slow and uncomfortable coach on rough roads, quite apart from the ever-present threat of highwaymen and indifferent inns. A.H. Dodd in his 'Roads of north Wales' explains that:

> The deplorable state of the roads in general at the opening of the eighteenth century is a commonplace, but those of Wales fell below even the unexacting standards of the time. A "Welsh journey" became a byword. ...In early eighteenth-century books they [roads in north Wales] were marked as "mere rights of passage". Such conditions did not foster traffic.[2]

Science led the way to exploring Wales in the seventeenth century, with botany as the driving force. Both before and after the Civil War, serious botanists were seeking to find and catalogue Welsh flora. Men such as Thomas Johnson, who made the first recorded expedition to the summit of Snowdon in 1639,[3] and John Ray, who made two tours of Wales,[4] focused on the plants rather than the parks and gardens they found there, although Johnson is clear that such botanising was very important to the scientist and, by extension, the gardener, as 'catalogues of this kind, like materials for building...' were essential resources.[5]

While the botanists, from necessity, coped with the nearly non-existent roads and harsh mountain weather, few tourists followed in their footsteps at the time. One factor that made Wales seem so separate from England was that the countryfolk spoke Welsh. Wealthy young men travelling on the Continent on the Grand Tour could probably muster some French or Italian or afford a translator, but Welsh did not feature in

Englishmen's lives. Johnson realised that as 'we were ignorant of the language of Ancient Britain we had need of an interpreter for which purpose we engaged Edward Morgan who was also a student of botany, and paid his expenses.'[5] Listening to Welsh being spoken or sung, accompanied by the harp, became a source of fascination for visitors to Wales. William Stukeley, the antiquarian, travelled into Wales for the first time in 1712, stating later that 'I had conceiv'd great notions of the old *Britons* betimes, and long'd to hear at last the language spoken soon after the deluge.'[6]

Johnson's descriptions of his travels are the earliest accounts of plant-hunting expeditions published in Britain. His tour of north Wales provided instances of the dilemmas and problems, as well as the generous hospitality, encountered by travellers. En route to Glynllifon in Caernarvonshire, the home of his sponsor and patron, Thomas Glynne, the MP for the county and an amateur botanist himself, he described the infamous Penmaenmawr, one of 'two passes full of horror' met with on the north Wales coast. This place was dreaded by everyone who made the journey: *(Figures 1 & 2)*

> Here huge high rocks hanging over the sea, admit of a narrow and dangerous path for travellers, for on the one side stones threaten to fall from the rocks, and on the other side the sea roaring fearfully at the foot of the huge precipice, promises death to him who slips.

Returning, Johnson's party were 'invited to a sumptuous repast at the mansion of the distinguished man, Richard Bulkeley', at Baron Hill above Beaumaris on Anglesey and 'after dinner explored the park on horseback'. The sight of Beaumaris, called the little London beyond Wales, gave huge relief after the long, mountainous and arduous journey en route to Ireland. It provided a welcome break in the journey, while the flat terrain of Anglesey itself gave a good road to Holyhead and passage onwards to Ireland and even had that rarity in Wales, milestones along the way.

Other seventeenth-century travellers in Wales, such as John Taylor, the Water Poet, travelling in the aftermath of the Civil War, found the going hard. 'This painful circuit began on Tuesday the 13 of July last, 1652. And was ended (or both ends brought together) on Tuesday the 7 of September following, being near 600 miles.' Taylor was convinced that 'well-stretch'd Welsh mountainous miles' were longer than English miles because the road went up and down so much. He encountered hardship on the road and needed a guide, 'for that I knew neither the intricate wayes, not could speak any of the language'.[7]

The terrible state of the roads accounted for much of Wales's isolation. Unless one had good reason to visit Wales – owning land and property, soldiering, overseeing a diocese or church property, business to conduct, or travelling to Ireland – few English people ventured across Offa's Dyke. Jonathan Swift, the great satirist and essayist, who became Dean of St Patrick's Cathedral in Dublin, sailed to Ireland from Liverpool if he could. Indeed, he said he would rather walk to Dublin than ride from Chester. In the summer of 1713, it took him three days to ride from Chester to Holyhead, a journey of some 83 miles.[8] Like Swift, many who had business in Wales or Ireland preferred to leave it until the spring or summer before they set forth to avoid rutted roads, quagmires and bad weather.

The traveller in Wales in the first half of the eighteenth century had to be intrepid. 'The word "travel" was not derived from "travail" without good reason, and there were still some very basic requirements before a tourist industry could begin – decent roads, comfortable carriages in which to travel them, and at least passable inns in which to stay.'[9]

Comfortable carriages were something of a rarity in Wales. In the 1740s Sir Nicholas Bayly of Plas Newydd on Anglesey is credited with owning the first carriage in north Wales, and so astounding was the sight of it that 'the plough was deserted, the wheel stood still, and the spade was thrown down' when it passed by.[10] In south Wales the first country squire to visit Monmouth in his own carriage was Capel Hanbury of Pontypool. He took a troop of labourers to open gates and pull down hedges where the road was too narrow and it took him nine hours to drive the twenty-one miles.[11]

The roads had to be improved. In England, with the passing of the first Turnpike Act in 1663, turnpike roads were being opened, the tolls charged being used for their maintenance. Wales was slow to follow and the Main Trust in Carmarthenshire was not established until a century later in 1763. By the time the last Welsh trust was established in 1836, turnpikes covered about a fifth of the road network in England and Wales. Even with the advent of turnpikes the Welsh roads were not always a smooth ride. Arthur Young, writing in 1767, said:

But, my dear Sir, what am I to say about the roads in this country! The turnpikes! As they have the assurance to call them; and the hardiness to make one pay for. From Chepstow...they continue mere rocky lanes, full of hugeous stones as big as one's horse, and full of abominable holes. Whatever business you have in this country, avoid it, at least, till they have good roads.

Echoing John Taylor on the ups and downs of Welsh roads, Young went on to say:

There is one circumstance which would make the best turnpike in England extremely hard to travel, and that is the perpetual hills; for you will form a clear idea of them if you suppose the country to represent the roofs of houses joined, and the road to run across them.[12]

By 1791 things were not much better in Monmouthshire, where it was said that men made their wills before embarking

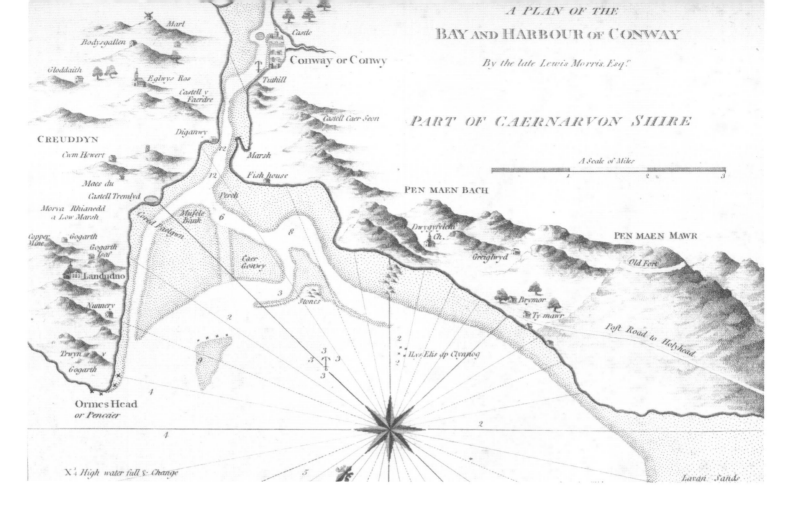

A PLAN OF THE
BAY AND HARBOUR OF CONWAY
By the late Lewis Morris, Esq.ʳ

PART OF CAERNARVON SHIRE

A Scale of Miles

Fig. 3 Lewis Morris's plan published in 1748 showing the treacherous and shifting sands at Conwy and the heights of notorious Penmaenmawr.

on a journey. Mrs Mary Morgan, en route to Pembrokeshire to visit her husband's family, recorded that:

> The road…has been intolerably disagreeable. Not that it is in itself bad, but they have such a terrible way of mending it. Their custom is to throw down vast quantities of huge stones, as large as they come out of the quarry, the size of a man's head and many of them four times as big. These are spread over the road in heaps, perhaps a mile distant from each other, covering a great many yards of it. You must either drive over them or wait till the people, who are there with large hammers for the purpose, have broken them. This they do only into pieces the size of a pretty large flint. [13]

Valentine Morris, the owner of Piercefield, just above Chepstow, was a vigorous supporter of the turnpike.

When questioned in Parliament about the establishment of a turnpike road in Monmouthshire, he was asked: "What roads are there in Monmouthshire?" He replied, "None." "How then do you travel?" "In Ditches." [14]

When Henry Penruddocke Wyndham (1736-1819) travelled through Wales in the summer of 1774, he remarked that 'In the course of thirteen days, we had seen neither coach nor chaise, but had travelled a mountainous country for the space of 167 miles upon Welsh hackneys [horses] hired from place to place'.[15] The Hon. John Byng (1743-1813) considered 'it is impossible to explore this country, but on horseback; as from Dolgelle, we

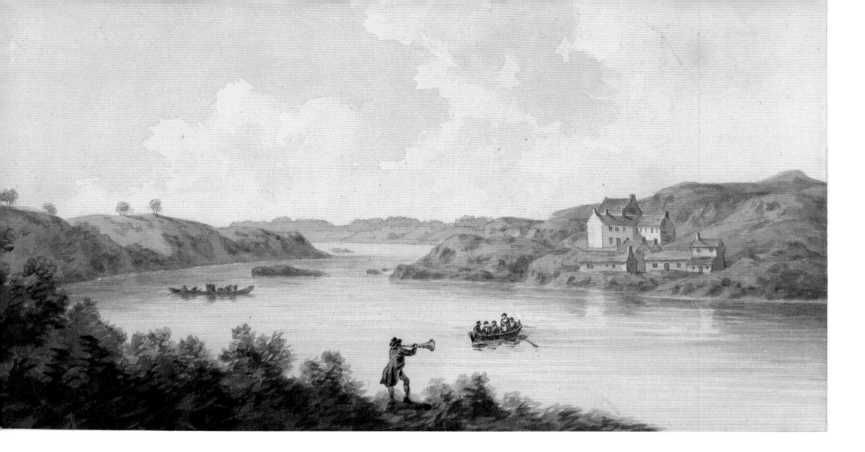

have travell'd nothing but narrow paths; and it is also necessary to be furnish'd with useful legs, and sound lungs: to suppose that Wales can be seen from a carriage is a grand mistake.'[16]

In north Wales, the ferry crossings along the way frequently caused alarm. Miss Jinny Jenks recorded that, 'Mr Jones was so obliging to meet us, and cross in the ferry to fetch and guard us. Mr Wynne and Mrs Lloyd being rather cowards, and first we, and then our carriage Ferry'd over the river Conway.'[17] *(Figure 3)* Nicholas Owen's *Guide to Caernarvonshire*, written in the 1790s, gives an account of the sort of conditions to be met with in north Wales:

This place [Conwy] being in the direct road from Holyhead to Chester, a ferry constantly plies under the town. The best passage is at high water; though the distance over the Conway is very trifling at the ebb, yet the sands are continually shifting in windy weather, and consequently are unsound to carry any heavy weight: even the horseman is sometimes obliged to gallop to prevent his

Fig. 4 'Summoning the Ferry', a watercolour by John 'Warwick' Smith. The hand-written caption reads: *Porthaethwy Ferry in Anglesea over the Menai, as seen from Bangor Ferry – The Woods of Plâs Newydd in the distance.*

steed from sinking.[18]

Of the formidable Penmaenmawr, Owen reassured his readers that the 'huge hanging mountain, once the terror of travellers; ...is now, by contribution of the Irish, and by erecting a turnpike, rendered an excellent road, no longer the dread of passengers, who survey the tremendous mass of rocks without any emotion but that of admiration or wonder.'

One way of hailing a ferry to cross the Menai Strait to Anglesey was with a speaking trumpet. This method was used at several crossings, such as that below Caernarvon across to Moel-y-Don or from Bangor across to Porthaethwy [now known as Menai Bridge]:

Arriving at the …turnpike, upon application to the gate-keeper, he will order the boat, should it be on the other side, by means of a speaking trumpet; otherwise you may wait a considerable time before you can cross Moel-y-Don ferry into the island of Anglesea. *(Figure 4)*

The route to Ireland was critical to improving access to north Wales. The 1801 Act of Union between the parliaments of London and Dublin provided the impetus to establish better communications between the two cities. It also brought the realisation that the roads involved were in a terrible state. Thomas Telford, the great engineer, prepared a 'melancholy' report for Parliament on the state of the road in 1810. The outcome was that a route to be improved by Telford was established through Shrewsbury, Llangollen, Betws-y-Coed and Capel Curig, to be followed by a completely new road across Anglesey to Holyhead, linked with suspension bridges at Conway and across the Menai Strait. This road through north Wales became the main route for Picturesque tourists. Telford related that it was:

…established through a rugged and mountainous district, partly along the slope of rocky precipices, and across inlets of the sea, where the mail and other coaches are now enabled to travel at the rate of nine or ten miles an hour, was indeed an undertaking, which occupied fifteen years of incessant exertion. [19]

As well as the work undertaken by Telford, others had a hand in improving the roads. Writing in 1813, Edward Pugh commended Lord Penrhyn:

…to whom the public is highly indebted, for one of the greatest improvements the country ever saw, in the planning and execution of an excellent turnpike-road, though one of the roughest and most mountainous countries in Great Britain; where before no animals, but the sure-footed Welsh poney, or the native mountaineer could travel. [20]

In 1801, Sir Richard Colt Hoare, 2nd Baronet (1758-1838), noted the construction of a new road through the Vale of Clwyd 'now rendered passable for carriages … by which many steep hills and much dreary country will be avoided'. [21] The work was not complete, however, and with some regret he noted that, 'had I known so much of it had remained undone I should not have attempted it in my chaise, for I found the latter part of it as bad as the beginning was good'. As a wealthy man, Colt Hoare generally used his own chaise to travel round Wales. M.W. Thomas, in his introduction to Colt Hoare's Journals, explains, 'the advantages of a chaise were the same as a modern motor car; ample luggage could be carried and the vehicle provided shelter from the rain, an important consideration in Wales.'

In the 1820s the German Prince Hermann von Pückler-Muskau (1785-1871) found his chaise similarly useful. He used a variety of transport: in his own carriage; by mail coach, stage coach (not as fast as the mail coaches), and by taking shorter excursions in a Fly [a kind of small landau, drawn by one horse]. He felt that:

It is one of the most agreeable sensations in the world to me to roll along in a comfortable carriage, and to stretch myself out at my ease while my eye feasts on the ever-changing pictures… I read and sleep in my carriage. I am little troubled with my baggage, which from long practice is so well arranged that I can get at everything I want in a moment, without tormenting my servants. [22]

Unlike the Prince, Byng travelled on horseback, sometimes alone, usually with a manservant to take care of his luggage, horses and dogs, but often in the company of a friend or congenial people he met on the way. This was unusual for the time, as most men of his class would have used a chaise or phaeton. For example, Lord John Manners (1778-1857) set off for Wales in 1797 with 'an equipage consisting of a post-chaise, a curricle, and saddle-horses' as well as the grooms to manage them all. [23] By the end of the eighteenth century, with north Wales firmly on the tourist trail, travellers were beginning to tackle the roads to the hills on foot. Hester Lynch Piozzi's friend,

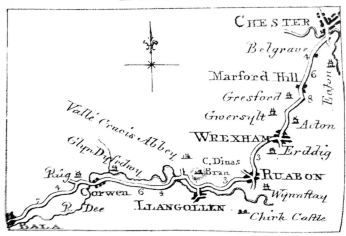

PLATE I.

CHESTER
Belgrave
Marford Hill
Gresford
Gwersylt
WREXHAM
Acton
Erddig
Valle Crucis Abbey
C. Dinas
Glyn Dyfrdwy
Bran
Rug
RUABON
Corwen
Wynnstay
R. Dee
LLANGOLLEN
Chirk Castle
BALA

Fig. 5 One of the tiny maps from Broster's *Circular Tour*.
Fig. 6 Edward Pugh with 'Wowsa' from *Cambria Depicta* (1813).

the antiquary and archaeologist Samuel Lysons, described a walking tour made with his brother in October 1785 that involved walking from Liverpool through Chester and Holywell:

> We afterwards continued our pedestrian route thro' St Asaph, Rhudlan, Abergelly, Conway, Beaumaris, Bangor, Carnarvon, from which we went to Snowdon...and proceeded thro' Bethgelert, Festiniog, Dolgelly, Welshpool and Montgomery, into Shropshire and thence thro' Worcestershire to this place [Rodmarton], having then completed a tour of five hundred miles, four of which we walked in little more than a month!![24]

The pioneer writer for the traveller on foot was the Rev. Richard Warner (1763-1857), who published two accounts of walking tours undertaken in 1796 and 1797. He was inspired by his mentor, the Rev. William Gilpin, whose curate he was in Hampshire. Incredibly, he walked from Bath to Caernarfon and back again, taking just over a month to travel 462 miles. His instructions to potential pedestrians included advice on what to carry:

> In preparing for a pedestrian tour, a few arrangements are requisite: a single change of raiment, and some little articles for the comfort of the person, form all the necessary baggage of the foot-traveller. ...A neglected Spencer [a short double-breasted coat], has, by the taylor's skill, been fitted up with a sportsman's pocket, that sweeps from one side to the other, and allows sufficient for all to be carried. [25]

John Broster produced his *Circular Tour from Chester through North Wales* in 1802 with walkers in mind. This was truly a 'pocket' guide, measuring just 5½cms x 9cms and 'embellished with plates', tiny but clear maps *(Figure 5)* that

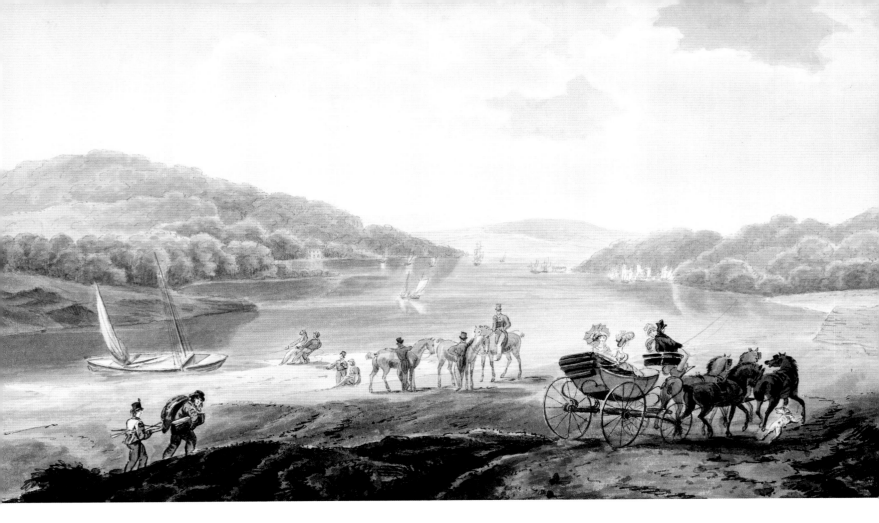

showed all the places Broster considered essential viewing en route. This 'Pedestrian's Circular Tour' began by stating that 'the tour of Wales is now become not only a fashionable, but a rational excursion':

> From the difficulty attending the travelling in carriages, into these parts most worthy of observation, several have commenced Pedestrians..., with infinitely more pleasure, than being dragged with funereal dispatch to the mountain's top, or hurled with considerable danger down its precipitous descent.[26]

The Welsh painter, Edward Pugh, aimed his book on travelling in Wales, *Cambria Depicta*, at the artist. He travelled somewhat lighter than many tourists, with 'a light knapsack

Fig. 7 The river crossing at Briton Ferry, a watercolour by Thomas Hornor, 1819.

on my back..., an umbrella in my right hand, and under my left arm a small portfolio suspended to my right shoulder by a broad piece of tape.' His little dog 'Wowsa' went with him. *(Figure 6)* Benjamin Malkin, travelling at the same time as Pugh, took a servant on horseback 'for the conveyance of books as well as necessaries'.[27]

The improvements to the Welsh transport infrastructure in the nineteenth century were welcomed by the guidebooks aimed at a wider audience. By 1813, George Nicholson felt that:

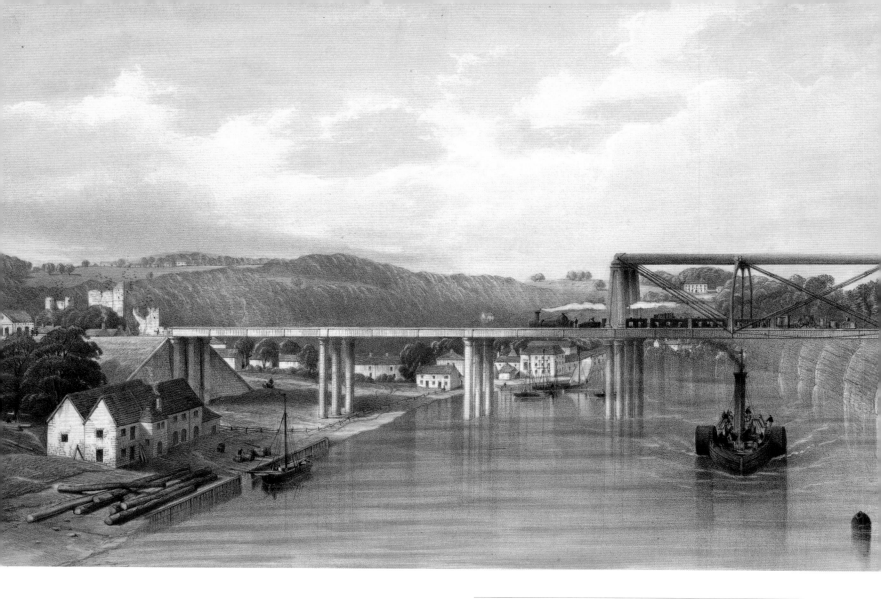

Fig. 8 Chepstow Bridge over the River Wye, Monmouthshire. This 1851 lithograph shows the Chepstow Bridge, designed by Brunel as part of the South Wales Railway, with a Bristol paddle steamer on the river below it.

The traveller will find...the macadamising principle penetrating far into those secluded recesses of North Wales, which geographically appear almost inaccessible. ... nor will the enterprising spirit of Cambria rest until these advantages are aided by the railway system already in progress between Merthyr and Cardiff. ...Good roads and steam have almost annihilated time and space, and London can be reached from Aberystwyth in twenty-four hours, when formerly it required that time to accomplish the distance between Aberystwyth and Shrewsbury.[28]

In south Wales the roads largely followed the old Roman route that linked Gloucester with Carmarthen. For example, travelling in 1796, Sir Christopher Sykes went from Chepstow – Newport – Cardiff – Caerphilly – Pontypool – Cowbridge – Llandaff – Pile [by Margam] – Neath – Swansea – Llannon – Carmarthen – St Clears – Tenby – Pembroke – Stackpole – Slebech – St David's – Fishguard – Cardigan – Aberaeron – Aberystwyth. In those days, people travelling west crossed the Neath Estuary via Briton Ferry. By the nineteenth century, with the development of ironworks at Port Talbot and the copper industry surrounding Swansea, 'Copperopolis', *The Cambrian Directory* recommended that travellers 'both horsemen and pedestrian, take the road by Briton Ferry, in preference to the turnpike', because of the unhealthy smoke issuing forth from Neath's copper works. *(Figure 7)*

Many travellers would begin their journey to south Wales from Bristol crossing the Severn by ferry. Gilpin travelled to Bristol by chaise and then crossed by boat, giving a description of the somewhat hair-raising passage:

> This passage as well as the other one across the Severn – are often esteemed dangerous. ...The boats too are often ill-managed. A British Admiral...riding up to one of these ferries...declared he durst not trust himself to the seamanship of such fellows as managed here; and turning his horse, went round by Gloucester. [29]

By the 1830s the crossing from Bristol had become safer, with the introduction of the steam packet. *Leigh's Guide to*

Wales told its readers that Bristol 'is a good situation from which to commence a Tour of Wales, as there are steam vessels constantly going to Chepstow, Swansea, Newport, and Tenby'.[30] *(Figure 8)*

INNS

At the end of a long day's weary travel, visitors sought out somewhere to stay. Wyndham wrote a great deal on the subject, saying that 'the English traveller will very rarely meet with such indifferent accommodations as are to be found at Caerphyli', and described the inns at Fishguard and Newport as 'villainous'.[1] Little did he realise that, twenty years later, his comments would still rankle with the locals. Lord John Manners (later the 5th Duke of Rutland), on his arrival at the inn at Caerphilly in July 1797, recorded that: 'Mr Wyndham...is remembered here, for having given so pitiful an account of the place, and the natives are very indignant against him'.[2]

Finding a room could be a problem and sharing was often the only way of getting a bed for the night. Byng said that it was essential to travel with his own sheets, as those to be found at inns were often flea-ridden and always damp. He complained that the waiters were 'sulky, insolent and uncomb'd'. Richard Warner felt strongly that:

> No man can justly estimate the value of a good bed, unless he have experienced the discomfort of a very bad one. ...our nocturnal accommodation has been far from tolerable. This circumstance, indeed, is the only drawback on the pleasure of a Welsh tour; if the country could but boast good beds, Wales would be a paradise.[3]

The situation was better in those parts of the country that proved popular with tourists. Welsh aristocrats were often responsible for building and developing places to stay, reflecting the fact that they all considered it entirely usual for their homes, parks and gardens to be places for visiting and realising that they could encourage visitors with the provision of comfortable inns. Pugh commented on the new inn at Capel Curig 'lately built by Mr [Benjamin] Wyatt', saying that

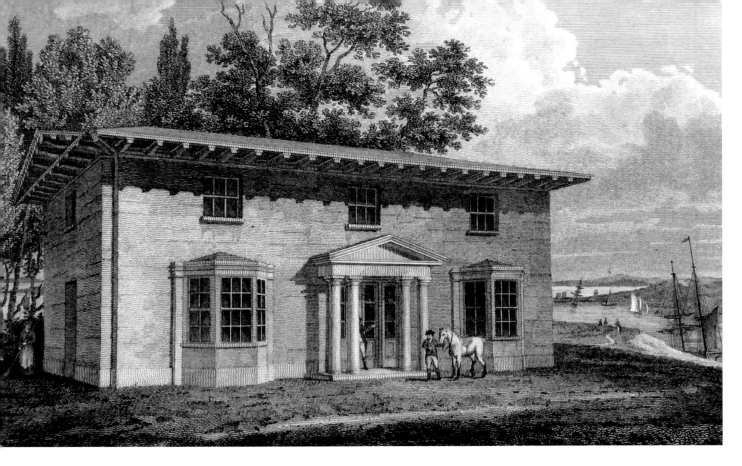

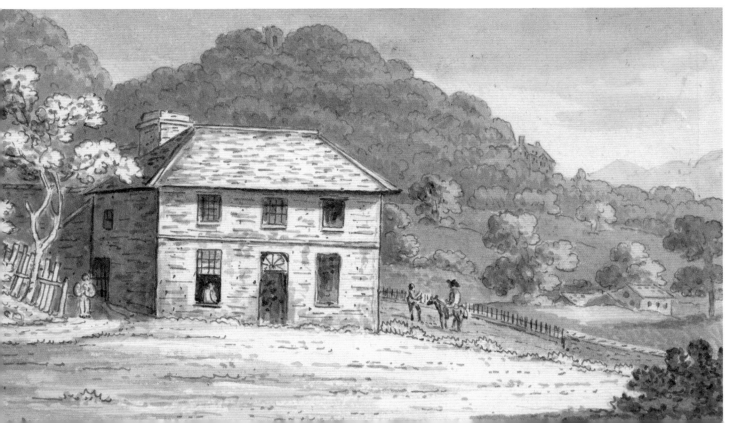

Fig. 9 The Penrhyn Arms at Port Penrhyn. Described as 'well-calculated for the Accommodation of the Tourist' and designed by Benjamin Wyatt, this drawing of the inn was made by his son, Lewis Wyatt.

Fig. 10 The Inn at Tan y Bwlch, sepia wash drawing by Sir Richard Colt Hoare. The little Picturesque tower later drawn by Edward Becker can be seen at the top of the picture.

Lord Penrhyn had ordered an addition of 'no less than twelve handsome rooms, which are now finished.' He also gave a good review to the Penrhyn Arms at Port Penrhyn, describing:

> a paradisiacal caravanserai – the very great overflow of strangers in every season of the year, as it lies on the great road to Holyhead and Dublin, gives it the appearance of the greatest London inns; but with this difference, that in the summer season, it is visited by numerous parties of strangers; some of the first rank, and others, who have laid aside the cares of business, for the pleasures of an excursion into the most romantic part of Great Britain.

Here, Lady Penrhyn created a reading room and 'made a present of it to the book subscribers, who are gentlemen resident in the town and neighbourhood.'[4] Samuel Leigh described it as 'a noble mansion' with pleasure grounds commanding a beautiful view, while Thomas Roscoe called it a 'princely establishment'. *(Figure 9)*

Lord Uxbridge built the large and elegant Uxbridge Arms at Caernarvon, where many travellers embarked by boat to view his home, Plas Newydd, from the Menai Strait: 'the hotel built by Lord Uxbridge, seems to take the lead'. In the Vale of Ffestiniog at Tan y Bwlch, the Oakeley family enhanced their inn considerably. As John Broster explained, it was considered a good place to stay:

> The pleasures and visual gratification of tourists are not sufficient in themselves to engross the mind entirely; the comfort of repose, or the invigorating aid of an wholesome meal, are sometimes sought with greater avidity than creeks

and barren rocks and lakes and no where can they be gratified more happily than at this small inn at Tan y Bwlch. *(Figure 10)*

Wyndham considered this a 'comfortable little inn' and liked it so much he used it as a hub for touring the area round about. Edward Daniel Clarke, writing in 1791, backed up this view, describing, 'a homely but decent and well-furnished inn… where gentlemen frequently pass some months in the summer'.[5] Byng gives an ecstatic description of it: 'Tan y Bwlch Inn beats us hollow in appearance, such a parlour! Such a snug situation with fine new stabling; then the dragging, every tide, for salmon, just below the house: that's a pleasure!'[6]

In south Wales, 'Mr Talbot of Penrice' built the Pyle Inn, close to Margam, 'a magnificent house of entertainment' that provided 40 beds and small pleasure-grounds for its guests, like Richard Warner, taking his *Second Walk through Wales* in 1797. In the same year the Pyle Inn met with the approval of Lord John Manners who described 'a most excellent inn, and in general so full, that travellers ought to write two or three days beforehand to secure beds.'[7]

An unknown lady, Eliza, described it in 1800:

> We arrived at Pyle by three o'clock but could not proceed, as it was too far to Swansea & there is no place between to sleep: we amused ourselves however very agreeably till dinner in the garden of the Inn, which is as uncommon as it is delightful, it is quite shut out from the observation of those in the house & from a sort of terrace the views are superb, looking over the Channel.

However, the advent of the south Wales Railway meant that by the 1870s this popular inn had become 'comparatively deserted'.[8]

One inn that was specially built to accommodate visitors to a famous landscape was the Hafod Arms at Devil's Bridge in Cardiganshire. Thomas Johnes, when creating Hafod a few miles away, was determined that his uplands Eden should be enjoyed by as many people as possible, and to this end established the Hafod Arms. Sadly, the popularity of Hafod created its own problems, with travellers complaining about

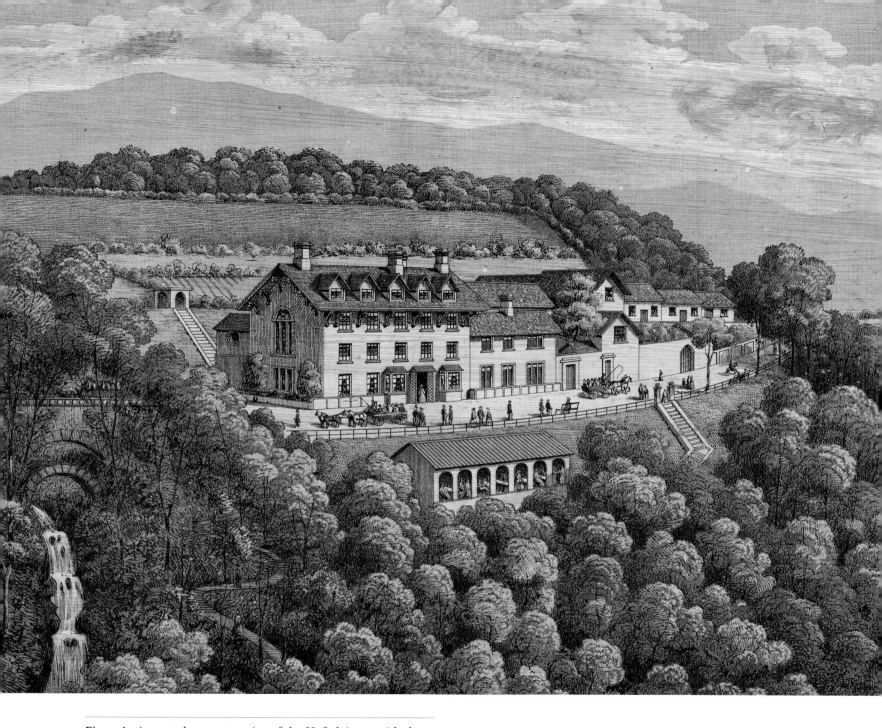

Fig. 11 A nineteenth-century print of the Hafod Arms with the renowned waterfalls of Devil's Bridge to the left.

the cost and finding the inn so crowded they had difficulty getting a bed. The Rev. John Skinner arrived there in 1802 and encountered this. He felt his troubles were increased by some of the writings of fellow travellers such as Warner:

September 25: It may not be malapropos to mention the great mischief occasioned by some tourists, who publish their incribations to the World: ...a very comfortable farm near at hand used to accommodate travellers when the Inn was full, but owing to an absurd story published by Mr Warner, they have since refused to admit any strangers to their house. This is not the only instance where I have found the publications of Tourists rather a detriment than an assistance to my travelling.[9]

Captain Jenkin Jones RN, visiting Hafod in 1819, left a good description of how the Hafod Arms operated:

The Hotel is erected amidst the wildest and most magnificent scenery, on a precipice contiguous to the Devil's Bridge, commanding a view of the grand cataract. It is a very commodious house but presumes on its situation, and having the command of the cards of admittance to the beautiful grounds at Hafod, from which it is a distant five miles, is very exorbitant, they will not grant a card unless those who travel in a post chaise change their horses there. I being a pedestrian, obtained my card and was fully repaid by my walk, but the expectations of the servants who show the house are so unlimited, that I would not see it.[10]

When Roscoe visited Hafod he also had his reservations about the inn:

After the fatigues of these ascents and descents, ...the comforts of the Hafod Arms are right welcome; but I would add a word in passing to hint that the worthy landlord might find the benefit of teaching the rudiments of civility to waiters in his establishment; it is well for the Hafod Arms that no other house of public entertainment is yet opened in the neighbourhood.[11] *(Figure 11)*

Nonetheless, whatever discomfort and problems encountered on their tours, nearly all visitors remarked on the hospitality of the Welsh. From the generosity of grandees like Lord Bulkeley to the assistance met with on the road, tourists generally encountered help and kindness on their way, even if the language was found to be baffling. The people, in spite of dreadful poverty and a lack of refinement from the perspective of the English tourist, were considered 'in regard to strangers, strictly honest, exceedingly civil, and attentive'.[12] They were also found to be 'wondrous inquisitive', while 'The Gentry have ye true Spirit of Hospitality, w'th no sign of Ostentation, but a disinterested Humanity.'[13]

FINDING THE WAY

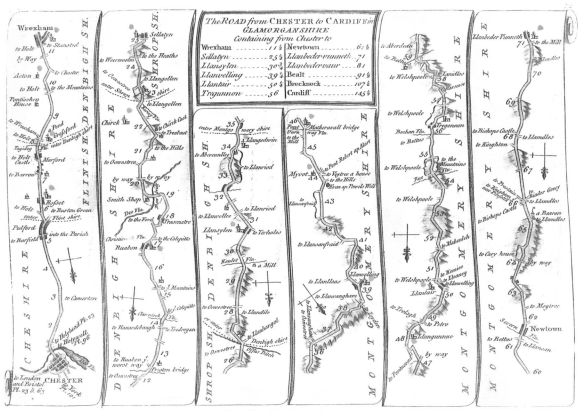

The ROAD from CHESTER to CARDIFF in
GLAMORGANSHIRE
Containing from Chester to

Wrexham	11½	Newtown	61½
Sellatyn	25½	Llanbeder-vunneth	71
Llansylen	30½	Llanbedervaur	81
Llanvelling	39½	Bealt	91½
Llantair	50½	Brecknock	107½
Tragunnon	56	Cardiff	145½

From Chester to Holywell see Pl. 96. Also from Wrexham to Holywell.

MAPS

Broster's tiny guidebook contained maps of his route, but early travellers had no such luxuries, relying on the main post roads [1] and, when going further afield, hiring a guide. The earliest cartographers considered Wales, together with other Celtic lands such as Scotland and Cornwall, as *terra incognita* and so omitted the country altogether. The first specific printed map of Wales was compiled in 1568 and published in 1573 by Humphrey Llwyd. Others soon followed, with Christopher

Saxton producing an *Atlas of the Counties of England and Wales* in 1579. Although this showed no roads, it detailed towns, rivers, buildings of note and, importantly for the garden historian, parks illustrated as a clump of trees with a ring fence around them. Much of this was based on personal observation and 'in

Fig. 12 The beginning of the road from Chester to Cardiff, from John Ogilby's *Britannia* (1675).

Fig. 13 (right) The final strip from 'the road to Aberystwith' as the traveller reached the sea.

Wales, for example, he was accompanied by locals who would assist him in naming the towns and villages which he saw from his surveying vantage points'.[2] John Speed's *The Theatre of the Empire of Great Britain* was published in 1610-11 and, while full of useful detail, included no roads other than the Great North Road. The cartographer who really made a difference for the traveller was John Ogilby (1600-1676).

Charles II appointed Ogilby 'His Majesty's Cosmographer and Geographick Printer' in 1674 and was rewarded with the publication of *Britannia: Volume 1 of an Illustration of the Kingdom of England and Dominion of Wales* in 1675, dedicated to him. This was the first road atlas in Europe and also initiated the scale of 1 inch to the mile. Ogilby created a completely new way of looking for a route, concentrating on the roads to be followed via towns, villages and landmarks between one point and another. *Britannia* contained 73 routes through England and Wales in the form of unique strip maps. *(Figure 12)* The first route was from London to Aberystwyth, coast to coast. *(Figure 13)* The maps were read upwards, from the bottom left-hand corner to the top right-hand corner. As Esther Moir wrote, 'All the road-users of the seventeenth and eighteenth centuries owed their greatest debt to Ogilby, who produced a road-book which was to remain the pattern for all future itineraries.'[3] Ogilby's revolutionary idea was copied everywhere and *Britannia's* function as a practical tour guide was enhanced in later eighteenth-century versions, which reduced the sumptuous but cumbersome folio to pocket-size road books that could easily be carried.[4] In many of these later versions, the strip maps could be removed for specific journeys. The manuscript journals of John Byng are scattered with hand-coloured 'Ogilby strips' of the various routes he took from place to place pasted in at the appropriate point in his account.[5]

WRITERS

In addition to a good map, visitors to Wales needed guidance to help them discover the history, topography, ancient relics and beautiful places to seek out. The best advice was to be found in the travel books that began to appear regularly from the middle

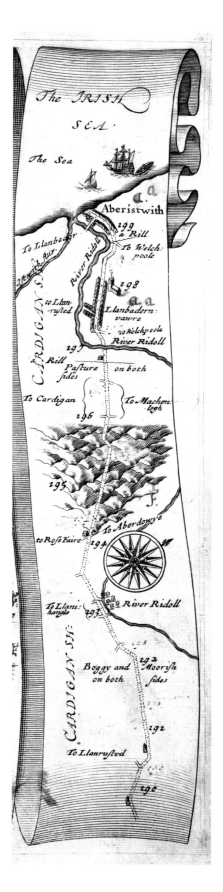

of the eighteenth century. After the botanists, the first people travelling for pleasure in Wales tended to be aristocrats and gentlemen with the money and time to explore the country. One such was George, the 1st Baron Lyttelton (1709-1773), the creator of the celebrated gardens at Hagley in Staffordshire, where art and nature went hand in hand. He was an early admirer of the beauties of Wales and wrote an account of his travels in the summer of 1756, published as letters to Mr Bower. It must have been a season of sunshine, for he only tells us of 'the most charming country my eyes ever beheld, or my imagination can paint.' Everywhere he went met with his praise, including the 'prettiest girls' and 'very fine trout' in Bala. With his taste educated by his Grand Tour to Italy in 1723 and his hands-on experience at Hagley, Lyttelton could not resist offering his suggestions for improvements that could be made to the gardens he saw with the judicious application of a little 'Art.' Only Chirk Castle met with his disapproval. Even the view from the 'frightful' Penmaenmawr, now that the road was protected by a wall, offered a very fine prospect of the sea and country.[1]

His romantic view of Wales in fine weather was possibly influenced by his desire to see Italy in British surroundings. The influence of the Grand Tour on both the observers of the landscape and the patrons and owners who set about bringing something of Classical antiquity to their surroundings cannot be underestimated. Seen as the culmination of wealthy young men's education, accompanied by tutors scathingly called 'bear leaders' by Horace Walpole, they set off on the Grand Tour to explore Civilization as offered by the countries of Europe they travelled through. Rome and Naples, with their treasury of Classical remains, were the highlight of such a tour and, while they may have also indulged in wine, women and song, many of the young men came back with paintings, sculpture, *objets d'art* and their heads full of the places they had seen. (*Figure 14*) In addition to the beautiful things they acquired, they also carried home the dream of the sunlit landscapes of Italy. As Donald Moore wrote, 'On returning home, they saw their own landscape with new eyes. They even sought to change it to conform with the vision they had seen, and create a new Elysium in some corner of a bleaker land.'[2] The Grand Tour is the *leitmotif* of

nearly all the gardens covered in this book.

The greatest Welsh travel writer of the day was Thomas Pennant (1726–1798), born and raised at Downing in Flintshire. An antiquarian, connoisseur and collector, he was a prolific author on subjects that ranged from zoology and natural history to archaeology and topography. He travelled to the Continent in 1765, but this was not the traditional Grand Tour, rather a journey in support of his zoological scholarship. His Grand Tour was made in his own country. He travelled up and down Great Britain and wrote detailed accounts of his tours.[3] He made several tours in Wales in the early 1770s, accompanied by his Welsh-speaking friend and fellow antiquarian, the Rev. John Lloyd of Caerwys. Importantly, he took his own artist with him. This was Moses Griffith, described by Pennant as 'that treasure', stating that, 'the public may thank him for numberless scenes and antiquities, which would otherwise have remained probably for ever concealed.' [4]

Pennant's Welsh tours were published in three volumes as *Tours in Wales* (1778-1783) and are 'regarded as being outstanding and easily the finest work in the considerable body of Welsh tour literature published from c. 1770 onwards'.[5] Every gentleman's library in the country possessed copies of his books and he was called the father of Cambrian tourists. Anyone planning a visit to north Wales would have consulted his works. His celebrity was such that an engraving of Moses Griffith's drawing of Pennant's home at Downing was included among the British views that decorated the Russian Empress Catherine the Great's famous 'Frog' dinner service, commissioned from Wedgwood in 1773.[6] Henry Skrine (1755-1803), recommending several books that he found helpful in his own travels in *Two Successive Tours of Wales* (1798), cited 'Mr Pennant's very excellent and accurate work', and said that, 'with these powerful assistants the reader cannot fail to traverse Wales with pleasure.'[7]

Pennant's *Tours of Wales* are full of detail but he was not often a careful observer of gardens and generally confined himself to a description of their setting and the landscape they occupied. A fleeting reference to 'a pretty *ferme ornée* belonging to Bell Lloyd Esq' near Lleweni in Denbighshire [8] recalled

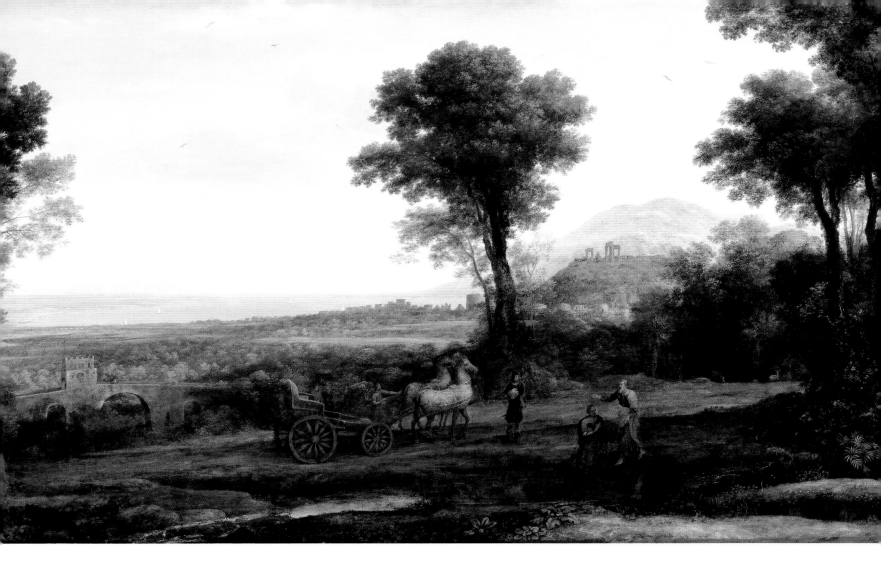

Fig. 14 *'Landscape with Saint Philip Baptising the Eunuch'* (1678). Claude Lorraine's tranquil view of the Roman countryside. His pictures were highly sought after by travellers on the Grand Tour in the eighteenth century.

William Shenstone's much-visited The Leasowes in England. This *ferme ornée* summoned up the Romantic dream of Arcadia; a pastoral paradise where Man works in harmony with nature, with every tree, rock, even animals, carefully placed to create a harmonious and exalted atmosphere, aided by artfully scattered Latin tags and scraps of classic poetry throughout the garden to heighten the mood. These ideas would be copied faithfully by the Ladies of Llangollen at Plas Newydd later in the century.

Like Pennant, Henry Penruddocke Wyndham, although a Whig politician and MP for Wiltshire, was most interested in topography and sites of antiquarian interest. A fellow of the Society of Antiquaries and a member of the Royal Society, he made his first visit to Wales in 1774. While mainly dealing with the Roman ruins, castles and abbeys that appealed to his antiquarian taste and omitting to see Margam's 'orange trees, in the garden grove, which I have since heard are the finest in all Britain', in his anonymous account of his *Tour*

of Monmouthshire and Wales (1775) Wyndham leaves a vivid picture of the country and travelling conditions. William Mavor wrote in *The British Tourists* (1800), a compendium of travel descriptions of the British Isles, that, 'on the foundations which Messrs. Wyndham and Pennant laid, it was easy to build.' Wyndham returned to Wales in 1777, this time accompanied by the Swiss artist, Samuel Hieronymus Grimm, whose work became so associated with the British Isles that he has been referred to as 'a very British Swiss'. On this trip, Wyndham repaired his omission of visiting Margam and added in several places he had overlooked on his first journey. Both trips were published in a second volume in 1781, with the same title, this time acknowledging his authorship and illustrated by Grimm.

While Wyndham, although clear-sighted about the deficiencies of the mountain roads and some of the Welsh inns, wrote very positively about most places he visited, the Hon. John Byng, who frequently referred to Wyndham's book, was possessed of a sharper pen and never hesitated to state his trenchant views. He was well placed to give his opinion on parks and gardens, for he was a friend of Lancelot 'Capability' Brown, 'the great planner of land', and also knew Humphry Repton, 'the now-noted landscape gardener', well. As the younger son of Viscount Torrington, Byng joined the army, ending as a Colonel in the Grenadier Guards, and then held a position as Commissioner of Stamps with the Inland Revenue. From 1781 onwards he escaped to the country whenever he could, riding around Britain 'to fly from the hateful noises, hours and stinks of London'[9]. He first arrived in Wales in 1784, returning in 1787 and 1793. His journeys were never published in his lifetime, emerging as *The Torrington Diaries* (he succeeded his brother as Viscount Torrington in 1812) in 1954. They established him as one the great British diarists of the eighteenth century.[10] His love of the countryside is reflected in his writing and he had very clear views about what he found acceptable in a landscape, deploring temples and statues and treasuring the ancient British past. He preferred the gentle, pastoral landscape of Bedfordshire, his home county, to the wildness of Wales and 'would not reside in Wales upon any account; ...it is far better to reside in an open unromantic country than in the midst

of waterfalls and steep hills.' Frequently acid about places he found wanting, when he found somewhere that appealed to him he did not hesitate to praise it highly, as at Tan y Bwlch.

Gathering together all the writers who came to Wales from the 1770s onwards could fill another book. They included gentlemen such as Sir Christopher Sykes, 2nd Baronet (1749-1801), from Sledmere in Yorkshire, whose manuscript journal of his visit in 1796 is full of his passion for measuring nearly everything he saw. The great lexicographer Dr. Johnson accompanied Mrs. Thrale, travelling through Wales in the 1780s. Hester Lynch Thrale, later Mrs Piozzi (1741-1821), together with Miss Jinny Jenks and Mrs Mary Morgan, provide the first women's voices in the story. Many more began to emerge in the nineteenth century. A congregation of erudite clergymen of every kind, from John Wesley to Richard Warner, wrote about their impressions of a country that was increasingly admired by men of taste. One clergyman in particular played a seminal role in attracting visitors to Wales. This was the Vicar of Boldre in the New Forest, the Rev. William Gilpin (1724-1804).

Gilpin's writing was crucial to the perception of Wales at the end of the eighteenth century. He first experienced the beauties of the Wye Valley in 1770, and, encouraged by his friends, published his *Observations on the River Wye, and several parts of South Wales &c.* in 1782.[11] He was the major exponent of the Picturesque theory, seeking in wild and rugged landscape 'that kind of beauty that is agreeable in a picture'. Anything rough and ruined suited his taste, preferably draped in ivy. *(Figure 15)* Wales's mountainous and wooded landscape, filled with suitably ruined castles, fitted the bill admirably. Gilpin advised, 'that the art of sketching is to the picturesque traveller, what the art of writing is to the scholar'.[12] Armed with a box of watercolours, a 'Claude' glass'[13] and a taste for pictures by Italian painters such as Salvator Rosa,[14] amateur artists and tourists began looking at Wales with a fresh eye. *(Figure 16)* Such paintings, copies or prints of them, spread the image of Italian landscape across the British Isles and 'had a part in making untrained eyes find beauties hitherto unnoticed in ... the mountains of Wales.'[15] Gilpin's books were an enormous success, with *Observations* going into five editions and translated into

Fig. 15 An eighteenth-century print showing tourists taking in the ivy-hung ruins of Caernarvon Castle. Every writer visiting North Wales stopped here.

French and German. This was followed by accounts of six more tours in different parts of Britain. His last book, published posthumously, included north Wales and, when he failed in his ambition to scale Snowdon, he quoted Pennant's description instead.[16] Peter Lord, writing recently about the English perspective of Wales, says that Gilpin's 'writings were important in encouraging an emergent fashion for Welsh landscape which resulted in setting mountain scenery at the centre of English

Fig. 16 'Rocky landscape with herdsmen and cattle' by Salvator Rosa. His views of dramatic and savage landscapes became very popular with eighteenth-century travellers to Italy.

ideas about Wales.'[17] The desire to paint Welsh landscape is echoed in nearly all the travel journals and guidebooks that burst upon the scene.

Edward Pugh's *Cambria Depicta* had the intention that it would:

> lead the painter to numberless objects, well worthy of his exertions, in representing them on his canvass; ... he will here find frequent and tempting opportunities of indulging and exercising it.
> ...Nor will the general observer ...be wholly disappointed by the perusal.[18]

Sir Richard Colt Hoare, 2nd Baronet (1758-1838), the antiquarian, archaeologist, artist and traveller, who made drawings and sketches during his travels, was much influenced by Pennant and quoted him frequently in his accounts of his Welsh tours, undertaken between 1793 and 1810. His wife, Hester, had a close link to her uncle, George, Lord Lyttelton, and the beauties of the gardens at Hagley. Following her early death in 1785, Colt Hoare embarked on the Grand Tour, travelling to Europe whenever he could over the next six years. He recorded his continental travels in great detail and he carried this habit to his travels in Wales. He also brought home fresh ideas for the great gardens at Stourhead that he inherited from his grandfather in 1785. An ardent fisherman – he mentions his fishing, successful or otherwise, throughout his Journals – he built a fishing lodge and summer retreat near Bala in Meirionydd.[19] His companion on many of his travels through Wales was Richard Fenton (1746-1821). A Welshman, born in St David's, Fenton was described as a barrister, topographer, antiquary, poet and scholar. Well-educated and well-read, Fenton found in Colt Hoare a great friend and companion. It is interesting to compare their reactions to the places they visited together. When Fenton published *A Historical Tour through Pembrokeshire* in 1811, he dedicated it to Colt Hoare, 'recollecting the numerous journeys in which we have traced together the vestiges of antiquity; the many hours of my existence which

your conversation has informed and cheered ... the friend of my fortunes and my life'.[20]

A hugely influential writer in the first half of the nineteenth century was John Claudius Loudon (1783-1843), born in Edinburgh. His writing and publications, such as *The Gardener's Magazine,* were aimed at a rising and increasingly prosperous middle class. He was a trenchant commentator, not hesitating to criticise owners whose pleasure grounds he found wanting. He expected a high degree of careful maintenance, from the conservatory to the flower and kitchen gardens. He recommended 'to all gardeners, whether in or out of place, to call and see other gardens as frequently and extensively as they possibly can.'[21]

Loudon's *Encyclopaedia of Gardening* was published in 1822. Its scope was immense, ranging across the whole field of gardening and horticulture, with advice on practical gardening and discussions on the garden styles of Europe. The *Encyclopaedia* stated that, 'we have visited all the counties of Britain ourselves in 1804, 5 and 6'. His opinion of Wales and its gardening potential was not very high but he marked those gardens he considered showplaces with a cross. Four in Wales – Plas Newydd on Anglesey, Wynnstay, Hafod and Stackpole were given this accolade.

As the 'Conductor' of his travels, written up in *The Gardener's Magazine,* Loudon repeated the view that employers should allow their Head Gardeners to see other gardens, as 'a gardener who does not visit his neighbours, cannot make any exchange of seeds, cuttings, or plants with them'.[22] In his *Encyclopaedia* he set out how gardens might be presented. Among his 'Expedient practices' for Head Gardeners when expecting large parties of visitors, he recommended that to add 'freshness and odor to the whole flower-garden – sprinkle every part with water excepting the walks; if with rose-water, which may be made at little expense where there is extensive shrubberies, and kept for sprinkling the hot-houses, so much the better'.[23] Such attention to detail is typical of the man, if rather demanding of those admitting visitors to their gardens.

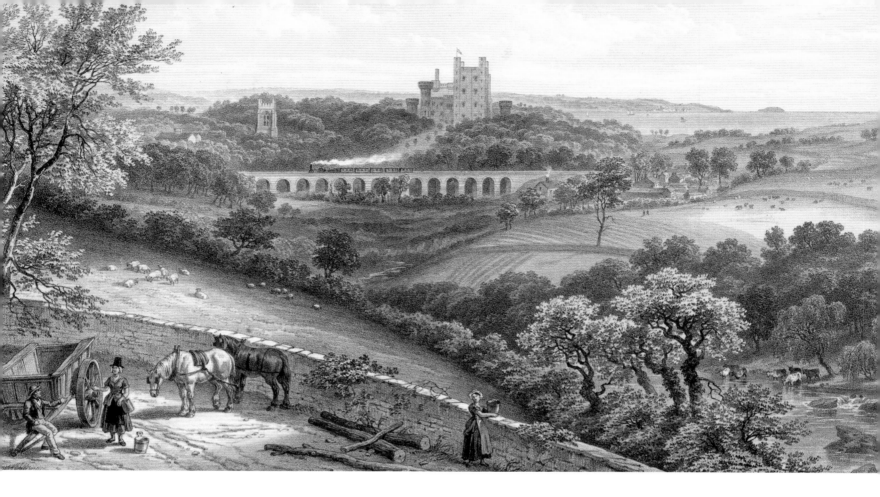

THE COMING OF THE RAILWAY

Fig. 17 Penrhyn Castle from the road to Penrhyn Slate quarries. Coloured lithograph by Thomas Picken, printed by G. Humphreys of Bangor.

Loudon's excursions with his wife on their eight tours of houses and gardens made between 1829 and 1842 were initially made in a one-pony chaise. By 1842 they were travelling the longer distances by train. Loudon was very aware of the huge change that railways would bring to garden visiting, stating that: 'when the railroad is extended – the principal public gardens of Britain may be visited in as many days as it now requires weeks.'[1] By 1845 some 2,441 miles of track had been laid and trains were carrying 3 million passengers a year. With third-class railway carriages initially roofless and affordable by nearly everyone, the Victorian day-tripper could travel. This provided an opening for the enterprise of Thomas Cook, a name now synonymous with organised travel. In the summer of 1845 he led his first professional tour from Leicester, a trip to Liverpool with optional extensions to Caernarvon Castle and Snowdonia. As the tour operator, Cook negotiated with the railway companies, from whom he received a commission on the ticket price. He published a handbook for his group that included an itinerary, a description of places of interest and travellers' tips. He accompanied his 350-strong party personally.[2]

Excursions became a familiar part of British social life. The newly-established *Railway Chronicle* (1844) welcomed and encouraged them: 'Railway excursions are now becoming our chief national amusement.'[3] In 1851 many of the six million visitors to the Great Exhibition travelled by train to London. They included some 165,000 passengers from the Midlands,

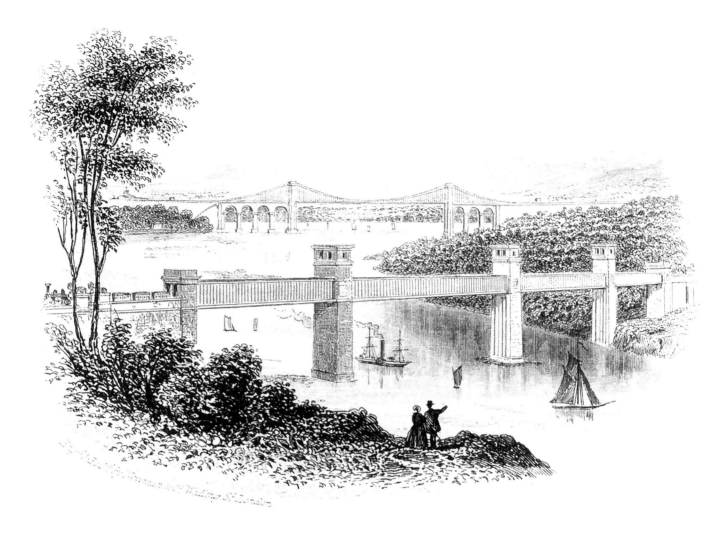

organised by Thomas Cook. Excursion trains were laid on for mill workers from Manchester to see Chatsworth and similar trains carried hundreds of factory workers from Birmingham and the Black Country to Aberystwyth on the Ceredigion coast, offering new and broader horizons for working people. By 1900 the mileage covered by railway lines had increased by 900%, and the number of passengers carried was around 11 million.

Industrial south Wales was soon criss-crossed by railway lines, with the South Wales Railway opening between Chepstow and Swansea in 1850. It was connected to the Great Western Railway by Brunel's Chepstow Bridge in 1852. There was initially no direct line from London to Wales, as the River Severn was too wide to bridge at the time. Trains had to follow a lengthy route via Gloucester, where the river was narrow enough to be

Fig. 18 Looking from Plas Newydd, the two great bridges across the Menai Strait (the Britannia Bridge in the foreground and Telford's suspension bridge behind) from Roscoe's *Wanderings and Excursions in North Wales* (1851).

crossed by a bridge. The western terminus of the line was built in stages, reaching New Milford in Pembrokeshire by April 1856.

In north Wales the Crewe to Holyhead line was proposed by George Stephenson, marching much of the way with Telford's great road to the west. With Robert Stephenson as Chief Engineer, the construction of the line began in March 1845 and included the great tubular Britannia Bridge across the Menai Strait, one of the masterpieces of British engineering.

(*Figure 18*) In August 1848 the Irish Mail train ran along the route for the first time. Guidebooks rapidly reflected the new mode of travel. William Cathrall's *Wanderings in North Wales* was sub-titled '*A Road and Railway Guide-Book*'. It began by providing the traveller with information ranging from details of the Chester and Holyhead line to a list of bankers in the region. Itineraries included where to stay and covered tours of four, six, nine and eighteen days' duration. Cathrall also gave travellers information about some of the costs involved:

> The usual charge for cars is 1s. per mile, but occasionally they can be had for 10d.; a vehicle with a pair of horses is charged 1s. 6d. per mile; post-boys, 3d. a mile. (*Figure 19*)

Many of the great houses that might be encountered en route were mentioned as the destinations of 'pleasant excursions'.[4] By 1868, *Murray's Handbook to North Wales* remarked that:

> This road [Telford's route], being the great highway between England and Ireland, was once traversed by a large number of conveyances, but the railways have banished them nearly all, and in a short time a coach of any description will be a curiosity in the Principality.[5]

Fig. 19 A 'neat car' or carriage available for hire at Bangor. Enhanced pencil drawing by Sir John Gardner Wilkinson from his sketchbook for 1835.

With the advent of railways, paddle steamers and road improvements, and the introduction of public holidays, the potential to travel for pleasure increased and the idea that the railway could form the basis of middle-class tourism followed hard on the heels of railway lines themselves. Mr & Mrs Samuel Carter Hall published *The Book of South Wales: The Wye and the Coast* to 'act as a Companion-Guide', following 'the route of the South Wales Railway from Gloucester to Milford Haven'. Describing their railway journeys between 1859 and 1861, it directed readers to landscapes and gardens such as Piercefield in Monmouthshire: 'among the most delicious landscape graces of England'. The book concluded, 'we have endeavoured so to picture the country through which it [the South Wales Railway] passes as to show how large and many are the inducements to tourists – seeking pleasure, relaxation, or information' and recorded their 'obligations to the Directors and the Secretary of the South Wales Railway, by whom we have been cordially aided in our pleasant task' – an example of clever marketing on the part of the company.[6]

Loudon's reports and the Halls' writing demonstrate how railways made garden visiting an option for a far wider public. Bradshaw's *Railway Hand-Book* (1863) became an important tourist resource. As you followed the railway lines into Wales, the *Hand-Book* listed important mansions, castles and houses that might attract the visitors' attention within easy reach of a railway station, such as 'Margam Abbey, the seat of C.R.M. Talbot Esq., M.P., beautifully wooded and remarkable for its orangery and gardens,' or 'Wynnstay, the hospitable and extensive mansion of Sir W.W. Wynn, Bt., in a beautiful park of 9 miles circuit.' Bradshaw firmly believed that, 'Railways may now be considered as accelerators of pleasure as well as business'.[7] The commission from the Chester & Holyhead Railway Company in 1852 for Joseph Paxton to design and set out 25 acres of pleasure grounds, to be known as Britannia Park, between Telford's suspension bridge and Stephenson's Britannia Tubular Bridge across the Menai Strait is a clear indication that Bradshaw was not alone is seeing the opportunities for tourism linked to the railways.[8]

As the nineteenth century progressed, general guidebooks began to appear. While undoubtedly useful, the charm and personal touch so evident in eighteenth-century diaries and journals is missing. Mentioning that 'Steamers from Liverpool to Rhyl, Beaumaris and Menai Bridge, weekly deposit a large amount of excursionists of all classes from the northern towns,' *Murray's Handbook* was aimed at the middle-class traveller, recommending that, when away from the railways: 'a tour on a good hack, which the traveller should bring from his own stables, and be accustomed to ride, is the pleasantest, the healthiest and the best of all modes of locomotion. This may or may not involve the necessity of a servant in a light driving cart with another horse, and the charge of luggage, rugs &c'.[9]

Some commentators considered the earlier exploratory mode of travel was preferable to blindly following the latest popular guidebook. In 1843 the *Edinburgh Magazine* sneered at:

Mr Plympton and a friend had been making a walking tour of North Wales; that is, they walked about five miles, stared at a mountain, or a fall, or an old castle, as per guide-book,

and then coached it to the next point, when the said book set down that "the Black Dog was an excellent inn," or that "travellers would find every accommodation at Mrs Price's of the Wynnstay Arms."[10]

In addition to the guidebooks, the promotion of garden visiting, begun by Loudon in his *Gardener's Magazine*, was carried on through the journals that became popular reading in the nineteenth century for an increasingly literate and leisured public. Among these was the *Gardeners' Chronicle*, originally founded in 1841 with Joseph Paxton as Editor and which, in various forms, was published throughout the century. *The Cottage Gardener* first appeared in 1848, renamed as the *Journal of Horticulture* in 1861. Accounts of showcase gardens emerge as being very accurate, and their readers, as gardeners themselves, regarded these publications as bibles and a fountain of knowledge. William Robinson, called the father of the English flower garden, heralded the beginning of the end of the craze for lavish bedding schemes so popular in Victorian gardens. Through books such as his widely-read *The Wild Garden* (1870) and his own weekly gardening magazine, he set out to spread his ideas and discoveries to other gardeners. *The Garden* first appeared in 1871 and continued for many years, popularising his views and those of fellow contributors, such as John Ruskin and Gertrude Jekyll. Articles about gardens in these journals were always based on personal visits, frequently carried out by well-known gardeners of the day. Through them we begin to meet the great Head Gardeners in Wales, like Walter Speed at Penrhyn Castle, Mr Muir at Margam Castle and John Roberts at Plas Tan y Bwlch. Their testimony is an important record of changes in garden design and taste as the century drew to a close.

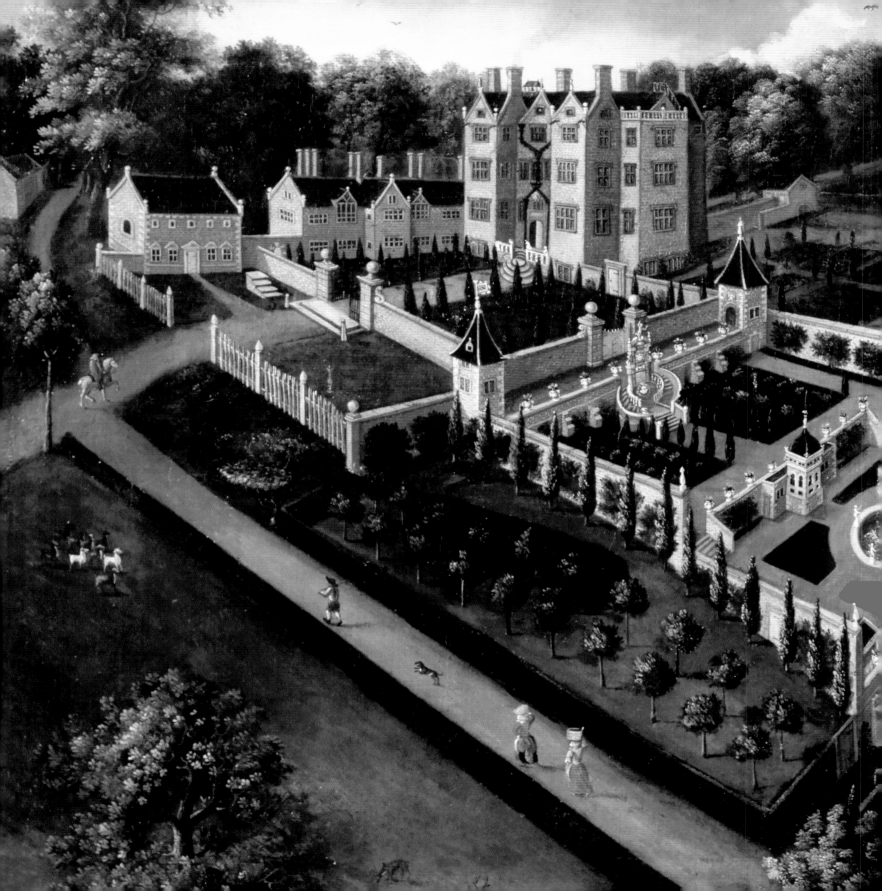

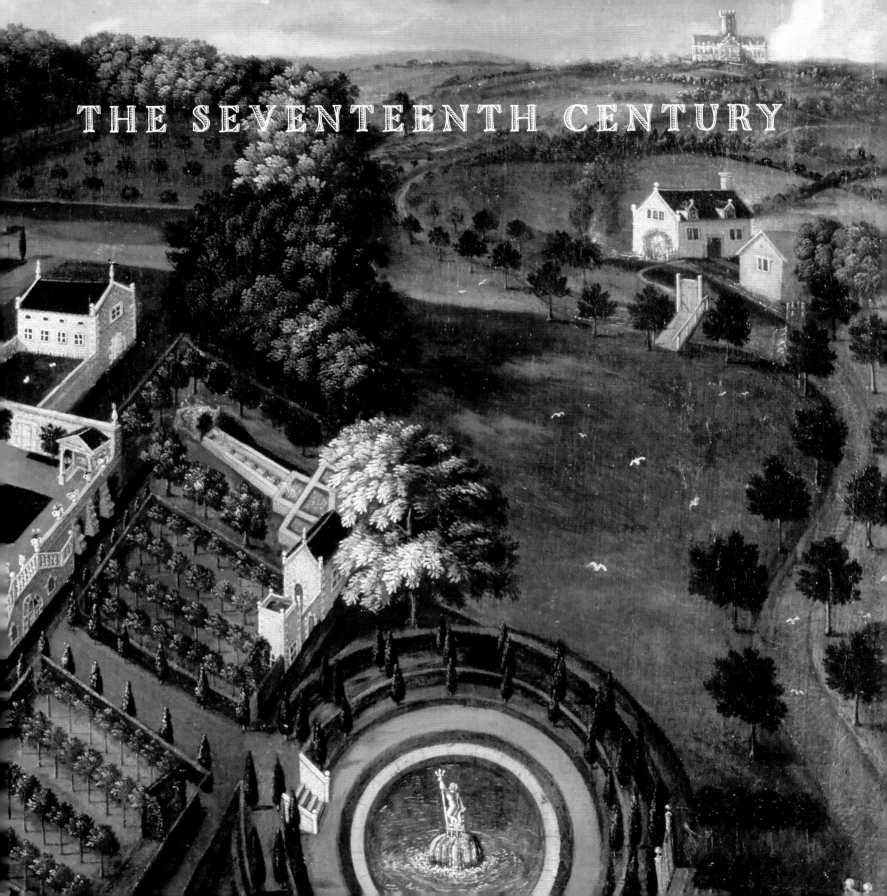

THE SEVENTEENTH CENTURY

By the seventeenth century the benefits of the Welsh-born Tudor dynasty in the previous century were evident throughout Wales. Welsh gentlemen now played an important part in court and city life in London. With access to court, commerce, money and manners, they flourished, and there was great traffic in new ideas. Welshmen made fortunes and their wealth and influence were reflected in their homes and gardens. Several of them had the money to embark on the Grand Tour to Italy and brought the inspiration of its great gardens home with them. Today, many of these houses and gardens have vanished from view, or remain as abandoned ruins. The fragments recorded by the writers who passed by reveal a taste for terracing, classic formal layouts and delightful small buildings, ranging from banqueting houses to gazebos.

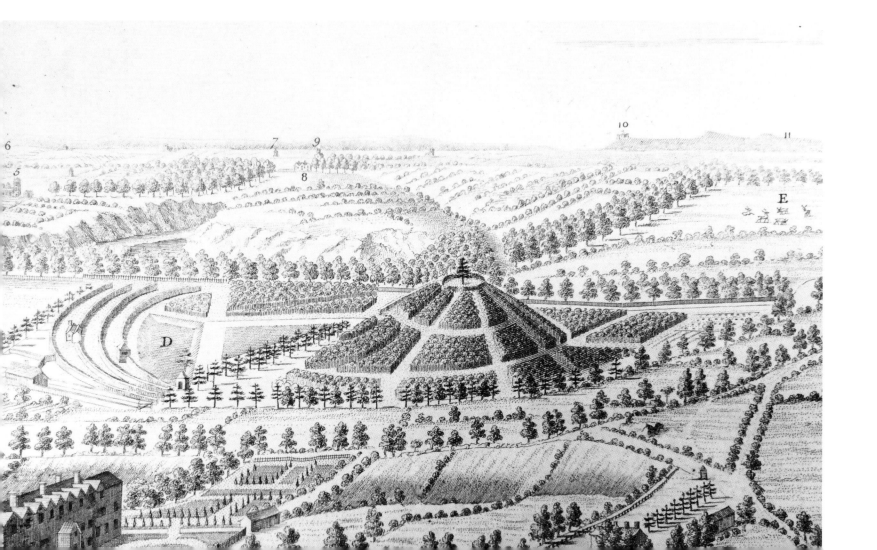

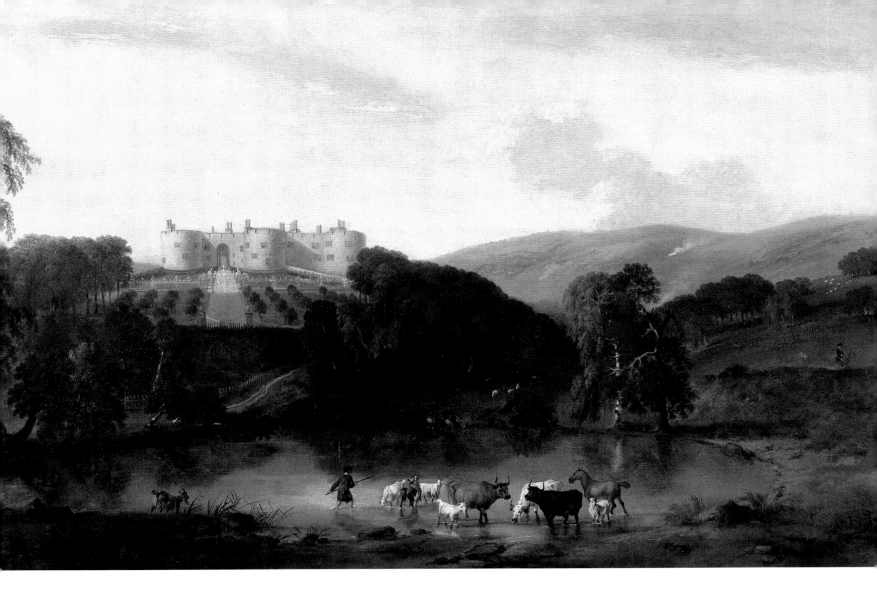

Fig. 20 (left) A detail from Badeslade's 1735 engraving of the west prospect from Chirk Castle, showing the 1651 walled garden with its viewing mount and the four curving walls facing south. The Banqueting House mentioned by Dineley is possibly the little building set into the wall beside 'D'.

Fig. 21 Chirk Castle from the north, painted by Pieter Tillemans in 1725. The formal array of trees leads up to the forecourt and the famous great gates in their original position. The bucolic scene also shows one of the two lakes that lay to the north of the castle.

CHIRK CASTLE – 'THIS EXALTED PILE'

The Myddleton family of Chirk Castle provide an excellent example of Tudor enterprise. Scion of a distinguished Welsh family, Thomas Myddelton (1550-1631) was an entrepreneur trading in London, making a fortune in sugar and by financing voyages. He was knighted in 1603 and became Lord Mayor of London in 1613.[1] He invested his money heavily in Wales, buying Chirk Castle in Denbighshire for £5,000 in 1595. Already a very old site, with part of Offa's Dyke running through the grounds,

the family enlarged and enhanced the castle and its grounds with a walled garden, a terraced garden and several summer houses. Myddleton's son, another Sir Thomas (1586-1666), was the garden designer and, in 1651, he created an unusual walled garden 'with four curving walls one above the other on a south-facing slope, and a circular viewing mount in the south-west corner.'[2] *(Figure 20)* He described his garden undertaking in verse: [3]

> When first, I did begin, to make
> This Garden, I did undertake,
> A worke, I knew not when begun,
> What it would Cost, ere it was donn,
> But I repent not, for ye poore,
> Doe there find work; had none before.

> I found some worke for every trade,
> Some walls did make, some Arbours made,
> Some mowed ye Allys; some I putt,
> To preuine ye vines, and Hedges cutt,
> And some poore woemen, that had neede,
> I kept, & payd them, for to weede.

By 1684, under the aegis of Sir Thomas Myddelton, the fourth Sir Thomas and 2nd Baronet (1651-1684), more improvements had been made. He had taken the Grand Tour in 1671 and, bringing fresh ideas home with him, began

Fig. 22 A detail from 'The North-East Prospect of Chirk Castle' showing the great Davies gatescreen commissioned in 1712 with Mars and Hercules standing guard. Engraving after Thomas Badeslade (1735).

a 'rebuilding and adornment of Chirk Castle [that] was exceptional'.[4] The gardens became extensive and Thomas Dineley described them during the Duke of Beaufort's visit to Chirk in *The Account of the Official Progress of His Grace Henry, the first Duke of Beaufort through Wales in 1684.* Dineley's Account was written and illustrated throughout by him as the Duke and his entourage progressed through Wales, inspecting musters of troops in every county under the Duke's command. Everywhere they went, they were lavishly entertained by the local gentry and Dineley noted the architecture and furnishings of the great seventeenth-century houses of Wales. It is Dineley's enthusiastic commentary and his vivid sketches that give us many of the first descriptions and views of great Welsh gardens. He wrote an appreciative description of the hospitality they received at Chirk on July 21 and 22:

> ...return to CHIRK CASTLE his Grace made a halt at Admirable WALLED GARDEN of Trees Plants Flowers & Herbs of the greatest variety as well forreign as of Great Britain, Orrenge and Lemon Trees, the sensitive plant [5] &c., where is a Banquetting house a collation of choice fruit and wines was lodged by the sayd Sir Richard Myddelton[6] to entertain his Grace in this his flourishing plantation. This place of pleasure would gratify not onely the nicest Florist (being an abode so perfect and finisht that it characteriseth its maker) but the most skilfull Arborists may easily satisfy their Curiosity there being scarce any outlandish variety of a Plant supportable in this northern Country but what is to be mett with here.[7]

These gardens became more elaborate when, in the early 1700s, a great Baroque landscape was begun for Sir Richard Myddleton, 3rd Baronet (1665-1716). *(Figure 21)* His son William

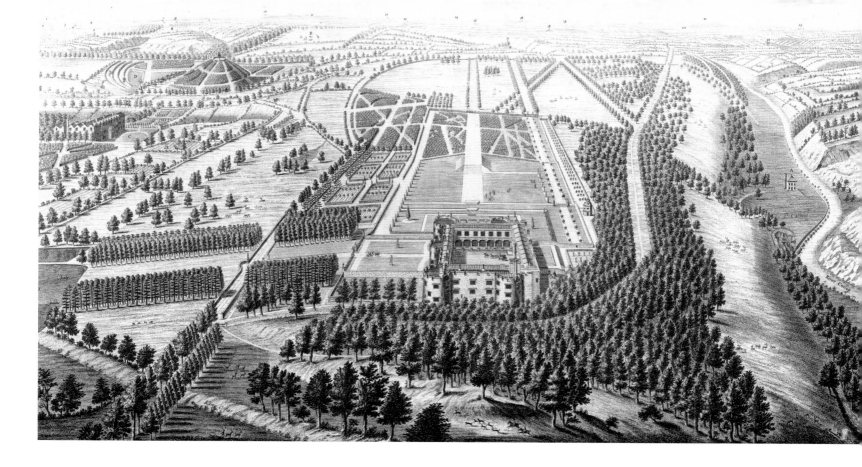

Fig. 23 'The West Prospect of Chirk Castle' with its view of 13 counties. Engraving by William Toms after Thomas Badeslade, 1735.

died shortly after his father in 1718 and it was his nephew, Robert Myddleton (the baronetcy had become extinct), who carried on with the development of the surroundings of Chirk. Between 1712 and 1719, a magnificent wrought iron gate-screen was commissioned from Robert and John Davies of Bersham, near Wrexham. This was erected in the castle forecourt, with large statues of Hercules and Mars standing guard. *(Figure 22)* These great formal gardens were flourishing by the time they were illustrated by Thomas Badeslade in 1735. *(Figure 23)*

Taste in gardens was changing as the eighteenth century advanced. People began to deride the elaborate formality that imposed order on the chaos of nature. Owners had also discovered that the upkeep of such complex sites, maintaining walls, hedges and topiary, was very expensive. With the advent of Richard Myddleton (1726-1795), the park and gardens at Chirk were subject to major change in 1764. Influenced by the new passion for graceful, sweeping, Classical landscapes and buildings as depicted in the works of Claude Lorrain or Nicolas Poussin, Myddleton and his wife, Elizabeth, had ambitious plans for redeveloping both the castle and its grounds and gave William Emes his first commission in Wales. Emes was asked to advise on improvements and the result was that thousands of trees were planted and, in 1767, all the roads crossing the park were closed to the public.[8] Emes, who came from the Midlands, was a designer of landscapes that reflected the work of Lancelot 'Capability' Brown. Like him, Emes created parks of great beauty noted for their use of trees and water. Such landscaping had the advantage of allowing agriculture into the parkland and using woodland as coverts for game. Landowners were not slow to see the economic advantages of this way of enhancing the setting of their mansions and castles. At Chirk, Emes developed

Fig. 24a & 24b Emes's Retreat Seat and part of the ha-ha overlooking the park at Chirk.

his plans over some twenty years, removing the formality in the gardens and beyond, creating swathes of woodland and flowing green spaces of pasture planted with specimen trees. When Wyndham called in 1774, work was still in hand and he noted that, 'nearly in the centre of a park ...the proprietor, Mr. Middleton, is now levelling and forming to the present taste'.[9] Emes built a ha-ha round the garden with a little classical pavilion, the 'Retreat Seat' (1767) from which to view the park. *(Figure 24a & 24b)*

The Myddletons were a rich and fashionable couple, as can be seen in their elegant portraits by Francis Cotes. *(Figures 25 & 26)* However, the considerable cost of their improvements to the landscape and additions to the castle led to financial difficulties. In 1773 Myddleton's Steward had to order 'Mr Turner's works to be dropt as soon as possible'.[10] This was Joseph Turner, a Welsh architect, who had been employed to transform the inside of the mansion with neo-classical designs. He evidently collaborated with Emes in creating some of the built features within the landscape, including a 'Green House' in the garden

(1766). In 1770 he designed a main entrance, set back from the road, 'flanked by curving stone walls and two single-storey ashlar classical pavilions'.[11] The splendid wrought iron gates were removed from the forecourt and re-erected between the pavilions as the entrance to the new drive running uphill to the north side of the castle. The fate of the statues of Hercules and Mars recorded by the Steward was more ignominious:

> Hercules and Mars driven out of their court and turned back to back, the former dragged to his place of residence and rest near the deer barn in the lower park and the latter into the plantations in the upper park, they have been near neighbours to each other upwards of fifty years, and have not in all that time had an angry instance of friendship indeed.[12]

The gates were remarked upon by Byng when he reached Chirk in 1784:

> *Sunday July 18* Chirk Castle, whose boundaries we had enter'd by one of the most superb iron gates, ever seen, in general, iron gates are very shabby old furniture, but this is of such excellent workmanship, as shou'd attract admiration; and did formerly (as you may observe)

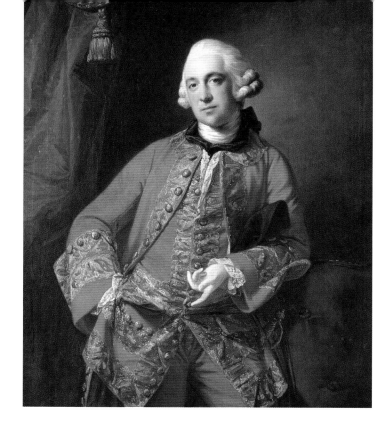

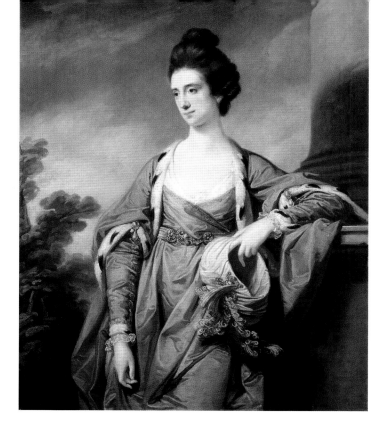

open to the front court.

All the approaching ground is pitifully dotted with mean plantations of fir and larch, and not of that magnitude to suit the size, and grandeur of the castle, which stands bare and expos'd.

If the walls were cloth'd with vines &c., and numbers of trees planted in the front, the present baldness wou'd be remov'd. If I find fault with the front part, I own myself pleased with the noble grove of oaks behind the castle, thro which we rode to a back gate of the park, that led to Chirk village.[13]

When he returned to Chirk in 1793, he commented on the siting of the kitchen garden:

A kitchen garden is a place of such luxury and necessity, and in which the master must wish frequently to walk to observe his hot-houses, fruit, &c., &c., that it should be very near the house and attach'd to the stable for the convenience of the dung. Now here it is, most strangely, one mile distant from the mansion! Why, Mr Myddleton might as well have his kitchen a quarter of a mile distant![14]

Fig. 25 & 26 Sir Richard & Lady Elizabeth Myddleton painted by Francis Cotes. By the 1770s when these portraits were commissioned Cotes had established himself as one of the most fashionable painters in London.

The 'present baldness' of Chirk described by Byng was noted by other travellers, such as Sir Christopher Sykes, who remarked that Chirk 'has a sullen cold naked look as you approach, and it would be much improved by some advanced Gate way'. *(Figure 28)* However, he was delighted with their treatment by the 'very genteel civil Housekeeper', who 'was also the only person in our Journey who refused to take a fee for her trouble'. Having viewed the castle, Sykes and his companions inspected the park:

The late owner or rather his Lady[15] made great and very Extensive plantations upon the Hills about it, in which there is now a ride of 4 miles, Mr Middleton's Chaplain & Steward was so polite as to take us round there, from various parts of which you have an unbounded rich and beautiful view.[16]

Fig. 27 A late eighteenth-century view of Chirk Castle showing young trees in the park. An engraving by P. Mozell after a painting by Moses Griffith.

Fig. 28 (left) Sir Richard Colt Hoare's view of the 'baldness' of Chirk Castle, from 'A Collection of Views of North Wales'.

In contrast, Warner, on his walking tour of Wales in the same year as Byng, rather approved of the stern grandeur of Chirk:

We bent our course towards Chirk Castle thro' the park, an extensive undulating tract of ground, adorned with noble plantations, scattered over it in a tasty and judicious manner. The situation of the mansion is very happy. It stands on the brow of a noble hill, exhibiting a view that stretches into 17 counties. There is something extremely

august and solemn in the building.[17] (Figure *28*)

After the 1770s there was little major change to the park and gardens until nearly a century later. The castle and its grounds were certainly considered worth visiting. Dr. Johnson and Mrs. Thrale visited on September 7, 1774, remarking that, 'Chirk Castle is by far the most enviable dwelling I have yet ever seen.'[18] When Colt Hoare reached Chirk in 1798, he viewed its surroundings with a critical eye:

> The removal of the stables on the left and a terrace wall substituted in their place would be an improvement. The castle stands on a gentle eminence, commanding a very extensive and distant view, the ground around it well-varied and planted. A piece of water, badly planned and managed, made on a hill, contrary to nature. It has been too general a custom first to think water absolutely necessary for the ornament of a park or garden, and then to form it on places where nature never designed it or would have placed it.

Fig. 29 Chirk Castle from the north in 1826 showing Emes's parkland as 'the best kind of park scenery'.

> Thus two errors are committed: Nature outraged, and a defect created instead of a beauty. A very handsome gateway of cast iron conducts you into the park. The Doric lodges are not massive enough in their proportions to correspond with the gates.[19]

Returning a year later, he discovered the abandoned figure of Hercules in the midst of 'a noble grove of lofty and aged oaks,' where 'an ancient British Druid would [be] more adapted'.[20] A few years later, John Broster informed his readers that, having seen Wynnstay, they could 'cross the Dee on the bounds of the extensive park and arrive at Chirk Castle', where 'by permission you may ride through the pleasure grounds on the mountain'.[21]

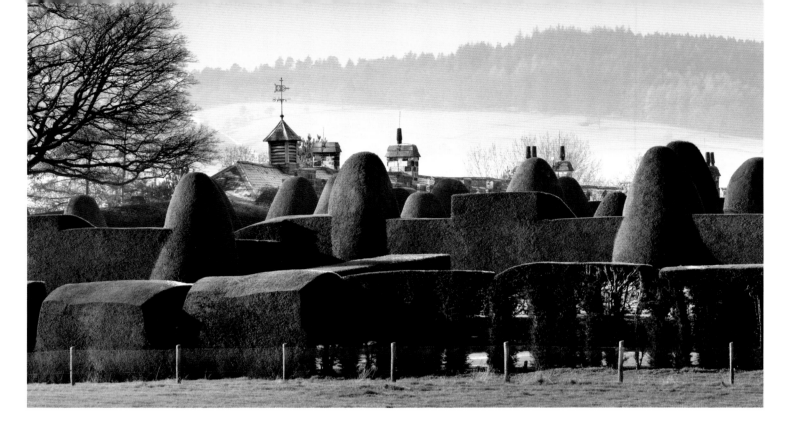

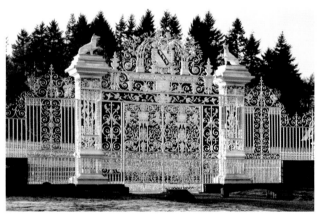

Fig. 30 (above) The late nineteenth-century yew topiary in the Formal Garden at Chirk, still a noted feature of the garden.

Fig. 31 The magnificent Davies gates, masterpieces of ironwork, in their final position.

Fig. 32 (right) Chirk Castle from the air, showing how the Victorian gardens sit with the great mediaeval Castle.

In 1796, on the death of Richard and Elizabeth's son, another Richard (1764-1796), who was unmarried, Chirk passed to his eldest sister, Charlotte Myddleton. She married, in 1801, Robert Biddulph of Ledbury, Herefordshire, and the family name became Myddleton Biddulph. Their son, Robert Myddleton Biddulph (1805-1872), succeeded his mother at Chirk in 1843. Shortly afterwards, Samuel Lewis, in his *Topographical Dictionary of Wales* (1849), described the now-mature parkland with a new road running through it:

The park is extensive, and is disposed with picturesque effect, the inequalities of its surface, and the declivity of the hill extending behind it and toward the north, having afforded a favourable scope for the arrangement of the trees and plantations. A new road, also, leading to the castle, in a winding direction through the park, so as to embrace a view of much interesting scenery in the valley of the Ceiriog, and avoid a steep hill, has been made of late, in lieu of that which formerly led from the village.[22]

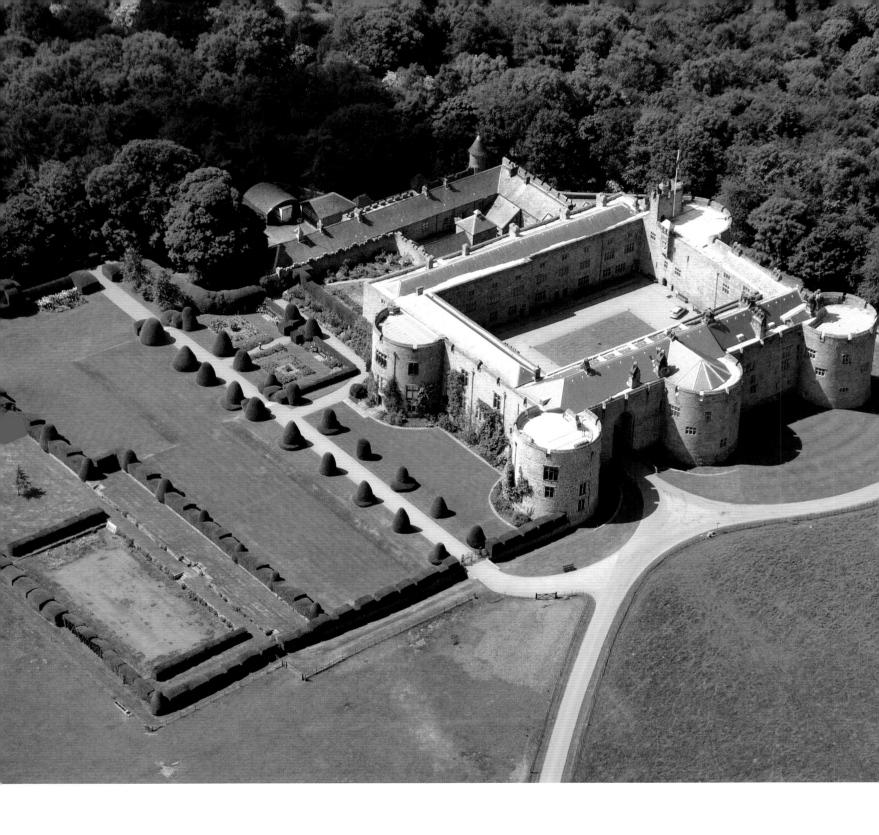

There were some additions to the garden features. For example, in 1854, on the site of Turner's 'Green House', a little conservatory was built to the design of Edward Welby Pugin, when he was working on the chapel and stables for Robert Myddleton Biddulph. This was the year that George Borrow made his walking tour of Wales, based on Llangollen. Chirk, 'abounding with all kinds of agreeable and romantic associations', was on his itinerary.[23] He described the park as, 'very lovely, consisting of a mixture of hill and dale, open space and forest, in fact the best kind of park scenery'. *(Figure 28)* Having been conducted all over the house by the 'genteel, good-looking' housekeeper,' they returned to the park, where their guide, John Jones, offered to show them something very remarkable:

After we had descended the avenue some way John Jones began to look about him. ...All of a sudden he exclaimed "There it is!" We looked and saw a large figure standing on a pedestal. On going up to it we found it to be a Hercules leaning on his club, indeed a copy of the Farnese Hercules, as we gathered from an inscription in Latin partly defaced. ...John Jones, in order that we might properly appreciate the size of the statue by contrasting it with his own body, got upon the pedestal and stood up beside the figure, to the elbow of which his head little more than reached.[24]

In 1872 Chirk passed to Richard Myddleton Biddulph (1837-1913), who changed the family name back to Myddleton in 1899. He made other changes, most particularly planting the yews that form the hedges and topiary for which Chirk is so well-known today. The garden lies to the east of the castle, set out in terraces linked with stone steps. These are one part of what were the great formal gardens. The cone-shaped yew topiary forms a border to the terraces and includes a yew arbour called the 'Crown on a Cushion'. *(Figure 30)* It is clear that in the nineteenth century the family had a great taste for everything Gothic, employing as they did Augustus Welby Pugin, famous for his designs for the interior of the Houses of Parliament, to provide decorative schemes for the castle (1845-48), as well as his son's work mentioned above. Alterations to the Chapel

were commissioned from Sir Arthur Blomfield, another Gothic Revivalist architect, in 1894. His nephew, Reginald Blomfield, was the great protagonist of the revival of the formal garden and, although he did not work at Chirk, the Myddleton's Gothic taste in the garden reflected his view that:

The long yew-hedge is clipped and shorn because we want its firm boundary lines and the plain mass of colour; the grass bank is formed into a definite slope to attain the beauty of close-shaven turf at varied angles to the light. The broad grass walk, ...is cool to walk upon in summer and dry on the pavement in winter. This is the feeling that one would wish to see realised in the garden again...the delicate touch of the artist, the finer scholarship which loves the past and holds the key to its meaning.[25]

Richard Myddleton welcomed visitors to Chirk on a regular basis. A notice records that: 'Chirk was open for two afternoons a week throughout the summer at a charge of a shilling, the proceeds being given to charity'.[26] In 1888, when the railway arrived at Chirk, the great gates were moved to their present position at the end of Station Avenue, providing easy access for house guests arriving by train – and, presumably for tourists too. *(Figure 31)*

However splendid Chirk appeared to the public, as the nineteenth century drew to a close all was not well with the funding of this great house. The crippling agricultural depression of the 1890s was keenly felt in north Wales. This reduced the rent roll and farming income and the agricultural estate at Chirk became insufficient to support the running of such an elaborate house and gardens. These difficulties reflect the difference between great estates based on land and farming and those supported by the wealth generated by industry. The Penrhyn Estate, for example, owned more land in Gwynedd than anyone else and was the third-largest estate in Wales, but it was the income derived from the slate quarries that was the estate's driving force. Although the Myddletons had some industrial interests, their income did not come close to that of the Penrhyns. By 1911 Chirk Castle had been leased to Lord Howard de Walden and the Myddleton family did not return to Chirk until 1946.

MARGAM ABBEY

Margam Abbey, in Glamorgan, south Wales, was another property with its roots in Tudor history that impressed Dineley. Originally a Cistercian foundation, the abbey and its lands were purchased by Sir Rice Mansel (1487-1559), during the dissolution of the monasteries in 1540. He set about creating a mansion, incorporating some of the abbey buildings that could be described by the late sixteenth century as, 'a faire and sumptuous house'.[1] On August 16, 1684, the Duke of Beaufort and his companions 'were conducted by Sir Edward Mansell and his son…to his Summer Banquetting house built after ye Italian [style] – the pavements are of marbles black red mixt and white chiefly the product of his own quarries'.[2]

The 'Banquetting house' overlooked the deer park, where the guests were 'entertained with the pastime of seeing a brace of Bucks ran down by three footmen'. Dineley considered that 'Margham is a very noble seat', and the modern additions, including new stables, 'very stately'. 'Its situation is among excellent springs furnishing all offices thereof with excellent water, att the foot of prodigious high hills of Woods.' *(Figure 33)*

Some twenty years later, two paintings of Margam, probably commissioned by Sir Edward Mansel (1637-1706), showed how the gardens and the house had continued to develop. The view of the house looking north from the sea *(Figure 34)* reveals that the Abbey gatehouse shown by Dineley had gone, while the main approach to the house was formalised with a series of splendid gates, leading guests and visitors up a tree-lined avenue. The prospect from the mansion *(Figure 35)* shows how the building was wrapped around the Abbey's Chapter House. A small knot garden lies to the west, with another beside the fishponds, and the deer park rolls east and south from the Banqueting House. This building was clearly of some size and, with its flat roof to the rear, probably served as a viewing platform to observe the deer and plan a day's sport.

Dineley's descriptions of Margam and the two paintings pre-date the arrival of the orange trees that redounded to the fame of Margam down the centuries. Legend says that the original citrus trees were rescued from a shipwreck and that Sir Thomas Mansel, later the first Baron Mansel (1668-1723),

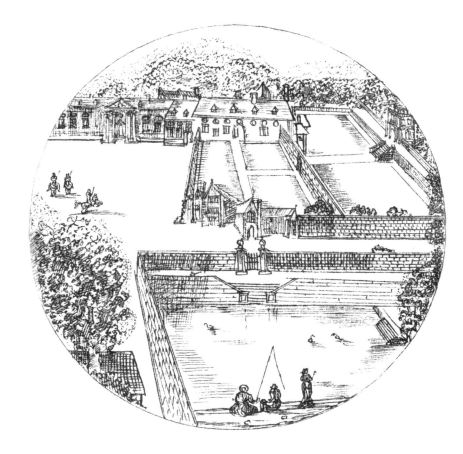

who was Comptroller to the Household of Queen Anne, presented her with some of their fruit every year. Certainly, a list of greenhouse plants provided by Joseph Kirkman, the gardener at Margam in 1727, noted 120 orange, lemon and citrus trees among them. Lord Lyttelton, writing in 1756, related that:

> In the garden they have fourscore large trees, mostly oranges and lemons and some citrons and bergamots, which usually supply the family with fruit; … They say that the original of them were taken out of a shipwreck and that they have kept them up ever since by grafting.[3]

Fig. 33 Dineley's drawing of Margam with the ancient abbey Gatehouse at the front, overlooking fishponds (long filled in) and the Summer Banqueting House up the flight of steps to the right.

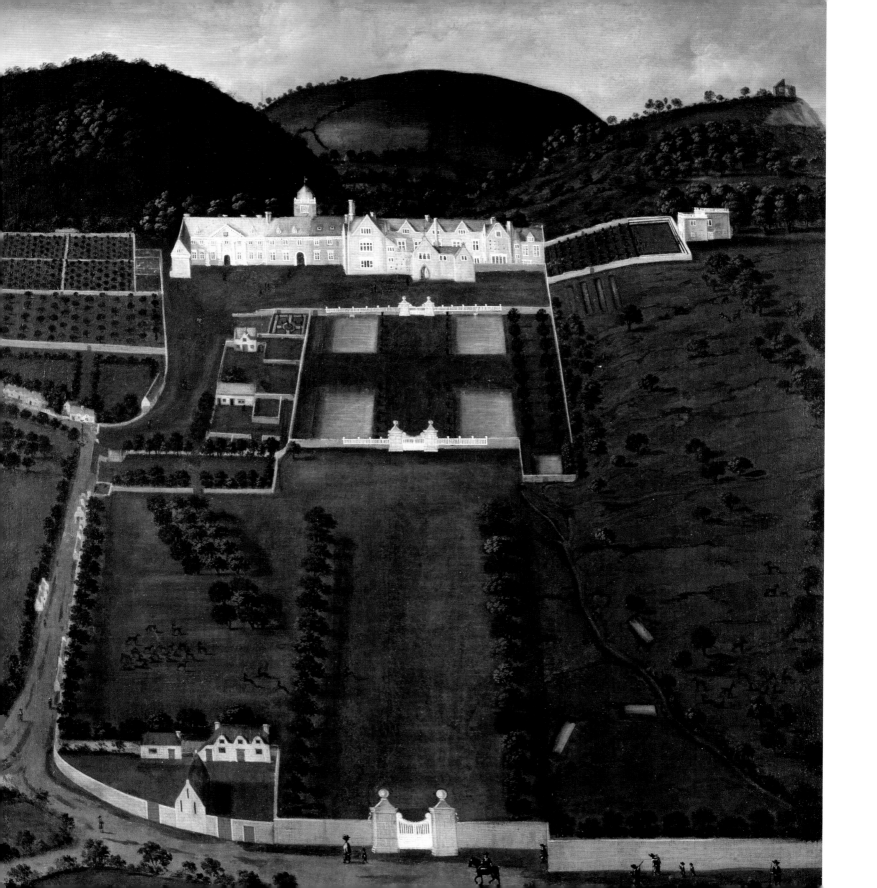

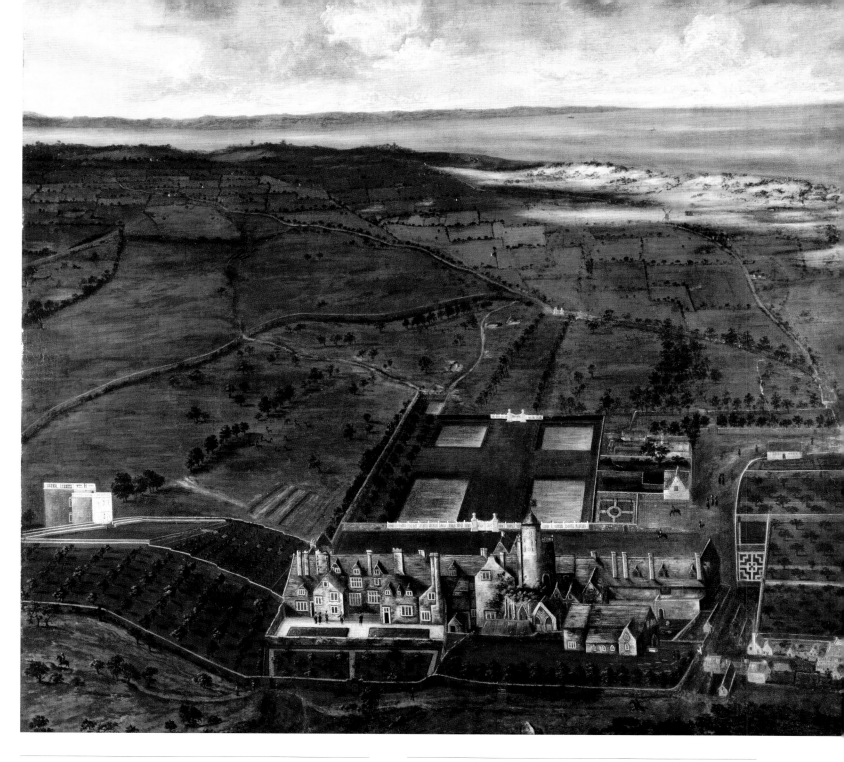

Fig. 34 (left) Margam House looking north. Oil on canvas, c. 1700.

Fig. 35 (above) Margam House, Glamorgan, looking south. Oil on canvas, c. 1700.

These orange trees filled a beautiful Orangery, built at Margam by Thomas Mansel Talbot (1747-1813).[4] In 1768 he had set out on the Grand Tour, returning home in 1772. Once back in Wales, he decided that the old mansion at Margam was not to his taste and he removed to another family estate, Penrice on the Gower Peninsula, where he set about creating a suitably Palladian villa, described as having 'all the elegance of Twickenham', in a remote corner of Wales. *(Figure 38)*

As its construction came to a close, he turned his attention back to Margam and ordered the building of a classical Orangery. Attributed to the architect Anthony Keck, who had designed Penrice, building began in 1786, and by the end of September 1789 some of the orange trees could be moved into their new home.[5] It was designed with large double doors at the back of the Orangery, affording access to move the orange trees in and out. It took three years to build and, at 327 ft long with pavilions at either end, it remains the longest such building in Britain. *(Figure 36)* In a letter to his friend, Michael Hicks Beach, Mansel Talbot described how he used the stones from the great old abbey to enclose the Orangery:

> My Dear Sir... I am very busy now in finishing my green houses at Margam by an inclosure of that with a high stone wall from the materials of the old mansion. The remainder

Fig. 36 (above left) The front of the Orangery at Margam.

Fig. 37 (above) Thomas Mansel Talbot commissioned this bust of himself while he was in Rome on the Grand Tour. It cost him the grand sum of £68. The Irish sculptor Christopher Hewetson specialised in portrait busts of British visitors on the Grand Tour.

Fig. 38 (right) The Orangery and Chapter House at Margam, a watercolour by Thomas Hornor, c. 1819.

> of its walls are now levelling and covering with earth & trees, no more to be seen – when I have the pleasure of seeing you here next summer there will only be the old paintings of it to look at, what a mass of buildings it was...[6]

In August 1787 Byng made his *Tour into South Wales*. He found Margam 'in much disorder' and sounded forth in good splenetic form:

> The Gardener attended me to the Magnificent Green House, building for the Reception of the Orange Trees, for which this garden has long been famous; and which are placed (in pitiful tubs for their growth) in a circular spot beneath

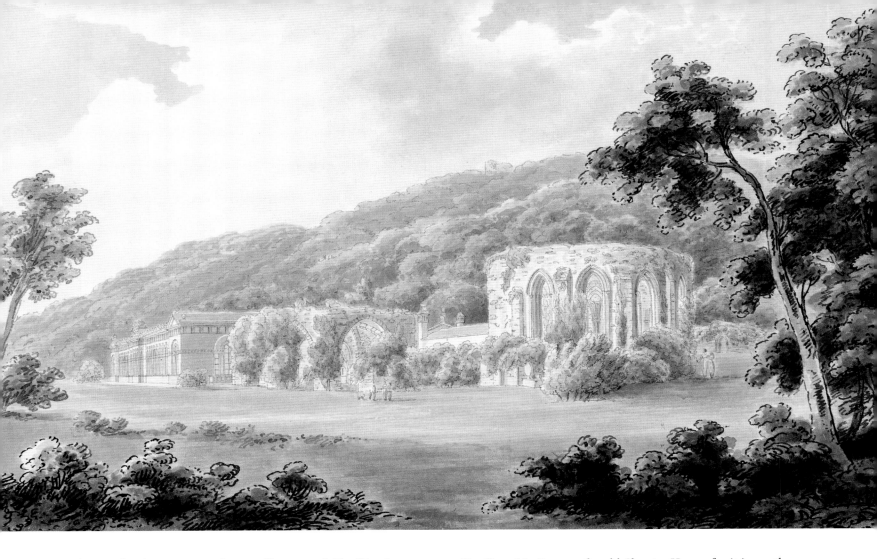

the woods. They appear to be very ill managed. The Wood Walks are very choak'd up, and every thing is in Ruin – By Mr T's beginning to build a fine New Green-House, we may suppose he wou'd soon create a new Dwelling House.
The present miserable Mansion is built upon the Site of the Old Priory of which there remain several beautifully vaulted Offices....
Probably, Mr T, a travell'd Gentleman, knows not of, or esteems this Treasure [the Chapter House]; but puts more store by some (unpacked) Boxes of Statutes (as the maid call'd them). He has brought them from Italy. This is one of the advantages of Travell, to come home with a vamp'd Correggio, and some shabby marbles, and then neglect the real antiquities, and Old Pictures at your Family seat!

But Pray, Mr. T, spare the old Chapter House, for it is worth more than all your orange trees, or your stag, to boot, or, even, your curiosities from Italy.[7] *(Figure 38)*

The last remnants of the old mansion were removed in 1793. Colt Hoare recorded in July of that year 'the mansion house nearly pulled down', and he 'viewed with grief the ruinous state of the chapter house'.[8] The grounds around it were levelled and laid out as pleasure grounds. Emes, who had worked on the grounds of Penrice, was asked for his advice for the grounds at Margam in 1779, but no plans or accounts survive.[9] Sir Christopher Sykes, revealing his passion for measuring things, described, 'the New green house' and how it was operated:

...an emince long building near 300 ft 8 ins wide besides the room at each end one intended for a library, the other to receive a Col: of fine statues made by Mr M........20 Y[ears] ago but never opened before the last Year. Some excellent busts and Statues -, but the gardener was totally ignorant of the names, and some of them were only half out of their packing cases, all of this was our unexpected treat as I had never heard of them.

On a Green before the old Green house neare the Orange and Lemon trees of 11 sorts the prettiest is the Nutmeg Orange tree, some others are very large several I measured were exactly two feet in Circumference in the Stem, and might be 10 or 11 feet high, in tubs of 2 ft and 3 ft 6 ins. But he said 3 ft was large enough for any, They looked healthy and are kept hardy, a little frost at night does no harm He sets then out the Middle of May, and they remain until about the 30th of Octr. There are 8 fire places under the floor, but he never lights them except when He fears the frost entering the house, He puts matts up on the inside as there are no shutters. There are some fine tulip trees one said to be the largest in Engl. He said 90 ft high, I think about 50 but it is a fine healthy tree and would be full of flowers in a few days.[10]

Not all visitors were impressed by the Orangery. Warner, visiting Margam on August 11, 1798, wrote that he did not like 'the unpleasant effect' of the 'stiles of architecture so completely dissimilar as the Chapter-house and the green-house, the one of a simple gothic structure, the other a splendid classical building'. He went on to say:

On entering the green-house, we were immediately struck with the want of due *proportion* between the length, breadth, and height of it – it is impossible there can be any beauty in a room one hundred and nine yards long and only twenty-seven yards wide.

He thought better of the pleasure ground, 'designed with taste, in the centre of which is an artificial pond, round which are placed, during the summer months, the tubs containing the orange trees'.[11]

By 1800 other greenhouses had been demolished and a new Citrus House, a glasshouse 150 ft long, was built to house a great

Fig. 40 A detail from the 1814 Estate map of Margam, drawn by Robert Wright Hall of Cirencester. The Orangery is clearly marked and the field marked '4' is approximately where the new mansion would be built twenty years later.

collection of citrus trees. *(Figure 39)* Colt Hoare, on another visit to Margam in 1802, noted that here 'the orange and lemon trees are trained against the wall on a treillage and their fruit thereby very much forwarded'.[12] Nicholson's *Cambrian Traveller's Companion*, first written in 1808, provided a good description:

> The trees in the green-house [the Orangery] are all standards, planted in square boxes, and have remarkably round branching heads. They are about 100 in number, and many of them 18 ft. high. About 40 in the conservatory [Citrus House] are planted in natural earth, and traced against a trellis framing, where the fruit attains its native size and flavour. The collection consists of the Seville, China Cedra, Pomegranate, Curl-Leaved, and Nutmeg Orange, Lemons, Burgamots, Citrons, and Shadocks.[13] The pleasure ground surrounding these orangeries, is peculiarly favourable to the growth of evergreens; among these a bay tree sprouting from one root in various branches, is upwards of 60 ft. high, supposed to be the largest in the world. The arbuti are innumerable; among which are scattered hollies, the Portugal laurel, &c., which attain an extraordinary size,

Fig. 41 Christopher Mansel Talbot in 1834. At this stage he had represented Glamorgan as a Liberal M.P. for four years, remaining an M.P. until he died in 1890 as 'Father of the House'. Pencil & chalk drawing by Alfred, Count D'Orsay.

Fig. 42 (above left) The façade of the Banqueting House, installed as the Temple of the Four Seasons after its recent restoration.

and present a rich and luxurious appearance. The care of Margam is assigned to a gardener, who is allowed to admit strangers, and frequently attends them through the walks.[14]

Edward Donovan also noted that the gardener 'is allowed to admit strangers of respectable appearance',[15] reflecting the fact that the Orangery, its pleasure ground and abbey ruins were readily accessible to visitors. With the mansion gone, when the Talbot family wished to come and visit Margam from Penrice they stayed at Margam Cottage, a house in the grounds. Agnes Porter, the Talbot family governess, writing in 1830, tells us that when she brought the children over to Margam from Penrice, the 'cottage' could accommodate twenty people. Visitors did find

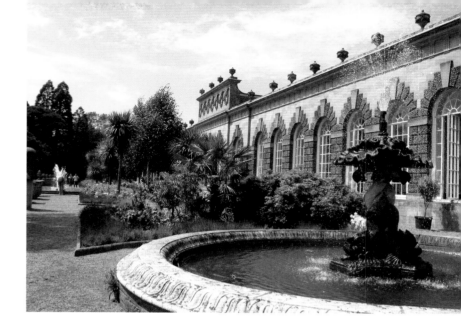

Fig. 43 The nineteenth-century terrace in front of the Orangery with one of two remaining fountains.

the absence of the mansion a little strange. Margaret Martineau remarked in 1824: 'It is a singular thing to see flower gardens, orangery, conservatory and spreading lawn with every sort of beautiful shrub and tree flourishing in this mild and fertile spot and yet no house'.[16] *(Figure 40)*

Christopher Mansel Talbot (1803-1890), as Liberal MP for Glamorgan and with a keen interest in public life, considered the elegant Penrice too far out of the way for his main residence and decided to return to Margam. *(Figure 41)* Like his father, Talbot had been on the Grand Tour and so, perhaps, appreciated the splendid Italianate Orangery lying across the site of the old mansion. Every trace of this house had disappeared by 1803, when Benjamin Malkin recorded that, 'there is at present no mansion house'.[17] Talbot decided to site his new home to the east of it, on the higher ground where the Banqueting House stood. He commissioned Thomas Hopper to design an enormous Tudor Gothic house. Work began in 1830 and continued for ten years. In 1835 the Banqueting House was demolished and its façade removed. Today it is built into the walled garden as the back of the gardener's house and is named 'The Temple of the Four Seasons'. The small statues were installed in the niches at this time. *(Figure 42)*

Edward Haycock of Shrewsbury (1790-1870), often described as the architect of Regency Wales, was the supervisory architect and designed parts of the interior and exterior of the house, as well as stables, terraces and lodges. Other radical changes were necessary, and the inhabitants of the little village of Margam, lying as it did immediately in the view of the new house, were resettled in Groes, a model village built by Haycock,[18] and the buildings razed to the ground. The site was largely covered by the kitchen gardens, some five acres in all, created for the new mansion. The glasshouses, apart from the Citrus House, included a forcing house, a fruit room, Mushroom House, Melon ground, vineries, Pine Store and Peach House.[19]

Even while the impressive new mansion was being built, parties of tourists still gained admittance to the grounds. In 1836, one visitor, Esther Williams, recorded that:

After dinner we formed a party to visit Margam abbey and house. ...The abbey is situated just behind the church we had attended the day before. It is a sound ruin of Gothic structure, and now overgrown with ivy, but having seen Tintern so recently we were not so well prepared to appreciate its beauty. The abbey grounds on which it stands are the property of Mr Talbot, the squire of the place who is now building a splendid mansion in sight of the ruins. ... The garden too is quite in keeping with the house, and may boast some rare flowers.[20]

The vast wealth necessary to build the house, add to the gardens and support a lavish lifestyle came from Talbot's early investment in ironworks from 1831 onwards, dockyards – the little local harbour of Aberavon was renamed Port Talbot after it was opened in 1837 – and he pioneered the introduction of the railway across south Wales. He was very successful and was known as the wealthiest commoner in Britain.

The new mansion, soon christened Margam Castle, had gardens to reflect its Tudor style, interpreted in nineteenth-century fashion. *(Figure 41)* The scheme was entirely Talbot's

and he gave strict instructions not to deviate from his plans.[21] These included an ornate, very wide terrace across the south and west aspects of the house. Running westward from the mansion was the Broad Walk, linked to the house by a grand flight of steps and carrying the eye down to the Chapter House and Orangery. The Orangery terrace, described as Italian gardens with three fountains, fed from a new lake above, was built later in 1852-53. (*Figure 43*)

Fig. 44 Hopper's Margam Castle seen from the Deer Park, a pencil and wash drawing by Lady Charlotte Louise Traherne.

Within twenty years of their creation, expert gardeners such as Andrew Pettigrew, the renowned Head Gardener for the Earl of Bute at Cardiff Castle, were writing about Margam. In the *Journal of Horticulture* in August 1878 he described it as, 'one of the most charming seats in south Wales...which deserves to be more widely known'.[22] The Orangery, 'the vast and elegant Doric building...with three graceful fountains in front...' was still worthy of remark. He admired the planting adjacent to it: 'thick clusters of Shrubbery which surround the cleanly-kept lawn have many plants of rare excellence. Wellingtonias from 50 to 60 ft high'.[23] In a second article, Pettigrew commented that:

the Orangery distinguishes it [Margam] from all other places in Britain...we think the trees cannot number less than two hundred, which for size and variety are unequalled in any establishment in the country...About the middle of October the Orange trees are taken inside the Orangery by means of a carriage specially designed to lift and carry them.[24]

Today, as you stand in what is now Margam Country Park, you catch glimpses of the giant Tata steel works at Port Talbot above the trees to the south-west. However, you do not encounter industrial pollution on the scale met with towards the end of the nineteenth century, as the industry generated by Talbot investment grew and grew. *The Gardeners' Chronicle*, in 1881, related how the writer and his companion followed the road: '...past copper works and tin-plate manufactures, and through a smoke-laden atmosphere that certainly would not lead one to expect such luxuriant vegetation as is displayed in the woods around Margam a couple of miles further on.' *The Gardeners' Chronicle* described how Talbot's ideas had matured, with 'the terraced flower gardens, separated from the park by massive ornamental balustrades... The whole of the beds ...are laid out in the Italian style, with portions of grass and gravel walks between the beds'. There was great use of specimen trees, and on a lower level from the Orangery was:

A perfect amphitheatre...in the centre is a large fountain with massive basin containing water lilies, and around this a large circular lawn on which in two rows stand three dozen of the largest Orange trees in the United Kingdom.[25]

In 1888, 'A Tourist' wrote a reminiscence of Mr Muir, the Head Gardener at Margam, describing the Broad Walk:

Through a vista formed by noble trees you see the mansion on the rising ground beyond and reach it by an ascent of broad and high flights of steps at intervals along the way.... Mr and Mrs Talbot usually arriving home from their yachting cruise towards the end of September, Mr Muir endeavours to have the flower beds on the terrace attractive then.

At the opposite ends of the house [the Citrus House] Solanum jasminoides is established and grows right through the roof, its flowers hanging down in wreaths, and of a size I have never seen equalled, nor had Mr W. Watson of Kew, who was my co-admirer of it, and who pronounced Margam as his ideal of a garden.[26]

One fascinating aside offered by the Tourist was that they were 'drying tobacco in the Orangery in September, and in November I had a sample [presumably a cigarette], manufactured from it by Mr Wills of Bristol'.

Fig. 45 Miss Emily Charlotte Talbot had her father's energy and commitment to Margam. It is said she placed her workers' welfare ahead of profit margins, and did a lot to channel the family wealth back into the community..

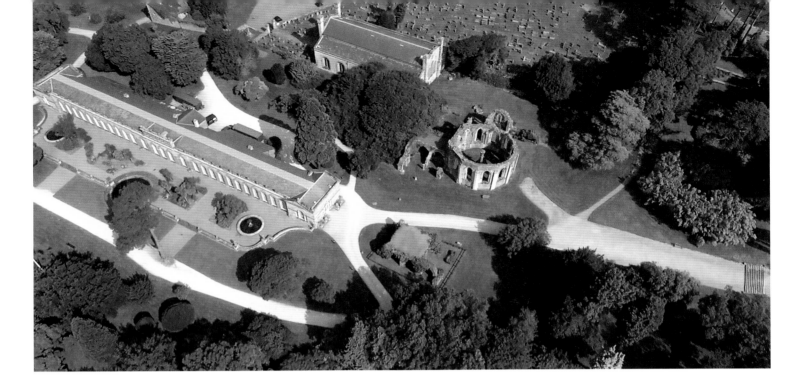

Talbot's daughter, Emily Charlotte Talbot (1840–1918) *(Figure 45)*, inherited Margam when her father died, as her brother, Talbot's only son, was killed in a hunting accident in 1876. She became one of the richest women in Britain, inheriting not only her father's estates and wealth but also his business acumen. *The Gardeners' Chronicle*, describing 'a short visit made last autumn' in 1893, said the Castle now belonged 'to Miss Talbot', and that 'many of the greenhouses now used are new, and were built some three and a half years ago by Messrs. Messenger & Co., Loughborough, and have given Mr Muir a much better chance with his Grapes and other things than was possible with the houses badly heated by the flues described in 1881'.[27]

This work was carried out just as Emily Talbot inherited Margam and, in addition to the great range of glasshouses for almost every kind of fruit and plant, there was now a new house devoted to 'large specimen Palms'. Much of the piece written in 1881 still held good, and so the writer of 1893 did not repeat those glowing descriptions. Some new notes included the fact that orange blossom from Margam was supplied for 'the royal marriage last July',[28] and that the groups of *Hydrangea hortensis* were so splendid 'as are rarely, if ever, seen in this country'.[29] This was only the beginning of Emily's plans and

projects for the gardens at Margam. Over more than twenty-five years, until her death in 1918, the gardens were maintained to the highest standard, with new plans and additions made. As she was almost fifty years old when she inherited Margam, Emily's taste was firmly rooted in the nineteenth rather than the twentieth century, as the descriptions of her gardens that survive from the beginning of the new century show. Standing at Margam today, you can still appreciate the view described by Andrew Pettigrew nearly 140 years ago, who felt that:

> It appeals strongly to one's sense of the beautiful to stand at a little distance and view the ruins of the abbey with the Orange house and church in front, relieved against the pyramidical-shaped hill clothed to the very summit with the sober-tinted foliage of the thickly-clustered Oak trees. *(Figure 46)*

Fig. 46 An aerial view of the central part of Margam's grounds today.

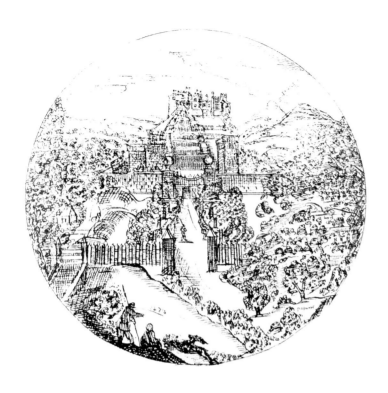

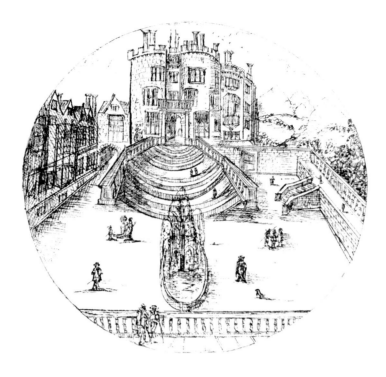

POWIS CASTLE

Known in Welsh as Y Castell Coch, the Red Castle, Dineley's drawings of Powis Castle, made during the Beaufort Progress in 1684, provide the first glimpse of what its surroundings looked like. *(Figures 47 & 48)* Powis welcomed the Duke and his entourage twice during their travels through Wales. This was possibly because the Duke's sister, Elizabeth, was married to William Herbert, 1st Earl, later Marquess of Powis (c. 1626-1696). Dineley's drawings do not show the great garden terraces blasted out of the red sandstone, but the work was certainly undertaken around this time. The design was considered to reflect Herbert's Jacobite taste as a Catholic and strong supporter of James II. He had inherited Powis in 1667 and set about making considerable alterations and improvements to the castle and its surroundings. The works on the castle and its gardens are attributed to Captain William Winde, an architect and soldier, who had built the Powis's London home, Powis House (later Newcastle House), in Lincoln's Inn Fields (1684-9).

Fig. 47 (above left) Powis Castle as approached from the west, drawn by Thomas Dineley.
Fig. 48 (above right) The courtyard of Powis Castle with its fountain and balustrades. The terraces lay below the balustrade on the right.

Following the Glorious Revolution of 1688, Elizabeth Powis, as Governess to the infant Prince James (later the Old Pretender), accompanied her husband following the King into exile in France, living with his court at St Germain-en-Laye.[1] *(Figures 49 & 50)* From engravings, it can be seen that these now-lost gardens in France bore a strong resemblance to Powis.

On the family's return from their French exile in 1703, a list of servants accompanying the wife of the 2nd Marquess [2] from Holland included 'Adrian Duval, native of Rouen: three months ago Lady Powis took him into her service at Ghent as a gardener. Has never been in England before'.[3] Duval appears

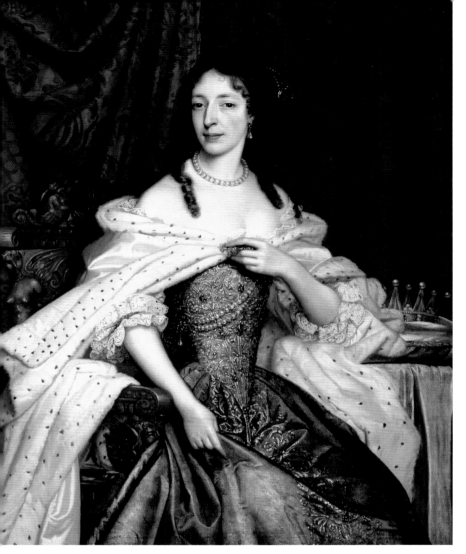

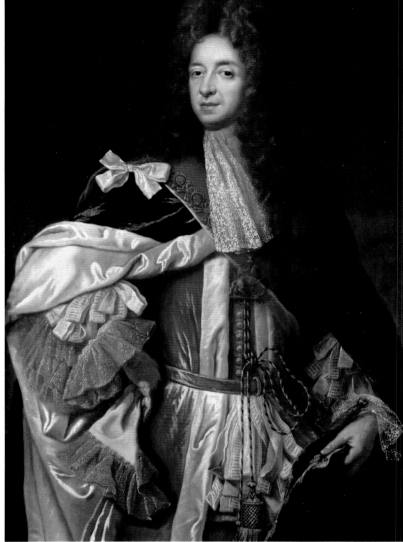

Fig. 49 Lady Elizabeth Somerset, later 1st Countess and Duchess of Powis, painted by John Michael Wright.

Fig. 50 Sir William Herbert, later the 1st Earl and 1st Marquis/Duke of Powis in his Garter robes. He was created a Knight of the Garter by James II while in exile in France. Painting by François de Troy.

to have been brought to Powis to continue the construction of the garden and possibly to continue William Winde's plans. Sir John Bridgeman, 3rd Baronet, was Winde's cousin by marriage and had used his help and advice in creating the gardens at Castle Bromwich Hall, in the West Midlands. Visiting Powis in 1705, he recorded: 'I din'd this week at Powis Castle the water-works and fountains that are finished there are much beyond anything I ever saw whose streams play near twenty yards in height the Cascade has 100 falls of water which concludes in a noble Bason.'[4]

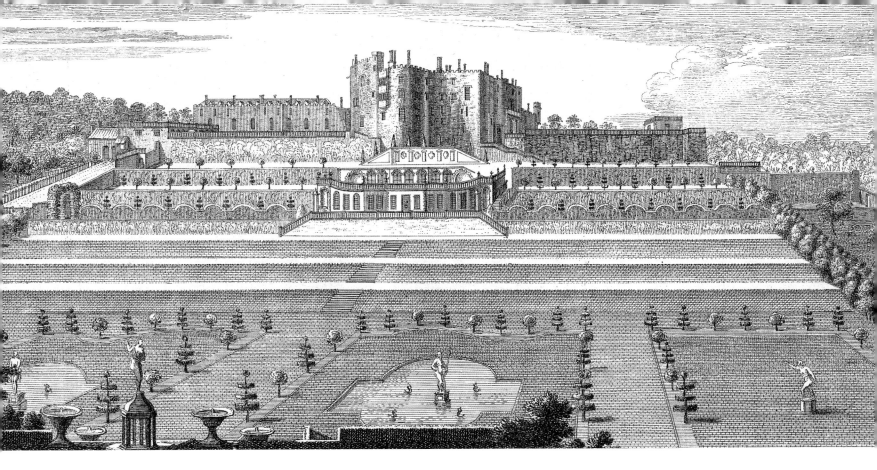

During a 'journey of 18 weeks' in 1732, John Loveday gave more details of the gardens at Powis Castle:

About 30 Years since, ye Gardens were made at great expense, they have an abundance of fruit. The smaller Patch, at ye front of ye house, was clear'd from Rock by many hands working a long time; ye lower Gardens were full of Wood and Rubbish, they were laid out by a Frenchman; ye great scarcity of gravel in ye Countrey makes ye Walks appear very bare & dirty; You go down to 'em by a great many steps, from thence you see the Castle is situate on a most strong red Rock...These Gardens are very large containing many long Walks in Woods. Here is a good brick Green-house, in it a very large Aloe, one of its leaves 4 foot long. An Aviary too, but not stock'd. The Water-Works in ye Garden are finer than I have seen elsewhere, several Leaden Cisterns, one lower than another, like so many stairs, when Water is convey'd into ye first, make a noble Cascade; Stone

Fig. 51 'The South East view of Powis Castle' and its gardens, from Buck's *Antiquities or Venerable Remains of Above 400 Castles, in England & Wales, with near 100 Views of Cities*, 1742.

Basons or Cisterns also, on each side down ye Descent are with ye same design. Higher than this, an open Room, call'd *ye Grotto*, where are Shells set in regular figures in ye Wall.[5]

The engraving by Samuel and Nathaniel Buck of the gardens at Powis (*Figure 51*), with wedding-cake topiary around the pools and the famously vast yews in their infancy, echoes this description. The view looks towards the Castle, with the terraces ascending from the pools and fountains. While you can see a pair of urns and a little temple topped with a statue focused on the castle, the artist is behind the cascade, so there is no contemporary view of it. Today there is no trace of the cascade and *'ye Grotto'*.

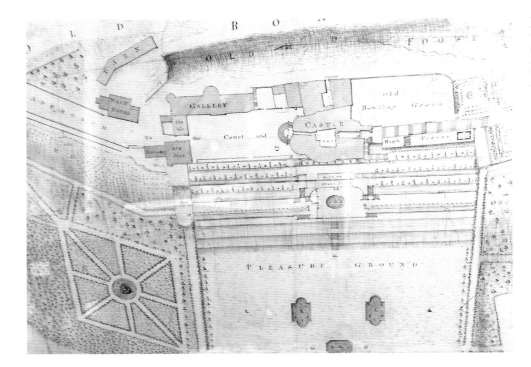

When Lord Lyttelton made his tour into Wales in 1756, he found the countryside very much to his taste, although, perhaps with his views honed by his experience of creating the much-admired landscaped park and gardens at Hagley Park in Staffordshire, he was always able to find room for improvement, as at Powis:

From thence we travelled, with infinite pleasure, (through the most charming country my eyes ever beheld, or my imagination can paint) to Powis Castle; … there are still remains of a great house, situated so finely, and so nobly, that, were I in the place of lord Powis, I should forsake Okely Park[6] with all its beauties, and fix my seat as near there, as the most eligible in every respect…. It stands upon the side of a very high hill; below lies a vale of incomparable beauty, with the Severn winding through it, the town Welsh-pool, terminated with high mountains…. above the castle is a long ridge of hills, finely shaded, part of which is the park; and still higher is a terrace, up to which you are led through very fine lawns, from whence you have a view that exceeds all description… The castle has an old-fashioned garden just under it; which a few alterations might make very pretty; for there is a command of water and wood in it, which may be so managed as to produce all the beauties that art can add to what liberal nature has so lavishly done for this place.[7]

The 'old-fashioned garden' as it was in 1771 is shown in the survey plan by Thomas Farnolls Pritchard, made for Henry Herbert, the 1st Earl of Powis (second creation). This clearly illustrates the by-now old-fashioned seventeenth-century viewing mount to the south-west, a bowling green, and the ornamental pools below the castle. (*Figure 52*) A year later, his son George, as the 2nd Earl, inherited the estate and the alterations that Lyttelton thought might make Powis very pretty were in train. William Emes, as 'a Layer out of Lands and pleasure grounds', was invited to make proposals for the castle grounds. His ideas, presented in 1772 with his 'Plan of the Park and Demesne lands…with general alterations', were radical.

The Plan *(Figures 53 & 54)* shows that he intended to leave no trace of the formal terracing and water features. Richard Payne Knight, full of fervour for the Picturesque and no friend to the Brownian ideal of sweeping, open landscape, persuaded the Earl to reconsider Emes's plan to destroy the terraces by blowing them up. Emes did carry out work in the park planting many trees, and was responsible for creating the Wilderness opposite the terraces, as shown in his plan. In 1778 he produced designs for the walled kitchen garden. However, George relished the fleshpots of London and rarely came to Wales. The work of his agent carried on nonetheless and a vast survey of the home demesne was drawn up c. 1785. It provided two views of the castle and its surroundings as they were at the time. *(Figures 55 & 56)*

The Earl ran up huge debts with his prodigal lifestyle and this became evident in the state of the castle and its gardens. By 1794, Byng found that: 'in the gardens, which were laid out in the wretched taste of steps, statues, & pavilions, not even the fruit is attended to; the balustrades and terraces are falling down, and the horses graze on the parterres!!!' Byng disagreed with Lyttelton, who had thought that '3000£ would render this a superb place.Now I would suppose that 3000£ were necessary to put it into proper trim'.[8]

The state of the gardens possibly reflected how taste in gardens had changed considerably during the eighteenth century. Warner found the situation 'elevated and splendid' but thought its 'two immense terraces in the style of last century', and compared it to 'Timon's villa':

Lo, what huge heaps of littleness around!
The whole a laboured quarry above ground;
Two cupids squirt before: a lake behind
Improves the keenness of the northern wind.
His gardens next your admiration call,
On every side you look, behold the wall!
No pleasing intricacies intervene,
No artful wildness to perplex the scene;
Grove nods at grove, each alley has a brother,
And half the platform just reflects the other.[9]

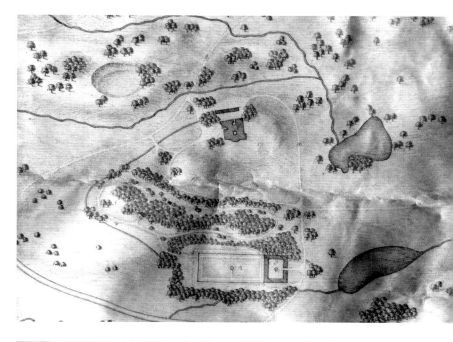

Fig. 53 & 54 (above) Detail from William Emes' proposed plan for 'Alteration's at Powis Castle with no trace of the formal gardens; (below) the dedication of the Plan.

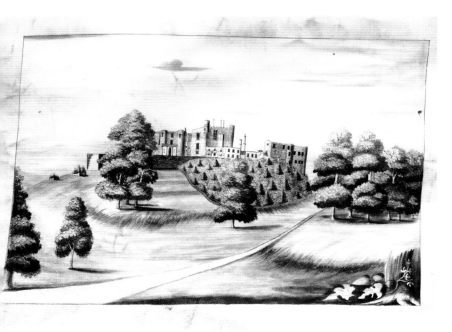

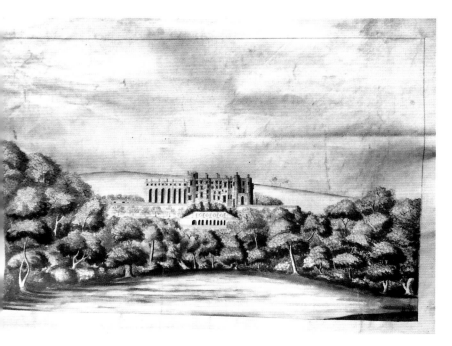

Fig. 55 & 56 Two cartouche views, drawn on vellum, of Powis Castle from the 1785 Estate map: (above) the East front, and (below) seen from the south.

As the eighteenth century closed, visitors' accounts related the continuing decay of Powis. The Rev. John Evans commented in 1798 that:

> This venerable castle is going fast to decay. The buildings are in a state of dilapidation; the garden and grounds are neglected, and the pride and ornament of the park is being removed for the sake of the timber. What the hand of time is doing for the one, the hand of avarice is doing for the other; so that at no very distant period the beauty and magnificence of Powys will be no more, and some poor drivelling boy will have to shew the passing traveller the spot where brave Cadwgan lived.[10]

This view was reinforced by Skrine, visiting at the same time, for while he felt that the 'sloping hills and swelling lawns of the park, covered with thick plantations, and decorated with abundance of fine timber, form a magnificent outline to the place', the 'neglected state it had long languished in deducts still more from its consequence'.[11] Colt Hoare compared Powis's gardens with the Villa D'Este at Tivoli, near Rome, and felt that, although the gardens and terraces were much neglected, it was a pity that:

> The modern taste of gardening has entirely put this old mode of laying out grounds out of countenance, for certainly it has a great dignity of character in it. It will not suit all situations but it is the only one fit for Powys Castle, from whence you could descend by no other means into the gardens but by a long flight of steps. This still remains as an approach from beneath. The walls overhung with fine ivy etc. have a very good effect.[12]

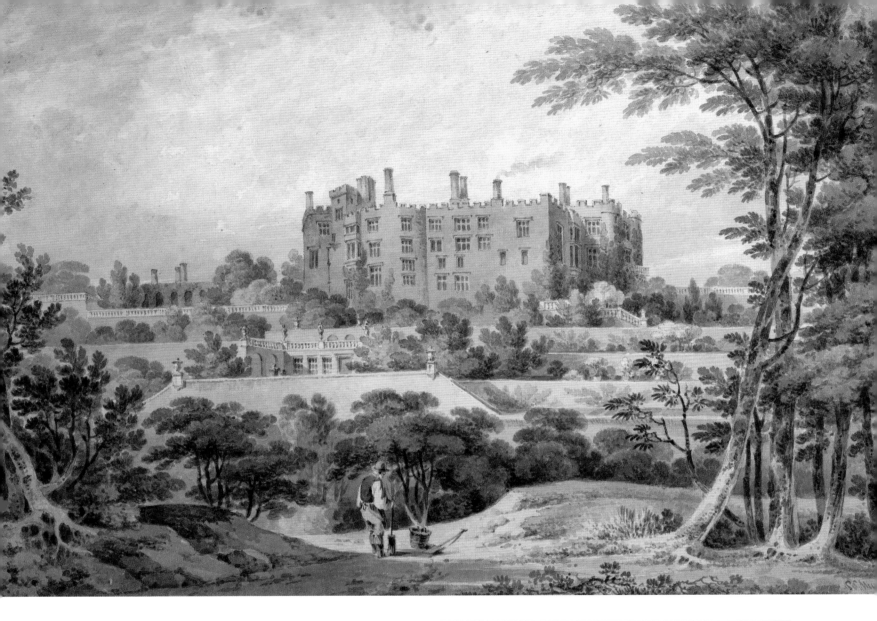

As the owner of a great park and garden himself, Colt Hoare felt he could offer constructive criticism on Powis:

The approach to the castle might be mended and rendered more striking by turning the road off to the right on entering the park, winding it round the hill so as to come up to the castle through the old stone quarry. This, my companion, Frowd,[13] told me was Lord Powys's idea, far better than that of Mr Eames who planned the present approach. I cannot approve of the different plantations which skirt

this delightful terrace on each side. They are disposed in clumps of fir, beech and oak, quite in the modern style of planting and according to modern customs also, not thinned sufficiently early. Having suffered much myself by these modes adopted in plantations I speak feelingly of others.[14]

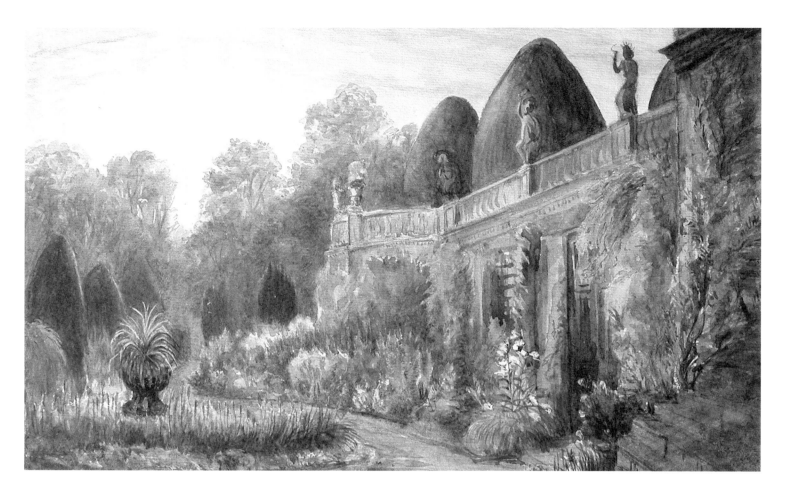

Fig. 58 The high Victorian style of gardening at Powis c. 1892.
A watercolour painted by Alice Douglas-Pennant of
Penrhyn Castle.

Loudon, listing Powis in his *Encyclopaedia of Gardening*
(1824), thought rather better of Emes's park: 'Much varied by
nature, and combines turf as smooth, close, and green, as the
finest lawn, blended with broken ground, rocks, and rough
thickets of thorns and oaks.'[15] Loudon was seeing Powis when
Edward Clive, 1st Earl of Powis (1754-1839)[16] had begun to carry
out improvements. *(Figure 57)* The Earl was a keen gardener
and at the age of eighty was observed 'digging in his garden

at six o'clock in the morning in his shirt sleeves'.[17] By 1836
Roscoe could remark that Powis 'has been greatly extended
and improved by the present noble owner. ...For the artist who
delights in wild forest scenery, or pastoral quiet, Powis park will
supply a continued treat'.[18]

The 2nd Earl of Powis (1785-1848) died as the result of a
tragic shooting accident and was succeeded by his son, Edward
(1818-1891). A scholarly man who preferred a quiet life, he lived
as a bachelor at Powis for thirty-three years. During that time,
the care for and improvements to the park and gardens were
maintained. This meant that in 1872 the Royal Oak Hotel in
Welshpool could advertise as one of its attractions that 'Powis

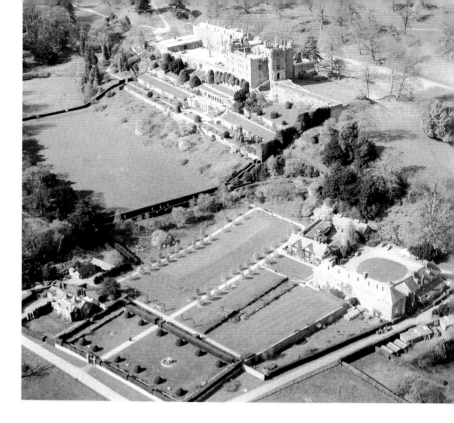

Castle is within a mile of the town, the Park and Gardens are open to the public'.[19] *(Figure 55) The Gardeners' Chronicle* in 1879 made it clear that Powis was open for visitors:

> The Hawthorns of different varieties in their season must be quite a sight to see, and are highly appreciated by the visitors from Welshpool and the neighbourhood, who come in great numbers to see them. We understand that the park is never closed, and that the public are allowed to walk into the Castle Court [on the south front], where they can get a good view of the terraces below.
>
> On the top terrace ...you meet those fine yews which give such a character to the Castle. How very 'interesting' these terraces must be at any season of the year! – every step one takes there is some pet to admire, from the Peonies to the Irises, which are quite giants of plants, and which on the whole are seen to advantage from the Castle windows. The Wilderness – some beautiful trees to admire, with glimpses of the Castle and its terraces. The American Garden is here, and must be a charming sight in its season, with Rhododendrons, Azaleas &c. – At the end of the Wilderness we came upon the young ladies' gardens with a pretty summer-house and grotto.
>
> One more feature about this noble place – that is, the Holly and Yew hedges; they are green walls and worth a journey to see. They are several miles in length, and Lord Powis takes great interest in them, as also in ornamenting his beautiful park with choice and rare trees from all parts.[20]

The arrival of the 4th Earl of Powis and his new wife, Violet, in 1891, heralded great changes for the park and gardens. *The Garden,* in its October 1893 edition, gave a detailed description of the gardens following their arrival at Powis:

> These terraces were, as they should be, wreathed with clematis and beautiful with shrub, and flower, and life, a picture of what a flower garden should be.
>
> One very marked improvement we note – namely, the substitution of a warm red gravel on the paths for a very cold and ineffective grey material. A very happy idea has been adopted in regard to colours, the three terraces having each its predominating colour, viz., the lowest white, the middle yellow, and the highest purple; not that other colours are excluded – but these characteristic tones are maintained all through. A feature of this terrace [the lowest of the three] has been for years a number of dome-shaped trellises 8 feet to 10 feet high covered with Clematis Jackmanii, and recently the effect has been heightened by the introduction of many more trellises and other light-coloured clematis.[21] *(Figure 58).*

There were pyramids of sweet peas and the conservatory-fernery was 'occupied by some interesting plants and Ferns'. In keeping with late nineteenth-century fashion, there was a

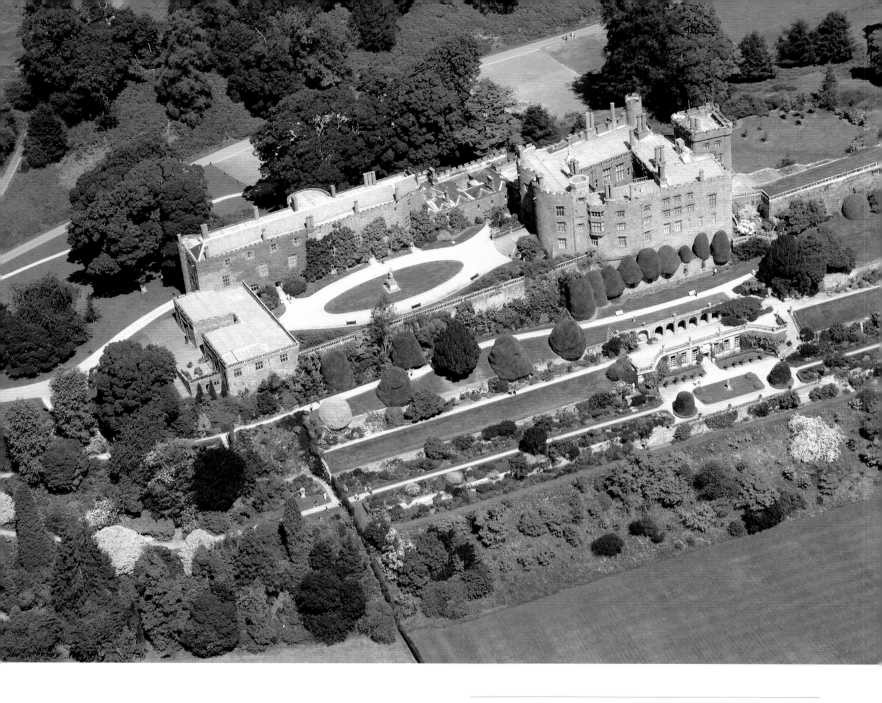

Fig. 60 Powis Castle and its terraces seen from the air.

Fig. 61 (right) A present-day view of Powis Castle.

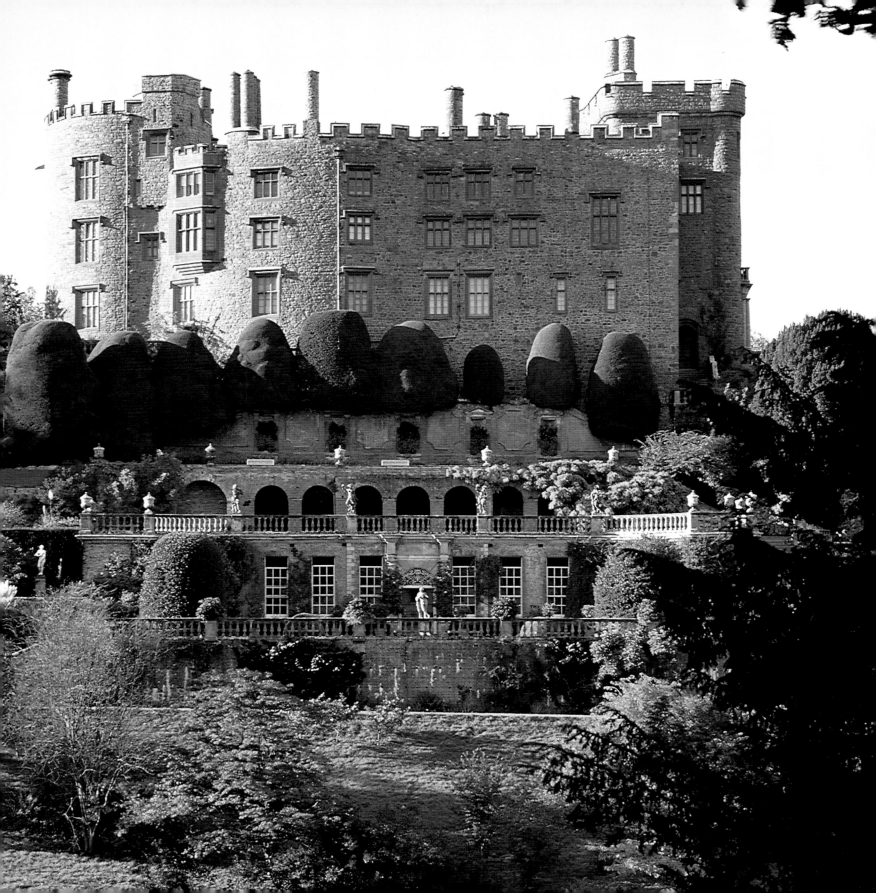

Fig. 62 The shady seat cut into the yew hedge.

mass of bedding plants, yet, 'although design and method are abundantly apparent, there is no air of formality in any of the arrangements, the stiffness of lines &c'. The second terrace walls were covered with fruit trees, roses and, 'what is not seen every day, a fine plant of Pomegranate.' Ascending to the third terrace, 'we find still further surprises in store. Beds of geraniums worked in four distinct colours'. The famous misshapen yews that still make a splendid impact were described:

Several of the large yews that skirt the castle have recently been pruned considerably, thus affording view long hidden. ...Among the former splendid trees there is one whose branches had overgrown the path, and by continual clipping has become quite a summer-house, wherein a seat has been placed, which doubtless is much resorted to as a curiosity as well as a shade. *(Figure 62)*

We are conducted by the end of a pretty dingle into a fine woodland called the wilderness, which is for the most part on a summit running parallel with the hill on which stands the castle. Immense trees are luxuriating here, and in the shelter afforded by them are clumps of Azaleas, Rhododendrons, Skimmias, &c., of quite unusual dimensions. Much has been done here during the last year in the way of thinning and opening out of glorious views to the opposite hills.

The opening out of the views from the Castle meant that, for the first time in many years, the 'useful pits and houses for the propagating and storing of the immense quantities of bedding plants', and the old vineries in Emes' kitchen gardens were clearly in view, something that Lady Powis very much disliked and addressed forcefully in the next century. *(Figure 60)*

The Gardeners' Chronicle, revisiting Powis in 1894, also described the 'hanging gardens', laid out with 'grand circular masses of various kinds of clematis, each 5-6 feet in diameter'. More elaborate still, on the third terrace was 'a border of Carnations and Picotees 200 feet long and 6 feet wide', while 'the extensive wilderness is rich in ornamental trees' and there were miles of 'well-kept walks through the Wilderness and park'.[22]

By 1911 Lady Powis was 'able to persuade George to give the management [of the gardens] over to me'.[23] She set in train plans for Powis 'so that the garden shall be one of the most beautiful if not the most beautiful in England and Wales'. As Helena Attlee says in *The Gardens of Wales:* 'Mission accomplished. Powis can certainly lay claim to the title which the Countess aspired.'[24] *(Figure 61)*

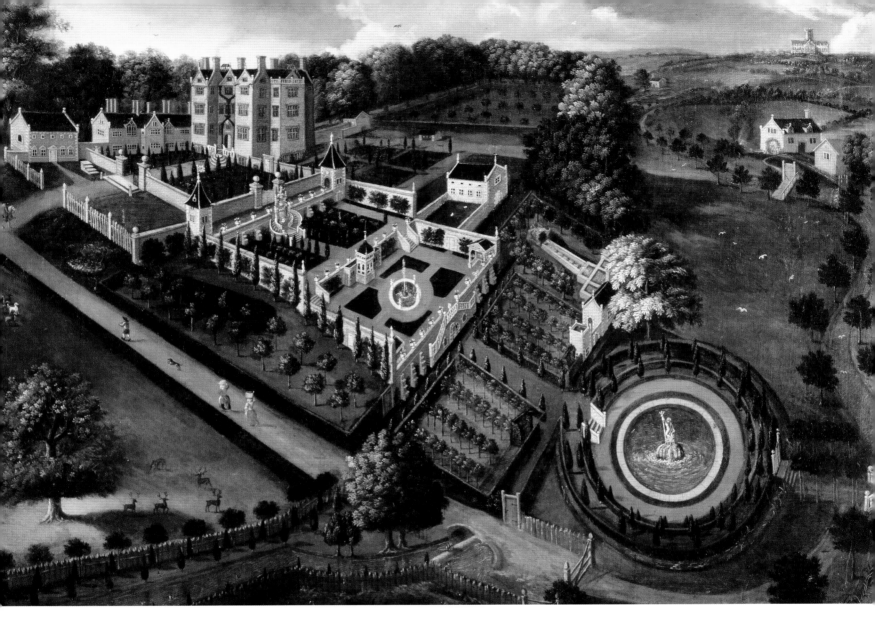

LLANERCH PARK

Somehow, the Duke of Beaufort and his entourage passed by one extraordinary garden. Llanerch Park in Denbighshire would have been a remarkable place by 1684. Mutton Davies (1634-1684) had inherited it from his mother, Anne, daughter and co-heiress of Sir Peter Mutton of Llanerch. From a Royalist family, Davies had gone abroad during the Interregnum to serve as a soldier in the Low Countries. He is known to have visited France and Italy during this time and this must be where he derived his inspiration for the astonishing gardens he created following the Restoration in 1660. The famous painting of Llanerch c. 1667 shows what an extraordinary creation Mutton Davies had wrought among the hills of north Wales. (Figure 63)

Fig. 63 Llanerch Park, Denbighshire, with the Jacobean house built by Mutton Davies' grandfather, Sir Peter Mutton, and the astonishing gardens. This is the earliest oil on canvas bird's eye view of a garden known in Britain. Artist unknown, c. 1667.

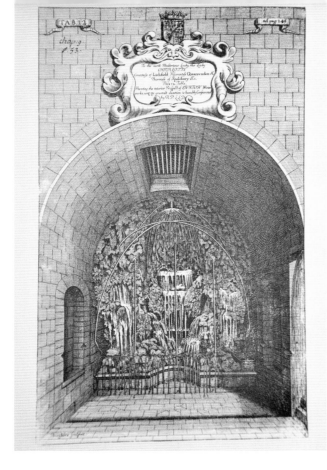

Fig. 64 An engraving from Robert Plot's *The Natural History of Oxfordshire*, showing the Grotto or Room at Enstone referred to by John Loveday.

The wonders of Davies' Llanerch even inspired praise poetry at the time:

The most courteous of men, within his houses his design is faultless:/The man brilliantly transferred to his garden fountains of cold water;/great is the praise of he who walks in the large garden which he has adorned:/his ground around his court/and his tricks are expensive.[1]

When Loveday came to Llanerch in 1732, he was greeted with 'great good Nature & an obliging Temper in Mr Poynter, ye Steward to ye Family'. His description of the gardens is as intriguing as the earlier painting:

The Gardens, from whence You have ye View, lie in Plats, one lower than another, – have pretty Water-Works in miniature, a Room (like that at Enstone in Oxfordsh:) where Water pours down a Rock, and resembles ye Notes of a Nightingale. In ye lower plat You are surpris'd with a very fine Bason of Water, in ye middle of it a Neptune, a great weight of Water continually pouring down ye Pedestal. An Orangery here. A private Building in ye Garden, wch was Mr Davies's Study, is now a Green-house.[2]

The mention of Enstone is a reference to the 'Enstone Marvels' in Oxfordshire, elaborate waterworks completed by 1636 and created by Thomas Bushell. They were the wonder of the age before the Civil War, visited by Charles I and Henrietta Maria. Robert Plot's *Natural History of Oxfordshire* (1677) gives a detailed description of how 'ye Notes of a Nightingale' might be produced, as well as a drawing of 'a Room', that Loveday considered similar to the one at Llanerch.[3] *(Figure 64)*

We know from visitors' accounts that Llanerch's gardens, marvels in themselves, were swept away later in the eighteenth century. History does not relate precisely when, but in her handwritten *Tour of North Wales* made in 1772, Miss Jinny Jenks related that these wonderful Italianate gardens had vanished from sight and new 'improvements' had been put in place:

The park is a very fine one and stands on top of a Hill, which stoops down to a fine serpentine water, of a great length, from which you command a most extensive and delightful view of the vale of Clwyd. ... I never saw anything surpass the soft beauties of this extensive prospect, and put us in mind of Blenheim park....and one is at a loss which to admire most, the taste with which the clumps of trees are left, or a winding coach road through it to the house, or the Water dispos'd (having before all been straight).[4]

Described as a 'brave young man', John Davies (1737-1785), the great-great-grandson of Mutton Davies, had adopted the spirit of the age and swept his forebear's splendid creation away, replacing it with what sounds very much like a Brownian landscape. *(Figure 65)* Dr Johnson, travelling through Wales with

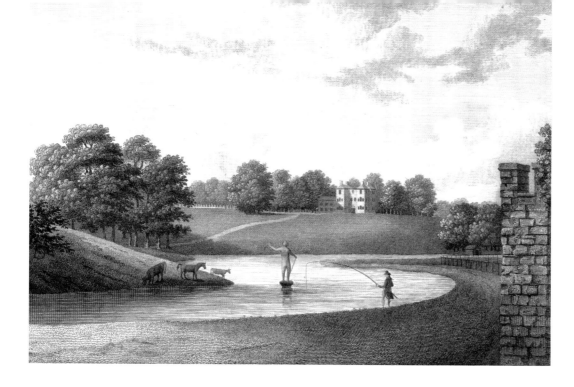

Mrs. Thrale in 1774, recorded that: 'there was an avenue of oaks, which in a foolish compliance with the present mode, has been cut down. A few are yet standing'.[5]

Even though the elaborate gardens had vanished, in the 1770s Pennant reminded his readers of Llanerch's former glory: '...made by Mutton Davies Esquire; on his return out of Italy, in the last century, and were fine in that sort of style, decorated with water-works and statues, emitting water from various parts, to the astonishment of the rustic spectators.'[6]

Phillip Yorke, the owner of Erddig, writing in 1799, recalled:

The old gardens at Llanerch are within my memory; they were made by Mutton Davies in the foreign taste, with images and water tricks. Among the rest you were led to a sun-dial, which as you approached spouted in your face; on it was written:

> Alas! My friend, time soon will overtake you;
> And if you do not cry, by G-d I'll make you.[7]

In the early 1800s, the Rev. John Evans described Llanerch House as, 'situated in a small but beautiful park, the lower part having its plantations relieved by a fine piece of water, and the upper commanding an enchanting prospect along the vales, flanked by the Clwydian hills.' Evans paid homage to Mutton Davies' gardens, saying, 'though the recent changes effected in these, may only be lamented by the gaping rustic, yet the admirers of ancient art will regret to find, that a false taste of more modern extraction, and of too extensive a display, has attempted to convert the venerable old house into an errant modern villa'.[8] This view was echoed by Loudon, mentioning the long-gone 'formal walks, clipt trees and hydraulic statues... The whole place is now modernised, and the fine old house too much so.'[9]

As late as 1872 Thomas Nicholas related that, 'the mansion, which stands in an extensive deer park, combines ancient and modern parts' and still mentioned 'the quaint terraces and gardens (the latter now removed)'.[10] As the nineteenth century drew to a close, few visitors seem to have recorded a visit to Llanerch. We are left with a tantalising view from the past, and can agree with Elisabeth Whittle that, 'if there were not corroborating evidence for its existence, it would be tempting to suggest that it was pure fantasy'.[11]

DYNEVOR PARK (NEWTON HOUSE)

Just beyond Llandeilo, high on a ridge overlooking the River Tywi, is Dynevor Castle *(Great Fort)*. It has stood there for over eight centuries. Wreathed in the mists of myth, poetry and legend (according to Edmund Spenser, Merlin is reputed to have lived there) – the inscription on the Buck engraving of 1740 describes its ownership down the years:

> The Royal Seat of Princes of South Wales while they flourished, afterwards it changed its Master often, till at length falling to the Crown, Henry the 7th made a grant of it to Sir Rice ap Thomas, K of the Garter, in whose Posterity it continues, ye present Possessor being George Rice, Esq.

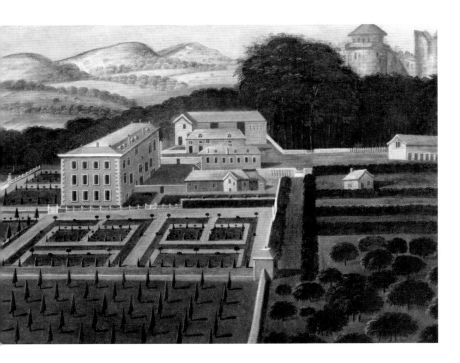

By the seventeenth century this great fort was largely ruined. Edward Rice, MP for Carmarthenshire, built himself a new home, Newton House c. 1660-64 below the old castle.

The house and its surroundings were very different from what can be seen today. There are four views of the castle, house and gardens by an unknown painter that show what they looked like in the second half of the century. Two of them are bird's eye views showing the formal gardens so typical of the period, imposing a geometric layout on the landscape, filled with topiary. *(Figures 66 & 67)* An avenue lined with what might to be pleached hornbeams leads up to a grand entrance gate very similar to that at Margam. The openwork railings enabled 'the viewer to look through the barrier into the next ornamental space.'[1] There are delightful little pavilions built into the garden wall running at the back of the mansion. The whole setting is a demonstration of seventeenth-century wealth, power and taste.

Castles and ruins, seen from a new, more modern house, were popular as romantic features of beauty in a park or landscape. But few of them were enhanced as those at Dynevor with the addition of a distinctive summer or Banqueting house on top of the castle keep. The Buck engraving shows what this remarkable structure looked like, but sadly it was largely destroyed by fire later in the eighteenth century. *(Figure 68)* Lord John Manners' Journal described its fate:

> We walked up a step path through a fine wood, at the bottom of which we saw the Tavey winding its gentle waters, and at length reached the top of the hill on whose lofty summit stands the romantic ruins of Denevawr Castle. ...6 years ago...most of the timber work, &c. was struck by lightning; and since that time, it has remained in its present dismantled state.[2]

By the eighteenth century Newton had passed through several members of the family, and George Rice (1724-1779) inherited the estate from his grandfather, Griffith Rice, in 1729, when he was only five. He took charge of the estate in 1742 and was elected MP for Carmarthenshire in 1754. His mother was related to the Duke of Newcastle, the Prime Minister of the day, so he was well connected with the Whig government and served as a distinguished politician until his death. *(Figure 70)* In spite of his time spent in London, he took great care of

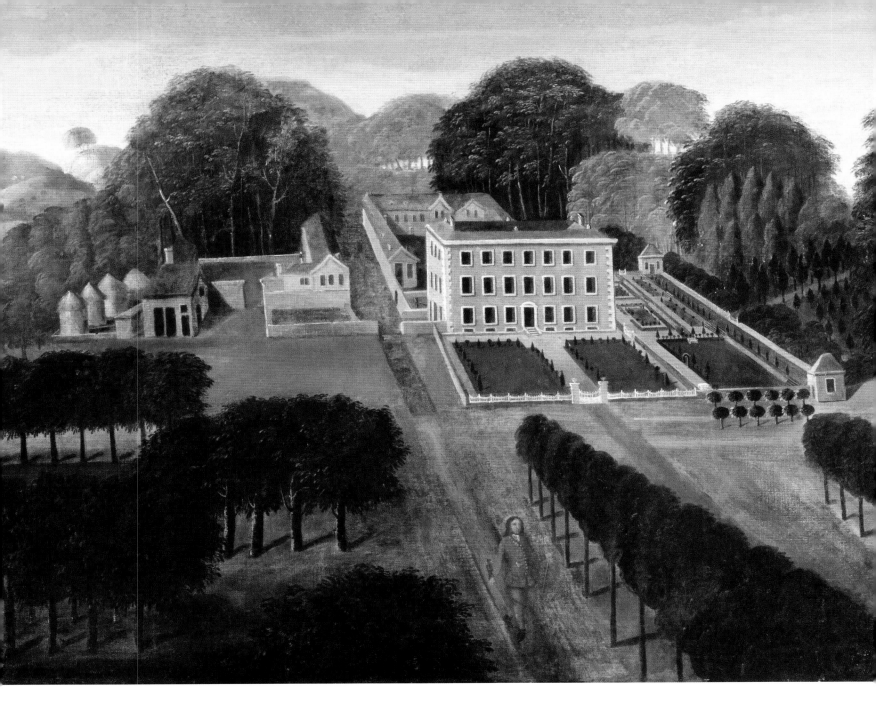

Fig. 66 & 67 (left and above) Seventeenth-century views of Newton House and its gardens by an unknown artist.

Fig. 68 The 1740 Buck engraving of Dynevor Castle with its keep embellished with a summer house.

his inheritance in Wales, as Dr. Richard Pococke observed in August 1756. He walked to the ancient castle:

> From the top of it is the most glorious and richest prospect I ever beheld; below the river winds through the most beautiful meadows, and by Golden Grove on the other side, … there are fine plantations about this place.[3]

In the same year, George Rice married Cecil, only child of William, Earl Talbot. She brought great wealth to the marriage and the Rices set about bringing things up to date at Dynevor, reflecting their own taste in much the same way as the Myddletons were doing at Chirk. *(Figure 69)* As at Chirk, the formal gardens were swept away and lawns now flowed up

to the house. By the time William Gilpin arrived at Dynevor in 1770 the house had been extensively remodelled, acquiring battlements and corner turrets crowned with cupolas. *(Figure 71)* Gilpin found the scenery very much to his taste:

> Mr Rice, the proprietor of it has built a handsome house in his park; about a mile from the castle, which, however, he still preserves as one of the greatest ornaments of his place. The scenery around Dinevawr-castle is very beautiful, consisting of a rich profusion of wood and lawn, but what particularly recommends it is the great variety of ground. I know of few places where a painter might study the inequalities of a surface with more advantage. …The picturesque scenes which this place affords are numerous. Wherever the castle appears, and it appears almost everywhere, a landscape purely picturesque is presented. The ground is so beautifully disposed, that it is almost impossible to have a bad composition. *(Figures 68)*

Fig. 69 (top) Lady Cecil Rice, wife of the Hon. George Rice, painted by Sir Joshua Reynolds. She sat for this portrait in February 1762. Her fortune enabled George Rice to begin the improvements at Newton. She went on to bear him six children.

Fig. 70 (below) The Hon. George Rice as a young man. Pastel by William Hoare c. 1740s. Popular in Bath, Hoare painted most of the important politicians of the day and George Rice aspired to high office.

Lancelot Brown was not far behind Gilpin, visiting Dynevor for the first time in August 1775 and writing to George Rice afterwards that 'Nature has been truly bountiful and Art has done no harm'.[4] George and Cecil Rice required plans for the grounds around their remodelled house and commissioned Brown to provide them. He made three more visits to Dynevor, providing his first plans for the kitchen garden and the garden walls, as well as a beautifully detailed deer fence for the deer park. In February 1776, he produced 'Plans for the entrance to Newton', returning to observe progress in February 1779 and 1782. His executors received a payment for the work after his death in 1783.[5] Brown made a point of visiting the estates where he worked, travelling from one to another up and down the country. This was especially remarkable at the time he was working for George Rice, as he was already 60. A letter to his patron said, 'My health is not of the best kind but I assure you not the worse for my Welsh journey.' Returning via Herefordshire, he reported that 'the post boys were so obliging as to take me through a river that filled my chaise with water'.[6]

Brown always kept a memorandum of his visits and notes from the Rices' agent record Mr Brown's directions 'with the Castle Field to be thrown into the Park...the bottom between that and Cae Llan to be drained...the wood brought into clumps'. This was possibly Brown's principal contribution to the landscape, creating smooth sweeping parkland ornamented with clumps of beech trees. An approach to the castle, borrowed as the natural eyecatcher for the place, was also made. The circuit walk was typical of this period, creating views focused on buildings and landmarks.

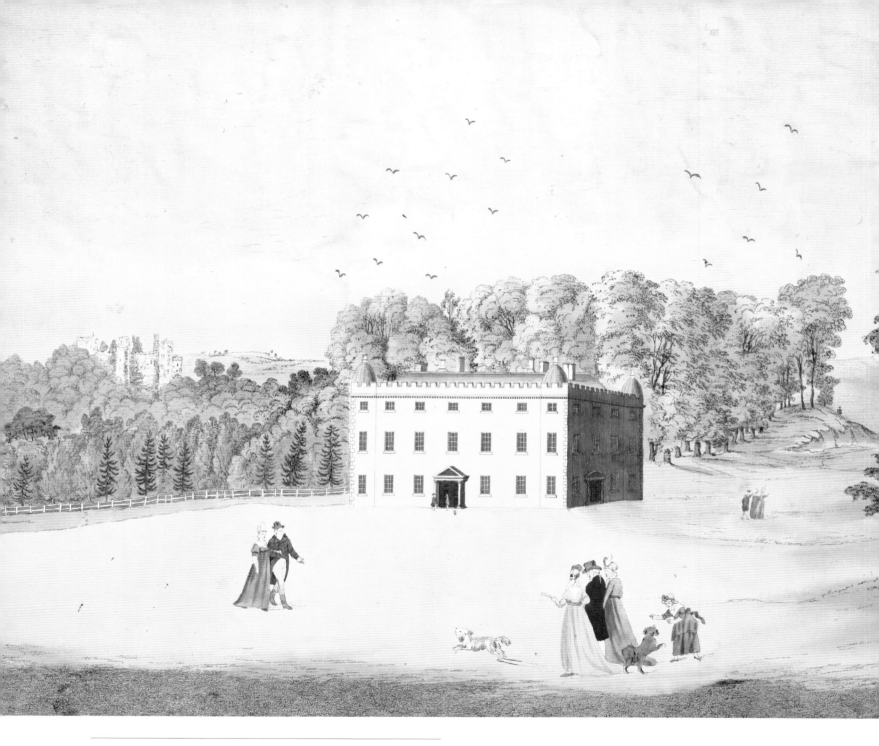

Fig. 71 A hand-coloured etching by James Bretherton, pre-1799, showing Newton House with the ruins of Dynevor Castle in the background.

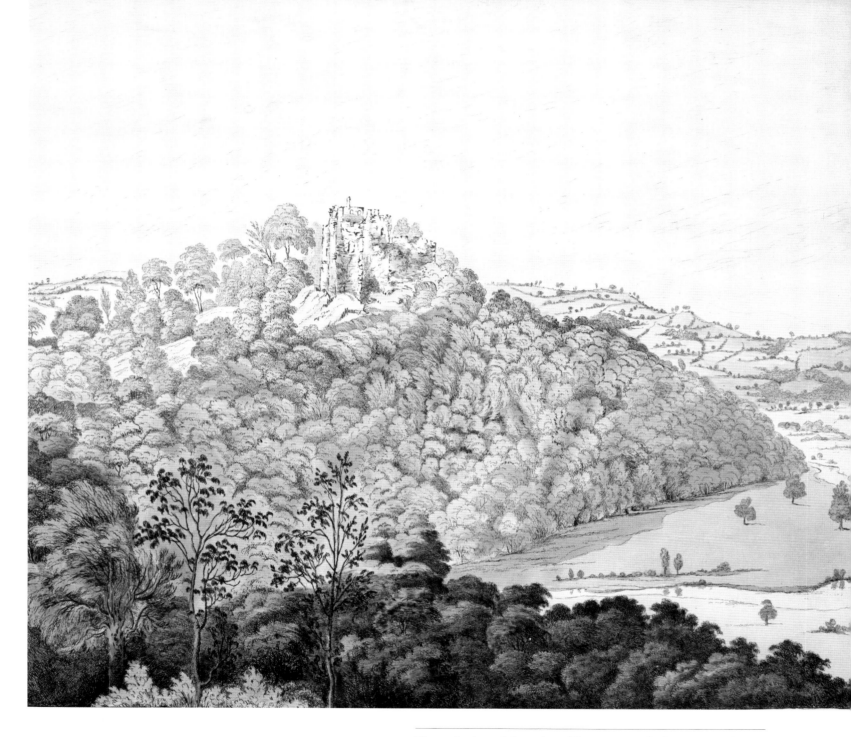

Fig. 72 A view of the ruins of Dynevor Castle from across the Towy River. Hand-coloured etching by James Bretherton, pre-1799.

Fig. 73 The park at Dynevor looking over the Towy valley.
Hand-coloured lithograph by James Bretherton.

Fig. 74 (top) Brown's Walk today looking back to Newton House.
Fig. 75 (below) Paul Sandby's evocative view of the park at Dynevor published in 1772.

Still called the Brown Walk, it is planted with splendid oaks together with beech and ash and runs along the eastern side of the valley, extending from the back of the mansion northwards towards the River Tywi. In true Brown style it unrolls as you walk, offering a gallery of different pictures as it progresses. First, a peep back at the mansion, then a long view of the deer park under mature trees with decorative groups of fallow deer moving across the scene, followed by the first glimpses of Dynevor Castle and the sinuous loops of the river. *(Figure 74)*

The great agriculturist, Arthur Young, writing in 1776 just as Brown was producing his ideas for the Rices, described the Park:

The country all the way to Llandilo is fine; but the picturesque beauties of Newton Castle…are superlatively so. The great feature of the place is that of a very large hill, of the greatest variety of form, rising out of a most fertile vale. Everywhere formed by higher hills, which approach in character to mountains, but all are cultivated. Through this vale winds the large river Towy, which breaks to the eye in beautiful reaches, scattered over almost every part, and apparently so distinct, that it is difficult to believe them the doublings of the same stream. The vale is formed of a variety of grounds, with woods, groves, hedges &c., in that sort of confusion which destroys the insipidity of a flat. The hills and slopes melt into each other so happily, that the outlines are all beautiful….Upon the whole I think this spot the most picturesque residence I have seen in England. Hill and dale, and wood and water necessarily unite to form many beautiful scenes: they are the notes which must everywhere give the harmony of a landscape, but they are here accompanied with their richest melody.[7] *(Figure 75)*

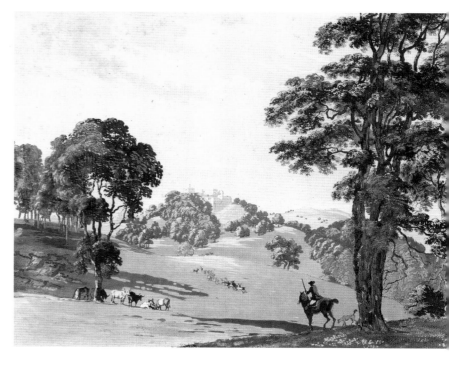

George Rice died before Brown's work was complete and it was left to Cecil Rice to oversee the final landscaping of

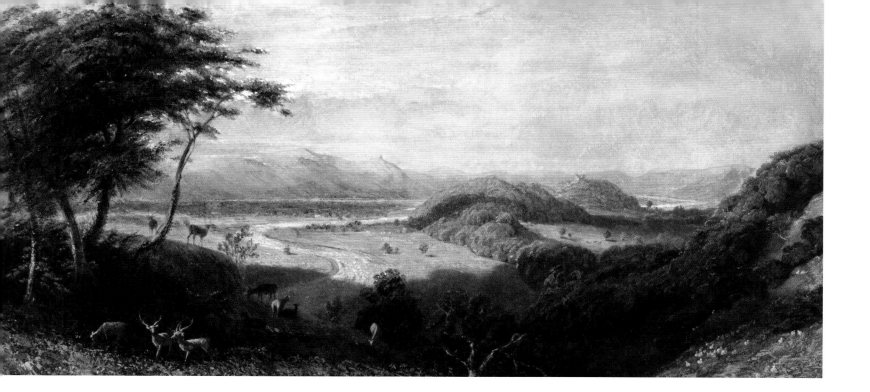

their park. Despite his excellent political work, George was never elevated to the peerage. It was his father-in-law, Earl Talbot, who secured the title of Baron Dynevor of Dynevor. There was a special remainder to Cecil so that, on his death in 1782, she became 2nd Baroness Dynevor in her own right. Mrs Mary Morgan came to Dynevor in 1791 on her way back from Pembrokeshire. She had missed seeing it on the outward journey 'on account of the rain'. Having finally achieved her objective, she remarked on the fact that Cecil was 'now called Lady Dynevor and the place Newton Park; ...I am such a bigot to the founding names in the Welsh language that I cannot bear to see them Englished'. She rhapsodised on the beauty of the park and called the ancient castle 'a sublime object'. She also noted that: 'The house, we were told, is nothing equal to the magnificence of the grounds, and therefore it is never shown.'[8]

Cecil Rice died in 1793 and her title passed to her eldest son, George (1765-1852), who became the 3rd Lord Dynevor. Like his father, this George was a Tory MP for Carmarthenshire, and was a stickler for family history and tradition. All visitors to Dynevor and Newton House remarked on the great beauty of the park and it featured on nearly everyone's itinerary as they progressed westwards towards Carmarthen and beyond to Pembrokeshire. Colt Hoare described it as George came

into his inheritance. Unlike some observers, he quite liked the style of the mansion and, as ever, had a little advice to pass on:

Few places can boast of such natural beauties of situation: wood, lawn and water are here in greatest perfection. The architecture of the house is not unpicturesque, being built in the form of a castle with battlements and four turrets with small cupolas at each angle. But the object which adds the greatest beauty and interest to the place is the old castle. The wood has nearly overtopped the castle, [so] that the summits only of it are visible, and I could have wished that a little more of this classical and interesting object had been exposed to view.[9]

His opinion of the house was utterly opposed by Dr George Lipscombe, who reached Dynevor in 1799. A physician, antiquarian and writer, he was passionate about everything

Picturesque, so much so that he even admired the fact that 'Everything looks venerable; -the very wall of the park is covered with moss and ivy.' He and his companion 'rung at an ancient gate, and were admitted by a pretty little Welch girl who told us, that although Lord Dynevor's family was not at the castle, she thought we might obtain permission to see the grounds'. Finding the ancient castle and park scenery noble and beautiful, he was appalled by the mansion, 'a structure devoid of taste or elegance, and a great disgrace to the scenery which surrounds it, as well as to the genius of the architect'. With his mind divided between 'the pleasure and admiration arising from contemplating the fine old ruin, the rich foliage of the trees … and the disgust excited by the clumsy awkwardness of the house, which is placed in the most objectionable spot on the premises', he looked for 'a situation more fit for the building of a mansion'. Having found one, he admonished Lord Dynevor that, 'should he be induced to undertake the improvement—his name will live, in the admiration and praises of men of taste'.[10]

Benjamin Heath Malkin (1769-1842) made his excursion through south Wales in 1803. His fervent admiration of the Picturesque is reflected in his writing:

> Newton Park, within the precincts of which is found the royal residence of Dinevowr Castle, appears to me unquestionably to be the first finished place in south Wales. The views of the vale are extensive and picturesque; the surface of the park is undulating and unequally disposed; the masses of full-grown timber are large and frequent, the foliage splendidly profuse. When to all this is added such a river rolling at the foot of the hill, and encompassing two sides of the domain in its meandring course, the native princes must be supposed not to have been so simple in their taste, but that they chose their residences with a view to beauty and magnificence as well as security from the attacks of their enemies. *(Figure 76)*

This opinion of Dynevor reflected the attitude of the day to a circuit walk, with the scenery now considered the most important element in the view rather than buildings and eyecatchers. Like so many, Malkin found the house a 'plain

structure' with 'no very striking recommendations'. He went on to relate that:

> Lord Dinevowr…carries the preservation of his woods almost to a fault; …There is a great deal of old timber which might be cut down without at all detracting from the sylvan character of the scene; and the young plantations which are thriving fast, would more than supply the loss. … This veneration seems to be hereditary; for the late Lady Dinevowr preserved many large trees, by encircling their trunks with strong hoops, as they are occasionally riven by the frequent thunder-storms.[11]

Colt Hoare's companion on many of his tours, Richard Fenton, as a Pembrokeshire man, would have travelled past Dynevor often and took many opportunities to revisit a place he clearly enjoyed:

> Every time I visit Dynevor I find fresh Beauties. The undulation of the surface of the whole Park is not to be equalled by anything in the kingdom; and the magnificence of the woods, whether we consider the disposition of their masses, the size and picturesque growth of particular trees, and their great variety, is unrivalled. There are some Cherry trees of vast growth… found in that place where the intended garden is making.

He praised Lady Dynevor's care for her trees in poetry:

> Whose lib'ral mistress unseduc'd by gold,
> Can see her oaks around her paths grow old![12]

Roscoe visited Dynevor in the 1830s and described being accompanied, as were other travellers, by a keeper or a guide to show him round:

> I entered Dynevor Park by the little gate beside the main entrance, accompanied by an intelligent guide acquainted with the neighbouring localities. On proceeding only a few yards to an elevated part of the grounds, a scene of surpassing beauty bursts upon the sight. The green and

sloping lawns, studded with stately trees, swell and extend before the eye. The tower of the old Castle rears its hoary head above the tall oaks by which it is surrounded.

He took the trouble to climb to the top of the old castle and 'beheld a prospect the most varied, luxuriant, and enchanting, that the eye ever ranged over'. He considered that the traveller could spend a whole day at Dynevor: 'A Summer's day from morn to dewy eve.'[13]

At around the same time, Catherine Sinclair hastened to Dynevor 'without loss of time', declaring that the ancient trees in the park looked 'as if they had been planted by Druids'. She thought the house resembled one that children cut out every day on white paper, 'perfectly square'. Returning the next day with a guide, she was informed that:

...the proprietor here felt so much satisfaction in the antiquity of his beautiful place, that no alterations, however, trifling, are permitted, and no changes are considered improvements. When an old fence or a mildewed wall gives way...it must always be rebuilt on the original pattern, and the aged moss or weeds are carefully re-adjusted in their places.

The gardens ...are charmingly embellished with fine old yews, cut and carved in the fashion of King William's time, and subdivided with walls, built in open arches, which produce a very light and cheerful effect. The green-houses are superintended by a first-rate gardener, who turned out, of course, to be Scotch, as wherever one enters a particularly well-managed garden, he might safely address the superintendant in the northern salutation, "Hoos a' wi' ye."

Catherine went on to praise the roses that were 'in the highest perfection' and remarked that 'the gardener here has not adopted the new fashion, so prevalent elsewhere, of training the roses into trees.' Many of the roses were grafted and trained 'looking so much like an umbrella.'[14]

The 3rd Lord Dynevor lived to the grand old age of 86, dying in 1852. He was succeeded by his son, George Rice-Trevor (1795-

1869). Unlike his father, he was ready for change and the plain house did not remain so for long. Richard Kyrke Penson, one of a dynasty of Chester-based architects, was commissioned to produce plans to remodel it. Work began in 1856, and by the beginning of 1859 the *Illustrated London News* could provide a detailed description of the mansion and the new Venetian Gothic-style stonework that now encased it. Buttresses linked with an arched arcade were constructed on the garden front to provide more support, with a conservatory built above them on the first floor, opening on to the main staircase. The house had also acquired French-style turrets with 'steep roofs, and finished with iron ornamental ridges...with vanes and cresting appropriately painted and gilt' in place of the pepper-pot cupolas.[15] *(Figure 77)*

Like most Welsh aristocrats and politicians, the 4th Lord Dynevor and his family spent much time in London. In addition to Newton Park, they also owned an English estate at Barrington Court, in Gloucestershire. However, they always spent the summer months at Newton Park. The arrival of the railway between London and Carmarthen in the 1850s meant that travel between the two became much faster and more convenient, not just for the family but also for the tourist. The Hall's railway-based guidebook diverted travellers to Llandeilo and Dynevor, relating its ancient history and informing the reader that 'the present peer is in real worth and personal qualities no whit behind his illustrious ancestors.'[16]

Given their wealth and position and the beauty of the situation, or perhaps because of it, the family did not engage in the elaborate and creative gardening that could be found on other Welsh estates in the nineteenth century. The photographs of the period show us the comparatively small and simple terrace garden, created at the same time as the house was remodelled overlooking the deer park. It is raised up out of the park with formal beds, yew trees, a neo-Norman fountain in the centre raised on small pillars and, up a series of steps to the west, a small Loggia. *(Figure 78)* The kitchen gardens and glasshouses were at a little distance from the house.

As the 4th Lord Dynevor had no sons, in 1869 he was succeeded by his cousin, the Rev. Francis William Rice (1804-

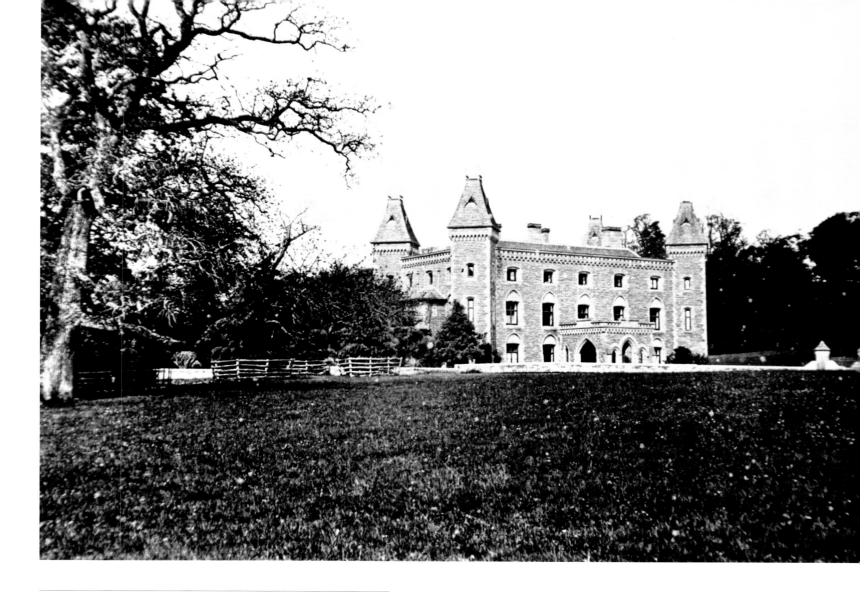

Fig. 77 A nineteenth-century photograph of the Venetian Gothic version of Newton House.

78), rector of Fairford in Gloucestershire. The estates that had extended to '30,000 acres in five counties from west Wales to Bedford and the choice of three mansions' were divided between Francis Rice and his cousin, Edward Wingfield, much in the latter's favour.[17] The 5th Lord Dynevor did not have the financial means or ambition to live in the style of his cousin or his grandfather. While he remained devoted to his Gloucestershire parish, he fulfilled his duties in Wales

as lord of the manor, as a local JP and as Deputy Lieutenant for Carmarthenshire, and supported local charities and organisations. He was succeeded in 1878 by his son, Arthur de Cardonnel Rice (1836-1911). Accompanied by his family, Arthur, as the 6th Lord Dynevor, arrived in Carmarthenshire in February 1879 to a great Welsh welcome. Thereafter he went on to spend a lot of time at Dynevor and was considered a fair and often kind landlord. During his tenure, Newton Park moved towards the new century. Like other Welsh estates, it was badly hit by the 1880s farming depression and Arthur was obliged to sell land. However, the family had important coal resources to fall back on and the country lifestyle of hunting, shooting,

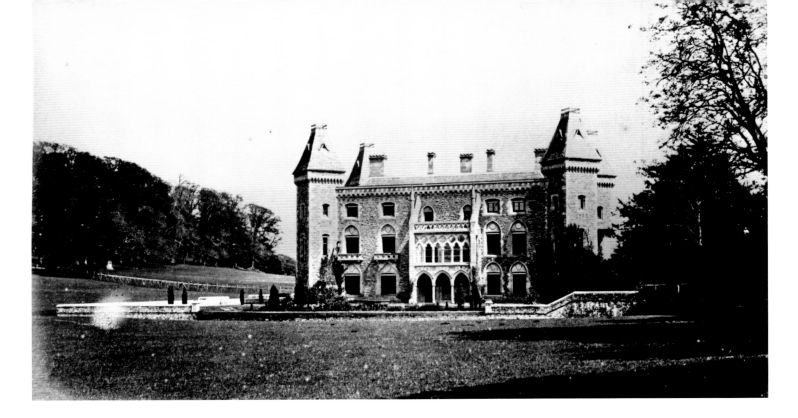

Fig. 78 The garden front of Newton House with infant yews overlooking the Deer Park. The Loggia is up to the right. The Brown Walk begins on the left-hand side bank.

fishing and entertaining guests continued.

Late nineteenth-century guidebooks, such as the *Imperial Gazetteer of England and Wales* (1870), still mention the glories of the Dynevor parkland, 'beautiful by nature and by art'. *The Gardeners' Chronicle* article of 1909, while it is, strictly speaking, beyond the timeline of this book, gives a good description of what the gardens must have looked like as the century closed. The great trees, as ever, attracted admiration and elsewhere in the park and gardens there were Camellias, Rhododendrons and Kalmias. The gardens were under the care of the Head Gardener, Mr A. Richardson:

> In all parts of the grounds are stately trees. On the north side of the castle is a group of Oak, Beech and Spanish Chestnut of great age, forming a dense canopy; and in the direction of the old castle ruins are many old notable trees. Overlooking the deer park on the north side of the mansion is a formal flower garden, the design being worked out in Box. The colour of the flowers used in this garden is almost exclusively scarlet.
>
> I noticed a Rose garden, the grounds of the beds being clothed with common Musk. This Rose garden is composed of a series of circles with grass intersections.....The flower garden is more informal in design, and appears to have been evolved from what at one time were vegetable, fruit, and possibly, flower gardens all combined; some of the old fruit trees still remain.
>
> The kitchen garden and greenhouses are situated nearly a mile from the castle. There is an old vinery, heated with a flue. The greenhouses accommodate plants that are useful for decorative purposes in the mansion.[18]

The twentieth century would bring much change to Dynevor, but if you visit it today, now under the care of the National Trust, you can still see 'the most glorious and richest prospect I ever beheld'.

PICTON CASTLE

'Never forfeited, never deserted, never vacant, proudly looking down over a spacious domain…to an inland sea', as Fenton tells us, Picton Castle is unique among the castles and great mansions featured in this book in that it is the only one still in the hands of the family who owned it and created its park and gardens. The present castle was built c. 1300 for Sir John Wogan and, passing by descent and marriage, by 1491 came to Sir Thomas Philipps.

By the time Dineley reached Pembrokeshire in the train of the Duke of Beaufort, the head of the family was Sir Erasmus Philipps. He took part in the great gathering of local gentry that welcomed the Duke on August 12, 1684, and Dineley tells us that the next day Philipps 'nobly entertained' the Duke and an impressive company of 'the Gentlemen of Pembrokeshire' to a dinner at Picton. While Dineley did not leave a description of Picton, his drawing of the castle is the earliest known image of it and shows a typical seventeenth-century layout, with four grass plats sheltered by walls in front of the castle.[1] *(Figure 79)* It may be that these areas were planted, but it should be borne in mind that level sweeps of mown turf were a symbol of wealth and highly prized. They demonstrated that the owner could afford the manpower to undertake the long and careful task of keeping it shorn and smooth. When Picton was inherited by Sir John Philipps as the 4th Baronet (c. 1666-1737) in 1697, the walled forecourt was demolished and the entrance to the castle was raised to the level of the principal rooms with a balustraded walkway. *(Figure 80)* In the same year, Sir John married Mary Smith, heiress to a prosperous East India merchant. Her wealth helped him to become one of the richest landowners in Pembrokeshire.

With money to hand, changes and alterations took place at Picton. Sir John's son, another Erasmus, kept a diary from 1719 detailing some of it: new Parlour floors, painting the Chapel and colouring the rooms. The Orchard acquired a new wall and the horse pond was repaired. In June 1725 we learn that:

Wm Evans of Haverfordwest made a little boat for ye Fishpond in the orchard. NB: Mr Webb of Trooper End

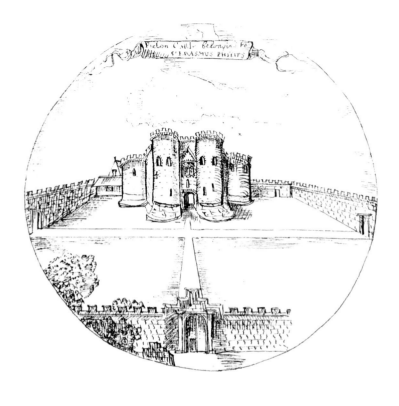

Fig. 79 Dineley's drawing of Picton Castle in 1684.

made this Pond and the Isle in the middle of it, and removed the dwarf trees out of the Lower Garden (which he turned into a Pleasure Garden). … *Sept. 1:* A Fountain was made in our Pleasure-Garden by David John, projected by Mr Webb.[2]

Like many large landowners, Sir John served as an MP, firstly for Pembroke and later, Haverfordwest. With his London political connections, in 1711 he was appointed as one of the commissioners for building 50 new churches in London. In this connection he met some of the best architects working in the neo-Palladian style, such as Nicholas Hawksmoor, James Gibbs and John James. John James sent him a plan for a summerhouse in 1728. According to Erasmus's diary:

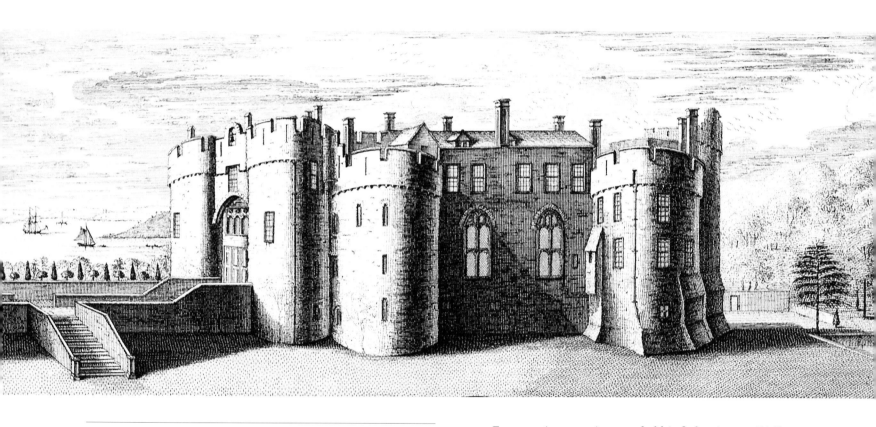

Fig. 80 A Prospect of Picton Castle by Samuel & Nathaniel Buck, published in 1740.

In May 1728 a [summerhouse] began to be built at Picton Castle/Masons Thos Smith, Wm Harwood/Joyner Mordecai Lloyd/a Model sent from London drawn by Mr James, the surveyor, wh[ich] not entirely follow'd – a Model drawn by Wm Hughes as well.

While nearly all the visitors to Picton at this time refer to what became known as the Belvedere, there are no drawings of what it looked like. One observer described it as 'a pavilion in the Italian style', but readers here must use their imagination. It is thought that there was a seventeenth-century viewing mount like the ones at Chirk and Powis that formed the base for the Belvedere.

Erasmus (1700-1743) succeeded his father in 1737. Well-educated and with a taste for art, he made his mark as a politician and connoisseur. His early travels abroad in 1719 were to Holland and Germany and he did not reach Florence until he was in his forties. He never married and died tragically, drowned in the Avon near Bath after his horse was frightened by some pigs. His brother, John (1701-1764), succeeded him as the 6th Baronet. The unexpected succession to Picton and its estates meant that he had to abandon his home at Kilgetty House, where he had already created fine pleasure grounds. An MP like his father and brother – his first seat was Carmarthen, the last Pembrokeshire – he was, unlike them, a staunch Tory. His perceived support for the Jacobite cause meant that, after the 1745 Jacobite Rising in favour of Bonnie Prince Charlie, he fell from political favour. He resigned his seat in Parliament in 1747 and thus found himself spending much more time in Pembrokeshire. This was greatly to the benefit of the castle and its surroundings. *(Figure 82)*

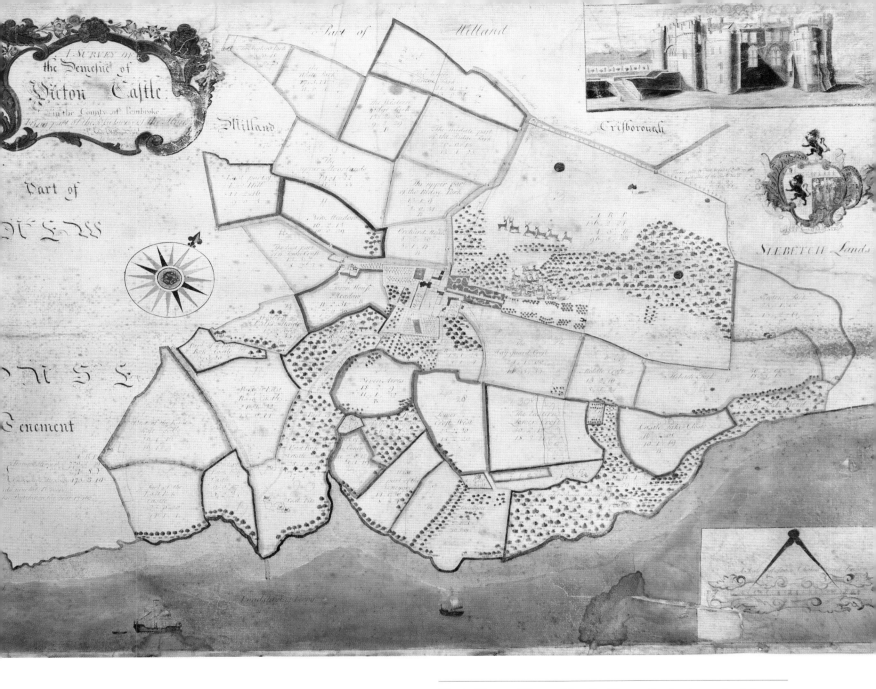

Fig. 81 The 1746 Estate Map for Picton Castle, drawn by John Butcher.

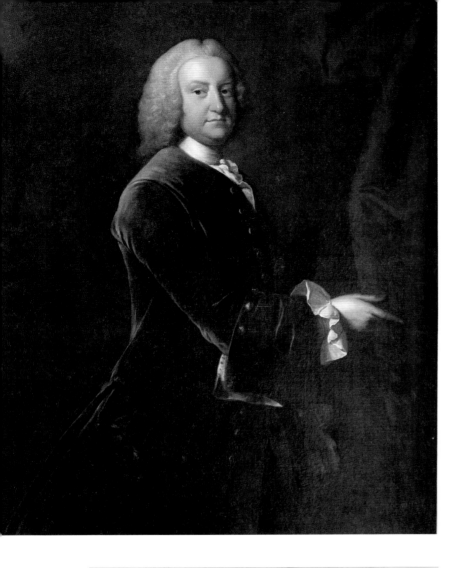

Fig. 82 Sir John Philipps, 6th Baronet. Sir John famously had a black slave who came from Senegal and was given to him together with a parakeet. He was called César Picton. Sir John was part of a group that worked to abolish the slave trade. It is thought he might have sought a slave from Senegal with the express purpose of freeing him once back in England. In time César became a wealthy and respected member of society.

Considerable work was undertaken in the house, including the creation of a delightful circular Library. The beautiful estate map of Picton dated 1746 still survives. It shows the surroundings of Picton as created for Sir John's father still *in situ. (Figure 81)* The detail of the plan gives a long avenue running eastwards from the castle entrance towards the Belvedere and the charming drawing of deer shows where the Deer Park was. Apparently, the deer could be a nuisance, breaking into the neighbouring gardens of Slebech, another great house facing the Cleddau. By the 1750s, Picton was beginning to feature on the itinerary of the gentlemen travellers of the time, but most of the written descriptions date from the latter half of the century, by which time (1764) Sir John had been succeeded by his son Sir Richard Philipps.

Politics clearly ran in the veins of the Philipps family, and Sir Richard sat as MP for several Pembrokeshire constituencies, including Haverfordwest and the county itself. In 1776 he was ennobled as the 1st Lord Milford. As this was an Irish peerage, like that of Lord Penrhyn, this meant that he could continue to act as an MP – Irish peers do not have the right to sit in the House of Lords. He was considered the most influential figure in the county and was Lord Lieutenant of Haverfordwest (1770) and Pembrokeshire (1776). Paul Sandby created a lovely picture of Picton in 1770s showing the south front of the castle before Lord Milford began his changes, overlooking a suitably pastoral scene. *(Figure 83)* By 1791 he had decided to enlarge Picton and enhance the grounds to reflect his family status and grander household.[3] The castle lost its medieval solar tower and a four-storey block was added at the west end of the castle. He also altered the park and made new plantations. The Watts engraving of this picture of Picton, published in 1779, provided the description: 'Picton Castle is now the residence of the Right Honourable Lord Milford, who has modernised the Ground, by a pleasing plantation of Firs and evergreens.'

Visitors began to seek out Picton. Sykes relates a morning visit to 'Lord Milford's – a pleasant situation', although he preferred Lord Cawdor's Stackpole Court not far away.[4] The comparison between the two was often made, with the observer coming down on one side or the other according to their taste.

Fig. 83 Paul Sandby's 1770 watercolour of Picton engraved by W. Watts.

Mrs Mary Morgan arrived at Picton, in 1791 as the work was begun on the castle. She found a great deal to admire:

> In a part of the grounds there is an elegant summer house, called The Belvedere. From the top of this you see everything in perspective. ...Under it is an arched way, through which you pass to the other parts of the grounds. From the roof of these arches hang long encrustations of the wall, which are exactly like large icicles, except that they are not transparent. This, I suppose is an accidental circumstance; but it adds greatly to the beauty of the place. There are niches in it, designed for statues, but there are none in them.
>
> Near the castle is a long vista, impervious to the sun, [offering] a delightfully sequestered walk.[5]

Lord John Manners arrived to spend a few days at Picton in August 1797. Riding from Stackpole Court, he and his companions met Lord Milford riding in the opposite direction. Manners' Journal gives a swift pen portrait of his host: 'He is a most wonderful man, being now in his 86th year, and yet so strong that he hardly ever sits down, can read the smallest print, and takes his exercise exactly as he did when young.' Bad weather held up the Manners party for several days but on August 26th they walked about the grounds. Returning from neighbouring Slebech, they came to a 'very large seat belonging to Lord Milford, which accommodated our whole party' [of six people]. Their route homewards took them to:

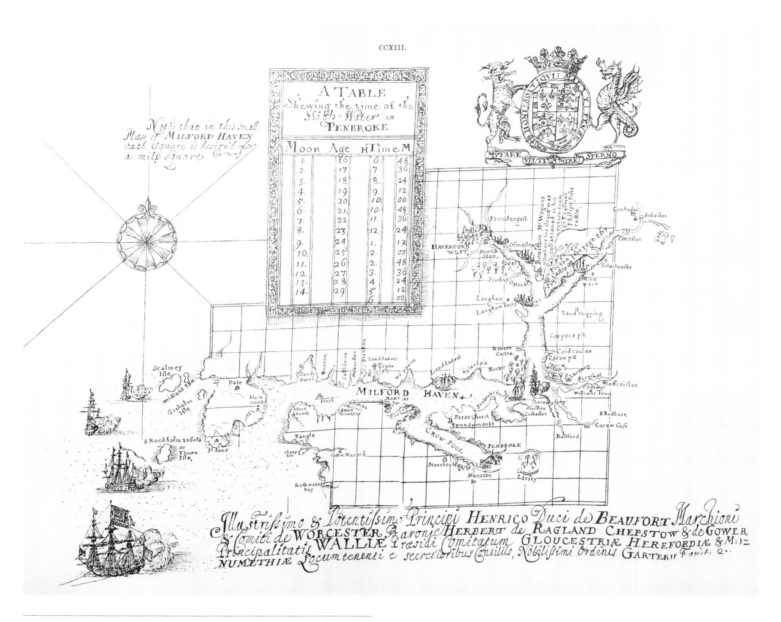

Fig. 84 A detail from Thomas Dineley's drawing of Milford Haven, showing how Picton sits between the two arms of the Cleddau.

...a summer house called the Apollo Belvidere, built on a high ground in the park, from which there is a very extensive view. On our return, we passed the hour till dinner, in looking at the stables, the conservatory (which is newly built, and is well stored with plants), the garden, and the hot house.[6]

The new building work was, however, not to everyone's taste. The Rev. John Evans reflected the view of many antiquarian visitors to Wales, who felt that ancient history should be preserved and not altered or abandoned, as with the Chapter House at Margam. He thought:

> ...the appartments are magnificent, and considerable alterations lately made, but it is always disgusting to the eye of taste, to observe ancient and modern architecture blended together in the same edifice.[7]

The inner reaches of Milford Haven which provide the setting for Picton Castle were also the means of access to many of the houses and estates in the area. This was true of the seventeenth as well as the eighteenth centuries, with Dineley describing how the Duke of Beaufort viewed Milford Haven and Picton from a yacht. *(Figure 84)* The river was an integral part of the landscape of Picton and was appreciated by all its visitors. Mary Morgan loved how the 'different scenes of one of the most beautiful rivers in the kingdom present themselves continually: vessels for ever passing and re-passing'. Visitors could cross the Cleddau using the Landshipping Ferry across to Picton Point, or sail down from Milford itself. Richard Fenton described:

> Gliding up gently with the tide, I enter the eastern Cleddau, and landing opposite Landshipping Quay, at the place where passengers take the ferry boat, walk up through beautiful woods to Picton Castle.[8]

Richard Fenton was the great historian of Pembrokeshire and the history and antiquity of Picton Castle appealed to him a great deal. Like Evans, he admired Picton because of its place in history and the fact that it still stood, largely intact, after five hundred years. He felt, on these grounds alone, that Picton should not be compared to more recent additions to the county's buildings:

It would be an insult to Picton Castle, to estimate its consequence and its beauties by a scale employed to measure modern villas, the works of a Brown or a Nash, by a few formal clumps disposed so as to give a glimpse of a distant horse-pond, the ruins of a windmill, a kennel in the mask of a church.... If such things constitute a fine place, every mushroom citizen of yesterday may command them.[9]

He evidently enjoyed himself raiding the kitchen gardens:

> The gardens are of a vast extent and luxuriantly cropped, and the hot houses and hot walls occupy an immense space; nor is the conservatory ill stocked. No dessert can be better or more amply furnished than that at Picton which exhibits a profusion of the richest fruit of every kind the whole season round.
>
> The park, now destitute of deer, is of a large compass, occupying that part of the grounds to the eastward chiefly, and flanked towards the river by a hanging wood, through which a most charming walk has been formed to wind in a very romantic direction to the estuary, and rendered more delightful by the frequent occurrences of seats placed to produce the happiest effect, and a hermitage yet but seldom visited, being at such a distance from the castle, a pity! as it is one of the most pleasing features that place can boast of. On the most elevated spot in the park, terminating an avenue facing the grand entrance of the castle, stands a handsome belvedere, a most central situation that takes in a view of the whole county.

Yet another roving clergyman, the Rev. T. Rees, admired Picton's setting on the water and its Norman antecedents:

> The grounds about Picton Castle are on a very magnificent scale, and laid out with proper regard to the baronial dignity of the mansion. They are very richly wooded; and have every advantage of water scenery from their position near the confluence of two handsome streams.[10]

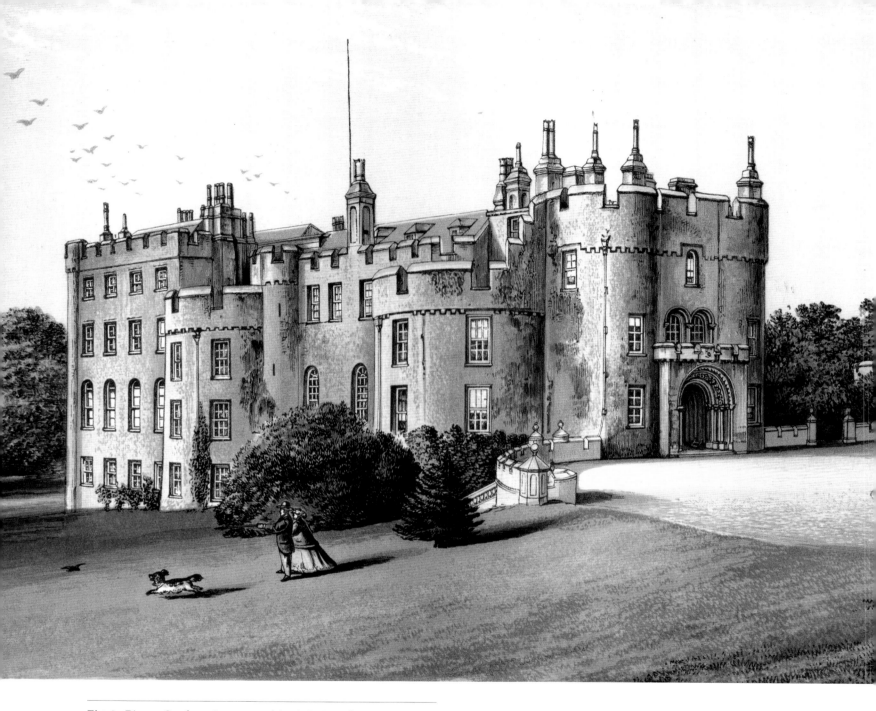

Fig. 85 Picton Castle as it appeared in *A Series of Picturesque Views of the Seats of Noblemen and Gentlemen*. It shows the new approach to the house and stairway to the garden. The bollards and chains to the right indicate where the Avenue leading to the remains of the Belvedere began.

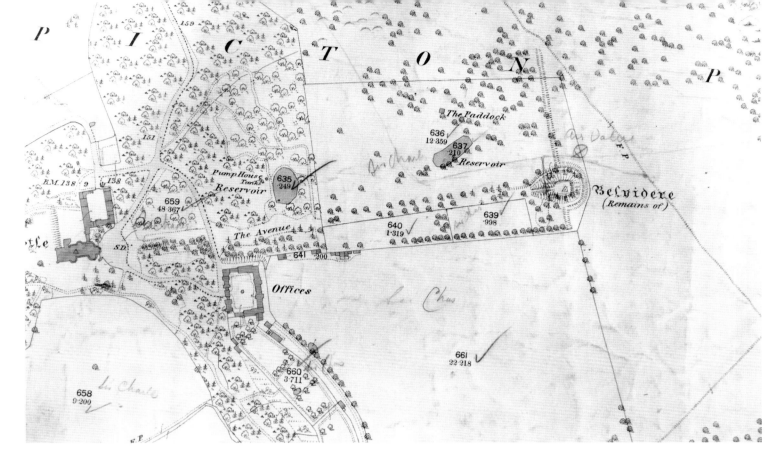

Lord Milford was childless and the matter of succession was a complex one, as there was an array of cousins who might be in line to inherit. The heir selected was Richard Grant. When Lord Milford died in 1823, Richard Grant adopted the name of Philipps and moved to Picton. Almost immediately created Lord Lieutenant for Pembrokeshire, following family tradition he went into politics and became MP for Haverfordwest. He was created a baronet in 1828 and in 1847 was elevated to the peerage as the first Lord Milford (of the second creation).[11] Like his predecessor, he wanted to make Picton his own. In 1827 he set about altering the front of Picton Castle, removing the balustraded walkway and creating a grand neo-Norman entrance with a carriage sweep to the door. There were stairways sweeping down to the garden. The walled garden to the west of the house was created at this time.

Roscoe, with his eye attuned to the beauties of scenery rather than buildings, advised his readers in the 1830s that:

If desirous of a pleasant walk of about four miles, the tourist may find himself seated in the park belonging to Picton Castle; and on casting his eye over the beautiful intermixture of umbrageous verdure, green and level lawns, and fertile fields, which compose the surrounding scenery, he will not regret the labour. [12]

Picton and Penrhyn Castle were among the only three properties in Wales that were considered sufficiently grand and notable to be included in *A Series of Picturesque Views of the Seats of Noblemen and Gentlemen,* published between 1866 and 1880 by the Rev. F.A.O. Morris. However, travellers' tales about Picton seem to die away by mid-century. *(Figures 85)*

Fig. 86 A detail from the 1889 OS map showing the Avenue leading to the Belvedere.

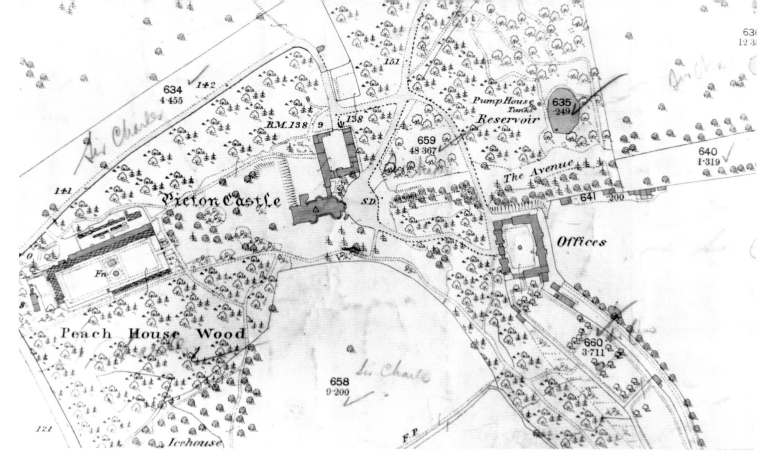

Fig. 87 Part of the 1889 Ordnance Survey map of the Picton Castle demesne. To the left is the great range of glasshouses within and behind the walled garden. The footprint of the Conservatory appears as a projection from the main house.

Fig. 88 A nineteenth-century photograph of the Avenue looking away from the Castle.

This was when the South Wales Railway finally got to the far reaches of Pembrokeshire and it is an educated guess that this is the reason for a lack of reportage. There was a station at Haverfordwest, but Picton was four miles in the other direction and so, perhaps, not a convenient place to explore. The Halls' *Book of South Wales* gives great detail about the station and history of Haverfordwest and onwards to Ireland, but the great house and the glorious grounds of Picton do not feature.

Lord Milford died in 1857. He had no children and the Picton Castle estate was left to his half-brother. James Gwyther was a clergyman and served the community, not as a grand lord, but as Vicar of St Mary's in Haverfordwest. There were terrible family ructions about the succession. After some years of wrangling in and out of court, the estate devolved to Charles Edward Gregg Philipps, created a baronet in his own right in 1887. With affairs settled at last, the gardens received new attention and the OS map for 1889 shows us the great range of glasshouses in the walled garden *(Figures 86 & 87)* and the footprint of a remarkable neo-Norman conservatory or winter garden. This was demolished in the 1930s and the only record is a splendid postcard. *(Figure 89)* The sale of postcards of this historic place demonstrates that it was still considered worth visiting and was a focus for local political and social life. The twentieth and twenty-first centuries would bring the creation of one of the finest gardens in Wales, renowned for its woodland full of colour in the spring as the rhododendrons and azaleas come into flower. Today's tourists will 'not regret the labour' of making their way to this lovely place.

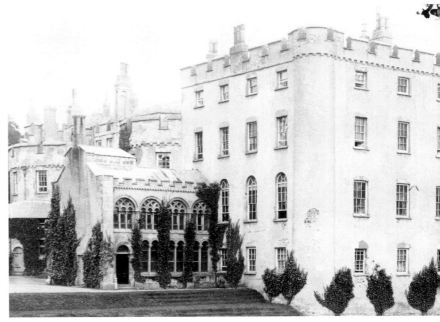

Fig. 89 Another postcard providing a glimpse of the glasshouses and what was then very fashionable island bedding.

Fig. 90 The Norman-style Conservatory that was demolished in the 1930s.

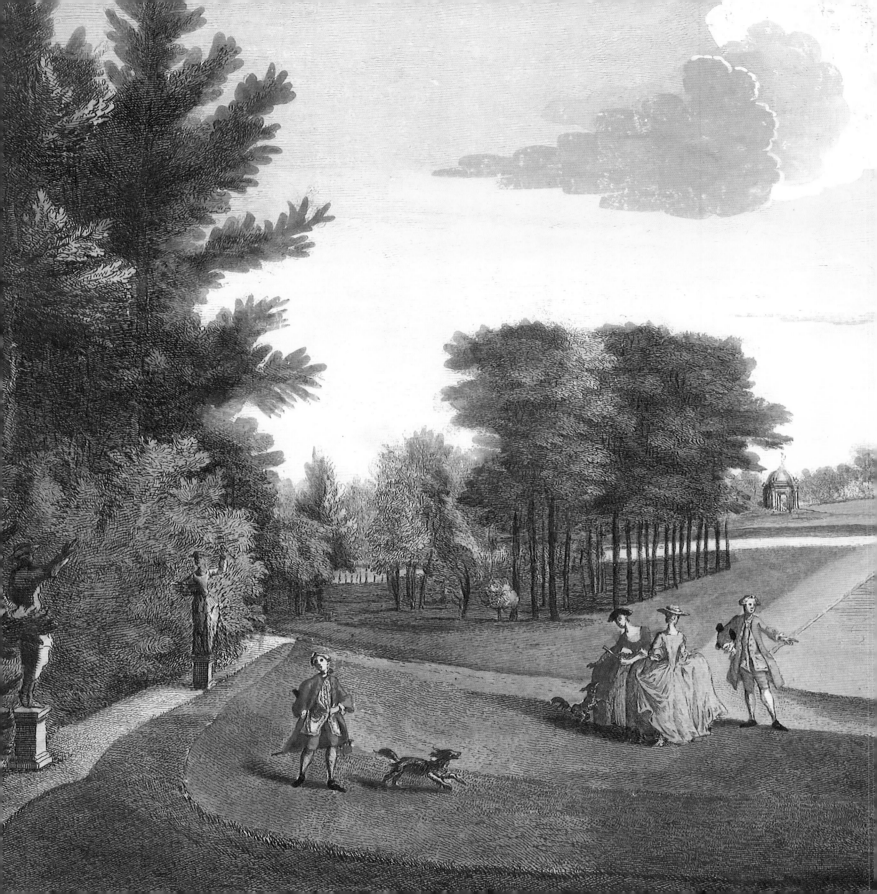

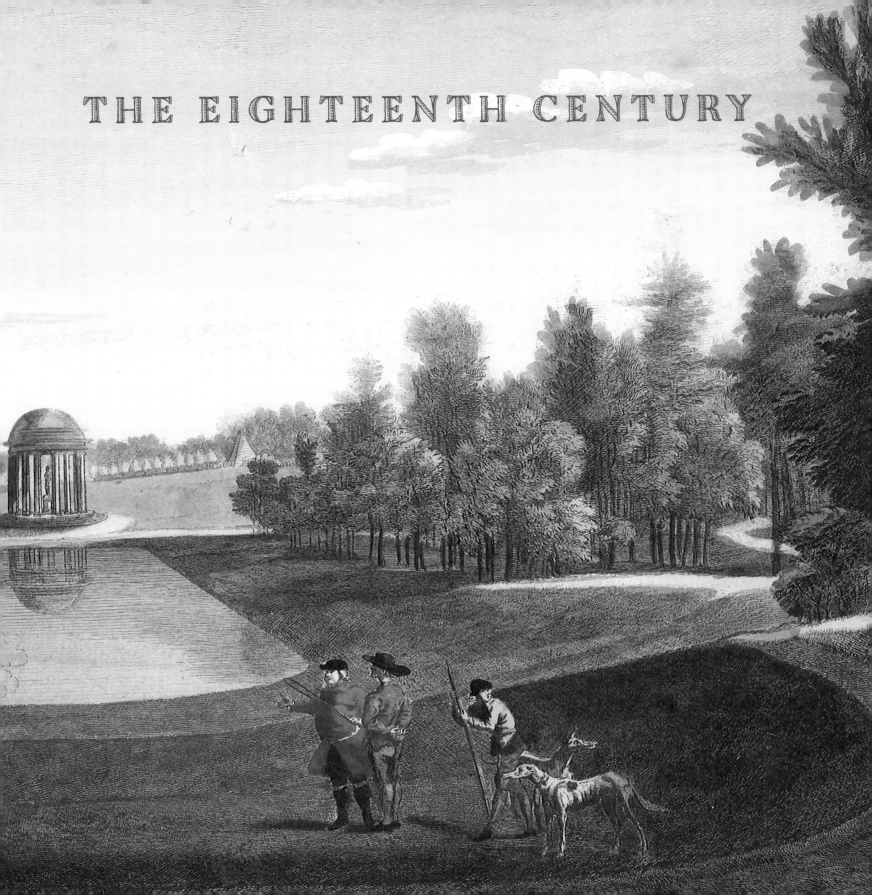

THE EIGHTEENTH CENTURY

THE EIGHTEENTH CENTURY

The gradual improvement of the roads throughout the latter half of the eighteenth century was augmented by better-sprung carriages, and these were supplemented by smaller and lighter chaises, chariots, curricles and phaetons. Both long-distance and local travel became easier, especially for women.[1] Mary Morgan marvelled at the number of carriages she encountered in and around Carmarthen: 'More than in Berkshire, Oxfordshire, Gloucestershire ...accounted for by the taste that now obtains of making the tour in Wales'.[2] This underlines the growing custom of visiting great houses and their parks and gardens. While the ability to travel and pay visits was concentrated among people in polite society, almost anyone sporting respectable clothes and able to tip the Housekeeper or Head Gardener was afforded access to the great showcase houses and gardens of the day. The gardens were designed to be as elegant as the houses for which they provided the setting and their layout moved away from formal designs like those at Chirk, with straight avenues, walks and canals radiating out from the house. Circuitous routes with rides, serpentine walks, wildernesses, eye-catchers and grottoes to enliven the way became the order of the day. As Richard Owen Cambridge pithily wrote in 1754:

> I remember the good time when the price of a haunch of venison with a country friend was only half an hour's walk upon a hot terrace; a descent to the two square fish ponds overgrown with frog spawn: a peep into the hog stye or a visit to the pigeon house. How reasonable was this when compared with the attention now expected from you to the

Fig. 91 (pages 106-107) 'A View at the Queen's Statue in the Gardens of Earl Temple at Stow in Buckinghamshire', a hand-coloured engraving from *The Beauties of Stow* by George Bickham (1750).

number of temples, pagodas, pyramids, grottos, bridges, hermitages, caves, towers, hot houses &c., &c.[3]

Stowe in Buckinghamshire was the great example and proved so popular with visitors that it had its own inn to cater for them and produced the first-known garden guidebook in 1744. *(Figure 91)* The elegant Claudian scene in Buckinghamshire was far removed from the wild mountains of Wales. Dr Thomas Herring, Bishop of Bangor, later Archbishop of Canterbury, travelling into north Wales in 1738 just after his elevation to Bangor, compared the two:

> The face of it [North Wales] is grand, and bespeaks the magnificence of nature, and enlarged my mind so much, in the same manner as the stupendousness of the ocean does, that it was some time before I could be reconciled again to the level countries. Their beauties were all in the little taste; and I am afraid, if I had seen Stow in my way home... I should have smiled at the little niceties of art, and beheld with contempt an artificial ruin, after I had been agreeably terrified with something like the rubbish of creation.[4]

WYNNSTAY

Wynnstay, near Wrexham, was one Welsh eighteenth-century site that reflected Stowe and provided a grand circuit for visitors. The park was one of the largest and most important in Wales, remarked on by every visitor to the area. Lord Lyttelton, in his *Account of a Journey into Wales,* gives an early description of Wynnstay:[1]

> From Wrexham we went to Wynstay, the seat of Sir Watkin Williams Wynn. Part of the house is old, but he had begun building a new one before his death[2] in a very good taste. One wing is finished, and that alone makes a very good

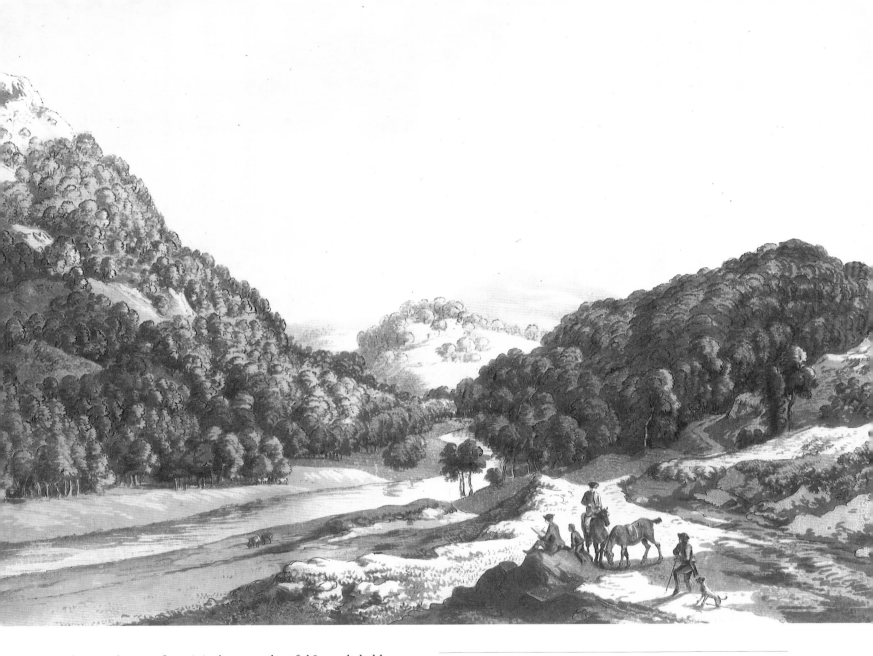

house. The view from it is the most cheerful I ever beheld; it stands in the middle of a very pretty park, that looks over that into a most delightful country; but if the park was extended a little further, it would take in a hill, with a view of a valley, most beautifully wooded; and the river Dee winding in so beautiful and charming a manner, that I think it exceeds that of Festiniog, or any confined prospect I ever beheld.... Tell Mrs C--- S---, that I would have her leave Clermont, and the banks of the Thames, and build a house

Fig. 92 Paul Sandby drawing the Welsh scenery during his tour of Wales with Sir Watkin Williams Wynn. From *XII Views in North Wales*, published in 1775.

in this lovely spot. I will visit her every year; she will not be at any expence in making a garden, for nature hath made one to her hands, infinitely better than that of S--.[3]

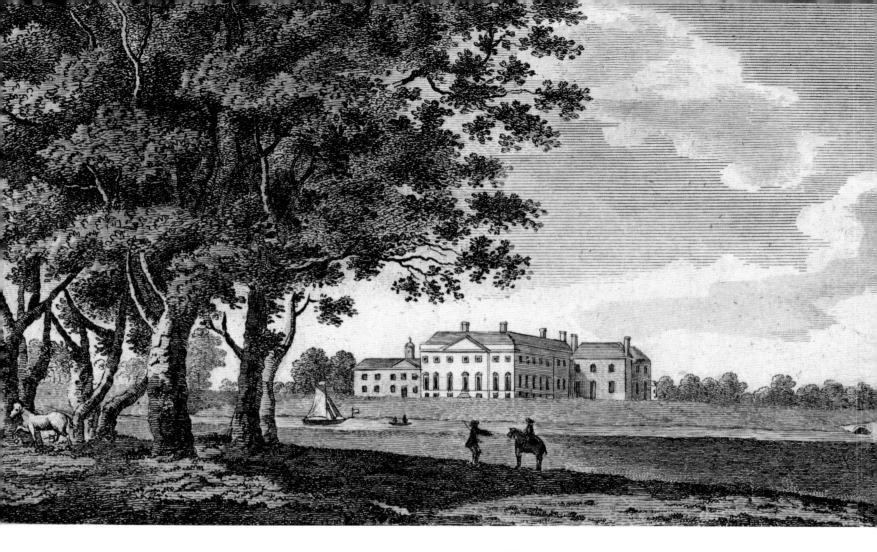

The demesne and pleasure grounds described by Lyttelton were detailed some 16 years earlier in 'A Pocket Book of Mapps of Demesne Land &c. belonging to Sir Watkin Williams Wynn Baronet' (c. 1740).[4] The sketches that ornament the map depict double lodges at the Ruabon and Oswestry gates, with straight avenues flanked by trees. The house itself stands on a terrace with a canal below, and deer grazing in parkland. One drawing shows the cold bath with a pretty attendant classical bath house behind it, set within a walled garden.

However delightful Lord Lyttelton found Wynnstay in the 1750s, some twenty years later Sir Watkin Williams Wynn, the 4th Baronet (1749-1789), as owner of the 'mightiest estate in north Wales,' gave Lancelot Brown a commission to create a park. Elegantly educated, he took the Grand Tour to Italy,

Fig. 93 'Wynnstay in the County of Denbigh', described as an 'elegant villa, most delightfully situated'. An aquatint by Paul Sandby, R.A., from *A Collection of One Hundred and Fifty Select Views in England, Wales, Scotland & Ireland* (London, 1782-3). The bridge on the far right-hand side was never built.

and returned to Britain as a true connoisseur of the arts. He inherited his estates as a baby, after his father died in a hunting accident. On coming of age in 1770, he set about putting Wynnstay on the cultural map. In 1771, accompanied by the artist Paul Sandby, he set off on a six-week tour of his estates and other parts of north Wales. This could be said to be the first

exploration of the area in search of the beauties of landscape. *(Figure 92)* Sir Watkin spent the princely sum of £111 7s 6d on this first Picturesque tour of Wales. He was responding to the growing appreciation and feeling for Britain's wilder natural landscape. The author of a piece in *The Gentleman's Magazine* in January 1768 suggested the 'taste for the Romantic scenery of nature, or the beautiful and stupendous monuments of art', would encourage 'the hardy invader of north Wales'.[5] Such monuments of art would include Sandby's landscapes that were published as a series of aquatint prints derived from his tours of Wales. *(Figure 93)* These views were hugely popular and helped raise awareness of the great beauties to be found in Wales, encouraging fellow artists and tourists to explore the country. In Pennant's view:

> Those that wish to anticipate the views in the intended progress may satisfy themselves with the purchase of the late publications of the admirable MR PAUL SANDBY, in whose labours fidelity and elegance are united.[6]

Sir Watkin first employed Richard Woods to work on the grounds. From 1770, Woods gave the formal canal a more natural outline and probably designed the kitchen garden that was under construction in 1775.[7] The commissioning of Lancelot Brown to work at Wynnstay in 1777 was possibly inspired by Sir Watkin's second wife, Charlotte Grenville (they married in 1771). *(Figures 95 & 96)* She already knew Brown, as his first position after he left his home county of Northumberland had been at Wotton, in Buckinghamshire, working for her father, George Grenville. Wotton had close family ties with Stowe and so, perhaps, Charlotte brought her childhood connections with Stowe and Brown's work there to Wynnstay.

Brown produced designs for the house and offices – unexecuted – the dairy, the pleasure grounds and park, including a new lake in the valley to the north-west of the house to be created by damming the river Belan. The Dairy was in the form of a Doric temple. Built in 1782, it had tiles specially made for it by Wedgwood.[8] The D-shaped pleasure ground and shrubbery was surrounded by Brown's ha-ha enclosing the

Fig. 94 (top) Lady Charlotte Williams Wynn, dressed in the Turkish fashion, with her three eldest children. Sir Joshua Reynolds, c. 1778.

Fig. 95 & 96 Pastel portraits of Lady Charlotte and Sir Watkin Williams Wynn, painted by Hugh Douglas Hamilton, 1772. This was only a year after their marriage in 1771.

grounds, outbuildings and the kitchen garden. Wyndham was an observer as the work went on:

> The house, which is not finished, stands upon the high point of it [the park]; from hence, the lawns sink in gradual slopes, – they are sometimes sprinkled with large and superannuated oaks, and sometimes covered with natural woods and coppices.[9]

This description underlines Brown's way of obtaining the flow of landscape from the house across a ha-ha to the park and then beyond to the wider view. He understood that the use of the parkland had to be practical and profitable. He made it possible to incorporate farming, shooting and hunting within a landscape that was also a visual symbol of wealth. Landowners were strongly influenced by the thought that profit and beauty should go hand in hand. Wynnstay, Dynevor and Cardiff Castle are the only known sites associated with Brown in Wales. Given his enormous output – he was responsible for some 170 landscapes over 35 years – Wales only has this tiny handful. His landscaping at Wynnstay was carried out between 1777 and 1783. As was his practice, he visited the project on an annual basis, coming to Wynnstay five times in all. Sir Watkin, possibly in an attempt to control the expenditure on his landscaping, would only use local staff on the work, paying Brown a fee of £300 for each supervisory visit and plans.[10] After Brown's death in 1783, the work was continued by his assistant, John Midgley, who was already supervising the project with the help of local cartographer, John Evans.[11] Brown's plan for the lake was completed by Evans with a large rockwork cascade. The lake was ceremonially opened in 1784 with a splendid feast held in the oak avenue attended by everyone who had worked and assisted on the project. 'All the teams and labourers he could hire', together with the neighbouring gentlemen and farmers, 'who cheerfully sent to his aid their teams, carts and colliers' to construct the 'Belan Water' each received a ticket of invitation from Sir Watkin, including 'Mr Evans on horseback' and 'Mr Midgley, with his levelling staff'.[12]

Shortly afterwards, Byng described his visit to Wynnstay:

> From the house we went into the shrubbery, which is neat and well laid out; (and was the last work of my friend Lancelot Brown) and thence into the kitchen garden & some paltry narrow hot houses…
> From the house, we rode to the lower part of the park, where works were carrying on, under the direction of a late servant of Lancelot Brown, who proceeded in a confin'd way with B's great plans; and which were explained to us by the schemer: B's intention was to have form'd a very fine piece of water by means of a great dam; and part of this plan is now advancing, but in a very inferior scale to what Brown proposed.
> From a small shrubbery, in which was a large open cold bath, adjoining the intended pool, we were let out of the park.'[13]

Over a decade later, in 1798, Skrine described the park and lake as they had developed:

> The park and grounds are well laid out, and the prospect towards Chirk castle and the great hills enclosing Llangollen is striking; but the place, as well as the house, was, even when I last saw it, in an unfinished state, and, upon the whole, rather disappointed me.…
> The Bellan lake, in the park, is a spacious sheet of water amidst large growing plantations, which in time will be highly ornamental.[14]

Sir Watkin was 39 when he died 1789. His mother commissioned James Wyatt to design a magnificent column in his memory with the inscription *Filio optimo mater eheu! Superstes* (To the best of sons his mother who – alas – survives, dedicates this). The column now featured in nearly every traveller's account of Wynnstay, like that of George Nicholson:

> It is highly and tastefully finished, rising from a spacious stone pavement, surrounded by a neat lawn, enclosed by majestic oaks, other trees of inferior magnitude and

appropriate shrubs. Though not seen from the house it is visible from various parts of the surrounding country.[15]

Sykes, passing by in 1796, found the column very handsome and, as ever, in his meticulous way, measured its details:

Winstay is a fine situation but the Grounds appear to want attention particularly near the House, a kind of Canal in front ought to be filled up. The distant prospect of Chirk Castle and Hills forming the vale of Llangollen bound the view very nobly. There is a pleasant walk near the river and a neat bath and there has lately been built a Doric fronted col' to the Mem. of the late Sir Watkin W. Wynn. It is a handsome coll' 160 ft high with a stair up the middle, and a landing every 16 steps, they are 2 ft 8 ins from center to outside at which place they are 1 ft wide and 7 ins.[16]

In 1813, Pugh described Wynnstay's new feature:

The entrance ... is through a beautiful avenue of lofty trees; – On the right of this is a very handsome monumental column, to the memory of the late Sir Watkin: its summit has a gallery, and the whole is crowned with a bronzed urn, from a design by Mr. Wyatt. Wynnstay is well situated, on a gentle rise, and commands a very interesting and delightful prospect of a valley, diversified with every thing that can satisfy a rational mind: nor does the colouring, given to it by Lord Lyttelton, exceed reality. [17]

Nicholson's account tells us that visitors were expected to call at Wynnstay and provided great detail as to what might be found there:

With permission, the traveller may examine its varied and magnificent improvements. The avenue is formed of oaks, beeches, chestnuts, and planes, which extend 1 mile. The Park – though the surface of the ground is not greatly diversified, yet being well wooded, and aided much by the interposition of art, the spot possesses advantages which

Fig. 97 Jeffry Wyatt's 1806 design for the Nant-y-Belan Tower at Wynnstay.

render it delightful....A herd of Buffaloes, some Chinese cattle, and pigs rough with curled hair, have been frequently in the park....The principal features are the lake, surrounded by a semicircular amphitheatre of wood, and terminated by the Column, seen from the seat near the rustic bridge.; ...the sequestered retreat of the marble Bath supplied by two lion-head fountains; the smooth lawn, affording varied glimpses of the water...; a Gothic seat upon an eminence well disposed to display the objects of water, lawns, interspersed

Irish Rebellion in 1798. It was designed by Jeffry Wyatt, later Sir Jeffry Wyatville, in 1806. *(Figure 97)*

John Evans included Wynnstay in his *Beauties of England and Wales* (1812) as the Brown landscape continued to mature:

> Considerable improvements have been made within a few years past, by the erection of baths, new plantations, and a fine sheet of water that reflects the images of several peculiarly handsome grown isolated trees*, on its margin, in front of the house. Under the direction of John Evans, Esq., ...the waters of several brooks and rills were made confluent, so as to form a torrent; which, dashing over a lofty ledge of artificial rockwork, covered with mosses and lichens, assumes the appearance of a natural cascade: and very similar to the much-admired one in the Marquis of Lansdowne's park at Calne, in the county of Wilts.[19] The rapid stream then winds through the Belan grounds, having its margins skirted with sylvan accompaniments; where a few years since, a sprinkling of stunted hawthorn bushes were nearly sole possessors of the soil.[20]

As well as the Nant-y-Belan Tower, Williams Wynn created another military memorial, this time to Waterloo. The Gothic Waterloo Tower, a castellated lodge built between 1815 and 1820, stands in a grove of oak, beech and sweet chestnuts on the top of a prominent knoll, designed as a viewing point, in the south-west corner of the park. It was probably designed by Benjamin Gummow, a local Wrexham architect. Bingley noted a custom that had arisen in connection with the Waterloo Tower: 'on it a flag is always displayed when Sir Watkin is at Wynnstay'.[21] The two towers were now added to the beauties of the place:

> Within the park, which reaches to the village of Rhuabon, is a carriage-way running along the banks of the River

with stately timber trees, and, at the end of the vale, the tower of Ruabon church; the vista of the waterfall, beyond which appear forest above forest, to the distant mountains. Upon a much enlarged scale is the New Drive, 5 m. in extent, conducted over lofty elevations, to a rotundo or Tower, intended to commemorate the heroes belonging to the Cambrian Legion of ancient Britons, who fell in their country's cause, under the command of Sir Watkin, in the Irish rebellion of 1798. This station affords a magnificent display of mountain, wood and meanderings of the deeply-imbedded Dee. [18]

The new drive was part of improvements at Wynnstay, where the 5th Baronet (1772-1840) spent some £40,000. He extended the range of the park to the south and west, making the most of the picturesque aspect of the Dee valley. The rotundo or Tower commemorated, as Nicholson reported, members of Sir Watkin's regiment of Welsh militia, The Ancient British Light Dragoons, who fell in Ireland during the

Dee, and commanding a constant succession of beautiful prospects. Two conspicuous objects passed upon this road, are a tower to commemorate the battle of Waterloo, and a cenotaph after the design of the Grapo di Bore, near Rome. This is dedicated to the memory of the officers and soldiers of the regiment of ancient British cavalry – or Cambrian regiment – under the command of the late Sir Watkin Williams Wynn, who were killed in the Irish Rebellion. It overlooks the romantic glen of the Dee, called Nant y Belan, the Martens' Dingle. The views commanded from this spot, both far and near, are at all times magnificent, but most so when seen at evening, and under the mellowing influence of the setting sun.[22]

Fig. 99 A 'bella-vista' from the Tower at Wynnstay over the Vale of Llangollen. A hand-coloured steel engraving by W. Radclyffe after David Cox, c. 1835. This was originally produced as an illustration for Thomas Roscoe's *Wanderings & Excursions in North Wales*.

The creation of a great park and gardens was not just for private pleasure. It was also meant to be admired by visitors. Brown's landscapes were set to unroll before you, viewed from horseback or from a carriage as it bowled along. *(Figure 98)* In 1821, the 5th Baronet accompanied his guests in just this way:

Fig. 100 The front view of the new Wynnstay, 'in keeping with the history and station of the noble family', with the carriage sweep and immense *porte-cochere*.

Fig. 101 A winter view from the Terrace at Wynnstay in 1886. All the statuary and vases were sold in the twentieth century. Pen & chalk sketch by Frances Elizabeth Wynne, 1886.

We stayed at Rhuabon whilst the Servant went with a note from Sir Charles [Morgan] to Wynnstay Sir W.W. Wynne, who rode down himself, & most cordially invited us to stay, which we did. Sir C. Angelena & I walked up to the house with him. The walk we went was very pretty The cold bath is very elegant, in the open air, lined with marble, & very spacious, with a dressing room at the back – a Column built of stone, erected to his grandfather[23] & very high – ...we walked round the garden which is very extensive – A fine conservatory in the flower garden, with many scarce plants, the papyrus, palmetto, etc. – After our walk, Sir Watkin took us a drive in the grounds, which were exceptionally extensive & picturesque, there are two pretty 'bella-vistas' – one is very handsome.[24] *(Figure 99)*

A year later, Loudon gave Wynnstay a star in his *Encyclopaedia of Gardening*. Repeating much of what had been written by earlier writers, he revealed his passion for kitchen gardens, telling the reader that 'the horticultural and floricultural establishments are very complete; and here the banana was fruited, and its fruit used at the dessert for the first time in England.'[25]

Guidebooks informed potential visitors that Wynnstay was 'shown to strangers who ask'.[26] Such visitors not only recorded the elegant additions to Wynnstay but also its trials and tribulations. In 1828 Amelia Waddell recorded in her diary:

The town [Ruabon] of Sir Watkin is visible in the distance ... the town is perpetually smoking from the different

manufactories with which it abounds. Entered the park by a handsome gate, 3000 head of deer inhabit the wide domain …we could not see the interior, Sir Watkin being expected from town that evening. The flower garden … the greenhouse …The pinery &c. are all excellent. …Waters confined for the cascade had burst their banks, flooded the grounds … washed down trees and carried away a bridge, the devastation was most frightful to behold. [27]

Following the death of the 5th Baronet in 1840, Wynnstay suffered devastation when the mansion and its contents were consumed by fire in 1858. The Georgian building had been re-worked by James Wyatt for the 5th Baronet c. 1820 (he had originally drawn up plans for the 4th Baronet). All trace of this vanished under the hand of Benjamin Ferrey and reappeared as 'a High Victorian version of French Renaissance' for the 6th Baronet.[28] This new edition of Wynnstay seems not to have attracted the good opinion of tourists and travellers in north Wales, other than to comment on the considerable extent of the park and the walls around it. Engravings from Thomas Nicholas's *Annals & Antiquities of the County Families of Wales* (1872) show 'the new mansion, replete with all the appointments of a sumptuous residence …a costly edifice in the Renaissance style'.[29] *(Figure 100)* This huge and ostentatious building, while undoubtedly impressive, lacked the charm of the earlier house and this might account for Wynnstay's gradual disappearance from travellers' accounts. *(Figure 101)*

The fourth Sir Watkin Williams Wynn was the largest landowner and one of the richest men in Wales in the eighteenth century. In his case, much of the money came from his enormous rent roll derived from 141,909 acres.[30] Sykes wrote: 'Sir W:W:Wynn is said to have £36000 a Year …, and [is] obliged to keep up a state as if King of Wales'.[31] Other Welsh landowners were creating beautiful houses in lovely settings, but using the profits of industry rather than land. The driving force of the early Industrial Revolution in Wales was copper. This was the essential commodity that supported the production of 'White Gold', sugar. Copper sheathing was used to improve the sailing ability of the ships that left Swansea carrying copper

slave goods, copper wire, ingots, bangles and the utensils used for making sugar and rum, which were highly prized by West African slave traders, who called copper 'red gold'. The goods were exchanged for slaves. The ships then sailed for the West Indies, where they unloaded the slaves and materials for the sugar plantation. Sugar and rum were then sailed back to Britain; hence the term 'triangular trade'. In the 1780s, sugar was said to generate 70% of Britain's GNP. The men who controlled the supply of copper ore from Parys Mountain on Anglesey had access to unparalleled wealth. Both Plas Newydd on Anglesey and Kinmel Park in Denbighshire were developed and enhanced using copper riches, as the men who owned these properties, Sir Nicholas Bayly (and later the Marquesses of Anglesey) and the Rev. Edward Hughes, also owned Parys Mountain, the source of copper ore that became the largest copper mine in the world: 'Lord Anglesey and the Rev. Edward divided more than once upwards of £300,000 in a year'.[32]

PLAS NEWYDD, ANGLESEY

The 7th Marquess of Anglesey, writing about Plas Newydd, said: 'Before the 1780s there is no documentary evidence to shed any light on the surroundings and gardens of Plas Newydd'.[1] While that is true, in 1756 Lyttelton recorded the beauty of the setting that remains to this day:

> We passed into Anglesea and landed at the seat of Sir Nicholas Bailey, which is the pleasantest spot in the island. He has Gothercised an old house with good judgement and taste. The view from it is charming; he sees the sweet country through which we had travelled, from Carnarvon

Fig. 102 Moses Griffith's watercolour painted for a special edition of Thomas Pennant's *Tours of Wales* with Plas Newydd 'embosomed in woods' overlooking the Menai Strait.

> to Snowdon above it, which ennobles the prospect; the Menai winds, in a most beautiful manner, just under his windows; his woods shade the banks of it on each side of it, quite down to the water, above which, intermixed with them, are fine ever-green lawns, which, if helped with a very little art, would, together with his wood, make a garden, or park, of the most perfect beauty; but all is yet in a rude and neglected state.[2]

Sir Nicholas Bayly, 2nd Baronet (1709-1782), inherited his father's estates in 1741. He married, in 1737, Caroline, the daughter of Brigadier Thomas Paget of Beaudesert in Staffordshire, and with her came another source of wealth, coal mines. The incredible effect of the vast wealth generated by the copper ore from Parys Mountain meant that he was able to begin improvements and development at Plas Newydd and he began the 'Gothercising' of the house with suitable crenellations and windows overlooking the Menai Strait.

Thomas Pennant, in his *Tours of Wales* (1772), also admired the setting of the house:

PLAS NEWYDD ...lies close upon the water, protected on three sides by venerable oaks and ashes. The view up and down this magnificent river-like strait is extremely fine. The shores are rocky; those on the opposite side covered with woods; and beyond soar a long range of *Snowdonian Alps.* – The mansion has been improved, and altered to a castellated form, by the present owner. *(Figure 102)*
IN the woods are some very remarkable druidical antiquities, Behind the house are to be seen two vast Cromlechs. ...These are the most magnificent we have, and the highest from the ground; for a middle-sized horse may easily pass under the largest.[3]

In 1774, Dr Johnson and Mrs Thrale enjoyed a sparkling view of Plas Newydd from the sea. Mrs Thrale recorded:

We put our pretty boat to sea again... The first thing that attracted our notice was Plasnewydd, the seat of Sir Nicholas Bayley, a place of no small dignity and great convenience. The situation is peculiarly delightful. On the banks of the Streight, raised by terraces so as to secure it from damp and adorned by woods which shelter it on every side but the front.[4]

Fig. 103 (left) The Cromlech at Plas Newydd being measured by tourists. Watercolour by Samuel Hieronymus Grimm, painted on his tour of Wales with Henry Penruddocke Wyndham in 1777.

Fig. 104 (above) The East Front of Plas Newydd with a view across the Menai Strait showing how the house presented itself before the terracing was created. Watercolour by John 'Warwick' Smith.

Fig. 105 (right) Sir Henry Bayly, later 1st Earl of Uxbridge, holding copper ore from his Mona Mine.

Wyatt and Potter had worked together for Lord Uxbridge at Beaudesert in the 1770s. *(Figure 104)*

Most of the work for Plas Newydd was carried out between 1793 and 1799 and observed by Colt Hoare in 1797:

Lord Uxbridge...is now building a large house...in the Gothic style of architecture; Hot and cold sea baths before the house. Stables: a picturesque Gothic building in a singular style.[6]

When Lord John Manners reached Plas Newydd in September 1797, he was escorted by Lord Uxbridge 'about the house and grounds, which, when finished, will be one of the finest places conceived. In the house, Lord Uxbridge is making very grand alterations, Mr. Potter is the architect, and the style is chiefly light Gothic.' He declared that the woods were filled 'with romantic walks, and the grounds are laid out with great taste.[7]

Having begun to set his house in order, Lord Uxbridge turned his attention to the gardens. Initially, he had sought advice from his friend and neighbour, Lt-Col William Peacocke, about several new plantations of woodland, but in 1798 he commissioned Humphry Repton to produce a Red Book for the landscape at Plas Newydd. Considered by many as one of his best landscapes, Repton created a park and garden, 'beautiful from many view-points'.[8] The Red Book for Plas Newydd has lost Repton's fourteen drawings but, written in his clear hand, gives a good idea of what he had in mind, as well as relaying some criticism of the landscape work that had been undertaken by Peacocke. Repton admonished Lord Uxbridge that:

...had your Lordship had leisure, or the persons you employed had skill to direct the improvements there had have been no necessity to ask my opinion.

This way of approaching Plas Newydd and Anglesey was popular and, in July 1787, Byng also sailed down the Menai from Caernarvon to Plas Newydd:

...contemplating the pleasant shores; and in an hour's time, came to Plas Newydd, – most beautifully placed on a turn of the Straights, commanding an extensive reach; the well-wooded opposite shore; and the loftiest mountains of Caernarvonshire. When landed we walked directly to the Druidical temple, the wonder of the curious; built of upright stones, and cover'd by a stone of such stupendous bulk, that one cannot conceive how it has been convey'd and erected there.[5] *(Figure 103)*

In 1782 Sir Nicholas Bayly died and his son, Henry (1744-1812), succeeded at Plas Newydd. He had succeeded his cousin as the 9th Baron Paget of Beaudesert in 1769, taking the surname Paget rather than Bayly. As Henry Paget he was created the 1st Earl of Uxbridge (of the second creation) in 1784. With money pouring in from Anglesey copper ore and Staffordshire coal, he was able to begin his own improvements to Plas Newydd. His 1785 portrait by Romney shows him holding a sample of copper ore from Parys Mountain. *(Figure 105)* He asked James Wyatt to come up with plans for the house, which were principally undertaken and supervised by his assistant, Joseph Potter.

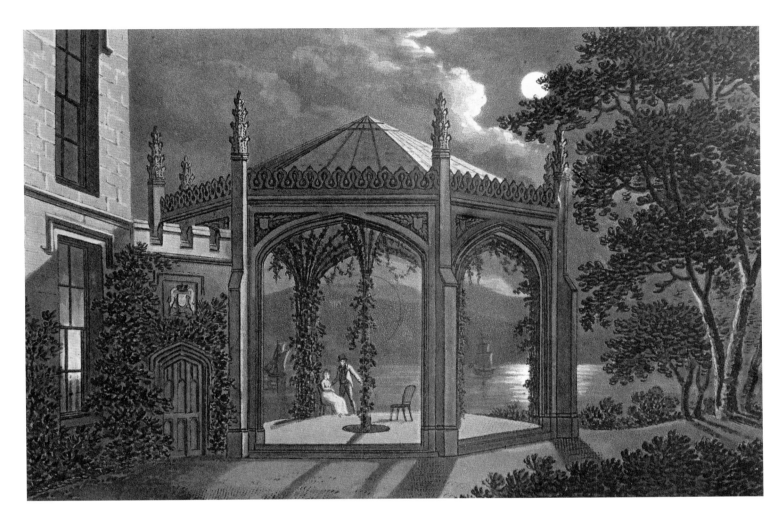

He was very aware of the position of the house and the fact that it attracted many visitors, who only saw it for the first time from across the Menai Strait:

The greatest beauty of Plas Newydd consists in the concave wings of wood on each side, forming a grand amphitheatre, which is hardly to be seen except from the water, or from the opposite shore, yet many persons may not have an opportunity of viewing the place from there, it becomes a very essential part of the improvement to bring these woods into notice from the grounds of Plas Newydd.

Repton covered every detail from realigning the approach to the house 'till it suddenly bursts on a lawn beautifully sloping towards the water', commenting on cottages, the front of the dairy, the kitchen gardens, the Conservatory and the

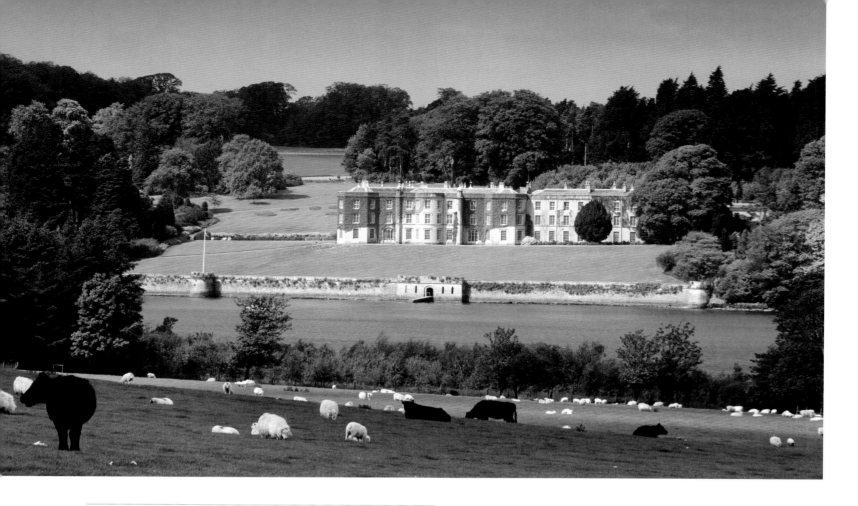

Fig. 108 Plas Newydd viewed across the Menai Strait.

Greenhouse. The arrangement of the woodland plantations and the new approach were crucial to his landscaping. *(Figure 106)*

Lord Uxbridge was clearly pleased with Repton's designs for Plas Newydd, as he commissioned a second Red Book from him for Beaudesert in 1814. Very elaborate and costly, Repton's plans here were never carried out. In his *Observations on the Theory and Practise of Landscape Gardening* (1805), Repton recorded the design of one element for Plas Newydd that features in almost everything written about his work, but which was never built. *(Figure 107)* His Red Book was lyrical about the effect he hoped to achieve – 'a design to shew how the genius of painting and gardening may hope to flourish under the Palm of Peace, if crowned with success':

On warm summer evenings when such a pavilion wd tempt us to walk out by moonlight, to enjoy the murmur of the waves, and the perfume of those plants which are most fragrant at that time. – the Straits of Menai & the mountain of Snowdon, wd be presented under the arches in a most singular fashion.

Aware of the visitors who flocked to Plas Newydd to see the famous cromlech, Repton also made suggestions as to how it might be protected:

This rare Druidical remain is too curious to be passed in silence, in a plan which proposes to show every object at Plas Newydd to the greatest advantage.[9]

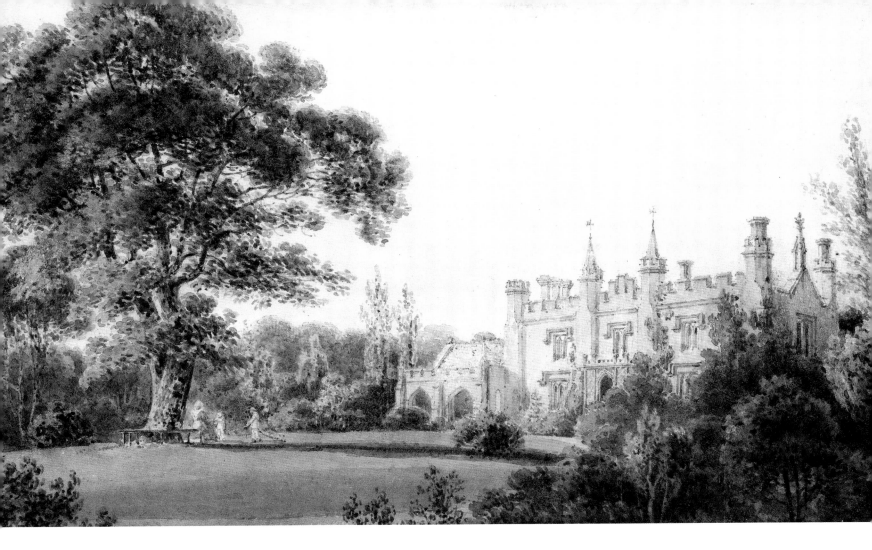

Colt Hoare, as a keen antiquarian, was thrilled with the sight of the cromlech, which had been seamlessly woven into the parkland by Repton as a great feature:

Thursday 9 August 1810: We... visited Plas Newydd, the magnificent seat of Lord Uxbridge, magnificent as a building and magnificent in the views it commands over the Menai.... The antiquary will have a rich treat in viewing the fine British monuments behind the house.[10]

Fenton, travelling with him, commented on the 'grounds much enlarged ...and the whole enclosed with a high stone wall. The Place is kept in a manner that does infinite credit to the possessor'.[11]

Fig. 109 Druid's Lodge at Plas Newydd, c. 1810. A watercolour by Thomas Richard Underwood.

The enhancing of Plas Newydd attracted favourable comment from everyone who visited Anglesey, even when Repton's design was still young. Nicholson related that, viewed from the Caernarvon side of the Menai Strait, you saw:

A parapeted bastion wall, placed as a defence against the sea, along which runs a handsome terrace in front of the sloping lawn, together with sea-baths on the left, and an elegant greenhouse on the right, add considerably to the

fascinating effect. The park, though not extensive, is well-wooded, and exhibits by the aid of walks and rides, laid out with judgement, very considerable diversity.[12] *(Figure 108)*

Possibly the most famous member of the family was Henry William Paget (1768-1854), created the 1st Marquess of Anglesey in 1815 'as a reward for his distinguished bearing on the field of Waterloo'. Inheriting in 1817, it appears that he did not spend a lot of time at Plas Newydd. When Prince Pückler-Muskau travelled to Anglesey in 1827, he left a description mentioning that Plas Newydd was 'seldom inhabited by the proprietor, whose principal residence is in England.'[13] His account began:

Dearest Julia, will you drive with me Plas Newydd...? The horses of fancy are soon harnessed.
We repass the giant bridge [Telford's newly-built suspension bridge], follow the high-road to Ireland for a short time, and soon see from afar the summit of the pillar which a grateful country has raised to General Paget, then Lord Uxbridge, and now Marquis of Anglesea, in memory of the leg which he left on the field of Waterloo.[14] About a mile and a half further on, we arrive at the gate of Plas Newydd. The most remarkable things here are the cromlechs, whose precise destination is unknown; they are generally believed to be druidical burial places. ...Some are of such enormous size that it is inexplicable how they could be brought to such elevated situations without the most complicated mechanical aid. It is, however, difficult to say what is possible to human strength, excited by unfettered will or by religious fanaticism. ...The cromlechs of Anglesea, which are not of the largest class, have probably suggested the thought of building a druidical cottage in an appropriate spot, commanding a beautiful view of Snowdon. It is, however, a strange heterogeneous chaos of ancient and modern things. In the small dark rooms light is very prettily introduced, by means of looking-glass doors, which answer the double purpose of reflecting the most beautiful bits of the landscape like framed pictures. In the window stood a large sort of show-box, a camera-obscura...[15]

Repton had recommended a Gothic treatment for this cottage, later called Druid's Lodge, in his Red Book. *(Figure 109)* Potter duly added a Gothic tower in 1819. The taste for 'Druidiana' evoking an ancient British past could be found in other gardens in Britain, but few could boast the great stones at Plas Newydd and they were clearly something the Paget family felt proud of. Even the Marquess of Anglesey's yacht was called The Druid. The description of the Druid cottage was echoed by the then-Princess Victoria, visiting Wales for the first time, aged thirteen, in 1832:

Sunday 26th August: You first enter a fine gate of stone with a lodge & go up an avenue of fine trees; on the right-hand side a little way from the lodge is Mr Sanderson's cottage, the agent of Lord Anglesea who offered Mama Plas Newydd. It is a pretty little gothic cottage surrounded by flowers. *(Figure 98)*

A little later on Victoria inspected the cottage for herself:

Friday 7th September: At 11 we walked over to Mr. Sanderson's cottage. It is extremely prettily fitted up, the wood carvings which surround the ceilings & sides are very pretty and well made. Amongst many other things the camera obscura upstairs is very curious and pretty.[16]

For whatever reason, the family do not seem to have spent much, if any, time at Plas Newydd after the death of the 1st Marquess, who spent most of his time either in London or at Beaudesert. For most of the nineteenth century Plas Newydd was let out. Louisa Stuart Costello, writing in 1845, refers to this apparent neglect:

Plas Newydd is a most cheerful, agreeable place, and one can only wonder at the entire neglect into which it has fallen for more than twenty years. Now that the rapid communication with London is to be rendered even swifter by a new line of railway from Chester to Bangor, there is no reason why Plas Newydd should be considered too distant on its Druid isle.[17]

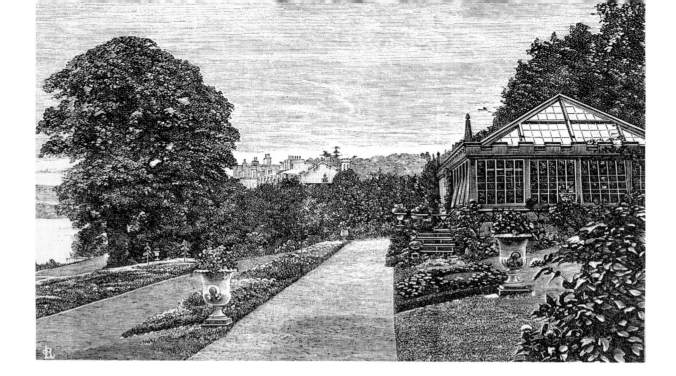

While the absence of the family and their apparent lack of interest meant that very little was changed on their account within the park and gardens, Plas Newydd continued to feature on visitors' itineraries when in Anglesey or travelling towards Ireland. By the time the writer for the *Journal of Horticulture* arrived at Plas Newydd in 1873, Margaret, Dowager Lady Willoughby de Broke[18], had been in residence for some fifteen years and had a great influence on the gardens, as described by the *Journal* writer:

A vista has been cut through the woods to the left, so that the pillar crowned with the statue of the Waterloo Marquis of Anglesey may be seen in the far distance. It is about midway between the mansion and the Menai Bridge. The lawn sloping from the terrace before the mansion-front is tastefully decorated with flower beds, the arrangement, planting and culture of which testify to the skill of Mr. Wright [the Head Gardener].

The stove represented in our engraving is small – 26 feet by 18 feet, but in it Mr. Wright has contrived to cultivate the largest variety of plants we ever noticed in so confined a space.

Fig. 110 'The Stove' at Plas Newydd, now the site of the Italian Garden, as it was illustrated in *The Journal of Horticulture* in 1873.

The Stove contained two tanks measuring 4ft 4ins high planted with water lilies with a palm in the middle. There were pillars and the back wall was covered in Fuchsias, Pelargoniums, Ferns and Begonias. The *Journal's* article tells us about: 'one of the peculiarities of the flower garden we must not omit; it is a remnant of the old styles of bedding, and deserves not to be obliterated, having the beds encased by flat very broad edgings of Box instead of grass'. The author concluded that, 'long would we linger over our reminiscences of this and other attractive places in this too-little visited Welsh county, but we hope we have published sufficient to induce others to participate in its kindliness.'[19] (*Figure 110*)

Travelling along the coast of the Menai Strait from Plas Newydd, visitors could follow the 'new and beautiful road made at the expense of Lord Bulkeley'[20] to Beaumaris, passing the celebrated two bridges across it that link Anglesey with Caernarvonshire, and arrive at that centre for Welsh hospitality, Baron Hill.

South East front of Baronhill the Seat of the Right Honourable Lord Viscount Bulkeley

BARON HILL

The original house of Baron Hill, perched above Beaumaris on Anglesey, was planned by Sir Richard Bulkeley to welcome Henry, Prince of Wales, the elder brother of Charles I, en route to Ireland to become Viceroy there. Sadly, he never saw it, dying suddenly in 1612; the house was completed by 1618. Its lofty position, facing travellers as they approached Anglesey from the east, ensured that this house in its various incarnations always impressed on first sight and, in common with Plas Newydd, a little further to the south-west, the views from its grounds across the Menai Strait to Snowdonia were highly praised.

The generous hospitality usually extended to visitors to Baron Hill, whether the Bulkeley family was in residence or

Fig. III Wyatt's elevation for Baron Hill (1776) as it would be seen across the Menai Strait.

not, was another reason that it was remarked upon by weary travellers. Loveday, returning from Ireland in July 1732, recorded that:

My Lord dispatched a letter to his Agent, ordering him to entertain Us, & shew Us what was to be seen, if He should not himself be in ye Countrey. Lord Bulkeley is a Gentleman of ye best good Temper, obliging & friendly, does not take State upon him, yet lives like a nobleman....For Situation, Nothing, except (as they say) Mount Edgcomb by Plymouth,[1]

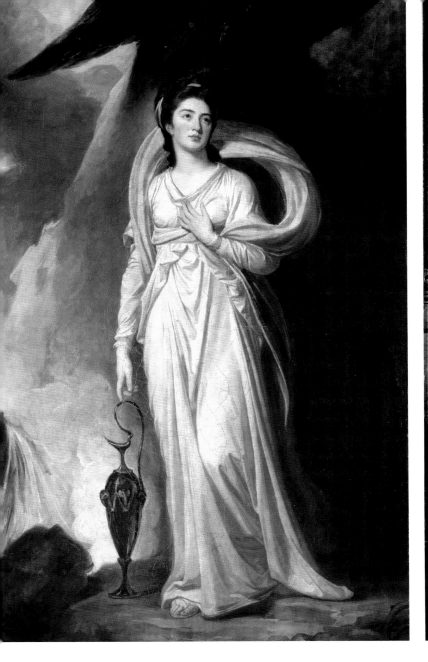

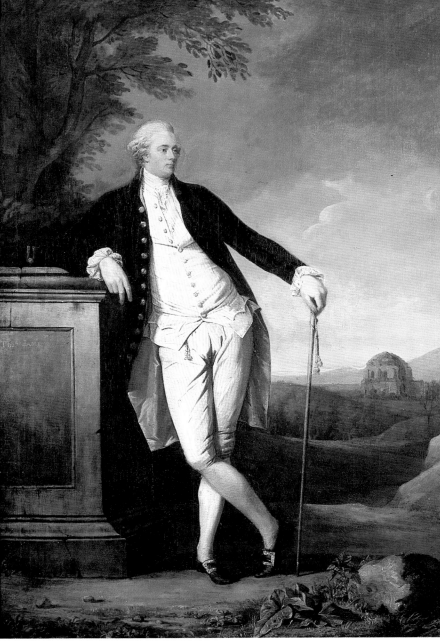

Fig. 112 Elizabeth Harriet Warren, Thomas Bulkeley's wife, painted by George Romney to mark the occasion of her wedding. She is depicted as Hebe, cup-bearer to the Gods and goddess of youthful beauty. Thomas Bulkeley changed his name to Warren Bulkeley in order to inherit the Warren fortune.

Fig. 113 This portrait of Thomas, 7th Viscount Bulkeley and 1st Baron Bulkeley of Beaumaris, depicts him while on the Grand Tour. He reached Rome by 19 January, 1774, and is shown standing in a view of the Roman Campagna, with the Temple of Minerva Medica in the background.

Fig. 114 The Watts' engraving of Baron Hill: 'Baron Hill has lately received such material Alterations and Improvements... under the direction of Mr Samuel Wyatt, that it may almost be said to have been rebuilt... The grounds, which are very beautiful, have been laid out and improved, under the direction of Mr. Emes.'

Fig. 115 (right) Colt Hoare's sepia wash drawing of Princess Joan's tomb, made on August 15, 1810.

can exceed Baronhill, 'tis planted high on ye side of an hill above ye town of Beaumaris...It is well-wooded, so yet there are very pleasant long Walks here.[2]

Not long afterwards, Dr Richard Pococke, writing to his mother from Holyhead on July 13, 1750, as he returned from Italy to Ireland, reported that, 'We din'd at Beaumorris – a way I had never been before – a little clean town: Ld Buckley's seat close to it, a fine situation and pleasant gardens on the side of the hill; we saw the house and the gardens...'[3]

Loveday and Pococke were seeing a house and gardens long vanished from view. Two rare paintings give a hint of what Baron Hill was like in the first half of the eighteenth century, showing 'A View from Baron-Hill as it Anciently appeared before the New Buildings and alteration in the Ground was made by Thomas James Viscount Bulkeley begun in 1775'.[4] The view looking towards the house reveals a tall, pale Jacobean-style building with many chimneys and ranges behind and to the southern side of the house. A stone walled terrace immediately in front of the mansion is pierced by a fine stone arch. The second view, looking across the Menai Strait, shows a brick path leading from the house through the arched gateway to a series of three walled enclosures that slope down to a brick-walled garden with espaliered fruit trees ranged along the walls. There is a charming small garden house tucked into a corner

with an ogee roof, complete with a ball finial on the top. While ancient bricks have emerged in recent diggings, there is no trace of this layout anymore.

By the second half of the eighteenth century, Thomas, 7th Viscount Bulkeley (1752-1822), was the principal landowner in Anglesey. A man of education and taste, Lord Bulkeley made the Grand Tour as a young man between 1773 and 1774. His companion and friend on the tour was George Grenville, later Earl Temple and 1st Marquess of Buckingham, who inherited Stowe in 1779. His sister, Charlotte, was married to the 4th Sir Watkin Williams Wynn of Wynnstay. There are records of the Bulkeleys staying at both Wynnstay and Stowe. Influenced by his Grand Tour and by what he saw at these great houses, Lord Bulkeley began to create his own villa and Arcadian grounds. He married Elizabeth Harriet Warren in 1777, and the architect Samuel Wyatt remodelled the house between 1776 and 1779 to welcome her. *(Figures 112 & 113)* To provide a suitable setting for the house Lord Bulkeley employed the skills of William Emes to design and lay out the park and gardens, sweeping away the earlier formal gardens. Just before these improvements were put in hand, Dr. Johnson recorded in August 1774 that:

Lord Bulkeley's house is very mean, but his garden is spacious and shady, with large trees and smaller interspersed. The walks are strait and cross each other with no variety of plan but they have a pleasing coolness and solemn gloom, and extend to a great length.[5]

Wyatt encased the original Jacobean house within his elegant villa *(Figure III)*. According to Loudon, it was 'supposed to be too high for its elevated situation',[6] a view echoed by Colt Hoare, who thought, 'nothing to me is a high house crowded with windows'.[7] Emes's landscape plans have been lost but he created a long Brownian sweep of parkland, integrating the house and the castle into one elegant landscape.[8]

The new house and its setting were recorded in 1779 by William Watts in his *Seats of the Nobility & Gentry*.[9] Nicholas Owen remarked on the renewed landscape: 'From hence [Aber] you have a charming view of Baron Hill... The house was rebuilt a few years ago by the present worthy nobleman, in a neat, modern Italian style. The disengaging of trees and formal walks in the front has greatly improved the prospect'.[10] However, not all visitors agreed. Byng, in waspish style, possibly commenting on the Conrad Metz engraving for Watts, recorded in 1784 that:

> Wednesday July 14: ...we walk'd up to Lord Bulkeley's seat at Baron-hill... From this house is the finest of prospects... the flattering painter has placed in the front, on the lawn, large clumps of flourishing trees; whereas the trees are small, and most scantily and ignorantly planted, and from some strange idea, are all topp'd; supposing that distant mountains cou'd not be descry'd but over pollard trees – a want of taste is very conspicuous.'[11]
> The house is of the ugliest shape, with windows of all shapes; cover'd without by Adam's Plaister, and within in the modern stucco'd frippery taste. – In giving this View of the house (whose name I should object to, as sounding Barren) all the Beauty of the Prospect is concealed;[12] *(Figure 114)*

Skrine shared this view of the house while admiring the setting and grounds of Baron Hill:

> Baron Hill, the beautiful seat of Lord Bulkeley, rises from a swelling lawn above Beaumaries in the midst of a thick grove. ...The castle – presents a grand object in front of the town at the bottom of the lawn of Baron Hill. The principal approach to that noble place is conducted through a part of

the ruin, and the grounds do credit to the taste with which their owner has embellished them; but the architecture of the house does not quite equal the surrounding scenery. In truth a pavilion-like structure, fronted with white stucco, covered with a fantastic dome, and terminating in spruce bows on each side, suits but ill with the rude grandeur of the opposite heights...[13]

On his first visit to Baron Hill in 1801, Colt Hoare noted that, 'the walks are good, many of which are conducted through Lord Bulkeley's grounds and open to the public.'[14] He returned in 1810 with Richard Fenton, who commented on 'the grounds – which are very delightful and richly wooded, the walks broad, clean and well gravell'd' and remarked on 'the largest Cherry tree that ever occurred to me, even larger than those ...in Lord Dynevor's Park'.[15] Fenton recorded that, 'the tomb of Princess Joan, Llewellyn's consort, which had for many years officiated most disgracefully as a watering Trough for Horses, ...has been set up by Lord Bulkeley at the termination of a walk in his pleasure

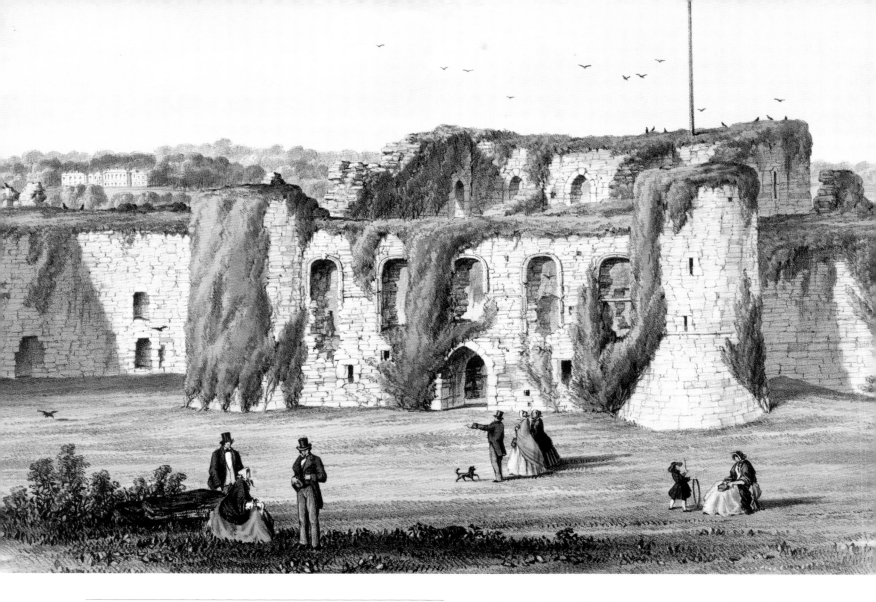

Fig. 116 A view of Beaumaris Castle with Baron Hill in the background, demonstrating how the two great structures related to one another. Coloured lithograph by T. Catherall, c. 1850.

grounds in a gothick Mausoleum erected for that purpose'. Colt Hoare noted the inscription (supplied in Welsh, Latin and English) that stated that the 'neat Gothic building' (Figure 115) and its contents were there 'for preservation as well as to excite serious meditation on the transitory nature of all sublunary distinctions... and placed there in 1808.'[16]

As at Plas Newydd, where the ancient cromlechs had been incorporated into the landscape, Lord Bulkeley, in creating this little Gothic folly to house Princess Joan's tomb, and using Beaumaris Castle as an object in the view as well as affording a lodge entrance to the park, was borrowing the past to enhance the present. Broster noted in 1802 that, 'the Castle...is now a venerable ruin, which is now inclosed with gates and lodges as an entrance to the pleasure grounds of Lord Bulkeley, adding a grand object to the prospect from his Lordship's seat.'[17] (Figure 116) Quite apart from the grounds themselves, it was the view from them that drew admiration from visitors to Baron Hill.

Fig. 117 A coloured lithograph of the much-enlarged Baron Hill by Newman & Co., c. 1850.

Fig. 118 *The Journal of Horticulture's* illustration of Nant, Lady Bulkeley's garden retreat.

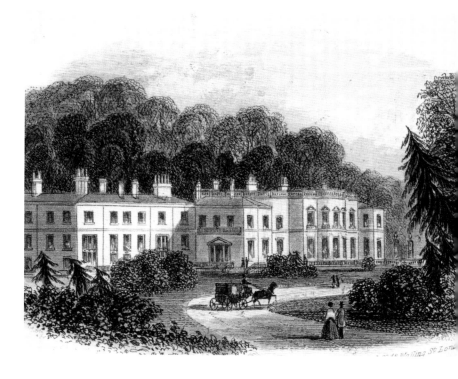

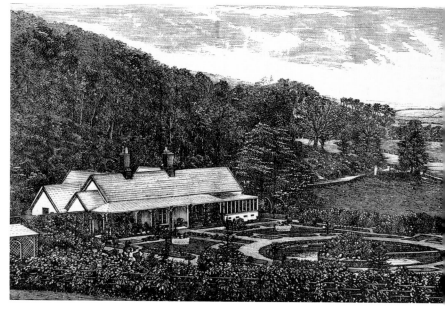

Evans wrote in *The Beauties of England and Wales*:

> The grounds surrounding this charming residence, are richly diversified by nature, and variegated by art; the lawns, groves and bridges, with other ornamental buildings, except in one instance, are finely disposed; and the numerous walks and rides, judiciously laid out. But the view from Baron Hill far surpasses all, and is justly the boast of the island. [18]

All the large houses along the Anglesey bank of the Menai Strait were focused on the great views of Snowdonia across the water. Parks and gardens in Wales were as celebrated for the prospects from them as they were for the landscaping, buildings and planting within them. At Piercefield, the views almost overcame the place itself. Baron Hill even inspired poetry:

> Isles, towns, the rising hills, the spreading bay,
> The muse delighted, owns the grand display!
> Here Flora smiles, and flowr's of every hue
> Their glowing petals spread, and drink the dew;
> For art and nature here their beauties blend
> And taste and Bulkeley for the palm contend.
> *Beaumaris Bay: a Poem* [19]

However poetic it seemed, there was still occasionally a 'want of taste' at Baron Hill. In 1828, Prince Pückler-Muskau commented that, 'the ruin [of Beaumaris Castle] stands in a park of Mr Bulkeley: with singular bad taste he has made a tennis-court within its inclosure'.[20] This lapse was also noted by fellow-German traveller, Dr S.H. Spiker, although he liked the 'large park, with primitive beeches and oaks of a beauty I have seldom seen equalled in England, and intersected by gravel walks, kept in excellent order'.[21] In 1830, Nicholson's *Cambrian*

Traveller added a 'fives court and bowling green' to the sporting facilities to be found within the castle.[22]

In common with other visitors, Spiker thought poorly of the architecture of the house itself, 'but nothing can be more noble than the extensive view from the open place in front of the house.'[23] This opinion of the house reflected the fact that it had gradually become much larger than the 'neat, modern' Wyatt house. Baron Hill was inherited by Lord Bulkeley's nephew, Sir Richard Bulkeley Williams Bulkeley (1801-1875), in 1822, and he began additions and alterations to the house. The Wyatt house suffered final disaster when it was gutted by fire in 1836 and burnt back to the brickwork. When it was rebuilt by London architect Henry Harrison it was still in the Italianate style, but the house and its surroundings were remodelled on a much larger scale. *(Figure 117)* In the process, much of the quality of Emes's work was lost underneath Victorian Italianate parterres and a balustraded terrace.

Later Victorian writers thought highly of the altered gardens and parkland. By 1873 there were seven lodge gates to the park, described by *The Journal of Horticulture* as, 'all opening to roads leading to the house':

> These roads, all gracefully winding through the well-kept turf of the park, are open to the public four days in each week – Tuesday, Thursday, Saturday and Sunday. Visitors to Beaumaris fully appreciate this most pleasant and beneficial privilege…in Beaumaris the townspeople have a park entirely gratuitously.[24]

The *Stockport Advertiser* reported in 1826 that, 'the Baron Hill grounds, which, as well as the flower garden and the model farm, are open to respectable visitors … on Tuesdays, Thursdays, Saturdays and Sundays'.[25] There were seats for the visitors to rest on 'opposite openings admitting views of the scenery'. In addition to two vineries 50ft long, 14ft wide, 13ft high, there was a greenhouse, a planthouse and an immense kitchen garden 'a full mile away' from the mansion. Five acres in extent, surrounded by a 10ft wall, this contained:

> The Cucumber house, in which are also planted Melons, Dwarf Kidney Beans, and Strawberries, is 123 feet long, but divided by a glass partition. This length is required, because Sir Richard Bulkeley wishes for a Cucumber to be on the table every day – whether he gets it we did not enquire –[26]

The principal flower garden, called Nant, was also a mile distant from the house and park. The writer for the *Journal of Horticulture* considered this garden 'an establishment quite unique, and as beautiful as singular':

> …hither Lady Bulkeley resorts almost daily; it may be regarded as her boudoir, and in the two rooms of the little villa, the windows of which admit a view of the entire garden, her ladyship receives visitors, and has her "five o'clock tea".
> The public are admitted three days in the week – Tuesday, Thursday, and Saturday, between the hours of ten and two. The garden is about three-quarters of an acre – It is one of the brightest, most varied, and best planted flower gardens we ever inspected.' *(Figure 118)*

The *Journal* recorded that this garden required 14,000 plants and Baron Hill 10,000, 'exclusive of potted plants for the conservatory, veranda and house'.[27] The plan of the Nant garden listed a Dolphin vase in the middle of a lily pond full of waterlilies, a large number of different geraniums together with lobelia, calceolarias, cineraria and dahlias. This multiplicity of plants reflected the nineteenth-century passion for carpet bedding. It is said that Alfred de Rothschild's Head Gardener remarked that people could tell the wealth of a garden owner from the number of bedding plants they put out: 10,000 for a Squire, 20,000 for a Baronet, 30,000 for an Earl, 40,000 for a Duke.[28] 24,000 plants would seem to be just right for the Bulkeleys with their proud ancestry.

Baron Hill, in its early incarnations or in High Victorian form, inspired admiration from nearly everyone who visited it, whether they were local people from Beaumaris or travellers

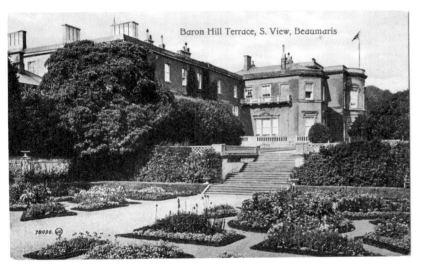

viewing it as they passed through Anglesey. Its popularity is reflected in the many picture postcards of the era, which tell a story of magnificent gardens that are now lost from sight. (*Figures 119, 120, 121 & 122* Thomas Nicholas said that the 'sumptuous estate of Baron Hill' by being open to the public 'indefinitely extends the pleasure which so delightful a landscape and carefully kept walks and parterres are fitted to administer'.[29]

From top left, clockwise:
Fig. 119 The fountain at Baron Hill.
Fig. 120 The Temple, looking across the glasshouses to the mansion of Baron Hill.
Fig. 121 The Lily Pond, Baron Hill.
Fig. 122 The Italianate terraces of Baron Hill.

PENRHYN CASTLE & THE PENRHYN ESTATE

Driving west along the A55 on the mainland side of the Menai Strait, you see a vast Neo-Norman castle looming on the horizon near Bangor. This astonishing creation, built between 1822 and 1838, was the work of Thomas Hopper. Commissioned by George Hay Dawkins Pennant, it is a demonstration of the enormous wealth to be found in Wales in the second half of the eighteenth century. The man responsible for the wealth and the energy that generated the money used to build this majestic castle was Richard Pennant, later 1st Lord Pennant.

Pennant (1737-1808), born on a ship returning from Jamaica, was heir to a vast, slave-driven, sugar-based fortune. In 1765 he married Anne Susannah Warburton (1745-1816) and, as she was joint-heiress to the Penrhyn estate, acquired a portion of the estate when his father-in-law died in 1771, completing the purchase of the whole in 1785. The Penrhyn Slate Quarry at Bethesda, which he began to develop in the 1770s, created the great part of his wealth. He was one of the great improving landlords of the late eighteenth century in Wales and all his endeavours, apart from the fact that he lobbied hard to prevent the abolition of the slave trade in British ships, bore rich fruit. It is said that the amount of Penrhyn slate sent to London was responsible for transforming it from 'a city of red-tiled roofs to one of blue-grey slates'.[1] In addition to his many business interests, Pennant found time to sit as an MP – with an Irish title he could sit in the Commons.

A purposeful man with a powerful personality, Pennant set about transforming the estate and economy of the whole area. His vision included the building of a road between Capel Curig and onwards to Holyhead,[2] improving the quarry in Bethesda and creating Port Penrhyn, the dock for shipping Penrhyn slate around the world, as well as the Royal Hotel in Capel Curig (1803). *(Figure 124)*

Around Penrhyn itself and across his estate, Pennant planted thousands of trees on the seaward side to provide shelter belts from the elements and improve the agriculture as well as the park and pleasure grounds at Penrhyn.[3]

He commissioned Samuel Wyatt to build him a new house in 1782. An estate map of 1768 shows an earlier house surrounded by formal gardens, but these were swept away with Wyatt's redevelopment of the house, complete with large stables and an entrance lodge. Wyatt wrapped his Gothic, crenellated design around the old house, facing it in yellow tile-work. *(Figure 126)* The original fourteenth-century chapel was possibly moved around this time to 'a grove a few yards distant'.[4] An 1803 map shows that there was designed parkland around the Wyatt house. It is thought that William Emes, working with Samuel Wyatt just across the Menai Strait at Baron Hill, might have had a hand in laying out this park, but there is no documentary evidence to confirm this. *(Figures 127 & 128)* When Colt Hoare visited Penrhyn in 1797, he noted:

> [the] house in a very exposed position, lately faced with Southampton tiles. Built in the form of a castle. ...Slate used in a variety of forms, as paling &c., &c. The outside of the stables are faced with slate which is screwed down to wooden plugs sunk into the wall. The hot and cold baths near the sea very complete. ...Lord P. has made many young plantations which seem in their present state to thrive well, but the S.W. wind here has great power over them.[5]

The extensive use of slate was something visitors to Penrhyn remarked on down the years. A year after Colt Hoare, Evans wrote that Lord Penrhyn had:

> ...inclosed his park with *pallisadoes of slate*; they are cut into strips of five feet long and about six inches broad, and are fastened to the railing by wooden pins.[6]

Evans had dedicated his *Tour through North Wales* to Lord Penrhyn. It leaves a vivid impression of parts of the scene that were completely changed in the nineteenth century: 'The south entrance to the park is by a grand Gateway, in the style of a triumphal arch.' The River Ogwen had been 'confined to cascades – seen from the front of the house, through vistas cut for the purpose, in the plantations.'

Fig. 123 'Lord Penrhyn's and Penmaenmawr from Bangor'. This watercolour gives a rare view of the Wyatt castle c. 1780-1800.

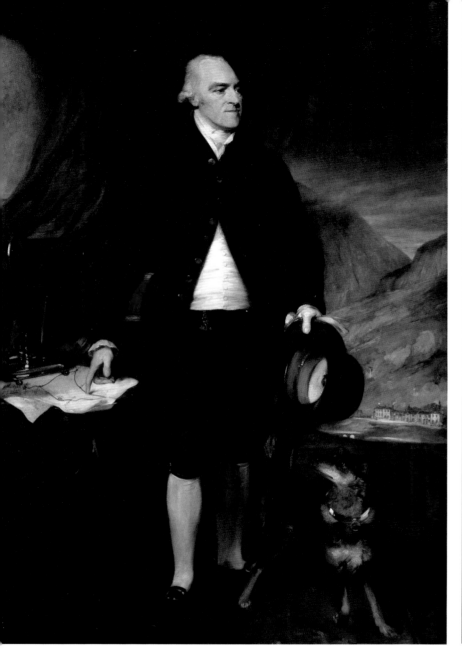

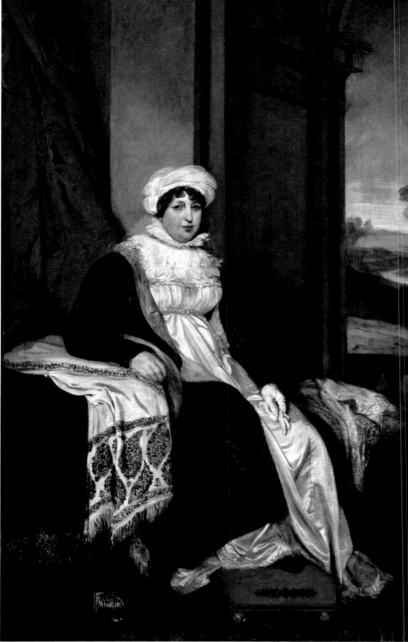

Fig. 124 Richard Pennant, 1st Baron Penrhyn, with his dog, Crab. He is pointing at a map showing the road he built from Capel Curig and in the distant background is the Royal Hotel. The road was to be incorporated into Telford's Chester to Holyhead route. Henry Thomson, oil.

Fig. 125 Anne Susannah, Lady Penrhyn with the view from Penrhyn in the background.

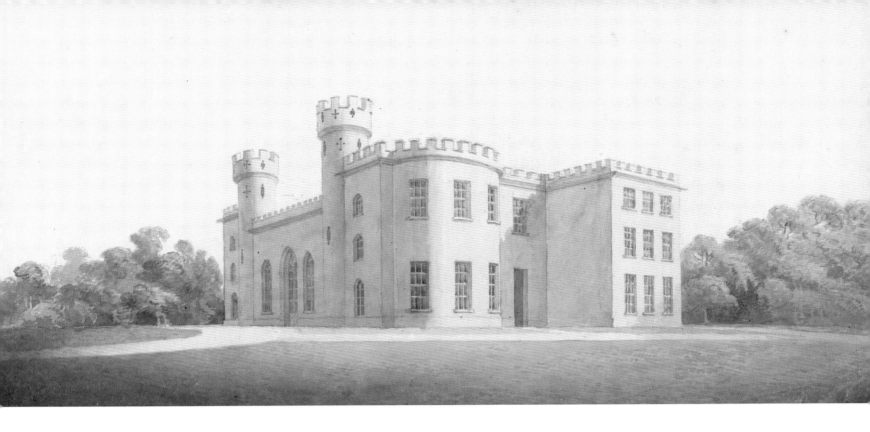

Fig. 126 A watercolour (1806) of Wyatt's version of Penrhyn Castle, described by Pugh as in 'the military manner'. This was painted by Moses Griffith for Thomas Pennant's *Tours of Wales* and is still on display at the Castle.

Pennant needed a good agent for his dynamic redevelopment of the estate and the quarries that helped to fund it. The man who emerged to fulfil this role was Samuel Wyatt's younger brother, Benjamin. He served the Pennant family for some thirty years, from 1786 until 1817. Writing after the death of both men, William Cathrall paid tribute to their achievements in the area:

About forty years ago this part of the country bore a most wild, barren, and uncultivated appearance; but it is now covered with handsome villas, well-built farm-houses, neat cottages, rich meadows, well-cultivated fields, and flourishing plantations. Bridges have been built, new roads made, bogs and swampy grounds drained and cultivated, neat fences raised, and barren rocks covered with woods.

Quite apart from the work involved in developing the estate and the slate quarries, Benjamin Wyatt shared a talent for designing buildings with his two more famous architect brothers, Samuel and James. This talent was focused on what he designed for the Pennants, not only at Penrhyn itself but also within the wider estate, where he created a range of attractive yet practical farm buildings. He also devised a series of delightful designs for Lady Penrhyn. *(Figure 125)* These ranged from a superb bath house to a dairy that sounds more like one created for Marie Antoinette at *Le Petit Hameau* at Versailles rather than windy north Wales. Marie Antoinette's rustic idyll was built in 1783 and Lady Penrhyn's cannot have been far behind in its creation.[7] In 1802, an unpublished tour described:

...a number of whimsical cottages – have been built, under the direction of Mr B. Wyatt, brother to the celebrated artists, who has also planned a Summer Salon, for Lady Penrhyn, denominated Ogwen Cottage, fitted up in a very

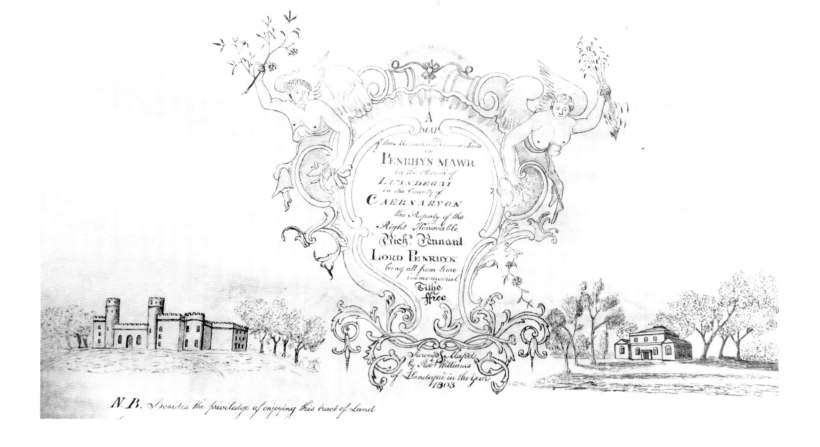

Fig. 127 & 128 (above and right) Details from Robert Williams'
1803 map of Penrhyn Castle and its grounds ornamented with
sketches of the mansion and Benjamin Wyatt's home at Lime
Grove. The map shows the mole that supported the Bath House
and '40' is the probable site of Lady Penrhyn's garden cottage.

ornamental manner, and surrounded by plantations of Firs, and parterres of flowers, which seem to thrive better than could be expected in these bleak regions. We visited the premises on our return from the Quarries...[8]

Ogwen Cottage or Bank, as it was known, was part of the fashion for the ideal 'simple life' that many aristocrats aspired to at the end of the eighteenth century. Fenton, travelling with Colt Hoare in 1810, gives a complete description of this *cottage ornée* and the dairy:

On our return, stop at Lady Penrhyn's Dairy, a peasant in holiday clothes,...; where, in short, the true characteristick of a dairy and all its appendages, neatness and cleanliness are united with elegance, proving that in every process which relates to milk, nicety cannot be carried to excess.

This 'ornamented Lactarium' had a floor, benches and lining made of Penrhyn slate and all the milk pans were Wedgwood Queen's Ware. There was a sitting room 'for the reception of her Ladyship and Company'. The 'Ground round it – a happy mixture of kitchen, flower, fruit Garden and shrubbery', included an Apiary with both straw and glass hives. There was a Piggery and a Poultry yard where a fountain played and 'even churning is performed by Water'. From the Dairy, 'a beautiful path through a rich sloping meadow reclaimed from a turbary (a piece of peat bog), following the windings of the river, brings you to another Beautiful spot':

Lady Penrhyn's dressed *cottage ornée* is happily placed so as to admit of a view, through a fine screen of trees, of a handsome bridge here thrown over the Ogwen leading to the Quarries,...It consists of one elegant Room, with a Bow to the River; and suitable offices, stabling, and kitchen and other appartments for the person having the care of it – all neatly and compactly united. The entrance to this little Paradise of sweets is through an avenue, the sides of which are decorated with knots of flowers in the form of baskets of different shapes, with handles covered and wreathed

with creepers of various sorts. To the right a winding walk through a plantation takes you to the mushroom walk, over rocky ground mixed with mossy and short grassy spots, where artificial mushrooms are scattered nicely imitative of nature, and a few of a gigantick size serving as seats.[9] *(Figure 129)*

The vision of the mushroom walk was preserved by Augustus Hare, recording his adoptive mother's recollections of childhood days spent at Penrhyn – her mother was a cousin of Lady Penrhyn:

How enchanting were the morning walks to the bathing house; how pleasant the picnic expeditions to Ogwen Bank, with its waterfalls and garden seats shaped like mushrooms!...In the afternoons, after dinner, we used to walk to Pennysinnant, an ornamented farmhouse, to see the poultry yard, on which occasions I gave great offence to Lady Penrhyn, by admiring the sight of the mountains more than her poultry, and she used to complain of it to my mother.[10]

Fenton related that Lady Penrhyn was responsible for more delights to be found in the grounds of Penrhyn Castle, including the Bath, which had a 'handsome vestibule', and dressing rooms for the ladies and gentlemen with hot and cold baths, as well as an outdoor swimming pool lined with wrought slate – 'the whole of this is princely, and unites magnificence with the practicable convenience.' *(Figure 130)*

In addition, there was another cottage nearby that was reached across:

a little slope decorated with the choicest flowers, in patches shaped like Baskets. The Front of the Cottage is covered with the choicest Creepers and other flowers, and even Laburnum, producing a pleasing effect trained as a creeper. The Vestibule is hung with the most appropriate paper, having niches papered with a paper to imitate Flower pots. *(Figure 131)*

Fig. 129 Edward Pugh's illustration of Ogwen Bank from *Cambria Depicta* (1816).

Colt Hoare echoed Fenton, recommending that: 'the bath on the shores of the bay deserves notice, as well as the beautifully ornamented cottage near it which commands a delightful view of the bay'.[11] The bath was the creation of Benjamin Wyatt. Taking in a little spit of land, he had it lengthened into a mole. Strengthened with stone, the top edges of the supporting walls were so well-finished and fitted together that they survive almost intact to this day. The whole creation had been much admired by Evans in 1798 as:

> Roman luxury accompanied by Roman taste, an elegant set of hot and cold sea-water baths, with dressing, tea-rooms, &c., the light is admitted through a beautiful dome at the top.* ...The building stands far out, and a communication is formed with the park by an amazing high carriage terrace. (*The building, terrace, &c., is said to have cost £30,000!)

Edward Pugh, travelling along the River Ogwen in 1812, noted:

> On entering the house, I was requested to write my name in a book chained to the wall, and kept for purposes of receiving the signatures of all strangers who come to the house. This cottage is built in the florid Gothic manner and is one of the prettiest devices that can be conceived.[12]

However, Pugh went on to remark that, 'this little Paradise – accords not with the terrific and magnificent scenery that surrounds them both.'[13] Although built for Lord and Lady Penrhyn and their personal guests, travellers in the area, particularly those who went up to see the impressive slate quarries, were able to enjoy the amenities offered by Ogwen Bank and the little *ferme ornée* close by, where they were even able to obtain refreshments. Cathrall's 1827 description said they:

> may also be mentioned as specimens of the elegant taste of the late Lady Penrhyn; the former with respect to the neat and elegant manner in which the grounds and shrubberies are laid out and as a most convenient place for taking refreshment when either Lord Penrhyn or her Ladyship visited these quarries, and the latter as an excellent dairy and most compact and complete farm-yard.[14]

The *ferme ornée* was called Pen Isa'r Nant ['at the very bottom of the bank', i.e. immediately on the river bank]. Ogwen Bank itself was still an elegant mansion 'surrounded with beautiful plantations' when Roscoe passed by in the 1830s.[15]

Richard Pennant died in 1808. Anne lived for another eight years. Loudon must have visited Penrhyn during her widowhood, as his *Encyclopaedia of Gardening*, awarding Penrhyn one of his rarely-granted stars, lists her as the owner and described it as:

> A castellated mansion of considerable antiquity, improved by Wyatt, surrounded by plantations, for the extent of which and for the various uses to which the Penrhyn slab [slate] is applied, this residence is chiefly remarkable. Park-pales, gates, doors, window-shutters, troughs, mangers, stall-partitions, hot-bed frames, and a variety of other articles are formed from it and found to be very durable.[16]

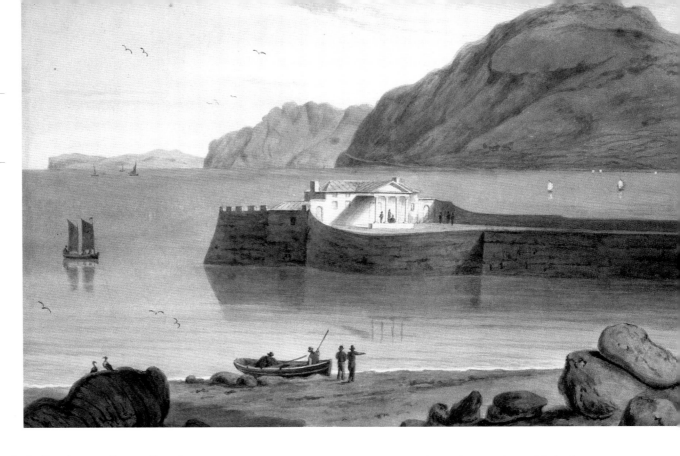

Fig. 130 The Bath at Penrhyn Castle c. 1800 by William Daniell.

Waiting in the wings for Lady Penrhyn to die was George Hay Dawkins (1764-1840), a distant cousin of Richard Pennant.[17] On Pennant's death in 1808, he assumed the surname and arms of Pennant by Royal Licence. *(Figure 132)* He set about stamping his own personality on the Penrhyn Estate, commissioning Thomas Hopper to draw up plans for a new castle in 1822. William Cathrall in his *History of North Wales* noted that:

[Lord Penrhyn's] successor is at present [1827] engaged in re-building the whole on an extensive scale and in the most magnificent style, so as to render it one of the most complete castellated baronial mansions, perhaps, in the kingdom.' ...A grand massive, substantial gateway, on a corresponding plan, has already been completed, together with a handsome park wall.[18]

Once the new castle was completed with its own chapel within its walls, the original chapel was redundant and the building, gradually becoming suitably ruined, became a picturesque eye-catcher. Visitors were made welcome to the new

castle from its earliest days. *Leigh's Guide to Wales*, published in 1831, tells us that, 'tickets to view this princely domain may be obtained at the Penrhyn Arms'. Catherine Sinclair, narrating her tour of Wales in 1833, was able to secure the help of the castle's architect to gain access to Penrhyn:

Fortunately Mr Hopper was the architect here, for he not only fulfilled all the proprietor's splendid intentions in building this residence, but also, some months ago, supplied us with an order to see it; and therefore, after our credentials had been carefully scrutinised, we triumphantly advanced to take possession.

Roscoe, visiting Penrhyn before 1836, commented on the new building, 'conducted on a magnificent scale, in the noblest style of castellated architecture':

Partially screened by surrounding woods, the effect, as you approach, is at once picturesque and imposing; ...the

Cottage at Penrhyn - by M. Griffith - 1806

lodges and entrances to the park, with its walls and massive gateways—are on the same noble and extensive plan, comprising a circuit of not less than seven miles. An elegant chapel, hot and cold baths upon the beach, outbuildings, &c. altogether serve to convey an idea of some royal establishment, rather than the quiet abode of a wealthy commoner of Great Britain.[19] *(Figure 133)*

A fine new castle meant fine new gardens, and more than five acres of ground were soon covered with a range of walled gardens, principally practical but also ornamental. Walled gardens for choice flowers and shrubs were essential on the windswept edges of Wales like Penrhyn. *The Garden,* in 1854, specifically mentioned that the flower garden was 'well-protected from the winds by trees'. It described a fruit wall constructed of Penrhyn slate as 'being of dark colour, – and that colour, as is well-known, absorbing heat'.[20] It was also noted that the Stove and Florists Flowers were provided by the Victoria Nursery in Uxbridge. This would have been an important order for this company, which only opened in 1853.

Dawkins-Pennant had no sons and, on his death in 1840,

Fig. 131 (top left) George Hay Dawkins Pennant, creator of the neo-Norman Penrhyn Castle.

Fig. 132 Moses Griffith's watercolour of Lady Penrhyn's pretty garden cottage in the grounds of Penrhyn Castle.

Penrhyn was inherited by his eldest daughter, Juliana. She married Edward Gordon Douglas in 1833, and he changed his family name to Douglas-Pennant in 1841. Juliana died young in 1842. Her husband remarried and was elevated to the peerage in 1866, becoming the 1st Lord Penrhyn of Llandegai. When he died in 1885, his son by Juliana, George Douglas-Pennant (1836-1907), became the 2nd Lord Penrhyn. It is said that Edward Douglas-Pennant made few alterations to the park and gardens at Penrhyn but he did have a passion for planting trees, and encouraged others to do so. He was also responsible for employing Penrhyn's most famous Head Gardener, Walter Speed. Under his new master, Mr Speed carried on his great work in the gardens and, a year later, *The Gardeners' Chronicle* arrived and found:

Fig. 133 W. Radlyffe's steel engraving (after David Cox) of the
new Penrhyn Castle, reproduced in Roscoe's *Wandering &
Excursions in North Wales* (1836). Puffin Island and Beaumaris
can be seen in the background.

geometrical flower-beds planted with the usual bedding plants'.
In common with all great houses, there were many glasshouses
for forcing flowers and the kitchen garden department with its
vineries, pine houses, frames and pits was where 'the utmost
order and regularity prevails'.[23]

By October 1891, when *The Gardeners' Chronicle* returned to Penrhyn, the Fuchsia had 'attained huge dimensions, having reached such a height as to be capable of being trained over a wide pathway upon a wire trellis, the effect of which whilst in full flower cannot be imagined without being seen.' *(Figure 134)* The writer also related that, 'around the castle there are no flower beds, thus, with the grass up to the walls, there is an air of quiet repose'.[24]

The *Chronicle* returned again to Penrhyn a year later and reported that:

> A portion has been recently added, and this is reached by a charming avenue, bordered with Fuchsia Riccartonii – truly a novel and grand approach....the new portion has been planted with a choice collection of the new kinds of Japan [azaleas?] and other hardy shrubs.[25]

Fig. 134 The Fuchsia Arch at Penrhyn using the arches re-discovered by Graham Stuart Thomas in 1976 and re-planted with fuchsias.

Mr Speed was the kingpin of the gardens at Penrhyn, serving three generations of the family over fifty-eight years. He finally died at Penrhyn in 1921. He was the subject of admiration when the 'Scribbler' visited Penrhyn for the *Journal of Horticulture* in 1895. Speed's eye for organisation meant that Penrhyn had 'the most clean and well-stocked gardens it has been our pleasure to visit'. The gardens now included a glasshouse containing palms and cannas, as well as Gardenias. These were the 'picture of health' and Speed offered the writer 'a sovereign if a mealy bug could be found on them'. The terrace was planted with begonias outlined in box and trellis

was 'festooned with Roses and Clematis'. *(Figure 135)* One sad revelation was that 'the avenue of splendid Fuchsias – had been killed to the ground by the severe frost'. However, they were throwing up plenty of shoots, 'although it will take a long time before they reach the size of those killed'.[26]

Penrhyn's great wealth was derived from the Bethesda slate quarries, but this was threatened by strikes and unrest amongst its workers. In the 1870s slate was one of Wales's major industries, employing thousands of people and generating thousands of pounds. As the century drew to a close, there was increasing antagonism between the workforce and

Fig. 135 A family watercolour of the top terrace and the begonia beds at Penrhyn, painted in August 1896 by Alice Douglas-Pennant.

the management. The twentieth century saw the collapse of this great industry, and the carnage of the First World War ultimately led to the decline of the fortunes of the family who had made Penrhyn so remarkable.

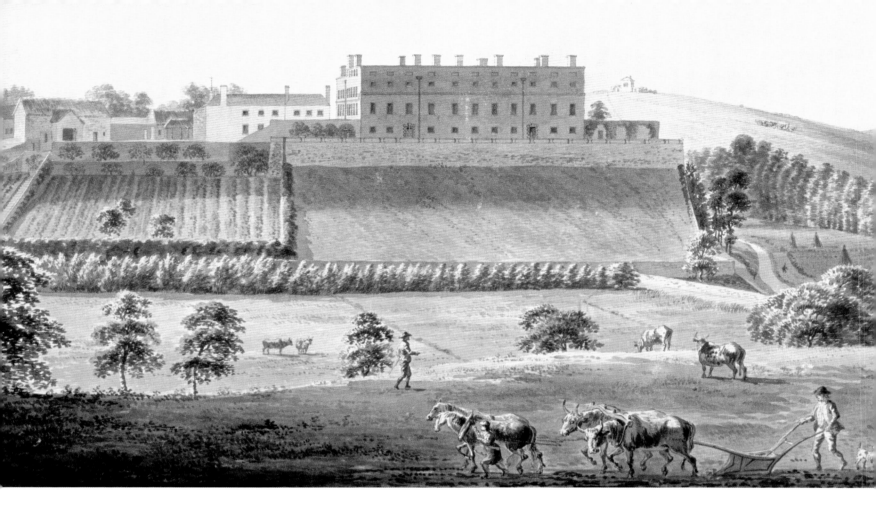

STACKPOLE COURT

Fig. 136 Stackpole Court in 1758.

Pembrokeshire, with its naturally beautiful, gently rolling countryside, lends itself to the creation of lovely landscaped parks. It was country 'where a man might make a pretty Landskip of his own possessions'.[1] Stackpole Court, just south of Pembroke, is just such a place. The estate had been an important one from mediaeval times and, having survived the Civil War, by the seventeenth century had been acquired by the Lort family. Elizabeth Lort, heiress to Stackpole, married Sir Alexander Campbell of Cawdor, Nairnshire, in Scotland. In 1698, on the death of her brother, Stackpole passed to her, sadly already a widow, and thence to her son, Sir John Campbell I (1695-1777).[2] From the beginning of the eighteenth century, the Campbells made Stackpole their home. John Campbell I married a Welsh heiress, Mary, the eldest daughter of Lewis

Pryse of Gogerddan, in 1726. As with many families, marrying rich heiresses like Mary made an enormous difference to the size, success and succession of great estates. Mary and John Campbell began improvements at Stackpole and, in 1734, began work to rebuild the house as a classic Palladian villa on a grand terrace. For more than thirty years, Sir John Campbell I enhanced the setting of his house. There was a south-east-facing walled garden, a fashionable Wilderness with straight walks and pavilions and groves of trees. He also created a now-vanished Belvedere high above the house – the hill where it stood is still called Belvedere Hill, while below it ran water meadows grazed by cattle. (*Figure 136*)

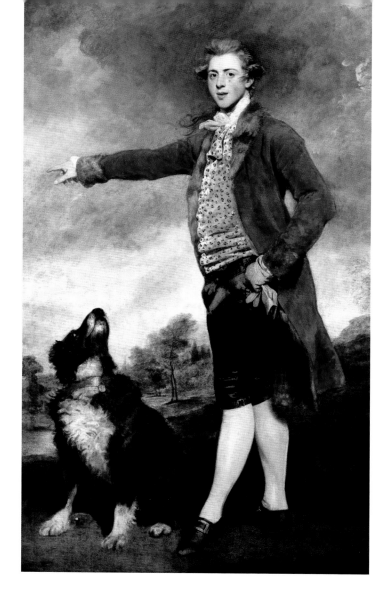

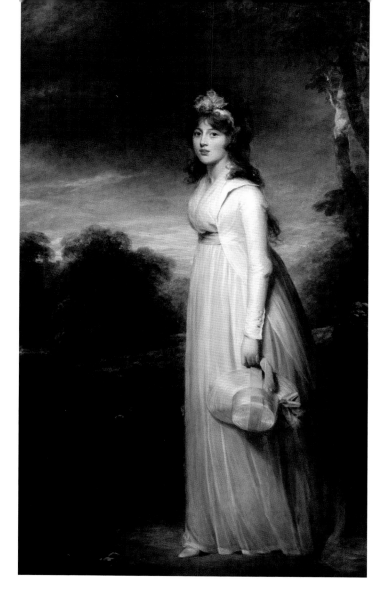

Pryse Campbell, the Campbell's son and heir, predeceased his parents, so Sir John Campbell II (c. 1753-1821) inherited the Scottish and Welsh estates on his grandfather's death in 1777. Initially, he represented the Parliamentary constituency of his Scottish estates, sitting as MP for Nairnshire. He returned to Wales and was elected MP for the Cardigan Boroughs in 1780. Described by John Mirehouse, his agent, as 'a man of excellent manners and cultivated mind,' he could afford to travel to the Continent and visited Italy and Sicily, as well as France and Switzerland several times between 1783 and 1788. He set about gathering together a remarkable art collection

Fig. 137 John Campbell, 1st Lord Cawdor. Portrait by Sir Joshua Reynolds, 1778.

Fig. 138 Lady Caroline Cawdor, painted by Sir William Beechey.

of paintings, sculpture and ceramics, including several works he commissioned from the great Italian sculptor, Antonio Canova. These were brought back from Italy to be displayed at Stackpole Court and his London home in Oxford Street.

Fig. 139 The view of Stackpole from the 'Caroline Grove', painted by John 'Warwick' Smith c. 1805.

Fig. 140 An 1823 watercolour of Stackpole from the Flower Garden side of the house and its main entrance. On either side of the entrance are the two statues of Marius and Sulla.

He also brought home to Wales great ideas for the landscape at Stackpole and, in the 1780s, with the help of the talented John Mirehouse, set about transforming the prospect from the house. His landscaping was on a huge scale. It began with the damming and flooding of the water meadows below the house to form the lakes that are such an important feature of the place to this day. The upper lake, the eastern arm of the water, was created by 1782. The New Deer Park, for which part of Stackpole village was demolished and rebuilt a quarter of a mile away, was established near the sea, and it is said that a million trees were planted across the estate. The nursery to establish these trees was so successful that trees were sold to neighbouring estates that were also improving their parkland.

In 1789 Sir John married Lady Caroline Howard, eldest daughter of the 5th Earl of Carlisle. Ravishingly lovely herself, she is said to have had a great influence on the beauty and design of the park and gardens. (Figures 137 & 138) There is a delightful view of the mansion from 'Caroline Grove', planted and named for her and painted by John 'Warwick' Smith in 1805. (Figure 139) Caroline's father was an important Whig and John Campbell spent much time in his political circle, supporting his father-in-law's views and working for the abolition of slavery. In 1796, Sir John's political work was acknowledged by William Pitt, the Prime Minister, and he was raised to the peerage as Baron Cawdor of Castlemartin.

Meanwhile, there was more work carried out at Stackpole. Lord Cawdor, like many of his contemporaries, such as Thomas Johnes at Hafod, was an agricultural improver and this work continued apace, with the introduction of new farming methods, including the seed drill, much to the dismay of his tenant farmers, who regarded it with suspicion. Most unusually for the period, the Stackpole Estate produced an agricultural surplus at this time. Lord Cawdor's project for the drainage of

the Castlemartin Corse, a huge marshy area, was rewarded with the Gold Medal from the Royal Society of Arts.

On the west side of the mansion was Lodge Park, the pleasure grounds for the house where the Flower Garden was created. An early visitor in 1791 was Mary Morgan. She found the situation of the house good, yet 'not, in my opinion equal to many others in Pembrokeshire, particularly to Picton'. She thought better of its surroundings:

The grounds are admirably laid out, and there is a very fine piece of water—it is not a navigable river, but a superb canal procured at great expense, and circumscribed with infinite taste. At your approach to the house stand two inimitable antique statues of Marius and Sulla, brought from Rome by Mr Campbell, when he was on his travels.[3] In the garden is a very large and fine cast of the Apollo of Belvedere, which Mr Campbell intends to place in a splendid library, which he is going to build. (Figure 140)

She went on to give a description of a romantic structure to be found in the grounds:
The grandfather of this gentleman erected a kind of

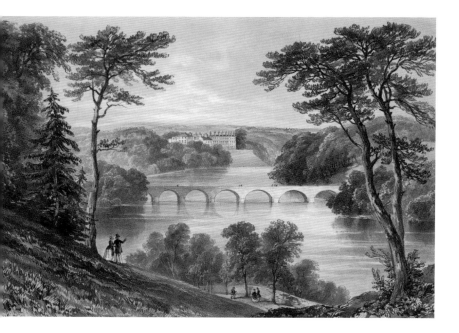

is made good use of, and Capable of further improvement from the removal of some dam heads. The House is a large old house of no particular form or fashion but commanding a beautiful house scene.[6]

The command of the water was not all that it should have been, as the eastern arm of the lakes kept losing water around the dam at its seaward end. To deal with this, Lord Cawdor employed James Cockshutt, a noted canal engineer working in south Wales in the 1780s. In a letter to Lord Cawdor, Cockshutt related how, in 1794, on an evening walk that coincided with a high spring tide, he saw 'a beautiful sheet of water covering the whole Haven…I could not view it without awakening a hearty wish to see a Head [dam] constructed that should constantly retain the same appearance'.[7] This dream was eventually accomplished towards the end of the nineteenth century. Lord John Manners arrived in Pembrokeshire in August 1797 and received a warm welcome from Lord and Lady Cawdor. His description of Stackpole relates that the famous eight-arch bridge was under construction at that moment:

The house stands on a rising ground, overlooking a made piece of water, which winds very beautifully in front and appears natural. It is wide, and of considerable extent, but was, when we saw it, empty of water, as a bridge of seven arches [actually eight], is building over it, a short way from the house.

This bridge by Cockshutt was the largest eyecatcher in Wales. It masked a cleverly-contrived controlling dam to maintain the water levels and linked the Home Farm with the New Deer Park with an ornamental park drive running along it. From now on, this magnificent landscape device featured in all the prints and drawings made of Stackpole Court. *(Figure 141)*

hermitage in a sequestered part of the grounds, whither he used to retire from the grandeur of the great mansion-house, and the pleasures of society.[4]

This was Sir John Campbell I's Grotto, built of water-eroded limestone, which stands on the northern bank of the upper eastern arm of the water.

One anonymous lady traveller, writing on 30 August 1795, described Stackpole Court a few years later as:

…a good house, badly situated; the whole estate undergoing great alteration…the kitchen and flower gardens…the conservatories, hot house and green house in great style! but bad taste.[5]

The great alteration was possibly the beginning of more work on the 'fine piece of water'. When Sir Christopher Sykes reached Stackpole in 1796, he commented that:

- he [Lord Cawdor] has made an excellent Road, and it is a very pleasant situation, with a Command of the water which

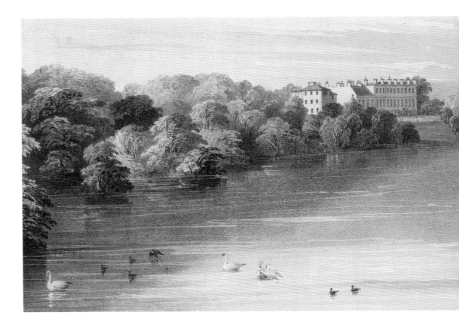

Fig. 142 The charming piece of water drawn by Fanny Price Gwynne c. 1846.

Manners described other features of the gardens:

About two hundred yards from the house are the pleasure grounds, which are very pretty, and abound with curious and various flowers. They have only been completed about two years, and were planned by Lady Cawdor. We walked into the kitchen garden, which is extensive, and has a great length of hot houses well stored with fruit.

He spent a week at Stackpole and his Journal contains a graphic account of Lord Cawdor's adventures in stemming 'the late expedition of the French on the coast of South Wales'. This referred to the ill-fated 'last invasion' of Britain, when French troops landed at Fishguard and were swiftly defeated. Lord Cawdor took his house party everywhere with him as he conducted business in the county, including seeing the despatch to Portsmouth of some of the French prisoners 'taken in the late expedition'. They 'took a walk to see the new bridge that is building', and viewed the country from a yacht sailing round Milford Haven.[8]

When Malkin reached Stackpole in 1803, he considered the magnificent water feature carefully:

This is a completely English place, in a deep and sheltered valley, laid out and ornamented at a very great expense. The house is large and handsome; the park and grounds are richly wooded, with a better share of verdure than might be expected from the neighbourhood of so stormy a coast. The water is much admired; and so it ought to be, as far as a lavish display of art deserves admiration. It may, however, be questioned, whether, in a country like this, of which the aquatic are among the leading beauties, a correct taste would have indulged itself in any such attempts. In some of the midland counties of England, where nature has dealt this prime ornament of the landscape but sparingly,

opportunity and liberality may well be employed in remedying her defects... Yet, notwithstanding, it must be allowed in the present case, that if it ought to have been done at all, it could not have been done better.[9]

Lord Cawdor was a true connoisseur, a Fellow of the Society of Antiquaries (1794) and of the Royal Society (1795). However, his passion for collecting art and antiquities, and all the improvements at Stackpole, did not improve his bank balance and by 1800 he was in dire financial straits. To offset some of his debts, he was compelled to sell the contents of his beautiful gallery at his London house. In 1804, the death of his lifelong friend, John Vaughan, provided an unexpected bonanza. As young men they had been on the Grand Tour together and, aware of the perils of foreign travel, had made wills in each other's favour. John Vaughan, long a widower, had never altered his and now Lord Cawdor was the proud possessor of the considerable estates of Golden Grove in Carmarthenshire, just across the Twyi Valley from Dynevor. From now on, the name Vaughan was included in the family name as a tribute to this bequest.

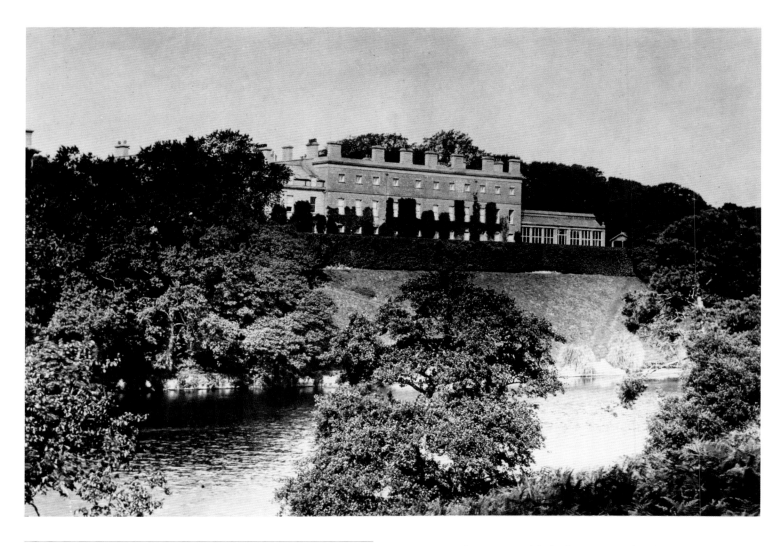

Fig. 143 Stackpole Court at its most grandiose with the Conservatory ranged on the right. A photograph by Charles Allen, taken in 1871.

In his Tour, published in 1810, Richard Fenton, the best possible guide to his home county of Pembrokeshire, left a long description of the Stackpole created by Lord Cawdor:

Though there have been objections to the heaviness of its architecture, it is a large and magnificent pile and well adapted to its site. It has two fronts, the principal facing the pleasure grounds and the grand approach; the other looking over a fine piece of water at the foot of the slope it stands on to the park. You enter the latter from a terrace of great breadth, extending the length of it,

and after descending a flight of steps, continued on a lower level the whole length of a spacious conservatory, furnished with a choice collection of the rarest shrubs and plants. On the opposite side is the park, of great compass, and well stocked with deer, but wanting a belt of trees to hide the barren sand-banks without it, and produce shelter where most wanted by breaking the sea breeze; and otherwise deficient in wood, though that effect, from the numerous young thriving plantations everywhere judiciously scattered, is likely soon to be obviated. The hills skirting the lake of the house, and forming its boundary, are richly wooded in every direction, as are the pleasure grounds and shrubbery in front, beyond which, but completely hid, are the gardens, including the hot-houses, of immense scale..... A charming piece of water admirably planned now fills the vale under the house, which, till this change of late years took place, crept an inconsiderable stream, choaked with reeds and osiers all the way to the place where it fell and was lost, in the tide. The dam for altering the level, necessary to unite the water, is happily hid under an elegant bridge of eight arches, connecting the grounds on the side of the mansion with the park. The lake is most abundantly stocked with aquatic wild fowl of every sort, if wild they may be called, that collect at a call, and come in flocks to dry land to be fed like barn-door poultry.[10] *(Figure 142)*

John Campbell, 1st Lord Cawdor, died in 1821 and was succeeded by his son, John Frederick Campbell (1790-1860), who married Lady Elizabeth Thynne, daughter of the 2nd Marquess of Bath, in 1816.[11] Until his father's death, he served as Whig MP for Carmarthen. In 1827 he was raised to the rank of Earl Cawdor and Viscount Emlyn. There were more alterations and improvements made at Stackpole, possibly to reflect John Frederick's new status. Between 1831 and 1832, the Georgian house acquired huge additions designed by Sir Jeffry Wyatville working with Henry Ashton.[12] Wyatville's plans were often grandiose and vast, designed to set off the background of the great families for whom he worked – during his lifetime he created houses for seventeen earls. At Stackpole the alterations

were considerable and the house ended up with 150 rooms, but the whole design was much simpler than Wyatville's recreation of Golden Grove for John Frederick, a neo-Gothic pile that has been described as a 'lugubrious monster'.[13] *(Figure 143)*

An 1833 description of Stackpole tells us that it was now 'built of hewn Limestone, and has an imposing grandeur of appearance'. In addition, 'the greenhouses and hothouses are stored with every species of rare and valuable exotics'.[14] It was not just under glass that rare and valuable species could be found. J.C. Loudon's *Gardener's Magazine* for 1836 recorded the tender *Edwardsia microphylla* [now called Sophora] thriving in the open garden, as well as a fine specimen of the rare walnut-leaved Ash. Loudon published his *Arboretum Brittanicum* in 1845 and recorded that in forty years this tree had reached 60ft and produced ripe seeds 'from which many young plants have been raised and distributed in the plantations'.[15]

When the Rev. Joseph Romilly visited Pembrokeshire in 1838, he recorded that:

We…went in a hired phaeton through Lord Cawdor's Park. We went under the guidance of the housekeeper on the terrace, which looks down on a fine artificial piece of water; on the terrace are two long Spanish cannons mounted. I did not at all admire the outside of the house though it has a double flight of steps. It wants a portico.[16]

During Roscoe's *Wanderings in South Wales*, published in 1837, he relates how, on a rich, fine autumn day, he set off on foot to explore Stackpole Court:

I was gratified by the permission of the noble owner to pass through the spacious park belonging to this domain, by which I saved a distance of between two and three miles, and had the pleasure derived from contemplating 'old hereditary trees', with all those sylvan delights and solitudes, made vocal by the warbling of a thousand birds, the secret whispering of the leaves, slightly stirred by the soft breeze… The carriage road which passes through the park gates commences at St Petrox, and within a hundred yards from

thence the broad expanse of the ocean almost suddenly breaks upon the view, here and there studded with white sails. From the same eminence a prospect is commanded over a considerable portion of the park. ...Nothing could surpass the variegated beauty of the foliage...blending their rich dying hues of the year's decline, threw an ineffable charm over the whole landscape. Here and there I perceived, scattered through the park, several extensive sheets of water, the margins covered with underwood and rushes.[17]

Other additions and ornaments were added to the pleasure grounds and woods on the west side of the mansion. Described as 'very pretty, laid out with great taste', the elegant pleasure grounds contained a fine classical summer house embellished with urn-shaped finials attributed to Wyatville; the beautiful semi-circular stone seat created by the sculptor Richard Westmacott Jr, was installed in the Flower Garden c. 1840.

The 1st Earl served as Lord Lieutenant of Carmarthenshire (the county of Golden Grove), dying at Stackpole in 1860 'aged 70 all but a day'. The 2nd Earl Cawdor was John Frederick Vaughan Campbell (1817-1898). Like his father, he sat as an MP, representing Pembrokeshire for nearly twenty years until he succeeded to the Earldom. The Stackpole that he inherited was in fine order and, like his forebears, he had his own ideas and additions to make. He set about bringing many agricultural improvements to the estate, and corresponded with many of the leading agriculturalists of the day. Under his guidance the estate became one of the most productive in Wales and, by 1883, he was recorded as owning more than 100,000 acres of land. Most importantly, he realised his grandfather's dream of completing the necklace of water that sweeps from above the house to the north towards the sea in the south. Carrying on from Cockshutt's idea conceived at Broadhaven beach, it was here that he constructed a dam that established the central and western arms of the lake now known as the Lily Ponds. Filled with water lilies, they are still a wonderful sight in the summer. The One-Arch Bridge that brought the carriage drive to the front entrance on the west side of the house was remodelled and raised in the early nineteenth century and, by 1875, another bridge had been created, the Hidden Bridge. This was a clever

structure that controlled the flow of water with two parallel walls, the water falling between, allowing the second wall to stay dry and serve as a walkway at the same height as the lake in front. The effect created meant that anyone on the drive would think that 'those on the path were apparently walking on the water!'

Over nearly half a century the young thriving plantations mentioned by Fenton had grown well and done their work of protecting Stackpole from the sea breeze. *Murray's Handbook* in 1860 stated that: 'a peculiar feature is the luxuriant growth of the extensive woods, which cover the sides of the valleys down to the water's edge'. It also said that: 'the climate is seldom rigorous...evidence of which is seen at Stackpole Court, where plants which require in other parts of England the protection of a greenhouse, flourish well in the open air'.[18] Indeed, Stackpole was as well-known for its hot houses as for the tender plants that grew outside. The walled kitchen gardens with their ten ranges of glasshouses produced passion flowers that fruited, pineapples, grapes and much, much more.

One great feature of the house was the Victorian Conservatory or Winter Garden attached to the northern end of the house. This presumably replaced the eighteenth-century 'spacious conservatory' mentioned by Fenton. The 1870s photographs (*Figures 144 & 145*) of the Conservatory show it full of exotic plants, as well as providing a setting for some of the lovely statues by Canova brought back to Stackpole by Lord Cawdor. An article in *The Gardeners' Chronicle*, although written in the early years of the twentieth century, provided a full description of the great conservatory, revealing that not much had changed over the nearly thirty years since 1880. In addition, it provides a rare description of the Pleasure Grounds at the front of the house:

A wide terrace on the south front runs the length of the house, which is about 360 feet, and a flight of steps leads to a further terrace extending 200 or more feet. The tender plants that thrive in the pleasure grounds, and particularly on this terrace, betoken the mild character of the climate. Standing unprotected in the grounds are such plants as Agapanthus umbellatus, Fuchsia gracilis, Escallonia

exoniensis, Chimonanthus fragrans, Calycanthus floridus and Pittosporum Tobira (a plant of this tree is about 15 feet high and 18 feet in diameter). There is a remarkable plant of Magnolia grandiflora, having a massive stem, gnarled by age, and filling a large space on the wall of the residence. Banksian Roses, too, of great size, flourish, with Garrya elliptica, Photinia serrulata, Buddleias, Magnolia Soulangeana, Honeysuckle &c. A spacious Winter Garden adjoins the building. Climbers such as Cobea Scandens and Bougainvilleas lightly drape the roof, Palms and other suitable plants furnish the floor, while carved figures and vases stand in prominent positions.

A charming woodland is entered from the terrace. It is planted with native Ferns, the commoner varieties of daffodil, the Winter Aconite, Bluebells, &c., and canopied, but not too densely, by a variety of trees.

Managed under the careful eye of Head Gardener W.B. Fisher, there were the extensive glasshouses for fruit and vines and a very large kitchen garden with everything showing 'the same excellent order and cultivation'. The years spent planting rare specimen trees at Stackpole meant that they had achieved great size and beauty. There were:

...large evergreen Oaks, magnificent gnarled Limes, huge Silver Firs, and big trees of Oak and Sycamore. Other notable trees are Pinus Lambertiana (60feet), a beautiful specimen of Sequoia sempervirens (probably planted 60 years ago and now 60 feet high), Tulip Trees, Planes, Abies Smithiana, Cryptomeria japonica (50 feet), Cupressus Lawsoniana (50 feet in height and 35 feet in diameter). Finally, towards the centre of the Flower Garden, there were the nine gigantic Beech trees 'forming a circle, their heads a dome, and constituting a grand natural temple'.[19]

When the 2nd Earl Cawdor died in 1898, aged 81, he was passing on a great legacy to his son, Frederick Archibald Vaughan Campbell. Sadly, the inevitability of death and taxes would mean that this great house, its estates and inheritance would vanish well before the end of the next century.

Fig. 144 & 145 Charles Allen's photographs of the contents of the great Conservatory or Winter Garden.

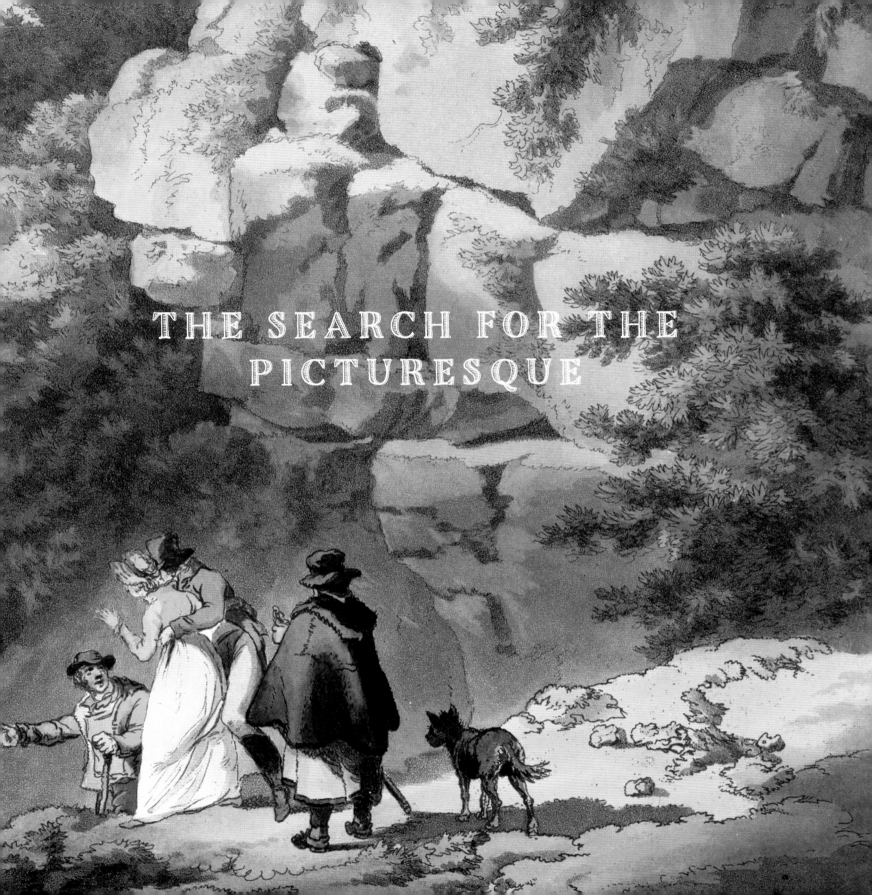

THE SEARCH FOR THE
PICTURESQUE

THE SEARCH FOR THE PICTURESQUE

By the 1770s, the growing appreciation of Britain's own natural beauty, originally seen in terms of 'horrid' – anything rough, shaggy or untrimmed – or 'sublime', was giving way to a new perspective, the Picturesque. Thomas Whateley's *Observations on Modern Gardening* set out his thoughts on both ideals:

> The terrors of a scene in nature are like those of a dramatic representation; they give an alarm, but the sensations are agreeable, so long as they are kept to such as are allied only to terror, unmixed with any that are horrible or disgusting; art may therefore be used to heighten them, to display the objects which are distinguished by greatness, to improve the circumstances which denote force, to mark those which intimate danger, and blend with all, here and there, a cast of melancholy.
> But regularity can never attain to a great share of beauty, and to none of the species called picturesque; a denomination in general expressive of excellence, but which, by being too indiscriminately applied, may be productive of errors. [1]

With improving travel conditions and the taste for garden visiting and sightseeing assisted by the plethora of guidebooks for the increasingly prosperous middle class, the late eighteenth-century 'English Grand Tour' – at the time Monmouthshire was considered to be part of England – was born. From 1789 the French Revolution and the ensuing Revolutionary and Napoleonic Wars made travelling across Europe increasingly difficult for the British. Colt Hoare commented, when he ceased his travels in Europe in 1791, that, 'continental war put a stop to these projects'. [2] Tourists who had previously delighted in Switzerland en route to Italy were now declaring themselves ravished by the 'Cambrian Alps', otherwise Snowdonia, 'that immense pile of mountains, which encircle

the mighty lord of this vast domain'. [3] They felt such mountains echoed Edmund Burke's description: 'They are delightful when we have an idea of pain and danger, without being actually in such circumstances…Whatever excites this delight, I call sublime.' [4] *(Figure 146)*

The new perspective, the Picturesque, was highlighted and popularised by the writings of three men: William Gilpin, who thought that temples were 'often a useless decoration', preferring 'the wild scenes of nature – the wood – the copse – the glen – and open-grove.' [5] Uvedale Price, a Herefordshire landowner and connoisseur whose *Essay on the Picturesque* in 1794 laid out his views, shared with his friend and neighbour in Herefordshire, Richard Payne Knight, who published *The Landscape: a Didactic Poem* on Picturesque landscape and gardening in the same year. They both detested the sight of an isolated house:

> Fresh from th'improver's desolating hand,
> 'Midst shaven lawns, that far around it creep
> In one eternal, undulating sweep; [6]

Price's *Essay* was widely read and added to the increasing passion for seeking out the Picturesque in the landscape by the tourists who began to flock to Wales. They wished to follow in the footsteps of the wealthy men who had the time and inclination to explore Wales in earlier years and many now fixed Wales on their itinerary. The guidebooks that appeared were essential reading. As Cradock said in his guide book, he aimed to '…induce the curious to visit the Wonders of the

Fig. 146 (pages 158-159) Tourists experiencing the 'Sublime' at 'The Cataract on the Llugwy' (the Swallow Falls today). A hand-coloured lithograph after Philip de Loutherberg (1806).

British Alps, in preference to the Mountains of Switzerland, or the Glaciers of Savoy'.[7] Reading such travels and journals followed up by personal observation inspired the man-made creation of Picturesque landscapes and gardens with little ruins, cascades and other touches to inspire the romantic imagination. Picturesque elements were being incorporated into gardens all over Wales.

PIERCEFIELD – 'PICTURESQUE AND SUBLIME'

One of the highlights in this new 'Grand Tour' was Piercefield in Monmouthshire. Sitting high on cliffs above the Wye valley, overlooking great loops of the river, is the remarkable landscape that surrounds what are now the ruins of Piercefield. The estate was purchased with a West Indian sugar fortune by Colonel Valentine Morris and, from c. 1753, his son, another Valentine Morris (1727-1789), created 'one of the most outstanding picturesque and sublime landscapes of the eighteenth century in Britain'.[1] *(Figure 147)*

While indelibly associated with the later Picturesque tour of the Wye, Piercefield is more truly a Romantic landscape and its dramatic position lent itself to aiding and abetting nature to create 'the most influential landscaping of the middle of the century in Wales'.[2] Valentine Morris was assisted by the gentleman poet and man of taste, Richard Owen Cambridge. It was said that:

> He was so captivated with the bold and romantic nature of Piercefield, that he treated for the purchase of it [in the 1740s], and was only induced to relinquish his intention from the love of society, which decided him in a choice of residence nearer London. He, however, recommended it to Mr Morris, and had some share in making those improvements which shewed the peculiar and striking features of the place to their proper advantage; and thus assisted in laying the foundation of that celebrity it has since acquired. [3]

Fig. 147 Valentine Morris of Piercefield.

Richard Pococke, Bishop of Ossory and Meath in Ireland, travelling through Wales going to and from his diocese, was an early visitor while some of the construction was still going on, writing in 1753:

> From Chepstow I went a mile to Persfield, Mr Morris's, situated over the west side of the Wye; it chiefly consists of a long walk over the brow of the hill near the river, in which many parts ends in rocky cliffs cover'd with wood, and some of them are perpendicular, the furthest above a mile beyond the house is an eminence which commands not only a view of the Wye, but of the Severn, Bristol Channel... The next is at an iron rail over a perpendicular rock from which one sees below the wood, river &c. The gardiner told us Mr Morris was standing on the projecting rock, and that soon after it fell down, on which he had this rail put up. The cliff must be 2 and 300 feet high. We were then conducted to a seat, which is the most beautiful I ever beheld; the river

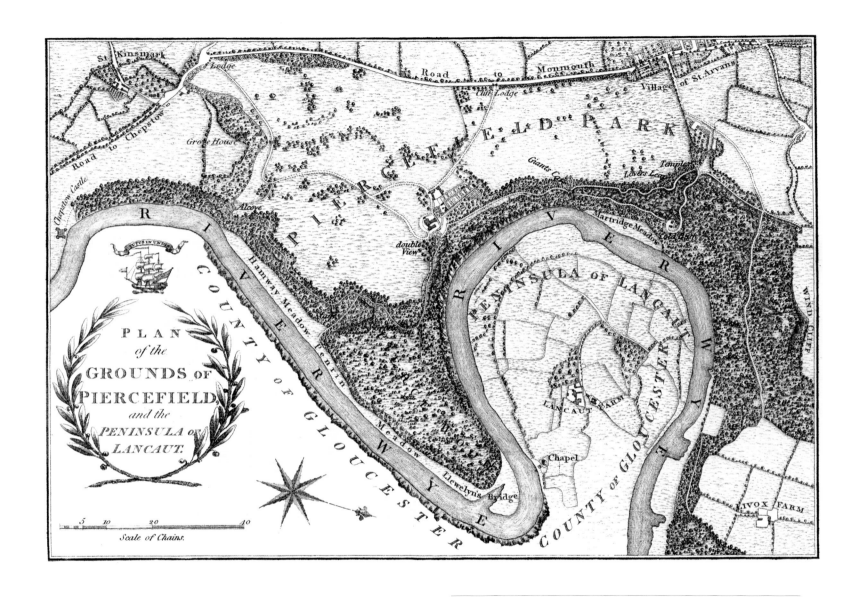

The map contains the following text labels:

St. Kinsmark

Lodge

Road to Monmouth

Cliff Lodge

Village of St. Arvans

Road to Chepstow

Grove House

P I E R C E F I E L D · · · P A R K

Giants Cave

Temple

Lovers Leap

Chepstow Castle

Alcove

double View

Martridge Meadow

WIND CLIFF

R I V E R

C O U N T Y O F G L O U C E S T E R

R
I
V
E
R

Hanway Meadow

Penith

Meadow

Llewelyn's Bridge

Star

PENINSULA OF LANCAUT

Chapel

LANCAUT FARM

C O U N T Y O F G L O U C E S T E R

W
Y
E

LIVOX FARM

TUTUS IN UNDIS

PLAN
of the
GROUNDS of
PIERCEFIELD,
and the
PENINSULA of
LANCAUT.

5 10 20 40
Scale of Chains.

Fig. 148 Archdeacon Coxe's Plan of Piercefield, from *An Historical Tour of Monmouthshire*, published in 1801.

winds so as to make a peninsula on the other side, which is a piece of ground gently rising to a point, on which there are two or three houses, and all this ground is diversifyed with an agreeable mixture of corn fields, meadow, wood. This seat commands a view of all I have mentioned to the south, and moreover of Bristol Channel, in three or four different parts divided by the land. The walk then winds, and there are several seats of view; in one part where there are large stones they are making a small Druid temple like Roltrich [the Rollright Stones in Oxfordshire]. On one eminence towards the house are several grass walks and a shrubbery of a variety of plants, and beyond that the house, lawn and plantations disposed in a very fine taste. This is one of the most beautifull places I ever saw.[4]

The prospects, seats and other delights unrolled before the visitor as they walked (there is some debate as to whether you followed the route from the north or the south). Every visitor listed the viewpoints, and rhapsodised about the landscape before them, but those who painted and sketched the spectacular views ignored the created viewpoints other than as an occasional framing device. As one anonymous letter writer said: 'The gardens are situated on the Rocks, I cannot call them the Banks, of the river Wye, and cut into Walks, themselves excessively beautiful, but the superior Beauty of the Views they command, so entirely engrosses the Eye, that they can be very little heeded.[5] Apart from the 1801 plan provided by Archdeacon William Coxe there are no early plans of the site, so the visitors' written impressions are hugely valuable in 'seeing' the structures Morris created. (Figure 148)

This early 1758 description is very evocative:

It is a place form'd within these seven years and the most worth seeing of any place perhaps in the Kingdom. Through the pastures we had a gradual ascent to the top of an high hill call'd the Windcliff, three hundred yards above the level of the Wye. The Wye in the meantime runs in such a Serpentine course and forms such Doubles, that some part of the Gardens seem to lie on the opposite shore:... Hence the

Gardens gradually descent along the River side of the House, they are cut out from the Trees which grow here naturally on the Sloping Banks of the Wye for Mr Morris has planted only some Shrubs here and there....they are cut out by the single direction of the Owner, who does not appear to have admitted one beauty of false taste, or trifling nature. At proper distances are Parapets to the River with Seats; at every Seat, and indeed at every Fifty Yards, the Scene and View is chang'd; ... the Parapets whence one looks upon the River and country are Breastworks, either of stone, or Iron Rails that are let into the Rock; ... the Grotto, as well as the Place allotted for Shrubs, is remarkably elegant, everything else belonging to this seat, deserves to be called Grand.[6]

A year later, another visitor recorded his impression:

[Piercefield] is very remarkable for its fine Romantick Prospects and pleasant situation. ...There is a handsome Approach to the House which is small, irregular and built at several times. You enter his Plantations at the farther end being the highest Part of his Grounds from whence you have a most extensive View of a fine & rich Vale... and at the foot of the Seat is the finest and noblest Romantick Prospect ever seen in a Bottom one hundred and twenty feet perpendicular below the Seat surrounded with high Rocks part horrid part Shaggy and part well wooded is a very Rich Vale of fine inclosures and round these meadows meanders the River Wye the whole forms an Amphitheatre the most beautifull and Romantick I ever saw.... This Prospect by means of a Serpentine Walk partly Turf and partly Gravel is diversified into several different Views all equally surprizing & Entertaining In one part of the walk is the Lover's Leap one hundred and twenty feet perpendicular another part is ornamented with a Cave very naturally cut out of the Rock and has a good effect both from itself and the View you have from it in another part is an artificial Stonehenge in another a Grotto so small scarce worth notice all along the Serpentine Walk which is Two Miles and three Quarters are many seats but I think all too near the Precipice on the

In 1767 Arthur Young wrote: 'Through the whole of these walks, it is evident that Mr Morris meant them merely as an assistance to view the beauties of Nature; ...without strong design of decoration or ornament. Everything is in a just taste.' He considered, 'In point of striking picturesque views, in the romantic style, Persfield is exquisite.' His principal criticism was that 'cascades were wanting'. Nonetheless, he considered that 'the united talents of a Claude, a Poussin, a Vernet', would scarcely be able to do justice to the scene. His route took him through:

- ...the garden, which consisted of slopes and waving lawns, having shrubby trees scattered about them with great taste ... commands a landscape, too beautiful for pencil to paint.
- A winding walk cut out of the rock; but with wood enough against the river to prevent the horrors which would otherwise attend the treading on such a precipice.
- a bench enclosed with Chinese rails in the rock.
- Another bench, inclosed with iron rails, on a point of the rock which is here pendant over the river, and may truly be called a situation full of the terrible sublime: you look immediately down upon a vast hollow of wood, all surrounded by the woody precipices which have so fine an effect from all the points of view at Persfield.
- a Temple, a small neat building on the highest part of these grounds.[9]
- The winding road down to the Cold Bath is cool, sequestered, and agreeable. The building itself is excessively neat, and well contrived, and the spring which supplies it, plentiful and transparent.
- An extremely romantic cave, hollowed out of the rock, and opening to a fine point of view. At the mouth of this cave some swivel guns are planted; the firing of which occasions a repeated echo from rock to rock in a most surprising manner.

right hand side of the Serpentine Walk are some very fine meadows laid out Park fashion there is one particular View [the Alcove] truly Noble consisting of the Amphitheatre of Rocks the River the Bridges the Town and Castle of Chepstow the Passages the Severn the Gloucestershire Hills and this all at one view (*Figure 149*) the Serpentine Walk is ornamented with a Shrubbery and sometime discontinued by means of the Land and Park His Kitchen Garden has all the Conveniences as hot Houses Stoves &c. Upon the whole it is a most noble fine Place particularly happy in its situation and still liable to more improvement but as it is extremely well worth the Travellers Observation. [7]

Within a relatively short space of time, Piercefield had become a place of note to visit. The poet, playwright and publisher Robert Dodsley wrote to William Shenstone at The Leasowes reporting that 'I went from Bath with a polite Party of Gentlemen and Ladies...The Place is certainly of the great and sublime Kind' and he refers to Mr Spence being 'much struck with it, and has attempteda description of it'.[8] Like many visitors after him, Dodsley regretted that the Wye, being muddy, did not offer a reflection of what towered above it.

- The grotto, a point of view exquisitely beautiful; it is a small cave in the rock, stuck with stones of various kinds; copper and iron cinders &c.
- The winding walk, which leads from the grotto varies from any of the former, passing over a little bridge which is thrown across a road in a hollow way through the wood. [10]
- The last point is the alcove, from this you look down perpendicularly on the river. [11]

Inspired by Gilpin's *Observations on the River Wye*, the walks became extremely popular with the tourists that flocked to the Wye Valley following his recommended tour – 'Mr Morris's improvements at Persfield…. are generally thought as much worth a traveller's notice, as anything on the banks of the Wye.' Gilpin thought that the views from Piercefield were not 'Picturesque' as he defined it, being:

> presented from too high a point; or they have little to mark them as characteristic; or they do not fall into such composition, as would appear to advantage on canvas. But they are extremely romantic; and give a loose to the most pleasing riot of imagination. [12]

Even when inspired by Gilpin to visit Piercefield as part of a tour to the West Country and beyond, not all visitors found it to their taste. Richard Sulivan made his tour in 1778:

> On the entrance of this gentleman's ground, the eye is hurt by a long strait walk, which has neither clumps of trees nor avenues to confine or variegate the scene. The house too is indifferent, and so whimsically placed, so as to not admit of a determination with respect to its front until it is examined nearly. The lawn, however, which reaches towards the river, is beautiful, and so carefully swelled and planted as to afford a most delightful field of pasture. On one side of this lawn, and to the back of the house, is the shrubbery, at the entrance of which you get as fine view of the old castle of Chepstow. Here, however, you get involved in the serpentine windings of the wood, and continue so until you come to

a grotto in an artificial hill, from whence you have a most romantic view.

He thought the shrubbery had 'too much sameness and regularity to be pleasing', and while admitting his was not the general taste went on to write:

> I will not pretend to determine how far this shrubbery may answer the expectations of other visitants – as for my part, I must confess, I was disappointed….. A plain meadow, however, has to me beauties, which I have never been able to discover in the finest artificial improvements that I have seen. And never did this unfashionable predilection impress itself as on our quitting the shrubbery and entering an extensive field ready for the scythe, and wildly interspersed with trees. [13]

The Piercefield walks 'were laid out for the pleasure of the owners, their friends and visitors'. [14] These visitors were not only British. In the late 1760s and 1770s, young Russian aristocrats began adding Britain to their version of the Grand Tour. Count Aleksei Semenovich Musin-Pushkin, the Anglophile Russian Ambassador to the Court of St James, said that Valentine Morris had 'the noblest villa and sweetest-minded wife in the country'. She, no doubt, contributed to the legendary hospitality at Piercefield. 'The noble manner in which these extensive gardens (always open to the public) were kept, savoured rather of princely than of private hospitality'. [15] There were 'people ready to attend whoever comes, to conduct them everywhere, and not one of them is suffered to take a farthing; yet they shew every thing with great readiness and civility; what a contrast to the insolence met with from the Duke of Marlborough's porters'. [16]

Coxe, in *An Historical Tour of Monmouthshire* (1801), described the generosity of Valentine Morris:

> Collations were indiscriminately offered to numerous visitors, and even his hot-house, cellar, and larder were open to the innkeeper of Chepstow for the accommodation of

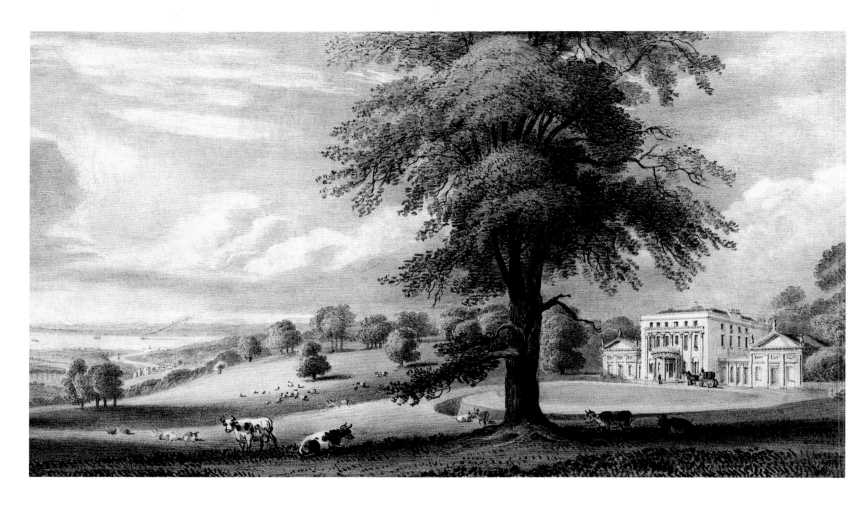

travellers. [17] ...He seems to have been a man of princely mind, but a thoughtless, unreflecting disposition. His beautiful property was nothing to him without admirers; and he was so grateful for admiration that he caused his servants to wait upon and feast, gratuitously, even the vagrant stranger, as soon as his foot had entered the magic circle.[18]

Combined with his taste for gambling, his lavish entertaining led to Valentine Morris's decline and fall. Beset with debts, he left for his plantations in Antigua in 1772. When he returned to England ten years later, he was imprisoned for debt. He died shortly after his final release from Newgate in 1789, while his 'sweetest-minded wife', overwhelmed by disaster,

died insane.

When Piercefield was sold in 1784, to offset some of Morris's debts, there was a second phase of landscaping by the new owner, George Smith from Durham, who made significant alterations to the routes and construction of parts of the walks for the benefit of visitors. The famous landscape had suffered nearly a decade of neglect and Byng, visiting in 1781 in the early

Fig. 150 Piercefield showing the 'Brownian' approach to the house with 'Lawns, groves and scattered trees'. The pavilions and portico [now lost] were added by Joseph Bonomi for Colonel Wood. G. Eyre Brooks, c. 1840.

morning, 'the best time for prospects, and long walks in very hot weather', noted that the walks were 'ill kept, some of them are almost impassable, viz. the zig-zag walk to the water, and that to the cold-bath'.[19] When Byng returned in 1787, Smith was beginning to make his mark on the landscape:

Sunday July 29 ... we proceeded on horseback to Piercefield Park ...so well known for its walks, and prospects; which has lately been sold to Mr Smith, who has fix'd Thursday the day of admission, but at Mr J's desire permitted us to come to day. –...But since my last visit here, the axe has done much havock; and now I part from it, with the same thoughts as formerly, viz. that it is a very fine thing to see, but not a desirable place to inhabit; I know not Mr S[mith]'s income; but it is not a station of retirement, or for a man of small fortune, and in a glare; and so famed, that an owner, and his servants become shew men.[20]

In 1789, the Rev. Stebbing Shaw noted that:

Since Mr. Smith has occupied the place, the pleasure grounds have been kept up with the same elegant taste, and the public indulged with the gratification of seeing them, as when they belonged to Mr Morris. ... Many pleasing additions have been made, which not only shew the views to greater advantage, but some of the serpentines, which rendered the walk too long, have been thrown into straight lines, for the accommodation of visitors.[21]

Smith commissioned a new mansion, built between 1785 and 1793, from Sir John Soane.[22] But when his bank crashed with the advent of war with the French, on 'Tuesday, December 10th 1793, at one o'clock' he too put Piercefield with its 'Capital New-Built Mansion...Gardens, Pleasure Ground, Lawn, Plantations, Beautiful Park' up for sale.[23] The house and estate (*Figure 150*) were purchased by Colonel Mark Wood (1750-1829), MP for Newark and 'formerly Chief Engineer at Bengal', so with a Nabob's fortune to spend. 'He [Wood] also built the handsome Lodges, and inclosed the Park with the high Stone Wall, which till that time, was incircled only by slight palisades.'[24]

He allowed people to see Piercefield on Tuesdays and Fridays from 11 a.m. to 4 p.m.

One diversion for visitors was described by George Manby in 1802, when 'a person with a bugle horn...was an unlooked for addition, nor did I ever hear the effect of sound so long in its decrease, and from other situations reverberating in such numerous replies from rock to rock'.[25] The provision of a sound track to the walk was started by Valentine Morris, and visitors were encouraged to rouse the echo with a charge of gunpowder given to the gardener to set off the guns.[26] Other travellers fired pistols in order to listen to the echoes. Charles Heath, in 1803, reported that, 'the explosion is repeated five times distinctly from rock to rock, often seven; and if the weather is calm, nine times'.[27]

Manby described how he sailed up the Severn, made possible by the regular ferries from Bristol to Chepstow for the benefit of tourists. The 'great boat' took carriages and horses; passage for a man and a horse cost 1/6, a foot passenger just ninepence.[28] Twenty years later, steamboats began a regular service from Bristol to Chepstow. On reaching Chepstow, 'there was a multitude of carriages always in waiting to carry passengers to Piercefield. ...The two-day tourists [sailing down the Wye] from Ross were now hugely outnumbered by the day-trippers from Bristol'.[29] *The Gloucester Journal* reported on July 21st 1827 that... 'Sociables,[30] phaetons, cars and pony-chaises for visiting Piercefield and Tintern Abbey, are increased at least tenfold during the last three years'.[31]

In 1803, a new owner purchased Piercefield, Nathaniel Wells (1779-1852). The son of William Wells, a plantation owner, and a black house slave called Juggy, he was educated and brought up in England. In 1794 he inherited a vast West Indian sugar fortune from his father. Shortly after Wells had taken possession, Joseph Farington, the landscape painter and diarist, visited Piercefield on September 16, 1803, and with his friend, the portraitist John Hoppner, walked along the cliff top. 'Having brought provisions with us we dined at the entrance of a subterranean passage cut through the rock [the Giant's Cave]. Not having knives and forks and glasses we sent to Pierce-field House and were furnished with them.' The next day:

View of the Wind cliff &c. taken from the "Lover's Leap" Piercefield Park

Fig. 151 Looking towards the Wyndcliffe from the Lovers' Leap.

the Woman who has care of the gate told me that Mr Wells is very exact about admission to see the grounds. Every person who goes for that purpose is required to write His or Her name and the book is carried to him every Saturday night. He does not refuse application for admission on other days than Tuesday or Friday, but should a person be seen in the grounds without leave, He would himself go to the gate and express himself angrily to Her.[32]

Charles Heath, the local historian, publisher and bookseller, describing Piercefield as 'the ARCADIA of Monmouthshire', wrote a series of guides and tours to the Wye Valley.[33] They sold well, as they provided a wealth of information for the traveller:

By the kind permission of Mr WELLS, these Walks are open for public inspection EVERY TUESDAY AND FRIDAY, From Morning till Night...
Strangers, who wish to visit Persfield, should pay attention to the days the Walks are open to the Public, ... as no admittance is to be obtained, at an intervening time.[34]
Another guidebook of the period advised:

To obtain admission to Piercefield, send your card, with a request for admission, directed for Nathaniel Wells, Esq., the urbane proprietor, who will leave orders at the lodge for the following morning.[35]

J.T. Barber, visiting with friends in 1802, found this rule was rigorously enforced. They applied at the Lion Lodge for admission and after some difficulty they were informed:

that we could not upon any account see the grounds, as they were only shown on Tuesdays and Fridays. This was on a Saturday; but to wait until the following Tuesday would be a tax indeed; and to proceed without seeing Piercefield a sad flaw in our tour'. [36]

Not to be thwarted, they rode up to the village of St Arvans and entered Piercefield's grounds through a back gate.
The Wye valley also exerted its charms on foreign travellers. The German Dr Spiker, visiting in 1816, wrote:

Piercefield is a superb villa, with a very extensive park; ... now the property of Sir Nathaniel Wells [37] who allows the public the gratification of viewing and romancing about his park every Tuesday and Friday. ...We enter the park through a side gate (visitors not being allowed to drive up to the great entrance gate) and proceed along a walk which runs round it, and which enables us to view the most beautiful part of it.... The Giant's Cave has a very picturesque appearance from a colossal figure of Polyphemus placed over the entrance, which reminds us of the Odyssey.

He could not view the Grotto as it was 'full of gay ladies and gentlemen', but thought the Druid Temple:

...not a successful imitation, as the blocks of granite, intended to convey the resemblance, are disposed too regularly on

either side of the place. The park upon the whole seems to be neglected by the present proprietor; the walks are in various places choked up with weeds and bushes, and every where covered with large stones.[38]

Prince von Pückler-Muskau made his way to the Wye in December 1828 and, taking the river route, set off to explore the area. 'In summer and autumn the Wye is never free from visitors; but as it has probably never entered the head of a methodical Englishman to make a tour in winter, the people are not at all prepared for it, and during the whole day I found neither guide nor any sort of help for travellers'. He found Piercefield very much to his taste:

Chepstow, Dec. 19th 1828: The grouping of this landscape is perfect: I know of no picture more beautiful.... Piercefield Park, which includes the ridge of hills from Wind-cliff (*Figure 151*) to Chepstow, is, therefore without question the finest in England, at least for situation. I remarked to the proprietor of the stage, who drove, that the possessor of this beautiful estate must be a happy man. 'By no means,' replied he; 'the poor devil is head over heels and ears in debt, has numerous family, and wishes with all his heart to find a good purchaser for Piercefield.[39]

In common with previous owners of Piercefield, Nathaniel Wells began to find his wealth leaching away. He first tried to sell the estate in 1819. The 1807 Act banning the slave trade in British ships, and the final abolition of slavery within the British Empire in 1833, added to his financial difficulties, as he was, like his father, a plantation and slave owner. As a result, the estate was put up for sale around 1837. Again, it did not sell, but the sale particulars describe: 'A magnificent stone-built MANSION, PARK, WOODS & WALKS, for ROMANTIC BEAUTY UNRIVALLED'. They detail 'the matchless beauties of this elegant and princely seat that infinitely surpass the happiest Powers of Description'. But they did use the tour writers' powers of description in their sales blurb, supplying several pages of extracts, concluding that, '...the concurrent

Testimony of all Mankind who have seen it, stamps Piercefield the most delightful Spot on Earth'.[40]

Shortly after the attempted sale, Louisa Anne Twamley described how:

At a little distance from the Lodge, we met a small boy, who walked with us to a tall tree, and catching at a rope hanging from it, rang such a sonorous peal on a great bell hidden among the branches....This startling summons having brought the guide to our assistance, we were conducted to the Alcove, the first view-point, and then in succession to the eight others, as "established by law".[41]

Roscoe arrived in the Wye valley c. 1836. When he reached Piercefield, unlike many before him and reflecting changing taste, Roscoe was not impressed:

Piercefield Park, far more the marvel of the last than of the present generation...is certainly a very pretty specimen of landscape-gardening; but so much puerility of design is mixed with the grand and simple beauty of nature, that a ramble through the three-mile walk of Piercefield Terrace is far less gratifying to a romantic wanderer than the same distance would prove through the wild greenwood or over the breezy hills. Grottos fabricated where grottos would not naturally exist, with dilapidated giants in stone over their entrance, and inscriptions, not of the highest order of composition, are very well calculated to make the unlearned stare, and as sure to make the judicious grieve.[42]

Nathaniel Wells moved between Piercefield and Bath, occasionally leasing Piercefield and its estate out to tenants. One disgruntled visitor, writing in 1833, said:

Travellers feel extremely ill-used now, in not being admitted to enjoy the beautiful grounds, formerly opened with the utmost liberality, but now entirely shut up, we were informed, from public view, having recently been let to a new tenant, who has not revealed his name, being desirous

to evade the odium of causing such an exclusion.[43]

After Wells's death in 1852, Piercefield was leased to John Russell (1788-1873), who purchased it outright in 1855. Initially he closed the walks, but the *Chepstow Weekly Advertiser* announced on July 24, 1858, that:

The public are informed, by the public prints, that, through the liberality of the present proprietor [Mr Russell], these delightsome walks, which have been for a long period closed to tourists, are now to be inspected, upon application at the Piercefield Inn [near the back gates to Piercefield], for a card of admission.

This drew some criticism in the same edition of the newspaper:

'Why the Dickens should we trot
A mile beyond the happy spot,
Where the grim lions couch in state
To grace our entrance at the gate,
And back, – a mile or more in addition
Before we can obtain admission
To Piercefield Walks…

The building of the turnpike road from St Arvans to Tintern in the 1820s separated the Wyndcliffe (*Figure 152*) from the rest of Piercefield. Control of this spot passed to the Duke of Beaufort and his agent, and a more commercial attitude to visitors emerged with the creation of 'The Moss Cottage, a pretty little summer-house, built by the Duke – to accommodate visitors, who may obtain some homely refreshments here, but usually bring their provision basket with them'.[44] In 1861, the Halls noted a charge of sixpence to see the view from the Wyndcliffe: 'The fee is designed to effect…a barrier to prevent the intrusions of mere idlers from the town, who would disturb the tranquillity of the scene'.[45] A complaint was sent to the local newspaper: '*Imposition:* The charge made at the top of the Wyndcliff – a thing unheard of till within the last year or two. Can the present proprietor be aware of this extortion

from visitors? He is reputed to be a liberal-minded man.' [46]

In 1861 Russell sold Piercefield to Henry Clay (1796-1874), a banker from a Burton-on-Trent brewing family. Piercefield still figured on the tourists' itinerary throughout the nineteenth century. *The Bristol Channel District Guide* in 1898 listed excursions by steamer to Chepstow, including Trip No. 14 to Piercefield Park when, having landed at Chepstow:

…we stop at the gates of Piercefield Park, the residence of – Clay Esq. If it be Tuesday, the open day, the gatekeeper will at once furnish you with a little man for a guide through the tortuous leafy groves, bringing you all unexpectedly into some most exquisite spots of romantic beauty….the up-hill and down-dale, combined with the rough inequalities of the path, are somewhat trying to tender feet.

This view was not shared by the author of *Murray's Handbook,* who, writing at the same time, reflected changing taste:

the grounds are extensive and varied, but were laid out in the day when the beauties of nature were considered as secondary to those of landscape-gardening, which developed themselves into grottoes and other architectural monstrosities. [47]

Piercefield remained with the Clay family until sold to the Chepstow Racecourse Company, who opened the racecourse in the park in 1926. As the twentieth century progressed, Piercefield dwindled away. Its glories linger on in the descriptions of the diarists, Tour writers and visitors who considered Piercefield '…this enchanting spot, where nature wantons with such variety, and combines so great a portion of the beautiful, the picturesque, and the sublime'.[48]

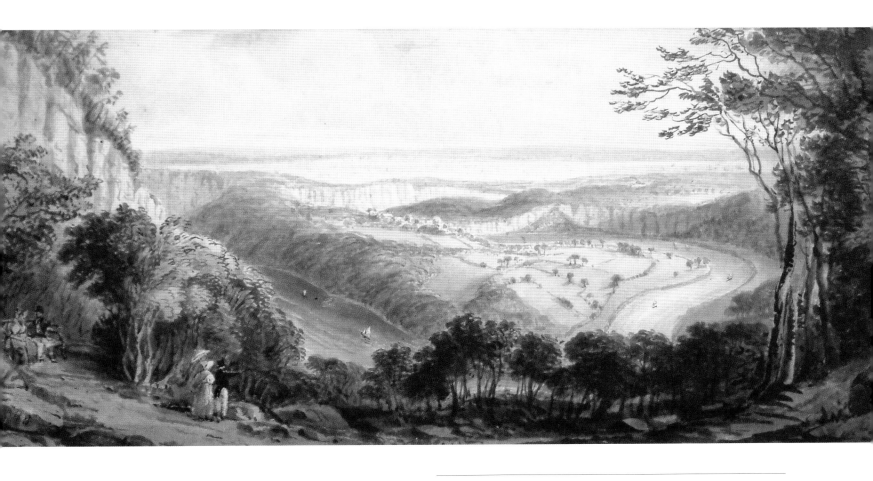

Fig. 152 The view from the Wyndcliffe.

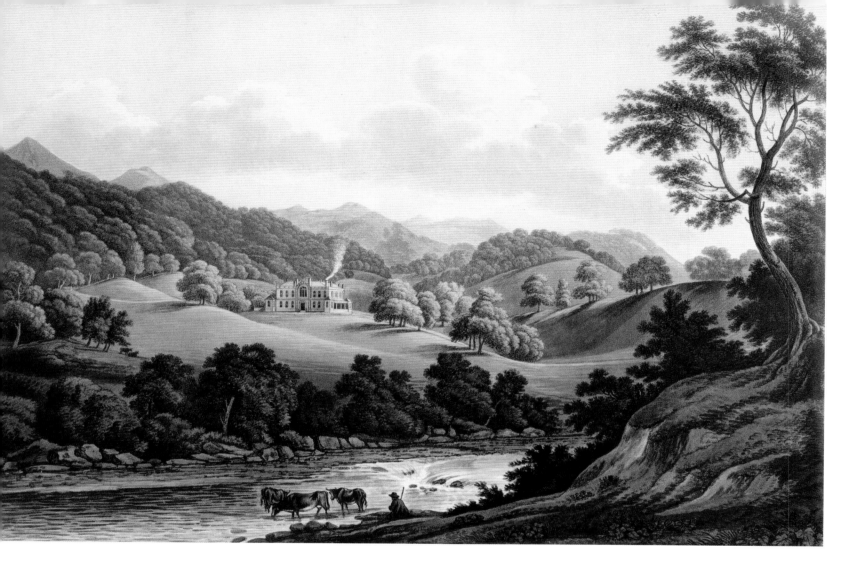

HAFOD – 'SINGULARLY ROMANTIC AND SUBLIME'

If Piercefield, while featuring highly on the itinerary of every connoisseur of the Picturesque, was principally a romantic landscape, Hafod, over 100 miles away on the other side of Wales, was the ultimate man-made Picturesque landscape, one of the most important in Europe and, as Malcolm Andrews says, 'a fitting conclusion to the north Wales tour'.[1] *(Figure 153)*

The estate is situated near Cwmystwyth [the valley of the River Ystwyth] in what was then upland Cardiganshire, and was inherited by Thomas Johnes (1748-1816), on the death of his father. Johnes acquired enormous wealth, with estates in

Herefordshire, including Croft Castle, as well as Wales. He arrived from Herefordshire with his second wife, Jane, in 1783, and set about creating a landscape of thrilling grandeur around a splendid new house in this remote and wild country. He laid out its grounds to display its natural beauties in sympathy with the Picturesque principles, taking advice from his cousin, Richard Payne Knight, and his friend, Uvedale Price, both of whom visited Hafod regularly. Another guide was William

Fig. 153 The mansion of Hafod overlooking the River Ystwyth. A watercolour by John 'Warwick' Smith, 1795.

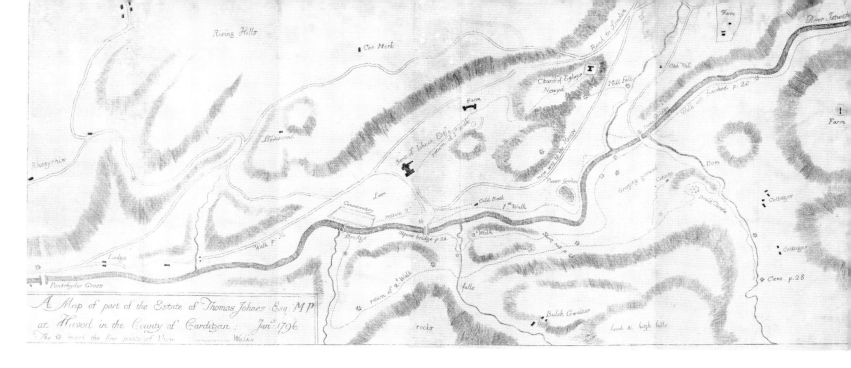

Mason, the author of the influential poem, *The English Garden*. In his work at Hafod over a quarter of a century, Johnes continually demonstrated Mason's view that the planting of trees was returning the earth to its original condition, Paradise. Gilpin reported to Mason that Johnes had told him that:

> The walks and lawns were laid out by Mr Mason: whose English Garden he took in his hand; and wanted no other direction. So if you want to see an exact translation of your book into good Welsh, you must go to Mr Johnes's seat in Cardiganshire.[2]

From the beginning, Johnes wished people to come and see: 'My idea of resembling a fairy scene'.[3] That he achieved his aim is in no doubt, as Hafod is considered the supreme example of a sublime Wilderness Paradise. This Eden was eloquently described by George Cumberland, who wrote his *Attempt to Describe Hafod* (1796) at the invitation of Johnes. Cumberland had seen Hafod 'in its original wilderness,' and in inviting him to see Hafod again, Johnes was anxious to show him 'that by *beautifying it* I have neither *shorn* nor *tormented* it'.[4] They became great friends and remained correspondents for the rest of their lives.[5]

Fig. 154 The map attributed to William Blake that illustrated George Cumberland's *An Attempt to Describe Hafod* (1796).

Fig. 155 Thomas Johnes of Hafod, a print after Thomas Stothard.

Fig. 156 The upper reaches of the Piran Cascade, an illustration for *A Tour to Hafod* engraved by J. Stadler after John 'Warwick' Smith.

Cumberland provided the first and fullest account of Hafod and its surroundings. Full of extravagant praise for the 'beautiful wildness of nature' about him, Cumberland also noted that Hafod included 'the luxuries of life...hot houses, and a conservatory; beneath the rocks a [cold] bath; amid the

recesses of the woods a flower garden;' He included a map ascribed to his great friend William Blake which showed the 'four fine walks from the house'. *(Figure 154)* These circuit walks allowed the visitor to enjoy a succession of views and experiences throughout the landscape:

The walks are so conducted, that few are steep; the transitions easy, the returns commodious, and the branches distinct. Neither are they too many, for much is left for future projectors; and if a man be stout enough to range the

underwoods, and fastidious enough to reject all trodden paths, he may, almost everywhere, stroll from the studied line.

On the opposite side of the river from the house were walks of great extent, 'which take up about three hours to trace'. These were wilder and more rugged, full of cascades and waterfalls, 'ravines', caverns and splendid views: *(Figure 156)*

> Dark the gigantic rocks projecting hung,
> Crown'd with gray oaks, in huge disorder flung;
> Thund'ring and hoarse a smoking torrent fell,
> Spreading a dingy wave, and foamy swell;
> Whose rushing streams in whirling eddies sweep,
> Loud-sounding, rapid, turbulent and deep.

The publication of *Fifteen views illustrative of A tour to Hafod in Cardiganshire* (1810) by Sir James Edward Smith, illustrated with aquatints after the watercolours of John 'Warwick' Smith painted in 1796, provided a visual version of Cumberland's text. Sir James was another man who, after encountering Hafod and writing about it, became a lifelong friend of Johnes. He travelled to Hafod in 1795, in the process befriending Johnes's beloved daughter, Mariamne, with whom he conducted a correspondence. She was just eleven years old and her own garden within Hafod was designed for her that year by her father's friend and advisor on tree planting, the noted Scottish agriculturalist, Dr James Anderson.

Cumberland concluded that:

> I shall undoubtedly be suspected of high colouring...so far am I from subscribing to such an opinion, that on re-perusing my. ...descriptions, I find them feeble, frigid, and far inferior to the subject. ..and never eye, I will venture to affirm, beheld these scenes without astonishment.[6]

(Figure 157)

So influential was Cumberland's work that many authors of travel journals and guides threw down their pens and begged leave 'to borrow the elegant description of it, drawn by the masterly pen of Mr. Cumberland'.[7] Shortly after the publication of the *Attempt to Describe Hafod*, Richard Warner paid his first visit, escorted by a local fisherman he had met at Devil's Bridge and who 'insisted on conducting us round the walks of Hafod'. They 'exhausted three hours in surveying only part of its beauties'. These included:

> walks varied and extensive, commanding views beautiful, romantic, and astonishing; woods and rocks; bridges and cataracts; the highly ornamented garden, and the crude, rugged, uncultivated mountain. Indeed, the whole together forms a scene so striking – we feel no inclination to tax Mr Cumberland with enthusiasm.[8]

A year later, Warner returned and 'walked over to Colonel Johnes's to breakfast, who, with his usual hospitality, had favoured us with an invitation thither':

After breakfast the Colonel was good enough to accompany us through that part of the grounds which lies contiguous to his house; the longer circuit – we could not attempt, as it would have taken us a walk of at least ten miles.

Warner left a description of a recent feature of Hafod 'formed after a plan of the Colonel's, very judiciously managed':

One walk...had escaped me, and perhaps the most romantic of the whole, where a very happy natural circumstance has been taken advantage of by the Colonel, and a fine and surprising effect produced by it. Proceeding from a rude

Fig. 158 Parson's Bridge, a simple span that would have met with Lipscombe's approval. One of the *'Fifteen Views'* of Hafod created by John 'Warwick' Smith.

stone bridge, under which an Alpine stream rushes with noise and fury, we followed its course upwards, by a walk formed out of rock, darkened with the trees that ever and anon throw their arms across the roaring torrent. ...just at the point when we hoped to gain a sight of it, a lofty dark rock...terminated the view and seemed to oppose all further progress [there was a cavern excavated in the rock]. We were directed to enter, and having proceeded through it a few yards, a sharp angle occurred, which we turned, and caught at once a view of a vast sheet of water, falling in front of the other extremity of the cavern, from a height above.[9]

Not all visitors to Hafod found Cumberland's description helpful. Colt Hoare thought that the beauties of Hafod had:

...been so exaggerated by Mr Cumberland that everyone who has an eye to see, and a judgement to discriminate the

beauties of nature must, like myself, be much disappointed in viewing it. After crossing some of the most dreary and barren mountains imaginable you enter a valley, apparently well-wooded at a distance... The scenery or beauties of this place consists in walks out through the woods on each side of the river which with other streams form... some very pretty cascades.[10]

Sykes was another who felt that Cumberland had said it all but who also had a view of his own to express:

I shall not attempt to describe this place, it is well done by Mr G Cumberland... The Kitchen Garden is very unfortunately placed at Hafod in the Center of the Scene and can be concealed from many points of view, cut even from the Approach; the House is a new one, and by no means an happy imitation of an Abbey. He has been almost as unfortunate as his friend Mr Knight.[11]

In addition to building his new mansion with the help of Bath architect, Thomas Baldwin, Johnes found time to build the inn at Devil's Bridge, some five miles away. As Jennie Macve records, 'Johnes wished a much larger public to enjoy the natural beauties and witness the manner in which he had made his land more productive and beautiful; – Johnes therefore resolved to build his own inn. In 1790 he acquired a large farm near Devil's Bridge, – and thus became the owner of the prime site overlooking the gorge, "fronting scenes of stupendous magnificence." The experience of Hafod and the plunging cascades of the Mynach river at Devil's Bridge were a carefully contrived contrast between the untamed wildness of the latter and Hafod, 'where Art had assisted Nature in creating a visual feast of picturesque scenes'[12] and, as one tourist wrote, they could 'exchange the sublime for beautiful, and repose ourselves on fairy ground'.[13]

A wild Eden was certainly expected by visitors to Hafod, even when access was controlled by tickets:

In order to obtain a view of this Paradise, it is necessary to get a ticket of admission from the Landlord of the Hafod Arms Inn, on which the visitor inscribes his name and the

number of his party. The regular hours of admission to the house and grounds are from twelve to two ... We were there soon after ten but ... Mr and Mrs Johnes, who were at home, most politely permitted us immediately to see the house.[14]

Commercial considerations were also important, but many visitors commented on the grasping ways of both the inn and Hafod household staff. In August 1799, the Rev. James Plumptre described what might be expected:

In coming away, I put half a crown into the housekeeper's hands who told me "she never took less than 5 shillings". I replied that I never gave more than half a crown. "It was a rule of the house to give 5 shillings" (having previously taken care to inform her that I was travelling on foot, and therefore in all probability not overstocked with money) – "Did Mr Johnes order that each stranger should give 5 shillings?" – "They never thought of shewing the house for less" – I replied that "I had often given 1 shilling at a gentleman's house and never more than half a crown" I was prepared for this behaviour of the housekeeper. I had met several parties in Wales, who had been at Hafod and all complained of her.

Plumptre spent some twenty minutes in the house and then went round the grounds with the gardener, a Scot, and, after the six-mile walk, gave him 2s 6d.[15] In 1803, John Barber related that:

...the demand of five shillings for the gardener's attendance was willingly paid, yet the same sum – required by the housekeeper, appeared to us more than the show of any Welch house was worth... there always appears to me something very unworthy in great men allowing their servants to extract the sums that they do from the spectators of their grandeur. [16]

The dream of the Picturesque was thoroughly appreciated by many who made the pilgrimage to remote Cardiganshire. George Lipscombe arrived in 1799 and found much to praise, as well as offering Johnes landscaping advice. As he approached the house for the first time he found:

Fig. 159 The Bedford Monument, dedicated in memory of the 5th Duke of Bedford. The Monument was designed and engraved by W. Pococke.

...a truly rural and sylvan scene...the mansion house, an elegant building, in the Italian style, with a conservatory adjoining.

The meadow, or lawn, to which it opens, lies in its natural state. No Brownonian attempts have been made to slope and swell it; a few trees are here and there scattered about, but they are all of the forest kinds; and the drive up to the

door is thrown into the most careless and elegant bend imaginable.

Lipscombe worried that his expectations had been raised by the descriptions of Hafod he had read. He had begun to suppose that, 'the *chef d'oeuvre* consisted in creating astonishment and feeding surprise, by a display of highly-finished ornaments, and laboured decorations.' He was delighted to find that Johnes's alterations and enhancement of the landscape were arranged 'to show some great natural beauties to the most striking advantage':

When I read of *Gothic, Chinese, Rustic*, and many other bridges, I expected to have found several attempts at prettiness, which the surrounding scenery would have rendered odious and disgusting. Instead of this, you are conducted over the three streams..., in one place, by a strong, rough arch, which cannot be said to belong to any order of architecture; and which serving for strength and utility only, is almost hidden in the surrounding trees: in two or three other places by a single tree, or a rude plank, thrown carelessly across, in the most artless style of genuine simplicity. [17] *(Figure 158)*

This distaste for Gothic and Chinese bridges echoes Payne Knight, who thought that:

> But false refinement vainly tries to please,
> With the thin, fragile bridge of the Chinese. [18]

As Lipscombe and his companion went through the grounds they noted the kitchen garden, where 'an extensive range of forcing houses' occupied most of the north side of the garden and where they were accompanied by a tame cockatoo that travelled with them round the garden eating hot house strawberries from Lipscombe's hand. They found Mrs Johnes's flower garden:

...which is walled in, and disposed in a neat, and perhaps elegant manner; but it is, I think, too formal to be pleasing. On one side is a small alcove, and the flowers here, as well as

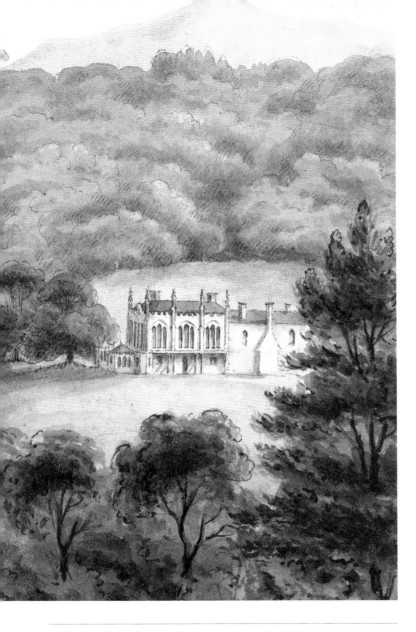

Fig. 160 A side view of Hafod showing how the house sat within its wooded plantations and what it looked like before the fire of 1807.

in the conservatory, are kept with great care.

The cavern and subterranean passage so admired by Warner was not wholly appreciated by Lipscombe, who wrote that:

The impression which I felt on seeing it, was not equal to what has been described by other travellers; for, by some means, the cave lessens the effect of the cascade, which besides it being thus rendered the sole object of contemplation, is cooped up in a narrow corner, and brought too near the spectator.

The relief that Lipscombe felt on no 'Brownonian' attempts on the landscape were shared by many visitors. Fenton, celebrating 'The Genius of Hafod' in poetry, declared:

> Far, far from hence, let BROWN and EAMES,
> Zigzag their walks, and torture streams;
> But let them not my dells profane,
> Or violate my Naiad train;[19]

Benjamin Malkin reached Hafod in 1803, finding that it fulfilled his dreams of the Picturesque: 'such an assemblage of beauty and grandeur, stretched out to the very limits of the perspective, as few spots in this island can equal for surprise and singularity'. He devoted over thirty pages to his description of the grounds, gardens and house, describing how Johnes had enhanced what was 'planted there by nature' while 'yet more … owe their luxuriance to the novel and well-directed efforts of their owner'. Malkin related that, 'I have purposely taken the direction contrary to that of Mr. Cumberland', although when 'I trod in his steps, with his book in my hand,…found myself assisted by the accuracy as well as interested by the vivacity of his detail.'[20]

One landmark had not been erected in Cumberland's day and Malkin recorded it in his second edition of his tour of south Wales (1804):

There is a very grand rock, lofty and naked, standing alone in the midst of woods, too extensive for the eye to measure. This rock is an object from almost every part of the opposite hills. Its top is a natural platform, as if placed there for a purpose, on which is now erected to the memory of the late duke of Bedford, which forms the principal ornament of the place, as well from, its association, as from its site and execution.

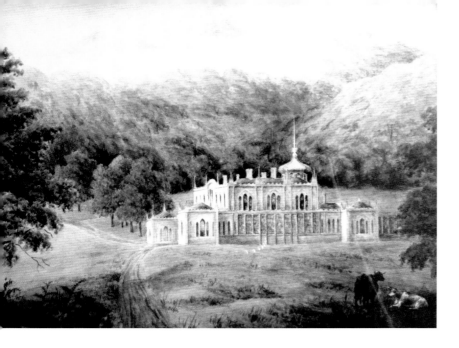

Fig. 161 A photograph of a watercolour executed when the Duke of Newcastle owned Hafod. This might account for the untended look of the 'lawn' approaching the house – the Duke spent the shooting season at Hafod and records of the time show only one gardener was employed. The long run of windows marks the conservatory. The 'needle' on top of the dome was made of glass and intended as a lightning conductor.

The young Duke of Bedford had visited Hafod and shared many of Johnes's views on improved agriculture. A handsome print of the monument, produced in 1803 by W.F. Pococke, stated that it was dedicated to the memory of Francis, 5th Duke of Bedford, who died in 1802, by Thomas Johnes:

> as a Testimony of the Sincerity with which he, in common with every Friend to the Improvement of the Country, Laments the Loss of The most Judicious and Munificent Promoter of The National Agriculture. [21] *(Figure 159)*

Having revelled in the wild scenery, Malkin then turned to 'a creation of fairy gaiety':

> A gaudy flower garden, with its wreathing and fragrant plats bordered by shaven turf, with a smooth gravel walk carried

round, is dropped, like an ornamental gem, among wild and towering rocks, in the very heart of boundless woods. … The spot at present contains about two acres. [Mrs Johnes's Garden] But this delicious retreat has not yet arrived at its perfection. It is intended to enlarge it…and it is still further to be ornamented by a Doric temple, from a design in Stuart's Athens.[22] There is another flower garden, of very different character, and still more singularly situated, to which strangers are never admitted [Mariamne's pensile garden]. …the taste in which it is laid out is not so studiously ornamental as that of the garden below: …and exhibits in a nursed state many of the most curious plants, which are the natural growth of high exposures in foreign climates.

The smaller domestic detail includes a mention of the cold bath, a description of a moss-house and of the vase designed by Thomas Banks and placed in Mariamne's garden to commemorate the death of her pet robin. As he quitted the place, Malkin reminded the reader of how young, in landscape terms, Hafod was:

> There is one reflection, which is particularly pleasing at Havod. Notwithstanding all that has been done, the place is yet in its infancy… Havod, fifty years hence, will stand alone in grandeur, if the plans of its first former are not abandoned by its successors. What we now see, is the fruit of only twenty years. … Hills, planted by the very hands of the present inhabitants, have already risen into opulence of timber; other hills are covered with infant plantations of luxuriant promise; and more of the lofty waste is now marked out, to be called into usefulness and fertility, in a succession of ensuing autumns. *(Figure 160)*

Loudon thought highly of Hafod, having spent time there advising on the glasshouses in 1805. His *Encyclopaedia of Gardening* awarded it one of the four stars he gave to Welsh gardens. He considered it:

> by far the most good and picturesque residence in either North or South Wales. The house, in a peculiar style of Gothic

or Moresque architecture, in the side of a secluded basin, among high mountains: the approaches to it full of beauty and contrast, the numerous walks displaying waterfalls, precipices, views, prospects, cultivated scenes, rude spots, seats, buildings, &c., singularly romantic and sublime. The kitchen-gardens and farm were extensive, and successfully cultivated.[23]

Loudon was an authority on farming practice and his reference to the Hafod farm is important. All the great Welsh estates had farming at their heart and Johnes was a passionate agricultural improver. He received the gold medal of the Royal Society of Arts three times for his vast plantations; he was the first president of the Cardiganshire Agricultural Society and corresponded with Arthur Young. He contributed to his *Annals of Agriculture* and published his own *Cardiganshire Landlord's Advice to his Tenants* (1800). Travellers through Wales typically included remarks about farming practices, the quality of the farmland, the crops and animals it supported, as well as the parks and gardens.

As the nineteenth century began, shadows started to fall over Hafod. In March 1807 there was a catastrophic fire which, in addition to much of the house, destroyed its celebrated Library. Borrow reported the legend that, 'its violence was so great that burning rafters mixed with flaming books were hurled high above the summits of the hills'.[24] Johnes had the house rebuilt and Colt Hoare reported in 1810 that, 'the stately mansion at Hafod with a portion of its valuable library has been burned since my last excursion to this place but phoenix-like is again rising most rapidly, and with renovated splendour ...'[25] However, more tragedy awaited Johnes and his wife. In 1811, their beloved only child, Mariamne, died.

Utterly cast down by Mariamne's death and faced with financial difficulties that required major retrenchment and selling of property, in 1814 Johnes sold the reversion of the estate, including the contents of the mansion. This almost amounted to bankruptcy. In failing health, he retired with his wife to Dawlish in Devon.[26] He died there in 1816, aged 67.

After Johnes's death, Hafod continued to exert its fascination on travellers and tourists. There was a long gap while Hafod, like Bleak House, languished in Chancery, but in

1832 the estate was bought by Henry Pelham, the 4th Duke of Newcastle. While he used it principally as a holiday home for his family and for shooting parties, the Duke did spend money improving the property. *(Figure 161)* This included constructing a new drive, taking it away from the immediate environs of the house. The improvements were noted in Nicholson's *Cambrian Traveller*:

> His grace seems much attached to this 'Paradise in the Wild', as it has justly been designated, and usually spends between two and three months here in the autumn of every year. His grace is carrying on extensive improvements, both in the mansion and the grounds, affording employment to a great many workmen, employed for the last two years.

Nicholson also noted that the Duke had made changes to the Hafod Arms at Devil's Bridge, with 'the character of the whole structure changed...into what is far more appropriate for the situation, a Swiss cottage.' At the same time, he warned his readers that 'tickets for visiting the grounds at Hafod are usually granted at the inn...; but during the progress of the present improvements, admission is not attainable'.[27] When he was in residence with his family the Duke did not always welcome the over-eager tourist, as experienced by the Rev. Joseph Romilly:

> *Monday 28th August 1837:* Directly after breakfast set off in company ...in a one horse phaeton to the Devils Bridge. As we were setting off our driver met the Duke of Newcastle's gamekeeper, so we inquired if strangers were admitted to Hafod, and he told us that they were not in consequence of the recent intrusion of some visitors into the house without leave. Of course the Duke of Newcastle of all men 'may do what he will with his own', but this was very annoying to an innocent traveller like myself.[28]

The Duke's absence for much of the year and possibly the decay that had set in after Johnes's death meant that in 1840, when Hafod was visited by Roscoe, he found time had wrought sad change:

My readers will be good enough to step into the carriage with me while I retrace my morning's drive to that former 'paradise of dainty devices'. ...A lovely ride along this lawny vale, at one graceful sweep brings the visitor in front of the mansion, the exterior of which is the only part that the present owner suffers the eyes of curious tourists to be edified by examining. ...The description of Hafod, so laboriously built by some Mr Cumberland, I find quoted in every guide-book I open; of course it is considered the *ne plus ultra* of the sublime and beautiful....

The grounds of Hafod are highly favoured by nature, in variety of form; and art has lent her improving hand, so gracefully, and naturally, that we forget that she has so much to claim in the beauty of Hafod. ... Colonel Johnes, the late lamented and excellent owner of this immense estate, planted *nearly three millions* of trees upon bare, heathery hills....but now, the beauty is fast waning in the neglect and general absence of its present proprietor. The pleasant and well-kept walks have become quagmires, and where a garden once shed its many perfumes on the air, inviting the approach of wandering guests, now a wilderness of tall grass and rank dandelions fill the space...where the hand of man should give its aid, in maintaining the improvements of art, all is going to decay. ...We will wish Hafod 'good-morrow kindly' – and hope to see it soon in better condition.[29]

In 1846, the Duke sold Hafod to Sir Henry de Hoghton, a Lancashire-based baronet. He embarked on a building programme that trebled the size of the mansion, and included an Italianate campanile designed by Anthony Salvin. The whole enterprise was never completed and de Hoghton only lived at Hafod now and again until 1854. Hafod was sold on to William Chambers, from Llanelli, who, with little ready money to hand, made few changes to either the house or estate. As *Murray's Handbook* related in 1868:

...Hafod, the princely estate of W. Chambers Esq., where the beauties of nature and art have been mingled in a rarely happy manner.In 1846 it was sold on to H. Hoghton for £94,000, under whose auspices the present improvements, including the bell-tower, erected in the Italian manner by Mr. Salvin, were carried out. ...The Ystwyth flows through the grounds, amidst constantly varying scenes, and numerous tributary brooks rush down the hillsides in cascades of every height, many of them unfortunately hidden from view by the luxuriant growth of trees; a judicious thinning advantageous alike to the timber and the landscape, is constantly being carried on by the present owner.[30]

By 1872, 'Hafod was in a state of crisis that could well have proved terminal'. William Chambers was embroiled in a disastrous lawsuit, which ended in 1865 and bankrupted him. He struggled on trying to find a buyer. Eventually, in 1872, a rich entrepreneur from Gloucestershire, John Waddingham (c. 1799-1890), bought Hafod. He spent the next sixteen years carrying out a 'careful and comprehensive building programme which sought to provide Hafod with all the accommodation required of a large country house'. A reference from 1887 noted that he had 'much improved the estate by planting larch, draining, fencing and building'.[31]

On John Waddingham's death, Hafod passed to his younger son, Thomas James Waddingham. He and his wife, Sarah, played an active role at Hafod and in the local community and, following his father's interests in the railway, he welcomed the proposed Vale of Rheidol Light Railway in 1890. Under his direction the Hafod estate was well run and managed, but there is little evidence that he made any major alterations or additions to the gardens or walks.

The appreciation of remarkable places like Piercefield and Hafod, followed with ventures into the mountainous regions of north Wales, was now firmly established Wales on the tourists' itinerary. By the beginning of the nineteenth century, it could be claimed as a benchmark for travel writers who, outlining other parts of Britain to explore, could say, "The romantic character of the north of Devon, combining along its coasts scenes of uncommon grandeur and beauty, which rival, according to travellers, the wonders of north Wales".[32]

PLAS TAN Y BWLCH

While Piercefield and Hafod set the scene for the Picturesque in Wales, one garden in north Wales could also be said to have been the creation of the Picturesque movement, Plas Tan y Bwlch [*Below the Pass*] in Meirionydd. The first written record of the Tan y Bwlch estate is dated 1602 in the Will of Robert Evans, but by the eighteenth century it had passed by marriage to the Griffith family. The first house on the site of the large Gothic mansion that you see today was probably built in 1748 by Robert Griffith. By the 1780s, the heiress to the estate was Robert Griffith's granddaughter, Margaret. In 1789 she married William Oakeley, a Shropshire gentleman, and the management of the estate passed into his hands. For nearly two centuries, the Oakeley family owned Tan y Bwlch and were responsible for its development and enhancement down the years.

Fig. 162 *A View of the Vale of Festiniog, or Tan y Bwlch, in Merionethshire,* showing the mansion (to the left) before it had been altered by William Oakeley. An engraving after S.H. Grimm by W. Walker & W. Angus, 1777.

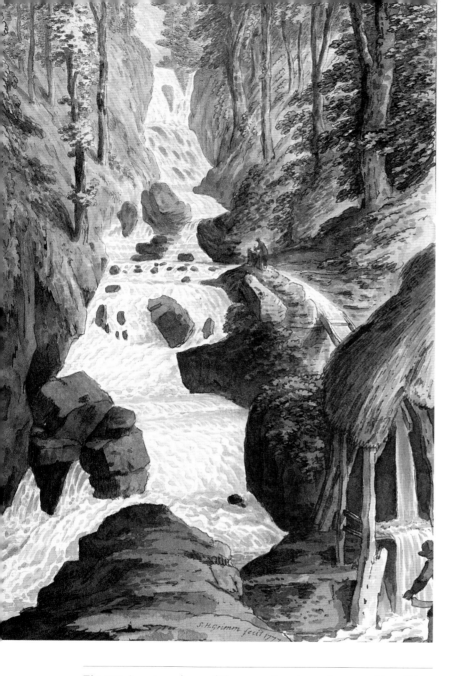

Fig. 163 A watercolour of the cascades along the east side of Tan
y Bwlch's grounds, drawn by S. H. Grimm in 1777. The leat to the
side of the cascades may have been used to divert the water to
power the mill at the bottom of the hill.

Nature's was the first hand to create a place of great beauty admired by travellers. Tan y Bwlch is situated in the centre of the Vale of Ffestiniog, or the Vale of Maentwrog, on a steep valley side looking south-eastwards, with glorious views over the Vale, the river Dwyryd and the village of Maentwrog, and to the mountains of Meirionydd beyond. Even before William Oakeley took up residence at Tan y Bwlch, the area had come to the attention of an increasing number of visitors to north Wales. Thomas Pennant provided one of the earliest descriptions in 1773:

> The whole scenery requires the pencil of a Salvator Rosa: and here our young artists would find a fit place to study the manner of that great painter of wild nature.
> The place lies in the *Tempe* [1] of this country, the vale of Tan y Bwlch, a narrow, but beautiful tract, about three or four miles long, divided by the small river Dwy'ryd, or The Two Fords, being formed by the *Cynsael* and another stream, which unite towards the upper ends. The vale is composed of rich meadows; the sides edged with groves; and barren precipitous mountains close this gem, as it were, in a rugged case. Here is a very neat small inn, for the reception of travellers, who ought to think themselves much indebted to a nobleman, for the great improvement it received from his munificence.
> ABOVE it is a house, embosomed with woods, most charmingly situated on the side of the hill. [2]

Pennant's reference to Salvator Rosa is an important indication of how the taste in scenery and landscape was changing, taking on a wilder, more thrilling character so evident in Rosa's work. This was in contrast to the serene Arcadian beauty popular in the middle years of the eighteenth century, derived from the paintings of Claude and Poussin purchased by the elegant young gentlemen taking the Grand Tour of Europe, and echoed in the designed landscapes of Capability Brown.

Pennant was followed by Henry Penruddocke Wyndham, who visited Tan y Bwlch twice, in 1775 and again, this time accompanied by the Swiss artist, Samuel Hieronymus Grimm,

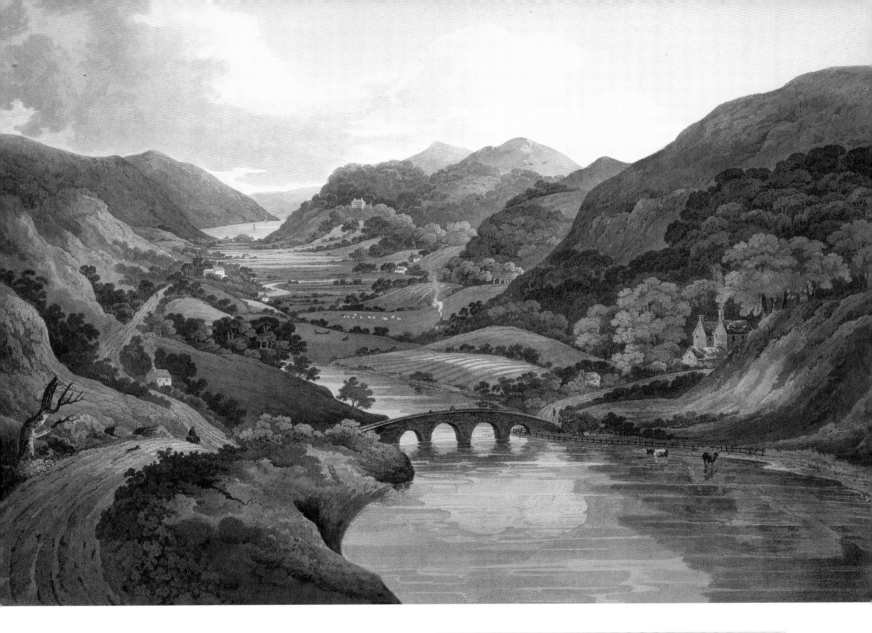

in 1777. He found 'the sylvan walks, amid craggy precipices,... extremely picturesque', and, on his second visit, declared that if one could manage in such an isolated spot so far from good roads: (*Figure 162*)

 ...if a person could live upon a landscape, he could scarcely desire a more eligible spot than that on which the mansion of a Mrs Griffith stands.[3]

Fig. 164 A view of Tan y Bwlch looking towards the sea– this shows the sinuous meanders of the river Dwyryd created after William Oakeley's embankments and drainage had been installed.

Joseph Cradock, a Leicestershire gentleman and man of letters, who had ascended Snowdon in 1774, reached Tan y Bwlch in the late autumn of 1776, when he was:

…much struck with the situation of Mrs Griffith's house at Tan y Bwlch, – at first sight it somewhat resembled Matlock Bath [in the Peak District of Derbyshire], but the hills in front are thrown to a fine distance, and behind the house they are covered in wood; – through a very spacious valley the river Dyryd runs, and from the tops of the mountains are frequent and not inconsiderable cataracts, – indeed most of the romantic prospects of North Wales, taken separately, are infinitely superior to those of Derbyshire.[4]

Byng did not think much of what he found at Tan y Bwlch. In 1784 he considered:

The Vale has (in my opinion) been puff'd off beyond its deservings by the pens of fanciful writers; and is in fact not worthy of such fiction, being very inferior to some spots we have lately seen. …Mrs Griffids house is surrounded by beauties it does not enjoy; as it takes the worst part of the view, and there are no walks or rides, cut in the wood.

All this was about to change with the arrival of William Oakeley (1750-1811) on the scene. He was a member of a distinguished Shropshire family who had lived at Oakeley, near Bishops Castle, since the fifteenth century. Marrying an heiress with a good estate drew him away from his home county and he set about improving his new estate with great energy. Both the house and its 12,000 acres received his attention. He clearly established himself well with his neighbours, for he was Deputy Lieutenant for the county by 1793. In that year Byng returned to Tan y Bwlch, but his opinion of the place was not much improved:

I…cross'd the long bridge to the inn of Tan y Bwlch (so celebrated by Welsh tour-writers, who have all follow'd each other like a flock of sheep) and to the hilltop beyond; passing by Mr Oakeley's house, who, to his woods surrounding and

to the streams rattling down the hill, has added neither walks not improvements, altho' the stream might be view'd and impeded more advantageously.[5] *(Figure 163)*

Like Thomas Johnes at Hafod, William Oakeley was an enthusiastic agricultural improver and he 'began the improvements …in the year 1791, but having been pretty much employed in building, clearing, and fencing, Up-lands and Wood-lands; the whole was not perfected until the year 1795'.[6] Importantly, he addressed the low-lying areas about the river Dwyryd. In those days, the river was navigable up to the village of Maentwrog and subject to flooding. A document of 1796 refers to some 1,423 yards of embankment being created with associated drains at a cost of £309.[7] This was only a part of the total work involved. Oakeley's letter to the Royal Society of Arts, submitting his improvements for their approval, detailed every measurement and cost of embankment, turf drains, fencing, and the planting of Black Willow, 'which grows well, and affords great shelter to cattle from westerly storms', still the bane of this part of Wales. The letter explained that:

Christmas Eve 1796: The quality of this land was general peat moss, and it was liable to sudden and rapid floods, as also to be overflowed to the depth of several feet by spring tides. 87 acres was embanked before I was in possession, but no draining or internal improvement had taken place. Observing, that if the floods and tides were effectually kept out, the crops, manure, and fences, would be secure from their ravages, I have now completely drained, divided, and laid out this land into regular fields.

Oakeley supplied the further detail that, 'My gardener has taken the admeasurement of the embankment, drains and fences'. In a second letter, dated February 1797, he added:

P.S. I have nearly completed the weeding, fencing and arranging, of considerable tracts of Oak Woodland.

This might refer to the beginning of 'arranging' the woodland in the Picturesque style. The *Transactions* of the

Society also reveal the name of William's gardener, John Jones, whose letter confirming all his measurements, together with one from the Rector of Ffestiniog, were included to support William's hoped-for award. He duly received a Gold Medal 'for having improved one hundred and forty-two acres of Waste Moor Land' [the river marshes].

His work on the valley floor was not only successful in agricultural terms but also visually. In addition to the Gold Medal, he received the appreciation of everyone who visited the area, as well as of the locals, who referred to him as 'Oakeley Fawr' [The Great]. From tourists' accounts it is evident that he had addressed the issue of the setting of the house, so criticised by Byng, and created walks and rides within the woodland. This is not surprising, for every man of wealth and taste was alive to the influence of the Picturesque and Romantic movements. They considered that gardening was a form of landscape painting. Even the oldest estates were caught up in the gardening mania.

In 1796, Sykes, on his tour from Yorkshire, was able to provide a description exactly contemporary with the improvements at Tan y Bwlch:

I wandered upon a Hill beyond Mr Oakeley's beautifull Wood and walks and have a fine view of this Vale and the Bays formed by the Rivers which fall into the Sea between Merionethshire and Carnarvonshire, and behind all the Mountainous Country we had passed. ...He has improved this Vale by embanking out the River and underdraining in the Meadows or Marshes as they were, for this vale is of the same nature as all the other we have passed, large flat marshes for ¼ of a mile to 1 wide, in which the Rivers take their many courses. He has also made many fine Walks in the Woods, and constantly employs some 30 to 40 hands.[8]

The 'Bays' he refers to are the sinuous bends in the river created by Oakeley's embankments. These wonderful curves were noted by Warner a year later, when he described:

Fig. 165 Edmund Becker's drawing of 'A little ruin in the wood of Plas Tan y Bwlch', 1812.

a meandering river rolling through extensive meads, which its fertilizing waters clothe with constant verdure. The elegant seat of Mr. Oakeley... Here for the first time since we have been in North Wales, we were gratified in seeing the spirit of Agricultural improvement exerted to some extent, and with considerably good effect. ---- Mr. Oakeley [has] rendered its produce just triple of what it hitherto had been. His large drains and neat embankments rather adorn than injure the picture; as the former are like small canals, and the latter have the appearance of raised terrace walks, surmounted with a neat white rail.'[9] (Figure 164)

The Rev. John Skinner (1772-1839), a passionate archaeologist, was touring in north Wales in 1800. Like so many before and

wide Ocean appeared before us; a chain of mountains
rising one above another; filled the other parts of this grand
Panorama.[10]

This delight in the prospects from the park and pleasure
grounds of Tan y Bwlch is an integral part of the Picturesque
appreciation of landscape. If there were hills and mountains
to be seen from a park or garden, so much the better. Even
when grounds were highly embellished with seats, grottoes,
artful ruins, cascades and fountains, the tourist in search of
the Picturesque would focus on the views and possibly ignore
the delights behind him. That there were such delights at Tan
y Bwlch is borne out both by the lyrical descriptions of the
Reverend Skinner and others, but also by pictorial evidence,
such as the view of 'A little ruin in the wood of Plas Tan y
Bwlch', now lost, drawn by Edmund Becker in 1812. *(Figure 165)*
Broster's *Circular Tour* mentions climbing above Tan y Bwlch
'through Mr Oakeley's plantations, amidst which the waterfalls
and alpine bridges amuse the slow ascending traveller'.[11] Only
a little later, Pugh recorded his impression of the house and its
grounds, revelling in the prospect and views:

after him, he was struck by the beauty of scenery in the Vale of
Maentwrog:

> The fertility of the much renowned Delta in Egypt could
> scarcely surpass the prospect we observed in looking down
> on the vale beneath; here the most luxuriant meadows just
> mow, stretched like a green carpet the whole length of the
> valley; mountains clothed with the richest foliage bounded
> it on all sides; a clear river ran through the midst; whilst the
> elegant mansion of the fortunate possessor of this beautiful
> domain, rose like a Queen, on a lofty eminence, to receive
> homage from her surround vassals.
> The house is surrounded by a grove of oaks and timber
> trees, rising quite to the summit of the hill, intersected
> at intervals by a variety of winding walks, everywhere
> diversified by rocks, cascades, rustic seats and bridges.
> Whilst we ascended the hill, there was sufficient to occupy
> the attention near at hand, in different views of the vale
> beneath; but when we gained the summit, as prospect of
> another kind at once arrested out attention. Here with

> Mr. Thomas, the landlord of this inn, very obligingly
> became my guide through the extensive grounds of Tan y
> Bwlch Hall. I do not remember a walk in which I was more
> interested; the waterfalls, though not great, are pretty bits,
> rushing down the dingles. Pursuing our ramble, often over
> ugly precipices, which, though terrific to some, only added to
> my gratification every step: ... After feasting our eyes during
> a considerable time, we descended to Tan y Bwlch Hall, the
> fine mansion and residence of William Oakley, Esq. The
> prospect from it is beautiful, commanding the vale below,
> with the woody hills; and from the return looking towards

the sea, there is also an agreeable view. The handsome and extensive meadows below the house, owe their existence and improvement to the judicious and skilful management of Mr. Oakley, who rescued them from the immersion of the tide; which is now very subservient, and keeps within the extensive embankments, thrown up at considerable expense. [12]

When William Oakeley died in August 1811, aged 62, his achievements were still highly regarded. The announcement of his death was accompanied by this obituary in *The Gentleman's Magazine*:

The loss the inhabitants of the 'Happy Vale', and its neighbourhood, have sustained by his death, cannot easily be estimated. The excellent roads formed under his direction through a district formerly impassable, are known to every traveller; the wastes which he embanked and fertilised; the barren eminences which he planted; and, above all, the delightful exhibitions of nature, in bold and picturesque scenery, which his taste developed and adorned, have afforded themes of rapture to every visitor.[13]

Tan y Bwlch passed to his son, William Gryffydd Oakeley (1790-1835), who was only 21 when his father died. As well as a great estate he had inherited his father's energy and commitment to Tan y Bwlch. Although a young man, he made his mark on the area almost immediately. By 1814 he was High Sheriff for Meirionydd, filling the same office for Caernarvonshire in 1815. In 1817 he married Louisa Jane, the elder daughter of R. B. Ness of Middle Hill, near Bath. He was very aware of all the developments associated with being a landowner in the area and began enclosing common land, made possible by the Enclosure Act of 1801. Enclosure has always been controversial but at the time it was seen as the way forward for the modern and efficient landowner.

The Oakeley slate quarries, above Tan y Bwlch in Blaenau Ffestiniog, made the family enormously wealthy. Initially, the family did not directly involve themselves in the business, taking royalties on the extracted slate. The money realised

was considerable. In the year 1824-25 these royalties amounted to £25,000, equivalent to £25 million today.

William Gryffydd began improving the grounds and setting for the mansion at Tan y Bwlch in a Picturesque style, following in his father's footsteps. The drive running north-west from the Tan y Bwlch Inn up to the house, crossing the tumbling stream via a pretty bridge, was created at this time and some of the cascades running downhill were enhanced. Colt Hoare, visiting in 1810, considered that, 'Tanybwlch Hall [was] a most picturesque object from every part of the vale.' [14] A reference by Roscoe in the 1830s mentions 'some magnificent specimens of rhododendron, of nearly thirty years' growth', which indicates that the grounds were being ornamented at about the same time as Colt Hoare's visit.

William Gryffydd also enlarged the Tan y Bwlch Inn, now called the Oakeley Arms. This successful venture was important in bringing visitors to the area and to the house. Almost every traveller mentioned the inn as being very good and used the facility available of being able to visit the Tan y Bwlch grounds and gardens. As Barber recorded in 1803:

The hotel is a most agreeable and comfortable house. Turning through a small gate, the visitor enters upon an oblong terrace, raised above the gardens to a level with the mansion, one side of it being supported by massive buttresses, and having at the western end a flight of steps leading to the shrubberies. Strangers are kindly admitted into the grounds of Plas Tan y Bwlch by the worthy occupier.[15]

One stranger was Prince von Pückler-Muskau. He wrote from Caernarvon on July 30, 1828:

In two hours I reached the great resort of tourists, Tan y Bwlch, whose chief attraction is a beautiful park extending over two rocky mountains overgrown with lofty wood, between which gushes a mountain stream forming numerous cascades. The walks are admirably cut, leading, through the best chosen gradations and changes, to the various points of view; from which you catch now an island

Fig. 167 & 168 Portrait photographs of William Edward and Mary Oakeley. When William died in 1912, in spite of the problems within the slate industry, his coffin was followed by hundreds of workmen from the Oakeley quarries.

in the sea, now a precipice with a foaming waterfall, now a distant peak or solitary group of rocks under the night of primeval oaks.

I wandered for above an hour along these walks; but was greatly surprised to see them in so neglected a state, that in most places I had to wade through deep grass, and to toil through the rank and overgrown vegetation.[16]

The neglected state of part of the scenic walks might be due to the fact that William Gryffydd had acquired Cliff House in Atherstone, Leicestershire, and was spending part of every year there from 1823. The Oakeleys were fox-hunting enthusiasts and the Atherstone Hunt became an integral part of their family life. To have a 'hunting box' in Leicestershire was a considerable status symbol in nineteenth-century society and the acquisition of Cliff House reflected the newfound slate wealth that the Oakeleys now enjoyed.

The life of a rich gentleman and his family also included visiting London for the season. In order to maintain things at Tan y Bwlch, William Gryffydd's nephew, William,

the son of his younger brother, Sir Charles Oakeley, 1st Baronet, arrived in Wales to act as his uncle's agent. William Gryffydd returned regularly to his estate and was closely involved in the establishment of the railway in the area, recognising that the advent of this new form of transport would transform the haulage of slate from the quarries to the Oakeley Wharf in Porthmadog. Having negotiated the sale of some land and woods to accommodate the line, he laid the foundation stone of the railway in 1833.[17] As William Gryffydd and Louisa Jane had no children, their nephew, William, was intended to be their heir. However, he died in 1834 and the estate was willed to Louisa Jane for her lifetime and then to his little son, William Edward Oakeley. William Gryffydd followed his nephew to the grave in 1835, aged only 45. It was left to his widow, Louisa Jane (c. 1793-1878), to step into the breach.

For a widow, aged just 42, to be in charge of a large estate and slate quarries, was a considerable undertaking in late Regency days. Nonetheless, Louisa Jane was undeterred by her responsibilities and took an active part in their management. Everything seemed to be in good hands and flourished.

Certainly, the gardens were still cause for remark by passing travellers. In 1838, Roscoe wrote:

After breakfast...I entered the grounds of the neighbouring mansion, eager to behold the truly romantic scenery around. Few things can surpass the pleasure of a morning ramble through the woods which clothe the heights above the hall, or the splendour of the prospect from the terrace over the vale, which is delightfully enriched with every feature of landscape and of water, and forms a rich panoramic picture. In my walk through the grounds, I observed some magnificent specimens of rhododendron, of nearly thirty years' growth, and more than forty yards in circumference; many other plants and trees appeared to grow equally luxuriantly, and both gardens and plantations were tastefully laid out, and well adapted to the soil and to the inequalities in the surface and aspect. [18]

A year later, Louisa Kenyon, visiting from Shropshire, recorded her impression of the gardens and it is clear that by this time Tan y Bwlch is very much Mrs Oakeley's:

Tan y Bwlch a neat inn near the entrance to Mrs Oakeley's grounds. Here we ordered dinner & whilst it was preparing walked to the house. The approach is on the side of the rock through a wood and we observed several very fine scarlet rhododendrons. A terrace in front commands a fine view up the valley & overlooks the gardens which seem well kept. [19]

Louisa Stuart Costello, the Anglo-Irish popular writer and novelist, echoed this view in her account of 1845:

...a seat of Mrs Oakeley, and she certainly has reason to congratulate herself on possessing the most delightful residence to be found throughout the Principality. Nothing can exceed the beauty of the view from the wide terrace of the house; and every part of the grounds which are liberally left open to the public, are arranged with exquisite taste. [20]

Fig. 169 This charming family sketch, still at Plas Tan y Bwlch today, shows some of the construction or clearing out of Llyn Mair. Mr Roberts, the Head Gardener, is credited with the work, but perhaps he had help from the family.

Fig. 170 An early twentieth-century postcard of 'Mary's Lake' with the Upper Lodge.

It is clear that Louisa Jane appreciated 'the beauty of the view', as she stipulated that a new Nonconformist chapel, to be built in the village of Maentwrog, should resemble a dwelling house from her prospect of the village from the Plas.

Meanwhile, William Edward Oakeley (1828–1912) was growing up far away from Wales. In 1860 he married the Hon. Mary Russell, daughter of Commander John Russell and the Baroness de Clifford.[21] (*Figure 167 & 168*) Two children followed: Edward de Clifford William Oakley was born in 1864, and his sister, Mary Caroline Oakeley, arrived in 1865. During the 1860s, William Edward, with his new responsibilities, began to take an active interest in his inheritance at Tan y Bwlch. Louisa Jane, now in her 70s, was becoming increasingly reclusive and was thought to be very eccentric. This made life difficult for William Edward, who could do little on the estate without her cooperation. His letters to her went unread and he was often referred to her maid for information. He even tried to have her declared of unsound mind but the doctors pronounced her quite sane. In 1868, Louisa Jane and her indispensable maid suddenly left Tan y Bwlch without warning. She never returned to Wales and died at Giffard Lodge, Twickenham, ten years later in 1878, aged 85.[22] In spite of their differences, William Edward was her executor.

Now wholly in charge of Tan y Bwlch, William Edward displayed the Oakeley energy in adding to and enhancing his estate, the mansion and its gardens. Louisa Jane had signed over the management of everything to him in 1868 and he brought his family to Tan y Bwlch in July of that year, probably for the first time, recording that, while:

> Tan y Bwlch looks greener than elsewhere...they are short of water here and the Quarries are obliged to stop work at 12 o'clock each day for want of water power.The children are wild with delight at all the shady walks.[23]

Fig. 171 A late nineteenth-century watercolour of Plas Tan y Bwlch, probably painted by one of the family.

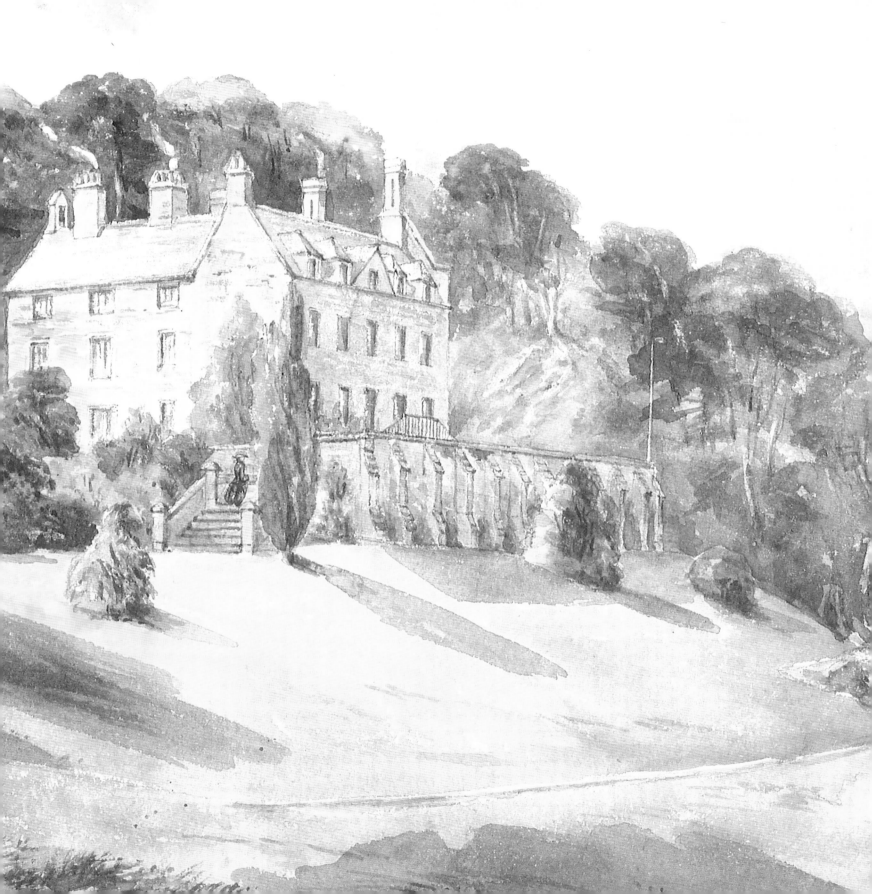

Brought up in expectation of immense wealth, with a large estate and successful slate quarries to draw on, it must have seemed to William Edward that his resources were boundless. He certainly spent money as if this were the case. By 1872, major alterations had taken place and Thomas Nicholas noted that, 'Plas Tan y Bwlch is newly-renovated and almost entirely re-built.'[24] The re-building involved re-siting the stable block to the west of the house and extending the terrace further to the east of the mansion itself. A terrace from which to observe the splendid view and overlook the pleasure grounds below the house seems to have always been part of the design of Tan y Bwlch.

William Edward's work on extending the walks and gardens meant that by the end of the century they covered some 70 acres. The range of what he put in hand was considerable: the man-made lake to the north-east above the house, called Llyn Mair [Mary's Lake], named for his wife – was created by building an embankment across the head of the narrow valley, where the little river that created the cascades began its journey downhill. (*Figure 169*) This was now controlled by a series of sluices and a weir. This weir also harnessed the water power so that, by 1884, Plas Tan y Bwlch was the first house in the area to be lit by electricity. The environs of the lake were enhanced by building Upper Lodge and a branch of the carriage drive was extended up to it. (*Figure 170*) In addition, there was a wooden boathouse and a summer house on the south side of the lake. To the north-west he created a deer park populated with red and fallow deer. He clearly loved and admired his wife very much, for so many of his improvements, like the lake, reflected her name. He installed a magnificent pair of gates leading onto the newly-extended terrace ornamented with both their initials. On the slopes opposite the mansion he had the same initials planted into the broadleaf woodland in dark conifers.

In all of this work he was aided and abetted by his devoted and hard-working Head Gardener, John Roberts, who was employed for more than thirty years.[25] His garden records demonstrate how Plas Tan y Bwlch operated as the mansion and gardens of a very rich man, reflecting the taste and aspirations of the day. Roberts arrived at Tan y Bwlch in the 1870s and, following fashion and, no doubt, his garden training, set out to demonstrate the wealth of his employer with lavish

carpet bedding in elaborate patterns. Such planting schemes required the latest technology of the day – glasshouses in which to grow the thousands of half-hardy, often exotic, brilliantly-coloured flowers needed for their design. Jenny Uglow's comment that 'there was nothing subtle about mid-Victorian flower-beds' is very apt.[26]

To achieve all of this, maintain the grounds and create new walks and vistas, Roberts had a garden staff of twelve men; eight gardeners and four under-gardeners.[27] In addition to the planting of the flower garden and the Walled Garden, Roberts was also in charge of ordering trees for Tan y Bwlch. In October 1880, there was a letter from the Fulham Nurseries confirming an order for 1,000 trees and shrubs at the grand cost of £21.00 (some £16,000 today).

Roberts' work was highly-praised when the writer for the *Journal of Horticulture* arrived in 1888. He found Tan y Bwlch delightful and still open for all visitors:

To the modern tourist in Wales the name Tan y Bwlch is one of the most familiar, thanks in no small degree to the wonderful Toy Railway between Portmadoc and Ffestiniog that was constructed some years ago for the conveyance of slates &c., from and to the quarries at the latter-named place, some of which bearing his name are the property of W.E. Oakeley Esq., who is also owner and occupier of the Plas.
Looking down from the mountain side on leaving the station we see a beautiful lake several acres in extent almost surrounded by woodland. ---The Lake though really artificial, made by Mr. Oakeley, was already formed by Nature and only required a few yards of embankment, which has been made in such a manner, under the direction of Mr. Roberts, the much-respected gardener, that we should not suspect any interference with Dame Nature's work.
 The mountain streams form a series of waterfalls. ...The carriage drive crosses the stream by a picturesque moss and fern-covered bridge, ornamented by several sham arches, probably built early in the eighteenth century.
We are very soon in the pleasure grounds, and surrounded on all hands by magnificent conifers, which thrive here uncommonly well – one huge specimen measuring, at 2 feet

from the ground, 14 feet in girth.

We find, attaining great heights the Eucalyptus, some nearly 40 feet, and would be much higher but for the strong winds that frequently carry off their leaders. The majority of these have been planted eight years.

Camellias in large quantities annually bear loads of bloom – large wall spaces covered with Magnolias that flower most freely, and Wistaria blooming twice annually; and further when we state that Liliums, Dahlias, and kindred subjects are wintered in the open ground, our readers will form some idea of the climate of this favoured spot.

The collection of Rhododendrons 'comprises the very best hybrid varieties known'.

The view from the terrace is exceedingly good – a farewell glance when you peep over the balustrade to the terrace below – for several years a home for the most elaborate carpet bedding in the Principality. The beds are now being turfed down, and carpet bedding entirely discarded.

In the glass departments general excellence prevails' and 'in the kitchen gardens long ranges of earth pits, full of violets, Marie Louise, Comte de Brazza, Victoria and Odoratissima, literally masses of flower, though gathered daily.[28]

The turfing down of the beds previously devoted to elaborate carpet bedding reflects the changing taste in gardening at this period. There was a reaction against such a labour-intensive and thus expensive form of gardening. The influential garden writer William Robinson was producing important books focused on a more natural style of gardening. His *Wild Garden* was published in 1870, followed by *The Sub-Tropical Garden* (1871) and, possibly his most successful book, *The English Flower Garden* appeared in 1883. Roberts kept his garden knowledge up-to-date and subscribed to Robinson's journal, *The Garden*, that set out his ideas for what he referred to as the 'mixed border', with its blend of shrubs, hardy and half-hardy herbaceous plants. He advocated the use of trees, rocks, water and pasture together with more widely available plants, setting a fashion in large gardens all over the country and one which was echoed in the late style of the gardens at Tan y Bwlch. His influence can possibly be seen in the arrival of

sub-tropical plants at Tan y Bwlch. Following the trend, Roberts also established a rock garden. 1880s and 1890s, photographs of the gardens (too faded to reproduce) show a long herbaceous border along the bottom of the Terrace below ivy-clad walls with the sides of the steps planted with Scottish roses and other climbers. *(Figure 171)*

It has been suggested that the turfing over of the elaborate bedding scheme was caused by financial necessity. Certainly all was not well with one of William Edward's principal sources of income, the quarries. By the mid-1880s the Oakeley slate empire had begun to collapse. This was not confined to his quarries but to the industry as a whole throughout north Wales. Depression in the construction business led to reduced demand for roof slates and this, combined with increasing industrial unrest and a lack of orders from overseas, caused a slump from which the Oakeley Quarries never really recovered. The estate's income also suffered as it was a victim of the 1880's terrible agricultural depression. By 1889, Roberts' garden budget was severely reduced. He cut down the number of men to eight and there is evidence of his selling garden produce and flowers to help him balance his books.[29]

In spite of financial pressures, Oakeley family life continued its regular course, with the autumn and winter spent in Leicestershire hunting or in London, always returning to Tan y Bwlch for the summer. In 1893, Mary Caroline married a Staffordshire neighbour, William Frederick Inge of Thorpe Hall, Thorpe Constantine, some eight miles from Cliff House. Like the Oakeleys, William Frederick was a keen member of the Atherstone Hunt and it is likely that this is how Mary Caroline met him. They had three daughters, Margaret Ethel, Hilda Mary, and Edith Katherine. While they all lived at Thorpe Hall, the tradition of spending the summer in Wales continued. However, tragedy struck in February 1903 when William Frederick, having 'prematurely curtailed a day's hunting with the Atherstone', died at his own hand.[30] Mary Caroline, a wife for only ten years, lived on as his widow for another 58 years. Her father died in 1912 and her role in maintaining the Oakeley spirit at Plas Tan y Bwlch in the twentieth century would prove to be crucial, as its money troubles continued in the new century.

Fig. 172 Sarah Ponsonby's watercolour of the rear view of Plas Newydd, made for Lady Frances Douglas in 1788.

PLAS NEWYDD, LLANGOLLEN

The lack of great wealth did not mean that delightful Picturesque gardens could not be created. Compared with the awesome grandeur of Piercefield or Hafod, in what was once the most romantic and out-of-the-way spot near Llangollen, there was a Picturesque garden on a much smaller, domestic scale, a 'Little Paradise'. This was Plas Newydd, Llangollen. The Ladies of Llangollen, Lady Eleanor Butler and Sarah Ponsonby, fleeing family disapproval of their close relationship in Ireland, arrived in Llangollen in 1780 and, having found the ideal place in which to create a retreat from the world, they set about developing Plas Newydd, its gardens and setting to reflect their taste and sensibility.[1] *(Figure 172)* 'Sensibility' was the ability to respond to things and occasions that inspired passion, distress and tenderness. The Ladies felt they had exquisite sensibility, and they sought to express it in their life and surroundings. They found inspiration from many sources: William Shenstone and his noted garden at The Leasowes in the West Midlands, which sought to please the imagination 'by scenes of grandeur,

beauty, or variety';[2] William Gilpin and Uvedale Price – the Ladies had copies of their books in their library; Rousseau's novel *Julie: Ou la Nouvelle Heloise* (1762), whose romantic image of a secluded garden they transferred to their own; the poem *Ossian*, which celebrated wild scenery and ideals.[3] Published in 1760, *Ossian* evoked '...dark woods, lonely heaths, mountain streams, green hills, mossy rocks, grey torrents, and storm-bent trees, impressive to the sentimental soul'.[4] They read the poem to each other regularly.

Beginning in a small way, as their funds were very limited, they began to create a Romantic idyll for themselves. As Sarah Ponsonby wrote in her Journal at the beginning of 1788, they sought to bring:

> To this delicious Solitude
> Where all the flowers and Trees do close
> To weave the Garland of Repose.[5]

A shrubbery with meandering gravel paths came first, then a kitchen garden, followed by the Dairy. These became the upper garden, while the River Cyflymen below in the dell was suitably treated to make it more romantic, with little rustic bridges *(Figure 173)*, alterations to create cascades, a Bower overlooking it from above and a Summer House within it all making their appearance over time.

In spite of their declared desire for solitude, almost at once neighbours came to call and friends came to stay en route to and from Ireland. Local visitors included the 4th Sir Watkin Williams Wynn and his wife and the Myddletons from Chirk Castle, who often sent gifts from their gardens for the Ladies to plant, including pots of cucumbers. Plas Newydd became a notable place and visitors included the Duke of Wellington, Sir Walter Scott and William Wordsworth and Robert Southey, both of whom wrote poetry there. Visitors today will find the great view of Dinas Bran to the north obscured by trees and the

Fig. 173 One of the rustic bridges in the
Dell, inspired by Christopher Hirschfield's
De l'art des Jardins (1779). A watercolour by
Lady Leighton.

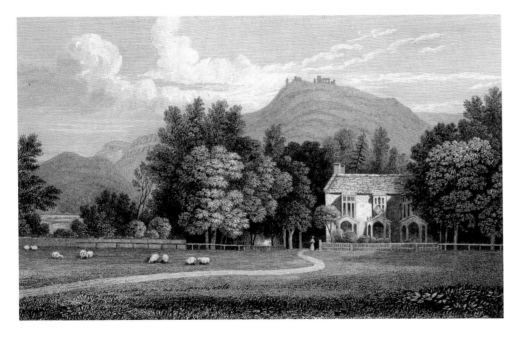

Fig. 174 Henry Gastineau's view of Plas
Newydd with Dinas Bran towering above
it, c. 1820.

Fig. 175 The Ladies' simple round Dairy at Plas Newydd.

arranged in the exactest order.

Nor is the dairy-house, for one cow, the least curiously elegant object of this magic domain. A short steep declivity, shadowed over with tall shrubs, conducts us to the cool and clean repository. The white and shining utensils that contain the milk, and cream, and butter, are pure "as snows thrice bolted in the northern blast". *(Figure 175)*

The wavy and shaded gravel-walk which encircles this Elysium is enriched with curious shrubs and flowers. It is nothing in extent, and every thing in grace and beauty, and in variety of foliage; its gravel smooth as marble. In one part of it we turn upon a small knoll, which overhangs a deep hollow glen. In its tangled bottom, a frothing brook leaps and clamours over the rough stones in its channel. A large spreading beech canopies the knoll, and a semilunar seat, beneath its boughs, admits four people. A board, nailed to the elm, has this inscription, "*O cara Selva! e Fiumicello amato!*" [Oh dear beloved forest and stream].[6]

...through the opened windows, we had a darkling view of the lawn on which they look, the concave shrubbery of tall cypress, yews, laurels, and lilacs; of the woody amphitheatre on the opposite hill, that seems to rise immediately behind the shrubbery; and of the grey barren mountain which, then just visible, forms the back ground. The evening-star had risen above the mountain; the airy harp loudly rung to the breeze, and completed the magic of the scene.

charming Picturesque detail related by visitors largely vanished, but the little river still chatters at the bottom of the wooded valley and Lady Eleanor's Bower and the Summer House are in situ, if recreated in a somewhat modern way. *(Figure 174)*

The Ladies' great friend, the Romantic poet Anna Seward, called Plas Newydd 'The Fairy Palace of the Vale', and described the gardens and grounds in her letters written in the 1790s, when their garden plans began to mature:

The kitchen-garden is neatness itself. Neither there, nor in the whole precincts, can a single weed be discovered. The fruit-trees are of the rarest and finest sort, and luxuriant in their produce; the garden-house, and its implements,

Writing in 1796, Seward went on to explain why the Ladies created a secluded spot rather than one embracing the wildness of Dinas Bran towering behind Plas Newydd, much admired by many travellers to the area:

Their scene, not on those wild heights which must have exposed them to the mountain storms, is yet on a dry gravelly bank, favourable to health and exercise, and sheltered by a back-ground of rocks and hills. Instead of seeking the picturesque banks of the dashing river, foaming through its craggy channel, and whose spray and mists must have been confined, and therefore unwholesome,

Fig. 176 The Ladies of Llangollen beside the looted font from Valle Crucis in its Gothic shelter, complete with its water feature. Lady Eleanor Butler is on the right, Miss Sarah Ponsonby on the left. Their riding habit style of dress was one they adopted over many years.

Fig. 177 The font, photographed in 2014.

by the vast rocks and mountains towering on either hand, they contented themselves with the briery dell and its prattling brook, which descend abruptly from a reach of that winding walk, which forms the bounds of their smiling, though small domain. Situated in an opener part of the valley, they breathe a purer air.[7]

Skrine, arriving in 1798, was impressed with what the Ladies had achieved:

We visited ...a cottage with some adjacent grounds, which two accomplished ladies from Ireland had laid out and ornamented with much taste and elegance. The situation is romantic in the extreme, commanding the town and the vale below it, in which several well-wooded hills form an agreeable contrast to the wild scene behind...[8]

Romantic 'in the extreme' was an attitude of mind that the Ladies strove for in how they lived their lives and how they embellished their gardens. One addition to the dell where the river ran was a medieval font removed from the ruins of Valle Crucis Abbey nearby. The Ladies re-erected it in a little grotto with their initials and the date set beside it. Initially, a spring was channelled into a pipe to drip romantically, but this part of the feature, still in place today, is long-gone. *(Figures 176 & 177)*

Visitors were allowed to see the gardens provided they had submitted their names beforehand. Occasionally, if a visit was ill-timed or the gardener not available, access to Plas Newydd was denied the traveller.[9] However, this was uncommon. As William Gerard Walmesley, travelling from Lancashire, found in 1819, visitors were generally made welcome:

Addressed a note to the Rt. Hon Lady Eleanor Butler and Miss Ponsonby requesting to see the grounds at Plas Newydd. In the course of quarter of an hour we received a polite message stating that we were at liberty to visit the grounds and that the gardener was in waiting to conduct us through them.[10]

While there is no remaining evidence to show how and where the flowers and shrubs were planted within the gardens, the Ladies' correspondence and day-books include details of lilacs, wild and scented flowers, primroses, pinks and carnations, snowdrops and forty-four varieties of rose. [11] Given the situation of Plas Newydd and the variety of scene even such a small space offered – the gardens covered two and a half acres, scarcely larger than Mrs Johnes's flower garden at Hafod – it is evident that it was a place of real charm and beauty. In August 1797, James Plumptre, after having breakfast with the Ladies, noted his surroundings:

Garden. Chiefly shrubbery and lawn, all planted by the Ladies, 19 years' growth.
Kitchen Garden. At end a garden house, and place for frames.
The farm and shrubbery. Bees. Hayrick. Field, barley.
New planted trees, new garden. Cistern of Water. Dairy.
A Hedge of roses and lilies growing under beech trees, Hedge of lavender.[12]

As time went on, the Ladies became a tourist attraction in themselves and anyone who was anyone made a point of calling on them. Loudon found Plas Newydd 'an elegant residence fitted up in the cottage style, and the grounds beautifully laid out by the elegant and accomplished proprietors'.[13] *(Figure 178)* In 1828, Prince Pückler-Muskau described his visit to Plas Newydd at Llangollen when the Ladies were well-advanced in age:[14]

No-one who is presentable travels in Wales unprovided with an introduction to them. Passing along a charming road, through a trim and pretty pleasure-ground, in a quarter of an hour I reached a small but tasteful gothic cottage, situated directly opposite to Dinas Bran, various glimpses of which were visible through openings cut in the trees.

Fig. 178 Plas Newydd with the Library window overlooking the garden. A hand-coloured engraving by T. Walmesley, c. 1800.

Fig. 179 The Ladies' 'Gothic Cottage', ornamented with some of the wood carvings that they, and later General Yorke, avidly collected.

Plas Newydd was purchased by another two spinster ladies, Amelia Lolley and Charlotte Andrew, who attempted to emulate the Ladies' lifestyle. Roscoe, during his *Wanderings & Excursions in North Wales* (1837), related that they welcomed visitors in much the same way as the Ladies had, even though his own taste had progressed beyond their delight in rural joys:

> The present proprietors are also two maiden ladies, who seem disposed to perpetuate the conventual celebrity of this place; and are certainly not less urbane than the former possessors, in permitting visitors to gratify their taste in the inspection of the beautiful grounds. Attended by my cicerone, the gardener, I passed from one object of natural beauty to another,—the vale of Pen-gwern surrounded by part of the Berwyn chain, the woody dingle, and brawling brook of the Cyflymen, with many others, which are supplied with the most gratifying conveniences for their leisurely inspection. After all, I must confess, filled as was my mind by the impressions of the majestic scenes with which it had become familiar, the miniature landscapes supplied by the situation of Plas Newydd, fell far short of the anticipation I had formed, and they forcibly recalled the emotion I remembered to have felt after viewing the mimic hills and vales, and passionless cascades of the poet Shenstone, in his retreat at the Leasowes.[16]

Some ten years later, while memories of the Ladies lingered on, their taste as reflected in their garden was fading. Louisa Stuart Costello, writing in 1845, related that: 'The cottage, as it now, is by no means either a rural or picturesque object. ...The trees, planted by the friends, are now grown high and shut out all view of the country.'[17] The fact that Miss Costello mentions the Ladies and Plas Newydd shows that their pastoral idyll continued as a draw for tourists.

He found the Ladies charming and welcoming. With their good manners and old-fashioned ways they seemed relics of a bygone age, and he reminded them that his grandfather had visited them some fifty years before.

Lady Eleanor died in 1829, soon followed by her dear friend, Sarah Ponsonby, in 1831. Such was their fame, even in death, that when Princess Victoria visited Llangollen in 1832 she was shown the sale catalogue of the Ladies' possessions as an example of their exquisite taste and sensibilities. The gardens were advertised as:

FOUR GARDENS
In the best order, and well stocked with all kinds of Fruit Trees, Vegetables, and Flowers.
FIVE PASTURE FIELDS
Of the richest Land, well timbered, Rustic Bridges, Summer Houses of richly carved Oak, and Rustic Seats, Cow and Calf-house, Garden-house, Yard, Store-house, &c.
An excellent Engine Pump.[15]

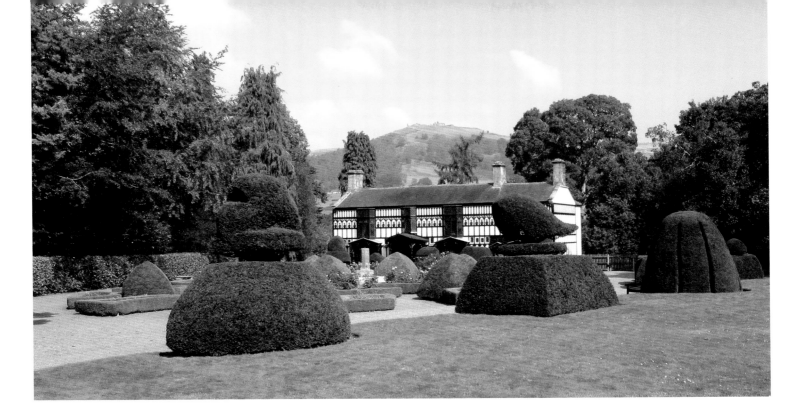

Fig. 180 Plas Newydd today with the Robertson's parterre (recently restored).

Following the death of the Misses Lolley and Andrew, and two further owners, Plas Newydd was purchased in 1876 by General John Yorke (1814-1890), a younger son of the Erddig family. He had known the Ladies as a boy and had fond memories of them. It was under his hand that the house acquired its black-and-white timbered exterior. *(Figure 179)* Like the Ladies, he adored antiquities and curiosities in wood and added to the already considerable collection that ornamented the house both inside and out. He stayed at The Hand Inn in Llangollen, making daily visits to Plas Newydd to oversee the alterations and additions. Records show that he maintained the gardens, planting magnolias, pampas grass, a fig tree and box. He had a house for his peacocks and added a black-and-white water tower to match the house. Here he considerably increased its size, adding a wing for his family so as not to disturb the Ladies' rooms and memorabilia.

He died in 1890 and Plas Newydd changed hands again, passing to the ownership of a cotton-broking family, the Robertsons. G.H.F. Robertson added an East Wing and created a formal garden in front of the house with yew topiary and a parterre. *(Figure 180)* The pretty rustic bridges had succumbed to rot and were replaced in stone in rather prosaic style. The railway arrived in Llangollen in the summer of 1862 and many tourists now added Plas Newydd to their itinerary. However, the Robertsons found the attention of these day trippers very intrusive. They had the Butler Field, named for Lady Eleanor, and which gave access right up to the house, moved to a side field to protect their privacy.

In spite of some intrusion by the succeeding centuries, this 'smiling yet small domain' where the Ladies passed their 'sweet and blessed retirement' still has great charm and appeal. Plas Newydd, with its romantic associations and a great story to tell, remains on the tourists' itinerary in the twenty-first century.

BODNANT HALL

The charm and small scale of Plas Newydd, which survived into the nineteenth century, was very different from the scale of gardening that was taking place on larger, richer estates. Romantic and Picturesque gardens were 'transformed again by new fads in the 1840s and 1850s, as the 'old' features were deemed to be *passé*.'[1] The dynamism of the entrepreneurs who made fortunes from the Industrial Revolution made a considerable impact on the houses and gardens of Wales. The nineteenth-century development of gardens like Penrhyn Castle in the north and Margam Castle in south Wales, generated with industrial wealth, has already been described. Easy access to the nearest railway station, as at Chirk, was an advantage for many owners of these large houses and gardens, as well as their visitors. Now, the railways brought rich men and their families from the sites of their wealth-creating factories to a beautiful but now-accessible Wales, in particular the north Wales coast. Here, new houses included Kinmel Hall, that grew from a reasonable Georgian house into the 'Welsh Versailles', or Bryn-y-Neuadd at Llanfairfechan, another chateau-style edifice built by the Platt family, funded by a fortune made from manufacturing cotton-weaving machinery.

'Within easy reach of Llandudno Junction, on the line between Chester and Holyhead',[2] Bodnant Hall had a garden

that is still a magnet for visitors. Famous as the creation of the Aberconway family, not many of today's tourists realise that the inspiration for and foundations of the garden came from a millionaire industrialist, Henry Davis Pochin (1824-1895). *(Figure 181)* Originally from Leicestershire, he made his fortune as an industrial chemist best known for his interests in china clay. He discovered, amongst other things, the process that enabled the production of white soap. He was also a successful businessman and entrepreneur, with interests in iron and steel, coal mines and railways. He was deputy chairman of the Metropolitan Railway Company, and a director of the Manchester Sheffield and Lincolnshire Railway Company. Having moved from Stafford, where he was an MP, he purchased the Bodnant Estate in 1874, where he began what has been described as an active retirement. In a lovely position on the east side of the Conwy valley and with magnificent views westwards across the river to the mountains of Snowdonia, here he began creating what was to become the world-famous garden, indulging his passion for great conifers, especially those from North America.

Initially, he employed Joseph Paxton's pupil and protégé, Edward Milner, to assist him with the planning and planting of his new garden. This was placed in a landscape already cultivated by Colonel John Forbes, a previous owner of Bodnant, then called Bodnod. He built the Georgian house remodelled by Pochin and laid out the parkland in 1792. He had died in 1821. Milner was a landscape gardener who was very popular with the new industrial barons of the second half of the nineteenth century. His style suited the extravagant and ornate houses of his clients, built in Victorian Gothic or Jacobethan taste and

Fig. 181 Henry Davis Pochin at work in his laboratory. His passion for and attention to detail is reflected in the great garden he created at Bodnant. Etching by P.A. Rajon after W.A. Ouless, 1875.

Fig. 182 A detail of Edward Milner's plan for the garden at Bodnant Hall, c. 1876-77. The design style for his plans is instantly recognisable, as is his use of serpentine paths interrupted with islands of formality found in his parterre beds.

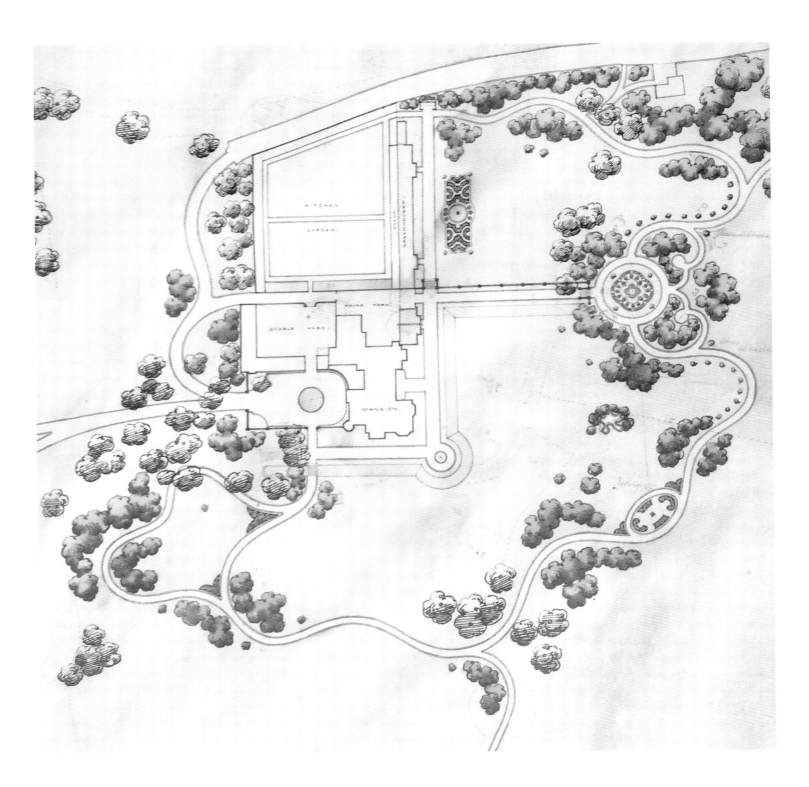

KITCHEN GARDEN.

HOUSE YARD

STABLE YARD

MANSION.

surrounded by formal terraces, often featuring a parterre and dropping away to views over a lake or parkland, enclosed by a shelter belt of trees. These gardens, pleasure grounds and parks would be backed up by extensive kitchen gardens and glasshouses manned by anything upwards of eleven gardeners. Milner was Paxton's protégé and his designs for Bodnant reflect this. His surviving plan for Bodnant included a design for a parterre, which would have been planted up in a kaleidoscope of colour. *(Figure 182)* Raising hundreds, or even thousands, of bedding plants and exotics took acres of glass. One of Milner's projects at Rangemore Hall in Staffordshire, created for the Bass brewing family, involved forty glasshouses with three-and-a-half miles of pipes. His design for the range of hot houses at Bodnant was not quite as vast, but was nonetheless extensive. Pochin's expertise in science and engineering was reflected in the creation of his hot houses and conservatory, demonstrating the latest technology, both in their construction and the horticulture they allowed. Pochin commissioned the design from Milner between 1876 and 1877, and he produced a plan that included a Mushroom House, Stove Room, an Early and a Late Peach House, Early, Intermediate and Late Vineries, a Greenhouse, Potting Shed and a Cucumber & Melon House. There was also accommodation for a gardener. *(Figure 183)* Milner's plan included a Conservatory and Fernery: for whatever reason, Pochin decided not to go ahead with them and, instead, asked the leading firm of Messenger & Co. to design them. They had executed Milner's design for the hot houses and were certainly influenced by his ideas. Pochin forwarded Milner's plans to them and they sited their Conservatory and Fernery where he suggested. They are still standing today.[3] *(Figure 184)*

As well as creating a sloping lawn towards the great prospect of the Conwy and the mountains, Milner helped Pochin plant up the famous Dell at Bodnant with the trees that he loved – the giant American redwoods and cedars and great Oriental conifers. Apart from the plans already mentioned, there is sadly no trace of correspondence or other drawings in the Bodnant papers and it is not certain how long he worked there. Milner died in March 1884, by when Pochin, following his advice,

had made giant strides at Bodnant. *The Gardeners' Chronicle* reported at the time that:

...the gardens have been laid out, greenhouses, vineries, and forcing houses built quite recently; but as the estate comprises some 2000 acres, and as the owner is an enthusiast of gardening, with an accurate knowledge of trees, shrubs, and all hardy plants, it is quite likely that the present extent of the pleasure grounds will be enlarged considerably.

The author of the article, J. Douglas, praised the Head Gardener, Mr. Sanderson, 'who is very careful, as all good gardeners ought to be, to follow out the instructions of his employer'. He went on to record features at Bodnant that are still in situ some 130 years later:

The first object of interest is a long and wide Laburnum arcade; the trees are arched overhead, and when in flower must form a striking feature. ...We have to pass from the well-kept grounds to the wilder portion by what is termed the Miller's Walk, on the steep and undulating sides of which rock gardens have been formed. *(Figure 185)* After walking a considerable distance up the stream – we find ourselves in the vicinity of extensive works. Mr Pochin is building a mortuary chapel on the sloping hillside, and to support the great weight of the chapel and to add to the romantic character of the scenery Mr Pulham of Broxbourne has been called in. Enormous masses of rock have been formed and added to the sloping hillside, not only to partly support the walls of the building, but to form a winding and rugged walk, natural yet picturesque. Mr Pulham has finished his part of the work in his usual excellent style, and the gardener has not failed to plant suitable plants, trees, and shrubs where they would add to the natural effect of the whole.[4]

Pochin first contacted James Pulham and Son in 1882 and, while Milner may have no longer been working for Pochin,

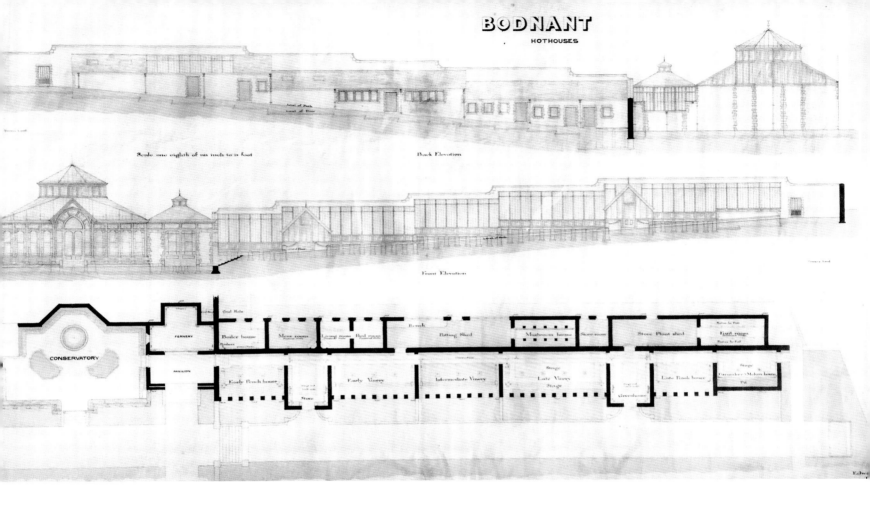

BODNANT
HOTHOUSES

Scale one eighth of an inch to a foot

Back Elevation

Front Elevation

CONSERVATORY

FERNERY

PAVILION

Coal Hole

Boiler house

Mess room

Living room

Bed room

Bench

Potting Shed

Mushroom house

Store room

Store Plant shed

Fruit room

Early Peach house

Early Vinery

Intermediate Vinery

Late Vinery

Stage

Late Peach house

Cucumber y Melon house

Stove

Greenhouse

Fig. 183 The plans for the range of hothouses at Bodnant, with (top) the back elevation showing how the gardeners and workmen accessed the hothouses; (middle) the front elevation with the detail of Milner's design for a Conservatory and Fernery on the left.

Fig. 184 The house at Bodnant with the Messenger Conservatory and Milner's range of hot houses in full working order. An illustration, based on a family photograph, from *The Gardener's Chronicle* (1884).

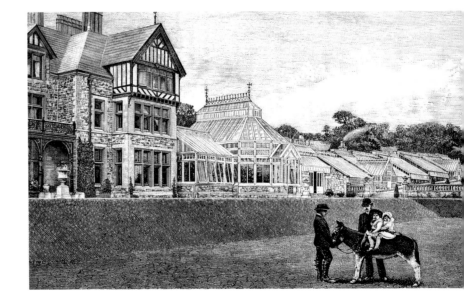

Fig. 185 The great Laburnum Arch at Bodnant in flower in May.

he almost certainly suggested using the product made by Mr Pulham of Broxbourne, Pulhamite. Nearly all of Milner's clients used this remarkably natural-looking artificial stone to create grottos, rocky streams and rivulets, ice houses and magnificent rockeries in their parks and gardens. Pochin initially required Pulhamite to line Messenger's new Fernery, '...the interior I want lining with Rockery work so as to make as nice a work of it as can be done'. Pulham replied, 'I hope you will have a work of picturesque beauty and a source of endless enjoyment all the year round.'[5]

Given that the Pulham works were in Hertfordshire, and road haulage was entirely horse-drawn, the advent of the railways played a huge part in the success of Pulhamite in gardens, carrying it across the country – to Dorset and Halifax, Monmouthshire and to north Wales. Even Pulham's workmen went by train in July 1882 to begin the work. Only four years later, a writer for *The Garden* was entirely deceived by Mr Pulham's 'excellent style', reporting that, 'the walk leading to the vaults are hewn out of the solid rock'. The Mausoleum, called The Poem, is a truly romantic place, from one side approached through trees and grass and, on the other, perched perilously on the rim of the Dell (*Figures 186 & 187*). The name 'The Poem' was a family mystery for many years, but recent research in the

archives has revealed its source as a charming piece of Victorian romantic fancy: it is the Place Of Eternal Memory.

The author of *The Garden* article could 'scarcely believe that so much had been accomplished within the space of a dozen years'.[6] He went on to describe the Dell, containing 'a miniature Niagara Falls', as:

> ...very beautiful. After crossing the ivy-clad rustic bridges, we come to the pinetum, containing a choice collection of conifers, all of which have been planted a good distance apart to prevent them disfiguring each other in after years. ...An addition has recently been made to the pinetum, the entrance to which is over a curiously constructed stone bridge, built to represent the natural strata of stone. When this has become a little more aged it will be very ornamental. In early spring the Yew Dell is enlivened with masses of Narcissus, Snowdrops, Glory of the Snow (*Chionodoxa Luciliae*), Arabis, Myosotis, wild hyacinths &c. (*Figure 188*)

Closer to the mansion, apart from 'a pretty little flower garden' that looked well and the Laburnum bower described as 'another noble feature', with the Laburnum trained over an arched trellis 200 ft long and 14 ft wide, the Fernery and glasshouses gained the writer's admiration:

Fig. 186 & 187 (left) 'The Poem' or mausoleum at Bodnant; (right) 'The Poem' perched above the Dell with some of the Pulhamite rock visible at its base.

> In a intermediate house is a remarkably fine plant, 16 feet square, of Begonia nitida trained on a back wall. It is literally covered with bloom. – At the back of this is a nice fernery, which adjoins the conservatory, 55 feet by 40 feet. On the roof are trained red and white lapagerias, Tacsonias, Clematises, Bougainvilles, &c. Along the front, semi-circular stands filled with pot plants present a rather nice artistic appearance than the usual wooden stages.[7]

The nineteenth-century gardening journals evidently found Bodnant as beautiful and fascinating as do the garden writers of today. In 1892, *The Gardeners' Chronicle* credited Edward Milner for his work and went on to relate that 'in recent years the taste of the proprietor, H.D. Pochin Esq., aided by the skill of his gardener, Mr Sanderson, has been mainly directed to the beautifying of the glen'. (*Figure 189*) This was the Dell, where Pochin had the banks of river Hiraethlyn strengthened and enhanced with:

Fig. 188 One of the many charming bridges to be found within the Dell at Bodnant. Illustration from *The Gardeners' Chronicle* (1884).

Fig. 189 The Hiraethlyn dashing through the Dell. An illustration from *The Gardeners' Chronicle* (1892).

Rustic bridges, some of wood, others simply large rough slabs of stone, cross the main stream and its tributaries, and shelter is afforded where some of the paths cross each other by little sheds with thatched roofs, over which Honeysuckle grows.

The great specimen conifers were getting into their stride, improved with a 'judicious mixture of Prunus, Hazel, Dogwoods and groups of flowering shrubs.' The writer pointed out that there were many visitors to Bodnant during the summer months who could admire 'the neatness and order which prevailed all over the place'.

Pochin died in 1895 and was interred in The Poem. Bodnant passed to his daughter, Laura (1854-1933), who also inherited his talent and enthusiasm for gardening. In 1877 she had married

Charles McLaren who, like his father-in-law, was MP for Stafford. As Lady Aberconway – Charles McLaren was knighted in 1902, becoming the 1st Lord Aberconway in 1911 – her name is forever linked with the garden at Bodnant, where she developed an exceptional gardening partnership with her son, Henry, the 2nd Lord Aberconway, that was responsible for making Bodnant, in the opinion of many garden writers, 'the most magnificent twentieth-century garden in Britain', founded on the creative work of her father.

This account of Bodnant covers only twenty years, a short period of time compared with the other gardens featured in this book, but what Pochin achieved in one generation with his Victorian energy and enthusiasm was remarkable. Today, the giant exotic trees in the Dell and the famous Laburnum tunnel, dripping gold in May, stand as his memorial. From its inception, people came to see Bodnant and its popularity as one of the most beautiful woodland gardens in Britain is well-deserved. In many ways it encapsulates so many of the features of Wales in one lovely space; dramatic scenery created by nature with a river gorge filled with a dashing river; ancient and noble trees; spectacular mountain scenery viewed across the river Conwy; a place where 'Nature has done much to make the place attractive, but art has probably done more'. *(Figure 190)*

Fig. 190 Spring at Bodnant, with Pochin's great conifers towering above the Dell.

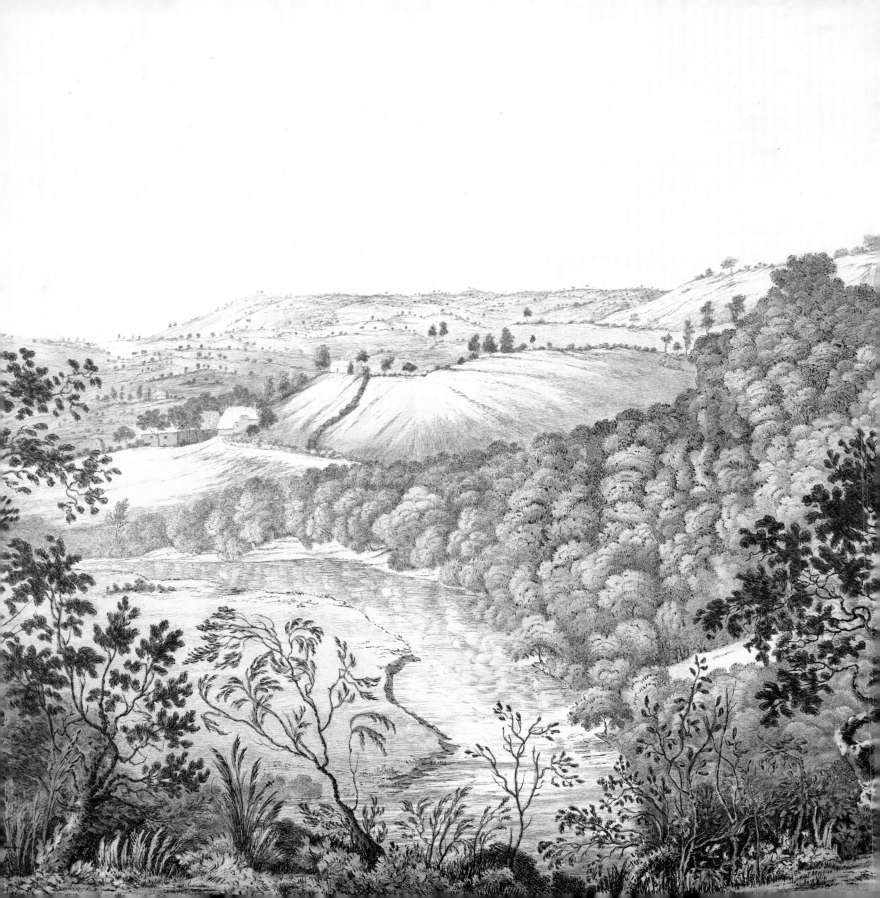

ENVOI

The written word played a vital part in attracting people to visit and appreciate not only the wider and wilder landscape of Wales, but also its beautiful parks and gardens. What a fascinating story the travellers have left behind them. As well as painting a vivid picture of the creation and historical past of Wales's gardens, they have provided evidence that can pinpoint new garden development, or reveal when landscaping and building was actually taking place. In some cases, such as Piercefield, Baron Hill, Llanerch Park and the charming creations of Benjamin Wyatt for Lady Penrhyn, the travellers' tales are all that is left to conjure up these lost garden delights. My research uncovered a plethora of written works still to be explored and other garden stories to be related that run beyond the bounds of this volume.

The great gardens of Wales reflect history, poetry, art and architecture. They demonstrate confidence in the future, creating beauty for generations to come. The visiting and appreciation of these great houses and gardens reinforces Loudon's view that:

Man is a social being, and never can reject the habits to which this part of his nature gives rise with impunity. To be happy he must see and be seen: it is the operation of this principle that has rendered the most beautiful seats of the country show-places, or places which all the world are invited to come and admire.[1]

Having enjoyed the experiences of the travellers and tourists to Wales, I do hope that readers of this book will be inspired to follow in their footsteps and come and explore the most glorious prospects of Welsh parks and gardens. Perhaps, then, they will share Nicholson's nostalgia on leaving Wales:

Cambria, as thy romantic vales we leave,
And bid farewell to each retiring hill,
Where fond attention seems to linger still,
Tracing the broad, bright landscape; much we grieve,
That, mingled with the toiling crowd, no more
We may return thy varied views to mark.'[2]

Fig. 191 'The most glorious prospect': a view from Dynevor overlooking the River Towy and Golden Grove. A hand-coloured etching by James Bretherton.

Baron Hill

Penrhyn Castle

Bodnant

Llanerch Hall

Plas Newydd, Anglesey

Wynnstay

Chirk Castle

Plas Tan y Bwlch

Plas Newydd, Llangollen

SNOWDONIA NATIONAL PARK

Powis Castle

ENGLAND

Key

Kilometres

0 10 20 30 40 50 60

0 10 20 30 40

Miles

N

Hafod

W A L E S

PEMBROKESHIRE COAST NATIONAL PARK

Dynevor

BRECON BEACONS NATIONAL PARK

Picton Castle

Stackpole Court

Piercefield

GOWER

Margam

© Crown Copyright 2016 OS 100050715.

GARDENS GAZETTEER

This Gazetteer tells the story of the parks and gardens dealt with in this book in the twentieth and twenty-first centuries. It gives details of where they are, if and when they are open to the public (correct at the time of writing), county by county. A ✛ indicates a site that must now be considered 'lost' to all intents and purposes.

ANGLESEY

✛ Baron Hill, Beaumaris

Privately owned with no public access.

Baron Hill remained the Bulkeley family home until the 1920s, by when the huge house was riddled with dry rot and had other problems. The family moved to another house nearby and the mansion was then used for storage. When the Second World War broke out, it was requisitioned and used as a billet for

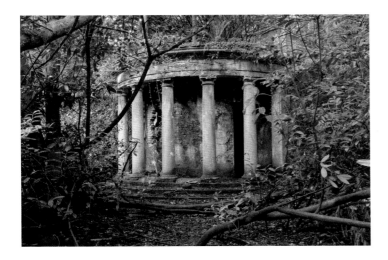

Fig. 192 The Temple at Baron Hill lost in the wilderness.

Polish soldiers. The house is now derelict and roofless. The great gardens have fallen into decay and, with the house, are lost in a wilderness of trees and undergrowth. There have been plans to redevelop the shell and rediscover the gardens and parkland, but since the financial crash of 2008 these would appear to have been abandoned. *(Figure 192)*

Plas Newydd, Llanfairpwll, Anglesey LL61 6DQ
Grade I

The National Trust
Tel: 01248 714 795
plasnewydd@nationaltrust.org.uk
www.nationaltrust.org.uk

The gardens are open weekends only from 1st January – 18th February, 11 a.m. – 3 p.m.; from 18th February – 24th December they are open seven days a week, 10.30 a.m. – 5p.m.; 6th November – 24th December 11 a.m. – 3 p.m. Admission charge if not a member of the National Trust.

The follies and extravagance of the 5th Marquess of Anglesey led, in 1904, to his Trustees stepping in to deal with a situation where his debts had mounted to a staggering £544,000. Retreating to Monte Carlo, he died there in 1905, aged just 30. He was succeeded as the 6th Marquess by his cousin Charles Paget (1885-1947), who had to deal with the depleted coffers and estate compounded by death duties. He decided to sell the Paget ancestral home of Beaudesert in Staffordshire and retrench within Plas Newydd. He and his wife, Lady Marjorie Manners, whom he married in 1912, moved to Plas Newydd in 1920 and devoted themselves to the house and estate in Wales, becoming the first family to use Plas Newydd as a family home in many generations.

to the National Trust in 1976 and with the Trust he created a treillage pavilion and planted the lower terrace with swathes of agapanthus. He installed a lion's head fountain created for him by his friend, Sir Martin Charteris, who was a noted amateur sculptor. The pavilion has recently been restored by the Trust. *(Figure 193)*

During the Second World War, the 6th Marquess took part in the 'Dig for Victory' campaign. Oats were grown on the cricket ground and an orchard planted. He also began a clearing in one of Repton's plantations for a rhododendron garden. This became the proud creation of the 7th Marquess, who was given a wedding present of two lorry-loads of rhododendrons and azaleas from the 2nd Lord Aberconway, sent from Bodnant in 1948. They were lovingly tended by Lord Anglesey until 2013, when ill-health prevented him from continuing so. This part of the gardens is open during the flowering season in April and May. The collecting of rhododendrons and growing them in gardens on the west coast of Wales reflects the kindly influence of the Gulf Stream. Plas Newydd has some of the finest rhododendrons to be found in Britain.

Lord Anglesey's deep personal interest in the gardens of Plas Newydd meant he was responsible for and oversaw much of the changes and improvements made after the Second World War. These ranged far and wide and included the planting of an arboretum on the site of the wartime orchard. Here, there are Australasian trees such as nothofagus and what is now a 'cathedral' of eucalyptus. As Stephen Anderton wrote, 'If you were asked to locate a picture of this arboretum, the last place on earth you would expect it to be is Wales. It is an extraordinary flash of novelty...it is a delight and, in its way, the perfect complement to the open grey skies and reflecting waters around the house.'[1]

The renowned cromlech is still *in situ*, surrounded by rather stark grassland and no longer accessible by the public. Potter's Dairy is now the reception area and shop for the National Trust and Druid's Lodge no longer a feature of interest. The terrific tempest in February 2014 wrought havoc among some of the older trees at Plas Newydd and much work has been involved in clearing them and considering ways of filling the resultant

Fig. 193 The restored Italian pavilion at Plas Newydd.

Both he and 7th Marquess cared deeply for Plas Newydd, and the twentieth century saw many improvements to, and enhancing of, the Repton parkland and the gardens closer to the house. In the 1930s, on what had been the foundations of the Stove, the 6th Marquess built a series of terraces where he conceived an Italianate summer garden. This site became a rose garden in the 1950s, but in the 1990s the 7th Marquess decided to return the terrace to its Italian form. Plas Newydd was gifted

gaps. This has meant that the Australasian Arboretum has benefitted from underplanting with shrubs from the southern hemisphere, consisting of species that are either endangered in the wild or have horticultural or historic importance.

There are plans that include the potential restoration and recreation of the garden features associated with the Abernaint Valley to the north of the Rhododendron garden. Long-term projects like these are so important in keeping historic landscapes alive and full of interest for a public who still maintain their love-affair with other people's gardens.

CAERNARVONSHIRE & MEIRIONYDD [GWYNEDD]

Penrhyn Castle, Bangor LL57 4HN
Grade II*

The National Trust
Tel: 01248 363 219;
penrhyncastle@nationaltrust.org.uk
www.nationaltrust.org.uk

The gardens are open all year round, apart from Christmas Day. 1 November – 1 March, 12 p.m. – 3 p.m.; 1 March to 31 October, 11 a.m. – 5 p.m. Admission charge if not a member of the National Trust.

The strikes at the Bethesda Slate Quarries in 1902-03, so long the life-blood of the Penrhyn Estate, caused the major decline in the industry as a whole and Penrhyn began to feel the results of tightened purse strings. Following the death of the 4th Lord Penrhyn in 1949, the great castle, its immediate demesne and one of the walled gardens were given to the Treasury in lieu of death duties in 1951. Much of the planted shelter belts, two of the walled gardens, the wider parkland and several of the buildings remain as the Penrhyn Estate and still belong to the Douglas-Pennant family. While it is possible to see Port Penrhyn, the walled gardens are private property and the beautiful bath house is a sorry wreck, as it was used for target practice by the Home Guard in the Second World War, who also

tossed hand grenades into it.

Over the twentieth century and under the guiding hand of the National Trust advised by Graham Stuart Thomas, good trees and shrubs were planted, adding to those planted in the eighteenth and nineteenth centuries. The majestic castle still stands on its knoll and has little planting to compete with its tremendous size. In this way, it very much resembles the dominance found at Chirk Castle.

The west-facing walled garden that is still part of the castle grounds originally contained a formal terraced garden. In 1928, Sybil, wife of the 4th Lord Penrhyn, made considerable alterations that included the building of the loggia and the creation of the pools and fountains you see today. The garden is sheltered and contains some lovely tender trees and shrubs. Survivors from the nineteenth century include the iron arches that originally carried the *Fuchsia Riccartonii* along the central walk. These were discovered, abandoned, by Graham Stuart Thomas in 1967 and, as he recorded: 'we decided to use the arches along the lower walk; they are now covered with honeysuckles'.[2] Lady Penrhyn also created a bog garden in the 1930s planted with 'primulas, astilbes, hostas, Japanese maples and the like'. This was given up during the war and gradually the whole area was overrun with *Gunnera manicata* and other garden thugs that like moisture. A wide-ranging restoration of the bog garden, including dredging, new sluices, planting a greater variety of moisture-loving plants and installing an ornamental bridge, is nearing completion. This includes its charming thatched Belvedere. *(Figure 194)* However, some intrusive decking has been installed which detracts from the ethos of the walled garden and its nineteenth-century atmosphere.

There are other plans in the pipeline, particularly around the ruined Penrhyn chapel, moved in the eighteenth century and serving as an eye-catcher. A sequence of small, intimate woodland gardens is being planted around it to enhance it. Work on a great garden never finishes and the gardeners have been dealing with another garden thug, *Rhododendron ponticum*. Much of this has been cleared and in its place you will now find ornamental Sorbus and fine new specimen rhododendrons.

Fig. 194 Restoration in progress for Lady Sybil's water garden at Penrhyn Castle with its thatched Belvedere.

Little of the delightful creations of Benjamin Wyatt made for the first Lady Penrhyn survive. It is thought that the ornamental cottage en route to the bath house is now the Head Gardener's home. Ogwen Bank is now a caravan site and the farmhouse of the *ferme ornée*, Pen Isa'r Nant, as a listed building, is now in residential and business use.

Plas Tan y Bwlch, Maentwrog, LL41 3YU
Grade II*

Snowdonia National Park Study Centre
Telephone: 01766 772 600
plas@snowdonia-npa.gov.uk
ww.eryri-npa.gov.uk/study-centre
The gardens are open daily from 10.00 a.m. – 5 p.m.
There is an admission charge.

Money troubles at Plas Tan y Bwlch continued in the new century. The 1900-1903 strikes in the slate industry vastly reduced its income and there was a serious lack of funding to support the house and it gardens. As a result, the estate was

first advertised to let, but with no takers it was first mortgaged and then offered for sale both in 1910 and 1912. 'The Pleasure Grounds in their wealth of Pristine Beauty' were one of the highlights of the sale particulars. At this point the estate was not sold and one of William Edward's Oakeley's granddaughters, Margaret, offered to purchase Plas Tan y Bwlch and the estate in 1915, when she would be 21. Before this date was reached William Edward died, aged 82. The fate of Tan y Bwlch then became entwined in complex inheritance matters, but by 1955 Mary Caroline, Mrs Inge, had outlived her brother and three daughters. She lived on in the great house in some style, finally dying there in 1961, aged 96. The mansion and remaining estate were willed to Edward Southwell Russell, 26th Lord de Clifford,

Fig. 195 The magnificent Terrace gates with William Edward and Mary Oakeley's initials incorporated within them.

great-grandson of Mary Oakeley's brother, the 23rd Lord de Clifford. The resultant heavy death duties meant that the estate was broken up and auctioned in 1962.

At this point the house and its surroundings very nearly succumbed to development, with plans to accommodate a country club with 40 chalets in the gardens. Only nine were built before financial difficulties meant that everything was sold off once again in 1968 and the Snowdonia National Park acquired Tan y Bwlch. Under their care it has become a successful Study Centre and much has been done to respect the Picturesque woodland walks and the gardens around the mansion. Snowdonia National Park owns very little of the original park, but the grounds still contain the wooded slopes above and behind the house, Coed y Plas. What was the deer park is now planted with commercial forestry. The Walled Garden with its great range of glass is no more; all that remains is a parking area. The gardens, especially the superb specimen trees, have been well cared for, but financial constraints mean there is more concentration on wildlife and ecology rather than the re-creation of expensive elaborate gardens.

Following the devastating storms of February 2014, the Snowdonia National Park formed a plan for Plas Tan y Bwlch to restore and replace the trees and plants that were lost to the tempest. More than 600 new trees and shrubs have now been planted in the garden. Each has been carefully chosen to not only reflect the botanical legacy of the Oakeley family, but to also take into account climate change as well as increase the biodiversity of the area. New and restored features within the garden include a magnolia glade, an arbour planted with laburnum and *Fuchsia magellanica* 'Riccartonii', and an Oriental-style garden which pays homage to the Oakeley's interest in plants from Japan and China. The complete restoration of the garden will take five years to complete. *(Figure 195)*

Fig. 196 The Garden Front at Dinefwr with white cattle grazing in the park.

CARMARTHENSHIRE

Dynevor Park (Newton House), Llandeilo SA19 6RT
Grade I

The National Trust & Cadw
(Dinefwr Castle)
Tel: 01558 824 512
dinefwr@nationaltrust.org.uk
www.nationaltrust.org.uk/dinefwr

The parkland and deer park are open daily throughout the year, 10 a.m. – 4 p.m., November to March; 10 a.m. – 6 p.m. April to October, apart from Christmas Eve and Christmas Day. Newton House opens at 11 a.m. daily. The enclosed deer park, Boardwalk, café and Newton House close one hour earlier than the parkland. Dinefwr Castle is open all year round and is owned by the Wildlife Trust, managed by Cadw.

The devastation to great houses caused by death duties in the twentieth century is a story that is repeated several times in the course of this book. The fate of Newton House and Dynevor Castle depended on the fortunes of the family that owned it, but as the twentieth century began, in the glow of an Edwardian summer, all was still well. The social round of weekend visits, shooting parties and entertaining continued. Arthur, the 6th Lord Dynevor, died in 1911, succeeded by his son, Walter (1873-1956). He and his wife, Margaret, presided over a gradually diminishing Dynevor, with farms sold both before and after the First World War. In 1934, the four Penson turrets on the house had to be removed for safety and crenellations, copied from the earlier phase of the house, were added. Sixty years later, the turrets were restored by the National Trust in 1994.

During the Second World War Walter Dynevor offered the War Office the use of Newton House, negotiating an agreement that allowed him and his wife to live in part of the house. The fact that they were on site possibly helped preserve much of the fabric of the mansion and its use, as a Casualty Clearing Centre and then a military hospital, must have also spared it from damage at the hands of rowdy soldiers. The estate suffered loss of income once coal was nationalised in 1947.

Walter, the 7th Lord Dynevor, died in 1956, succeeded by his son, Charles, as the 8th Baron. He died suddenly six years later, at which time the death duties on his father's estate had not been settled. Richard, the 9th Lord Dynevor (1935-2008), was faced with having to find the money for double death duties, a heavy burden. He did what he could, selling off farms and trying to raise funds with a well-regarded Arts Festival. Eventually, worn down by his unceasing efforts to preserve Newton House and the Dynevor Estate with its priceless castle, he sold it in 1974. The deer park and nature reserve were acquired by the National Trust in 1987 and the house four years later. The great ancestral castle on its hill was rescued by the Woodland Trust and is managed for them by Cadw: Welsh Historic Monuments.

Today, although Newton House is open to the public, where you can see the detailed seventeenth-century paintings of the house and gardens under the shadow of Dinefwr Castle itself, it is the parkland and deer park, marketed as Dinefwr, that are the jewels in the crown. It is the only parkland national nature reserve in Wales, designated in 2007. To celebrate the 300th anniversary of Lancelot 'Capability' Brown, in 2016 a locally-sourced oak was planted to fill in where one ancient tree had given way to the years. The Dynevor family have never lost touch with their ancestral home and were present for the tree planting. The Brown walk has been improved and enhanced so that visitors of all ages and abilities can reach the first viewpoint. With over 300 trees at least 400 years old, to be in the park on a sunlit afternoon watching the deer and celebrated white cattle move across the scene, is to feel you have wandered into Paul Sandby's eighteenth-century view of this lovely place. Time has stood still. *(Figure 196)*

CEREDIGION

Hafod, Pontrhydygroes, Ystrad Meurig, SY25 6DX
Grade I

The Hafod Trust in partnership with the Forestry Commission (now Natural Resources Wales).
The Hafod Estate Office
Tel: 01974 282 568
enquiries@hafod.org
www.hafod.org

Hafod can be visited throughout the year. There are five way-marked walks to follow. These vary in length and difficulty but follow much of the landscaped walks created by Thomas Johnes. A guide map can be purchased from the Hafod churchyard (also available from Tourist Information Centres in the locality). Guided tours and group visits can be arranged through the Estate Office.

At the beginning of the twentieth century, the Waddingham family were still living at Hafod. The estate was well run and profitable and survived the agricultural depression at the end of the nineteenth century almost unscathed. A great deal of income came from forestry, with the larch plantations providing thousands of pit props. There was such a demand for these that a sawmill was established in the station yard at

Fig. 197 The Gothic Arcade, restored in 2016 using a drawing by John Piper as inspiration, combined with the remains of its pillars.

Devil's Bridge. The railway arrived in 1902, bringing new visitors to Hafod: 'In 1911 the Railway Company hired its own motor charabanc for combined tours by road and rail to Hafod'.[3] After 1918, James Waddingham, now a widower, largely retreated from public life. Ill health forced him to leave Hafod for Aberystwyth in 1932 and he died there in 1938. Even in his absence 'the lawns...and the kitchen garden were maintained'.[4]

At the beginning of the Second World War Hafod was bought by W.G. Tarrant, a high-class builder from Surrey (he was responsible for the St George's Hill estate, and the golf club there and at Wendover). Although money during the war was short, he did some work in the house, including moving the kitchen from a bleak outpost into the main part of the house. He died at Hafod very suddenly in 1942. He and his wife were the last permanently resident owners. The estate passed through a succession of owners, with farms being sold off at each stage and gradual decay setting in. By 1945 the house was in a poor state of repair and in 1949 all the fixtures and fittings were auctioned, including the windows, stairs, and floors.

Not surprisingly, when the Forestry Commission took over in 1950, they could not find a use or a buyer for the surviving wreck. Piecemeal demolition of the Victorian wing began, and eventually the remainder was dynamited in 1958.

The Forestry Commission's plantings meant that by the 1960s much of Johnes's great plantations and woodland had been replaced and the riverside meadows planted up with conifers. By the 1980s, a few of the old estate walks were still in use, but most had disappeared. As they had been just shelves cut into the slope, they were hard to detect and some had been swept away by occasional landslips. Many of the bridges had collapsed or decayed. The main drives still served the farms, lodges and cottages, as well as forestry traffic. Almost all of the properties within the demesne had been sold privately.

Much of what the visitor to Hafod sees today is the work of the Hafod Trust. In 1991, the Welsh Historic Gardens Trust began a major research project, creating a Conservation Partnership Agreement with Forestry Commission Wales. By 1994 it was possible to hand over this work to the newly-created Hafod Trust. The Trust has focused on recreating Johnes's network of walks and some nine miles, almost entirely on the historic routes, have been restored, waymarked and opened again for the public to enjoy. Research has identified more than 100 probable viewing platforms, and some forty of these have been opened up. Working with the Forestry Commission, about ten hectares of conifer plantation has been clear-felled and the land fenced and restored to grazing.

The twenty-first century has continued to see imaginative and careful restoration work carried on at Hafod. Mrs Johnes's Garden was the Hafod Partnership's major project in 2009. Planting began in 2012 and the first phase was completed in 2013. There will be more to come. Sensitive to the spirit of the place, the planting here has a deliberate focus on North American species that would have been available in the late eighteenth century before the influx of Victorian introductions. The 1880s stable block survives and houses the Estate Office. With a project of this size, real dedication and hard work is necessary to keep the restoration that has been completed in good order, while also looking forward to new opportunities. A recent restoration, almost a recreation, has been the Gothic

Arcade (2016). Like so much at Hafod it is very atmospheric, and visitors today can still feel the intense romance of this beautiful spot and recall its days as a Fairy Paradise. (*Figure 197*)

CONWY

Bodnant, Tal-y-Cafn, LL28 5RE
Grade I

The National Trust
Tel: 01492 650 460
bodnantgarden@nationaltrust.org.uk
www.nationaltrust.org.uk/bodnant-garden

The gardens are open year round: January, February, November and December, 10 a.m.-4 p.m.; March–October, 10 a.m.–5 p.m. Admission charge if not a member of the National Trust.

With the dawning of the twentieth century, Bodnant began its blossoming, based on its splendid Victorian foundations, into the superb garden we know now. The five famous terraces that everyone associates with Bodnant were created over a decade between 1904 and 1914 by Henry, 2nd Lord Aberconway. Replacing the sloping lawns attributed to Edward Milner, they descend from the house facing west and were carefully designed so as leave the two great cedars planted by his grandfather unharmed. In 1909 he began work on the Dell, developing it further as a woodland and water garden in the style of William Robinson's *Wild Garden*. Over the years, Lord Aberconway devoted himself to creative and imaginative planting throughout the grounds, including assembling one of the finest collections of rhododendrons and azaleas in the country. Starting with the magnolias, the flowering of the gardens in spring is one of the great sights of Wales.

In 1949, Lord Aberconway gave the gardens (but not the house) to the National Trust, retaining control over its management and design, and working together with the great family of Bodnant gardeners, the Puddles. He died in 1953 and was succeeded by his son Charles, the 3rd Lord Aberconway, who

Fig. 198 The newly-restored 'Bath' at Bodnant created around the pool shown in Edward Milner's early design for the garden.

maintained a deep personal interest in the gardens. Both he and his father were Presidents of the Royal Horticultural Society. When he died in 2000, the Hon. Michael McLaren, Charles Aberconway's son and Pochin's great-great-grandson, became the Director of Bodnant Garden. From 2008, working with Troy Scott Smith (now Head Gardener at Sissinghurst in Kent), they began a radical programme to revitalise the gardens, cutting back and removing old overgrown trees, replacing tired planting schemes and recreating vistas looking outwards to the splendid views of Snowdonia. This work continues with John Rippin as Head Gardener and fresh thoughts and new plantings emerge every year. It would be possible to write an entire book about all the rare and wonderful trees and shrubs planted at Bodnant. Suffice it to say that it shines as an example of the best early-twentieth-century garden design in Britain. (*Figure 198*)

DENBIGHSHIRE

Chirk Castle, Chirk, Wrexham LL14 5AF
Grade I

The National Trust
Tel: 01691 777 701
chirkcastle@nationaltrust.org.uk
www.nationaltrust.org.uk/chirk-castle

The parkland is open all year round, 7 a.m.–7 p.m. or dusk if earlier; and from June–August until 9 p.m.; the gardens are open daily except over Christmas, February, March, October & November, 10 a.m.–4 p.m.; April–September 10 a.m.–5 p.m. Admission charge if not a member of the National Trust.

Between 1911 and 1946, Chirk was leased from the Myddleton family by Thomas Evelyn Scott-Ellis, the 8th Baron Howard de Walden. He and his wife loved Wales and entertained lavishly at the Castle, adding their own improvements. Lady Howard de Walden made changes in the gardens, creating an informal garden and shrubbery with winding paths and flower beds that were laid out for her by the garden designer Norah Lindsay. These borders were altered after the Second World War. In 1912, the de Waldens thatched the Hawk House to accommodate falcons. It had originally been firstly Joseph Turner's 'Green

Fig. 199 Chirk Castle from the park.
Fig. 200 Hercules in his new position in front of Chirk Castle.

House', then E.W. Pugin's conservatory. It was restored in 1977, following a fire. After 1946, when Lord Howard de Walden died, the Myddleton family returned home, with Lt-Colonel Ririd Myddleton and his wife, Lady Margaret, becoming the custodians. Lady Margaret was responsible for bringing the gardens back to life, as wartime austerity had severely reduced their maintenance. She devised plantings of trees and shrubs that were not as labour-intensive as the complex herbaceous borders created by Norah Lindsay. Oaks were planted along the south drive to celebrate the Coronation in 1953, and much of the magnolia planting was undertaken by Lady Margaret. She died at Chirk in 2003, aged 93. The family continued to own the castle and estate until 1978, when Chirk was accepted by the Secretary of State for Wales in lieu of death duties before being transferred to the National Trust in 1981. The Myddletons continued to live in part of the castle until 2004.

In 1983 the statue of Hercules was rescued from the woodland by helicopter. It was restored and moved once again to the lime avenue to the east of the castle in 1988. (*Figure 200*) The Banqueting House described by Dineley is incorporated into the grounds of what is now Whitehurst House, just over a mile away from Chirk. The 1651 walled garden is also part of this

property, and you can still see traces of the curved terracing. Today, Chirk is notable for its gardens and topiary and it is a matter for congratulation that the Emes parkland retains so much of its intrinsic character.

✣ Llanerch Park, St Asaph LL17 OBD

Privately-owned.

Llanerch Hall is not open to the public so I have not been able to see it in its present incarnation. The Jacobean house seen in the famous painting was added to and encased within a more modern building in the nineteenth century. In the 1920s, the house was owned by Captain and Mrs Piers Jones and they commissioned the landscape gardener, Percy Cane, to remodel the gardens in 1927-1929 in an Arts & Crafts style. He created formal gardens close to the house with wooded dingles further away. The walled garden to the west of the house was remodelled as a pleasure ground.

As for the park, as the Cadw Register says: 'The park is now very sparsely planted, and the 1st edition Ordnance Survey map shows that it has been seriously depleted since the late nineteenth century'. Today, some of the parkland is now the Llanerch Park Golf Course and visitors can fish in what was the Llanerch pool, now that Neptune has vanished from view.

Plas Newydd, Hill Street, Llangollen LL20 8AW Grade II*

Denbighshire County Council
Tel: 01978 861 314.
Out of season enquiries (October to Easter) 01824 708 281
heritage@denbighshire.gov.uk www.hanes.llangollen.co.uk.

The house and garden are open (closed on Tuesdays except in June, July and August) 1st April (or Good Friday, whichever is earliest)- 31st October; 10.30 a.m. – 5 p.m. (last entry 4 p.m.); October 10 a.m. – 4 p.m. (last entry 3 p.m.)

In 1910 Mrs Gertrude Wilson bought Plas Newydd, where

Fig. 201 & 202 Above: The summer house below Plas Newydd. Below: The re-creation of Lady Eleanor's Bower. Both buildings were made possible with Heritage Lottery Funding.

she remained for most of the First World War. Her husband and son were in the army. In 1917 she gave permission for the development of allotments on Butler Field to help the war effort. She too was troubled by intrusive day trippers and increased the cost of the admission tickets to admit 'only the select and appreciative few' [5]. She sold the house in 1918, and in the space of just over a year Plas Newydd changed hands three times, finally being rescued by the 7th Earl of Tankerville and his wife. They had been very taken with the area around Llangollen and decided Plas Newydd would make a delightful summer residence for the family. The Countess wrote 'a charming letter to the Council' assuring them that she would continue the tradition of opening Plas Newydd to visitors.

In 1931 the Earl died and a year later, a century after the first auction, the contents of the house were auctioned again. The house, grounds and garden buildings were finally bought by Llangollen Urban District Council in 1933. The Council immediately opened them to the public. There were various uses for the house, but over time it deteriorated, and in 1962 the Council took the decision to demolish the East and West Wings added by General Yorke and the Robertsons. A restoration plan was put in hand and in 1976 Llangollen Council handed the house and its grounds to Glyndwr District Council. In 1996 this became Denbighshire County Council and Plas Newydd was accredited as a museum.

The twenty-first century saw a real impetus to restore and recreate the gardens around the house and in 2004 an Heritage Lottery-funded restoration programme was put in hand. This has resulted in the re-creation of both Lady Eleanor's Bower and the Summerhouse, where the Ladies had their 'rustic seat'. (*Figures 201 & 202*) The enthusiasm of the staff and volunteers for what is still a delightful place is evident today when Plas Newydd and its setting, considered a gem in the landscape, is threatened with council cut-backs and retrenchment. It is to be profoundly hoped that their dedication will be rewarded.

✛ Wynnstay, Wrexham, LL14 6LB
Grade I

Divided ownership. No public access.

The twentieth century saw unfortunate change and damage to this iconic place in the story of Welsh garden history. The 6th Baronet had no male heirs but his daughter Louisa married her cousin, Herbert Watkin Williams Wynn, who succeeded to the title and estate in 1885. As the 7th Baronet, he installed a munitions factory on the estate during the First World War. He died in 1944 and, owing to heavy death duties, the Williams Wynns moved from Wynnstay to nearby Plas Belan, a house in the estate grounds, and finally left Ruabon forever in 1948.

Wynnstay became a boarding school, Lindisfarne College, remaining so until 1995, when the core of the estate was

Fig. 203 Capability Brown's Dairy at Wynnstay, unfortunately affected by modern development.

put up for sale. Most of the gardens and buildings, many of them in a ruinous state, were purchased by developers. Enabling development meant that a scheme was devised for the restoration of the garden but Capability Brown's ha-ha was the subject of brutal treatment, with part of it filled in to accommodate grass-cutting machinery. The vast mansion has been divided and, with the stables, outbuildings and gardens, developed to contain 70 individual houses and apartments. Although now cut in two by the A483, the park still retains many of its historic features. Brown's lake has gone but some of Evans' cascade remains at its lower end. The Bathhouse survives in Bathground Wood and Brown's exquisite Dairy is overshadowed by development *(Figure 203),* James Wyatt's Column still stands, although the winter storms of 2014 toppled the bronze urn from the top so that it was badly damaged and its fabric is at risk. The Nant-y-Belan Tower, perched as it was on the steep hillside, collapsed at some point in the 1950s and is now a ruin and the prospect from it lost in trees.

Even though restoration work has been undertaken, particularly with the renovation of the curved wall of the kitchen garden, seeing even part of Wynnstay's gardens and landscape is difficult. The stretch of water that was the canal in front of Wynnstay is now the only remaining lake and is a commercial carp fishery, whose owner does not encourage visitors who are not prepared to wield a fishing rod. The gardens are parcelled out among the various domestic holdings that make up the mansion, its ranges and outbuildings, making visits complicated as several dozen owners are involved. Much of the further park still belongs to the Wynnstay estate and is now farmland. Some time ago, the Estate bought back this farmland and Bathground Wood. This woodland had been vandalised by the Forestry Commission and given over to conifers. The Estate sought permission to replant the Lime Avenues but this was refused due to the presence of a bat population. Many of the trees have now blown down and the avenues are in a sorry state. One of the many tragedies at Wynnstay is the fact that during the bankruptcy proceedings with Lindisfarne College, the bank sold off every piece of garden statuary from the site.

There are plans in the pipeline to develop more housing at Wynnstay. These were delayed by the credit crunch, but there is still a threat to the historic integrity of the site, particularly the walled garden. However, one must always hope for the future and the 300th Anniversary of the birth of Capability Brown in 2016 has served to shine a spotlight on this once-great park and gardens.

MONMOUTHSHIRE

Piercefield, Chepstow
Grade I

Fig. 204 The sad ruins of Piercefield House.

The park is now Chepstow Racecourse and the broken shell of the house is fenced off. However, it is possible to follow much of the scenic paths overlooking the river Wye. A guidebook, *Overlooking the Wye: A guide to the heritage of the Wye Valley,* and a free map, are available from the Chepstow Information Office.

In the twentieth century Piercefield remained with the Clay family until it was sold to the Chepstow Racecourse Company, who opened the racecourse in the park in 1926. In common with many great houses commandeered in the Second World War, the mansion at Piercefield suffered at the hands of troops billeted there and Colonel Wood's estate walls were breached to allow light aircraft to be brought into the park. After the war the house continued its slide to dereliction. The woodland walks, separated from the home demesne, are now in private hands. This divided ownership has, until now, done much to

preserve them. Designated as a nature reserve, the walks were reopened in the 1970s as part of the Wye Valley Walk.

Despite many dreams and plans for it, Piercefield today is a forlorn and largely lost house and gardens; being part of a Grade I Registered Historic Park has done little to protect it. The ruined house is owned by the Reuben brothers as part of Chepstow Racecourse. *(Figure 204)* The walks and six of their structures were conserved as part of the HLF-funded Landscape Partnership 'Overlooking the Wye' (2008-2012). The route is still dramatic and beautiful but while the structures of the preserved viewpoints have been restored, many of the views, so deservedly famous, are largely lost to overhanging trees. Campaigners for this iconic place in Welsh landscape history still strive to raise its profile, hosting events to highlight Piercefield's plight organised by SAVE and other friends of Piercefield.

PEMBROKESHIRE

Picton Castle, Haverfordwest, Pembrokeshire, SA62 4AS
Grade II*

The Picton Castle Trust
Tel: 01437 751326
info@pictoncastle.co.uk
www.pictoncastle.co.uk

Open daily all year round, 10.00 a.m. – 5.00 p.m.; Admission charge. During the winter months when the Castle is closed, there is an Honesty Box for donations.

Much of the lovely landscape at Picton remains as beautiful as it ever was. Time and politics may have brought change, but the essential character of Picton defies them both. When the twentieth century began there was a garden staff of 23, many of whom would have been employed in the walled garden and its glasshouses. Many of these gardeners joined up during the First World War and the gardens were neglected. The neo-Norman Winter Garden or Conservatory was demolished in the 1930s

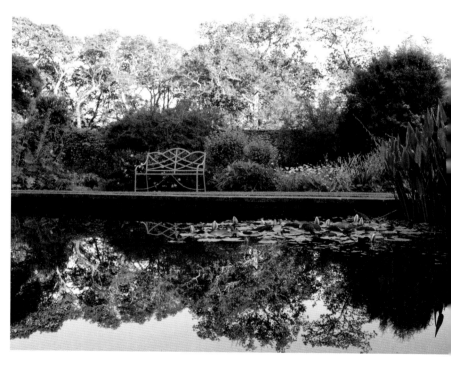

Fig. 205 & 206 Summer views of the gardens at Picton Castle.

and over time the great range of the glasshouses began to decay, the last one collapsing in 1950.

During the Second World War, in preparation for the Normandy Landings, an American army camp and airstrip was established at Picton Castle Home Farm. There is no trace of it today. It is since the war that the gardens of Picton Castle have now come into their own. Enhanced and improved by the Philipps family, they are certainly one of the finest gardens in Wales. Lady Marion Philipps and her husband, the Hon. Hanning Philipps, were largely responsible for redeveloping and planting the gardens that are so colourful today. As Lady Marion wrote:

> In 1954 little remained of the grandeur of the past. We set about transforming what remained of the gardens to suit the existing features of woodland and running streams leading through ponds to the tidal waters of the Milford Haven. In order to grow successfully the shrubs, trees and plants which we have collected from many countries all over the world, great attention has been given to shelter.

In 1987 the family handed over control of the castle and its grounds to the Picton Castle Trust, a charity dedicated to preserving Picton for future generations. The gardens cover some 40 acres of woodland walks and glades full of superb rhododendrons and azaleas that flower exuberantly in the spring over sheets of bluebells and other wild flowers. There are magnificent giant conifers, a tree fern glade and a Myrtle Avenue. The Walled Garden with its pool and fountain is full of roses, a collection of medicinal herbs and a Fernery. Looking forward, the Picton Castle Trust has recently been successful in obtaining Heritage Lottery Fund support to begin their inspiring Walled Garden Project. This focuses on the garden ranges that include the Head Gardener's Office, fruit store, potting shed, bothy – where the young, unmarried gardeners lived – as well as looking forward to restoring the garden walls, gates and railings. It is planned to improve the volunteer and visitor facilities, and provide enhanced opportunities for educational projects. Engaging a wider audience for beautiful historic gardens is the key to their survival in the twenty-first century. *(Figures 205 & 206)*

Stackpole Court, Bosherston, SA71 6DQ
Grade I

The National Trust
Tel: 01646 661 359
stackpole@nationaltrust.org.uk
www.nationaltrust.org.uk

The estate and parkland are open all year round from dawn to dusk. Admission charge if not a member of the National Trust.

In the twentieth century, many Welsh estates were laid low by death duties and wartime ravages and this was the case at Stackpole. The 3rd Earl Cawdor succeeded his father at the very end of the nineteenth century in 1898. As his father lived until the great age of 88, he was already in his late 50s and died himself in 1911. The 4th Earl, Hugh Frederick Vaughan Campbell (1870-1914), survived his father by only three years, dying in 1914 aged 44. John Duncan Vaughan Campbell, known as Jack (1900-1970), became the 5th Earl Cawdor when he was fourteen. The Cawdor estates had to struggle with double death duties and outlying parts of the Welsh estates were put up for sale. During the Second World War Jack Cawdor served with distinction with the Queens Own Cameron Highlanders, but the War Office did not treat his demesne with any gratitude or respect in return. It appropriated almost three-quarters of the Stackpole Estate to create the 6,000-acre Castlemartin Range. Stackpole Court was requisitioned to billet soldiers and, as at Baron Hill and Margam Castle, this caused untold damage to the house and its contents. Soldiers stole lead from the roof and the great Roman statues brought home by Sir John Campbell II were badly damaged.

After the war, Jack Cawdor made over the Welsh Cawdor estates to his son, Hugh John Vaughan Campbell, Viscount Emlyn (1932-1993), on his twenty-first birthday in 1953. This gift was possibly a poisoned chalice. The house was no longer supported by a reasonable estate income, having lost so much to the war effort. It needed urgent treatment to deal with the wet and dry rot caused by the wartime damage, quite apart from the maintenance needed to keep such a vast building

Fig. 207 The classical summer house at Stackpole Court, attributed to Sir Jeffry Wyatville.

in good repair. Within ten years, despite trying to come up with a plan for the future, Hugh Emlyn had Stackpole Court demolished. He lived on the Golden Grove estate until he succeeded his father as the 6th Earl Cawdor in 1970, removing to his Scottish estates at Cawdor Castle. In 1976 he sold his remaining Welsh lands and the woods, lakes, parkland and coastline were passed to the National Trust by Treasury Transfer, as had happened at Penrhyn Castle.

Truly described in its own guide by the National Trust as the 'former grand estate', much has been lost at Stackpole, quite apart from its great house. The walled Kitchen Garden with its array of glasshouses was in use by the family until 1946. These were finally demolished in 1970. This garden is now host to a thriving Mencap project that grows and sells its produce.

The National Trust's view of Stackpole was focused on the Pembrokeshire coast and its nature and wildlife rather than its heritage as a great landscape park. This was a great pity, but plans have been put in hand to repair this omission and they are gradually being achieved. The Flower Garden, part of the pleasure grounds, and now called the Rose Garden, has

had a host of secondary growth removed from it. It has been re-planted as an informal arboretum with fine ornamental and specimen trees. In particular, the famous circle of nine beeches, once reduced to bare stumps, has been re-planted, albeit on a very small scale. The rose pergola has been restored and planted with traditional roses. In the wider estate, what was commercial forestry is being felled and replaced with broad-leaved trees. In some places the planting of eighteenth-century beeches is regenerating well. All of this will take time to come to fruition and there is still much work to be done. The hard question is, what should be done with the great water feature made by the lakes that form a necklace around where the great house once stood? Of all the park and garden features dealt with in this book, the water at Stackpole is the most significant and, with its bridges, contributes hugely to its designation as a Grade I site. Full of silt and requiring major work to bring them back to something of their former glory, the lakes will need an enormous sum of money spending on them. Where will the money come from? Will any restoration be sustainable long term? What must be done to maintain the distinction of Stackpole's landscape as Grade I? Just as the maintenance of great landscapes caused much discussion for their original owners in years gone by, such dilemmas continue in the twenty-first century. The National Trust needs encouragement as it wrestles with such perennial problems. *(Figure 207)*

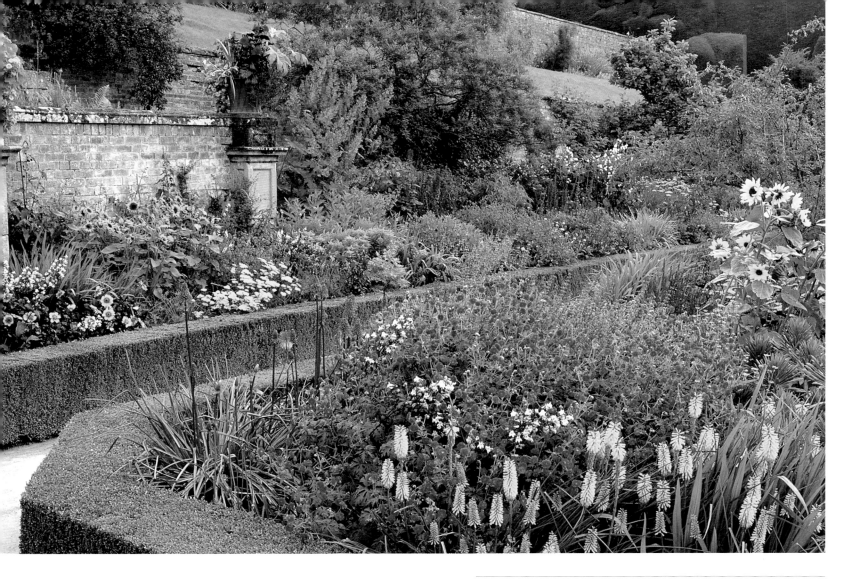

POWYS

**Powis Castle,
Welshpool SY21 8RF
Grade I**

The National Trust
Tel: 01938 551 929
powiscastle@nationaltrust.org.uk
www.nationaltrust.org.uk

The gardens are open throughout the year other than
Christmas Day. January & February and November &

Fig. 208 The Powis Castle terraces in high summer.

December, 11 a.m. – 3.30 p.m.; March & October, 11 a.m. – 4.30
p.m.; April – September, 11 a.m. – 5.30 p.m. Admission charge if
not a member of the National Trust.

Described in *The Garden* as, 'a majestic red castle sitting atop
extravagant, terraced, hanging gardens overflowing with beauty,
in a scene worthy of Nebuchadnezzar himself', the gardens
of Powis Castle have achieved deserved fame in the twentieth
and twenty-first centuries. [6] Under the guiding hand of Violet,
the 4th Countess of Powis, the gardens became a romantic

Edwardian scene of great beauty. In particular, the planting of the restored terraces, begun under her tenure, have been wonderfully enhanced and maintained since Powis Castle was passed to the National Trust in 1956.

In 1910, Lady Powis seized the opportunity offered by a damaging storm to dismantle the site of what she considered unsightly glasshouses. Here, she created the fountain and formal gardens, with a hint of what had been at Powis in the past. The avenue of apple trees she planted is now over a century old. The Cadw Register entry for Powis relates that, 'by the time of Violet's death in 1929 the gardening staff numbered at least twenty'. [7] Her death was a dreadful blow to Lord Powis, who had already lost his eldest son at the Somme in 1916. Further tragedy followed, when his second son was killed on active service in 1939. For part of the Second World War the Castle was used as a girls' school, with the gardens and park tended by Land Girls. The Earl moved out to the Head Gardener's house. With his immediate family gone, the Earl decided to leave the castle to The National Trust on his death in 1952. The title and wider estate passed to his cousin. Today, the 8th Earl of Powis lives on the estate.

In the 1970s, under the aegis of Graham Stuart Thomas, a noted plantsman who served the National Trust as its Garden Advisor, the plantings on the terraces were revised and the work of Powis's renowned Head Gardener, Jimmy Hancock, at the time ensured that these gardens have never dropped from a garden visitor's 'Top Ten' over the decades that have followed. There is criticism of the lower reaches of the terraces where they adjoin what is now known as the Great Lawn. Their plantings do not match the glories that flow above them. The Great Lawn itself, where the water gardens once stood, is left as a blank canvas, with the occasional pattern mown into it. It suffers a lot of damage from the modern trend for holding weddings in historic houses and gardens – the great lawn is the ideal place for a marquee. (*Figure 208*)

WEST GLAMORGAN

Margam Abbey/Margam Castle, Port Talbot SA13 2TJ
Grade I

Neath Port Talbot Council
Tel: 01639 881 635
margampark@npt.gov.uk
margamcountrypark.co.uk

Margam Country Park is open daily free of charge (parking fee) from April – 31st August, 10 a.m.–6 p.m.; 1st September – 31st March, 10 a.m.– 4.30 p.m. (last entry 1 hour before closing)

Emily Charlotte Talbot enjoyed nearly thirty years as mistress of Margam, using her wealth to add to and improve the house and gardens. She died in 1918 and Margam was inherited by her nephew, Andrew Mansel Talbot Fletcher of Saltoun in Scotland, while Penrice passed to her niece, Evelyn, wife of the 4th Baron Blythswood. Andrew's father, Captain Andrew Mansel Talbot Fletcher, was a keen horticulturalist, helping to finance the plant hunting expeditions of Frank Kingdon Ward. Some of his introductions of rhododendrons and azaleas were planted at Margam and survive along the Broad Walk.

The contents of the mansion were sold in 1941, with the house requisitioned for military use for the duration of the Second World War. The fate of the orange trees and the other citruses was sealed with the arrival of the American Army, billeted in the house and grounds in 1944. The Head Gardener relates that the troops used the Citrus House to sleep in and put all the trees outside, where they perished from cold. Although the estate had been purchased by Sir David Evans-Bevan in 1942, after the war the house remained empty. Sir David never lived in the Castle and, subjected to robbery and vandalism, it declined into an empty shell.

In 1973, the estate was acquired by the Glamorgan County Council (now Neath Port Talbot Council). This began a new chapter in the history of Margam, as the Council began to tackle years of neglect. There was urgent work undertaken on the Orangery, but disaster struck when the mansion when it

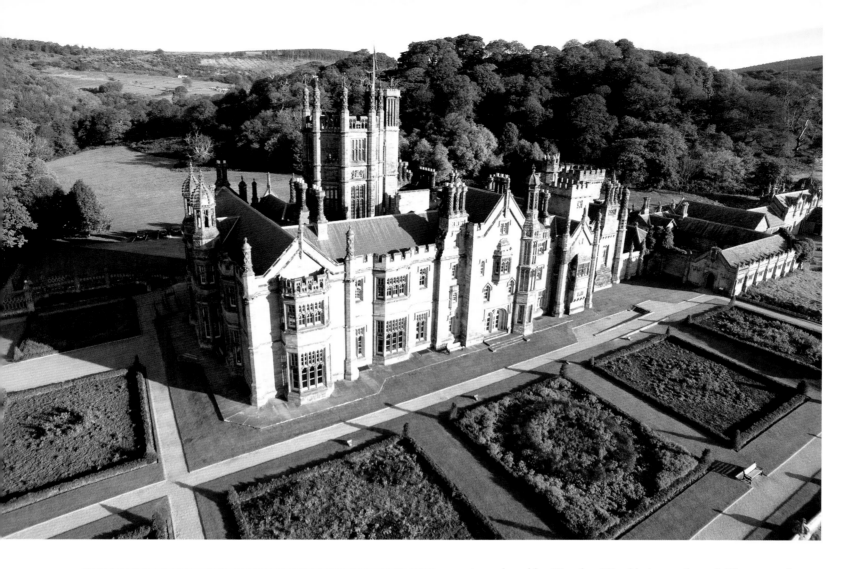

Fig. 209 Margam Castle from the air showing the newly-restored flower beds around the mansion.

was gutted by fire in August 1977. Gradually, a programme of restoration and improvement work has been undertaken.

Since 2012 the Citrus House has been restored, with its technically-innovative glass work recreated, and it is steadily being filled with a variety of replacement citrus trees. Much work is ongoing with repair and restoration of the historic core of the estate. On the Broad Walk, overgrown shrubs have been cut back, rhododendrons that had reverted to *Rhododendron Ponticum* being destroyed, and some of rhododendron varieties

introduced by Kingdon Ward being replanted. There are plans to make the fountains outside the Orangery work once more and recreate the lost central fountain. The delicate remains of the Chapter House have been stabilised and improvements are being carried out to the Orangery gardens, the Temple of the Four Seasons and the ha-ha. Around the Castle itself, now with a roof over its ruined interior, often used as a 'Gothic' location for television programmes, the terraces and the parterre beds are well on the way to seeing new life again. The deer park continues some 400 years on with the original breed of Fallow deer, now accompanied by Red deer and the rare Père David deer. It is inspiring to watch the work at Margam in progress. *(Figure 209)*

PICTURE CREDITS

The author and publisher would like to thank the following people, museums, libraries and organisations for permission to reproduce their material.

© Amgueddfa Cenedlaethol Cymru – National Museum of Wales: Figures 7, 14, 16, 21, 25, 26, 34, 35, 38, 94, 95, 96, 112.

Collection of the Author: Endpapers, p. 11, Figures 1, 6, 15, 18, 20, 22, 33, 47, 48, 79, 84, 85, 91, 92, 99, 100, 107, 114, 129, 133, 159, 175, 176, 177, 180, 201, 202.

Archives and Special Collections, University of Bangor: Figures 3, 5, 127, 128.

© Bodleian Library, University of Oxford: Figures 2, 103, 111, 163.

© Bodleian Library / Wilkinson Collection: Figure 19.

With thanks to John R.E. Borron: Figure 161.

© The British Library Board: Cover image and Figures 71, 72, 73, 123, 146, 164, 178, 191.

© The Trustees of the British Museum: Figures 83, 97.

Courtesy of Carmarthenshire Archive Service and Lady Cawdor: Figure 136.

By kind permission of the Cawdor Estate: Figures 137, 138, 139.

© Chepstow Museum: Figures 148, 149, 150, 151, 152.

Denbighshire County Council, Ruthin: Figure 173.

By courtesy of The Frick Collection, New York: Figure 69.

© Peter Gill: Figure 12.

© The Hafod Trust: Figure 197.

© Charles Hawes: Figures 61, 62, 208.

© Houghton Library, Harvard University: Figure 172.

© Thomas Lloyd: Figures 89, 90, 119, 120, 122.

© Llyfrgell Genedlaethol Cymru/National Library of Wales: Figures 4, 10, 11, 13, 17, 23, 28, 46, 51, 57, 68, 75, 93, 98, 101, 102, 115, 116, 117, 126, 130, 132, 141, 142, 153, 154, 158, 162, 165, 166.

With thanks to Madoc Books: Figure 64.

© Margam Country Park: Figures 36, 43, 44, 45, 209.

By kind permission of the McLaren Family Archives: Figures 182, 183.

© Michael McLaren: Figure 190

© Meirionnydd Archives, Dolgellau: Figure 170.

© Msemmett: Figure 192.

Myriad Books/Photograph © Simon Kirwan: Figures 32, 60.

© National Portrait Gallery, London: Figures 41, 147.

© National Trust Images: Figures 29, 66, 67, 106, 124, 131, 198, 207.

© National Trust Images/Andrew Butler: Figures 30, 31, 74, 196, 199.

© National Trust Images/John Hammond: Figures 49, 50, 70, 76, 104, 105, 125, 156.

© National Trust Images/Catriona Hughes & Claire Reeves: Figure 157.

© National Trust Images/Nick Meers: Figure 108.

© National Trust Images/Stephen Robson: Figure 134.

© National Trust Images/Kane Thomas & Clare Turgoose: Figures 58, 135.

© Oxford University Images/History of Science Museum: Figure 181.

The Pardoe Collection by courtesy of The Georgian Group: Figures 27, 65, 140, 174.

© Pembrokeshire Archives, Haverfordwest: Figures 77, 78, 86, 87, 88, 143, 144, 145.

© C. Perrin: Figure 204.

Courtesy of the Picton Castle Trust: Figures 80, 81, 82, 205, 206.

© Plas Tan y Bwlch: Figures 167, 168, 169, 171.

Courtesy of the Trustees of the Powis Estate: Figure 52, 53, 54, 55, 56.

Private Collections: Figures 113, 160.

Private Collection with thanks to Guy Peppiatt Fine Art: Figure 109.

© RHS Lindley Library: Pages 7, 9, and Figures 110, 118, 121, 184, 188, 189.

© RIBA Library Collections: Figure 9.

© Mike Roberts: Figure 39, 42.

© Charles Robinson: Figures 24a, 24b, 185, 186, 187, 193, 194, 200.

Royal Commission on Ancient & Historic Monuments Wales: Figure 59.

© Tony Russell: Figure 195.

© The Science Museum/Science & Society Picture Library: Pages 14, 15, and Figure 8.

© Glynis Shaw: Figure 203.

© Victoria & Albert Museum, London: Figure 37.

© West Glamorgan Archives: Figure 40.

© Yale Center for British Art, New Haven: Pages 42, 43, and Figure 63.

Every effort has been made to trace copyright holders of material and acknowledge permission for this publication. The publisher apologises for any errors or omissions to rights holders and would be grateful for notification of credits and corrections that should be included in future reprints or editions of this book.

NOTES

INTRODUCTION

1 Elisabeth Whittle, *The Historic Gardens of Wales: An Introduction to Parks and Gardens in the History of Wales* (Cadw Welsh Historic Monuments/HMSO, London: 1992), p. 4.

2 Julian Mitchell, *The Wye Tour and Its Artists* (Logaston Press in association with Chepstow Museum, Monmouthshire Museums Service: 2010), p. 19.

3 Esther Moir, *The Discovery of Britain: The English Tourists 1540 to 1840* (Routledge & Kegan Paul, London: 1964), p. xiv.

4 Henry Penruddocke Wyndham, *A Tour through Monmouthshire and Wales in June and July 1774, and in the month of June, July and August 1777* (Salisbury: 1781, 2nd ed.), p. 2.

5 *Bradshaw's Descriptive Railway Hand-Book of Great Britain and Ireland* (1863, reprinted 2012 by Old House), Section II, p. 39.

6 Mrs Piozzi, *Thraliana: The Diary of Mrs Hester Lynch Thrale (later Mrs Piozzi)*, Vol. II 1784-1809, Katherine Balderston (Ed.), (Oxford at The Clarendon Press: 1942), p. 194.

7 *The Landscape Gardening and Landscape Architecture of the Late Humphry Repton, Esq: Being His Entire Works on These Subjects. A new edition: with an historical and scientific introduction, a systematic analysis, a biographical notice, and a copious alphabetical index.* J. C. Loudon (Ed.), (Longman, A. & C. Black, London: 1840), p. 616.

EXPLORING WALES

Travelling Conditions

1 Thomas Dineley, *The Account of the official progress of His Grace Henry, First Duke of Beaufort... through Wales in 1684*, by photo-lithography from the original MS of Thomas Dineley, preface by Richard W. Banks. (London: 1888)

2 'My intentions weare to have made you a Visitt long since, but have been soe afflicted with my rumatisme that dare not yet encounter a welsh Journey', Thos. Yale to Joshua Erdisbury, Jan. 21, 1696 in A.L. Cust's (Mrs Wherry), *Chronicles of Erthig on the Dyke*, Vol. I, p.46, cited in A.H. Dodd, 'The Roads of North Wales' in *Archaeologia Cambrensis*, V (1925), pp. 121-148.

3 Thomas Johnson (d. 1644), English apothecary and botanist, noted for his edition of *Gerard's Herball* (London: 1633) to which he added some 800 new plants. He wrote an account of his Welsh journey, *Mercurii botanici pars altera Sive Planta-rum gratia suscepti itineris in Cambriam siva Walliam descriptio* (London: 1641).

4 John Ray (1627-1705) was one of the most significant scientists of his time, known as 'the Father of Natural History'. He began a system of classification of plants and together with his friend, Sir Francis Willughby, they set out to catalogue the plants and animals of Britain. His first journey to North Wales was during August/ September 1660. It was on his way back to Welshpool that he first heard of the death of Oliver Cromwell. In May 1662, after the Restoration, he made a much longer tour around most of Wales describing how he found Princess Joan's 'stone coffin' 'at a place called the Friery about half a mile from Beaumaris 'whereof they now make a *Hogs-Trough*' . This was later retrieved by the 7th Lord Bulkeley and installed at Baron Hill as a decorative feature.

5 Thomas Johnson, *The itinerary of a botanist through North Wales in the year 1639 A.D.* trs. William Jenkyn Thomas (Bangor: Printed by Evan Thomas, 1908), a translation of Thomas Johnson's *Mercurii botanici...*, (London: 1641), pp. 4, 6, 7.

6 William Stukeley, *Itinerarium Curiosum, or, an Account of the Antiquitys, and Remarkable Curiositys in Nature or Art, Observ'd in Travels thro' Great Britain* (London: 1724), p. 48.

7 John Taylor, *A Short Relation of a long journey, made round or oval by encompassing the principalitie of Wales... reproduced in Travels Through Stuart Britain: The Adventures of John Taylor, The Water Poet*, John Chandler (Ed.), (Sutton Publishing Stroud: 1999), pp. 259, 270, 272.

John Taylor (1578-1653), was a noted London figure. He published his various journeys round Britain (largely written in verse) giving them to interested people or those he was wishful to impress. He began life ferrying people across the Thames, and during the Civil War, as an ardent Royalist, he joined the King in Oxford where he was made the official Water Bailiff. Taylor was 72 when he made his journey through Wales. He died two years later and is buried in the churchyard of St Paul's, Covent Garden.

8 A.H. Dodd, 'The Roads of North Wales', *Archaeologica Cambrensis V* (Journal of the Cambrian Archaeological Association, 1925), p. 122.

9 Mitchell, *The Wye Tour and Its Artists*, p. 3.

10 Edward Hyde Hall, *A Description of Caernarvonshire* (1809-1811), Emyr Gwynne Jones (Ed.), (Caernarvonshire Historical Society, Caernarvon: 1952), p. 37.

11 Herbert Evans, *Monmouthshire* (1911) quoted in *A Gwent Anthology*, A. Roderick (Ed.), (Christopher Davies, Swansea: 1988), p. 166.

12 Arthur Young, *A Six Weeks Tour, through the Southern Counties of England and Wales*, (London, Salisbury & Edinburgh: 1769), Letter IV, pp. 153-154.

13 Mrs Mary Morgan, *A Tour to Milford Haven in the year 1791*, (London: 1795), p. 120.

14 William Coxe, *An Historical Tour of Monmouthshire* (London: 1801), p. 14.

15 Wyndham, *A Tour through Monmouthshire and Wales*, pp. 140-141. The hackneys or little horses he mentions were 'exceedingly hardy, and possessed strength much superior to their appearances. ...They are turned into a common pasture for the night. Every inn in the country is provided with a paddock for this purpose.'

16 The Hon. John Byng (later 5th Viscount Torrington), *The Torrington Diaries; a selection from the tours of the Hon. John Byng between the years 1781 and 1794*, Cyril Bruyn Andrews (Ed.), (Eyre & Spottiswoode, London, 1954), p. 157.

17 Miss Jinny Jenks, *A Tour in North Wales* (1772), (NLW MS 22753B), p. 26. Available online at www.gtj.org.uk/en/item1/5698 as part of the online collection *Gathering the Jewels*.

18 Nicholas Owen, *Caernarvonshire: A Sketch of its History, Antiquities, Mountains, and Productions. Intended as a Pocket Companion to those who make a Tour of that County* (London: 1792), pp. 12-13, 17.

Nicholas Owen (1752-1812) came from Pencraig, Llangefni, Anglesey and graduated from Jesus College, Oxford in 1773. In 1789 he was installed in Bangor and eventually, in 1800, became Rector of Sarn Melltyrn with Botwnnog on Pen Llyn in Caernarvonshire. He is recorded as having provided information about the county to Edward Hyde Hall for his *Description of Caernarvonshire* (1809-1811).

19 Thomas Telford, quoted by J. Rickman, ed., *Life of Thomas Telford* (London: 1834), p. 213 and cited by Barrie Trinder, 'The Holyhead Road: an engineering project in its social context' in *Thomas Telford: Engineer - Proceedings of a seminar held at the Coalport Chinaworks Museum, Ironbridge, April 1979* (Thomas Telford Ltd, London: 1980), pp. 42 & 43.

20 Edward Pugh, *Cambria Depicta: A Tour Through North Wales, illustrated with Picturesque Views* (London: 1816), pp. 17, III.

21 Sir Richard Colt Hoare, *The Journeys of Sir Richard Colt Hoare through Wales and England 1793-1810* (Alan Sutton, Gloucester:

1983), p. 17.

22 Prince Hermann von Pückler-Muskau, *A Tour in England, Ireland, and France, in the Years 1828 and 1829 by a German Prince in Four Volumes* (London: 1832), Vol. 1, Letter 1, p. 15.

Prince Hermann von Pückler-Muskau was a writer, traveller and garden designer. He inherited his estate at Muskau that lay across what is now the German-Polish border in 1811. Inspired by his tours abroad, in 1816 he began creating an extensive landscaped park at Muskau. He sold the estate in 1845 settling at Schloss Branitz near Kottbus, south of Berlin, where he proceeded to lay out another great park and gardens.

23 Lord John Henry Manners (later the 5th Duke of Rutland), *Journal of a Tour through South and North Wales and the Isle of Man &c., &c.* (London: 1805), p. 1.

24 Samuel Lysons to Hester Lynch Piozzi, 12th October 1785 from *The Piozzi Letters: Correspondence of Hester Lynch Piozzi, 1784-1824*, Vol. 1, 1784-1791, Edward A. & Lillian D. Bloom (Eds) (University of Delaware Press, London & Toronto: 1989)

25 The Rev. Richard Warner, *A Walk through Wales, in August 1797* (Bath & London: 1798), p. 3.

26 John Broster, *Circular Tour from Chester through North Wales, embellished with plates* (London: 1802), pp. ii, 17, 67.

John Broster was a successful printer who established himself as a printer in Bangor in 1807. He had been a printer in Chester for a number of years before this and until 1817, when he handed over the reins to his son Charles, the company traded as J Broster & Son, Chester and Bangor.

27 Benjamin Heath Malkin, *The Scenery, Antiquities, and Biography of South Wales: Two Excursions in the year 1803* (London: 1804), p. vi.

28 George Nicholson, *The Cambrian Traveller's Guide and Pocket Companion: in every direction, containing remarks made during many excursions, in the principality of Wales, and bordering districts, augmented by extracts from the best writers*, (Stourport & London: 1813), Preface pp. iv-v.

29 The Rev. William Gilpin, *Observations on the River Wye, and several parts of South Wales &c. relative chiefly to Picturesque Beauty, made in the Summer of the Year 1770* (2nd edition, London: 1782), p.133.

30 Samuel Leigh, *Leigh's Guide to Wales and Monmouthshire* (London: 1831), p. 76.

Inns

1 Wyndham, *A Tour through Monmouthshire and Wales*, pp. 17 & 80.

2 Manners, *Journal of Tour through North and South Wales*, p. 77.

3 Warner, *A Walk through Wales*, Letter IX, Conway, August 22nd, pp. 137-138.

4 Pugh, *Cambria Depicta*, p. 93.

5 Edward Daniel Clarke, *A Tour through the South of England, Wales and part of Ireland, made during the summer of 1791* (London: 1793), p. 281.

6 John Byng, *Tour into North Wales 1793* from *Rides Around Britain* (The Folio Society, London: 1996), Donald Adamson (Ed.), p. 450.

7 Manners, *Journal of a Tour through North and South Wales*, p. 81.

8 *Black's Picturesque Guide to South-Wales and Monmouthshire* (Edinburgh, London & Chester: 1871), p. 300.

9 The Rev. John Skinner, *Tour into South and North Wales 1802*, (Cardiff Central Library, MS.1. 497), ff. 25 & 26.

10 Captain Jenkin Jones, RN, *Tour in England and Wales, May-June, 1819*, (Trans Historical Society of West Wales, I, 1911, NLW, MS785a), pp. 97-144.

11 Thomas Roscoe, *Wanderings in South Wales including the Scenery of the River Wye*, (London & Birmingham: 1837), p. 18.

12 Louisa Costello, *The Falls, Lakes and Mountains of North Wales* (London: 1845)

Louisa Stuart Costello (1799-1870) was an Anglo-Irish popular writer, novelist and poet who wrote on travel and French history. A friend of Walter Scott, she was considered by Elizabeth Barrett Browning to be 'a highly-accomplished woman...full of grace and a sense of beauty'. (*Letters of Elizabeth Barrett Browning Addressed to Richard Hengist Horne*, London, 1877), pp. 154-155.

13 John Loveday, *Diary of a Tour in 1732 through parts of England, Wales, Ireland and Scotland*, (Edinburgh: 1890), p.80.

FINDING THE WAY

Maps

1 In Wales the major post roads either ran along the North Wales coast to Holyhead and Ireland or, similarly through South Wales to Milford Haven and Ireland. Centuries later these routes are still the main arteries of Wales carrying the A5 and A55 in the north, the M4 and A4 in the south.

2 Glasgow University Library: Special Collections Department, Julie Gardham June 2002, special.lib.gla.ac.uk/exhibns/month/june2002

3 Esther Moir, *The Discovery of Britain*, p. 9.

4 Carole Fabricant, 'Eighteenth-century Travel Literature' in *The Cambridge History of English Literature 1660-1780*, John Richetti (Ed.), (Cambridge University Press: 2005), p. 721.

5 John Byng's original hand-written travel journals have sections of these hand-coloured strip maps pasted on the appropriate pages with his route coloured in yellow. At the time of writing these were held in Cardiff Central Library.

Writers

1 George, 1st Baron Lyttelton, *Account of a Journey into Wales in two letters to Mr. Bower* (London: 1774).

2 Donald Moore, *The Discovery of Welsh Landscape* (Christopher Davies, Swansea: 1976), p. 150.

3 Thomas Pennant, *A Tour in Scotland 1769* (1771); *A Tour in Scotland, and Voyage to the Hebrides 1772*, (1774); *The Journey to Snowdon* (1781); *The Journey from Chester to London*, (1782).

4 Thomas Pennant, *The Literary Life of the late Thomas Pennant, by himself* (London: 1793), p. 10.

5 Quoted from the National Library of Wales on Thomas Pennant: llgc.org.uk/collections/digital-gallery/pictures/journeytosnowdon.

6 This dinner service was an incredible undertaking made up of 952 pieces. The view of Downing was described in French as being in Flintshire 'the country of the celebrated naturalist Monsieur Pennant, who has contributed with all his power to the perfection of this work'.

7 Henry Skrine, *Two Successive Tours of Wales* (London: 1798), Preface, p. xvi.

8 Thomas Pennant, *Tours in Wales, Volume II* (1810), p. 149. This was the home of Bell Lloyd (1725-1793), Pontruffydd Hall of which there only survives a beautiful ruined gothic arch.

9 Byng, *Rides Round Britain*, p. 400.

10 *The Torrington Diaries; a selection from the tours of the Hon. John Byng between the years 1781 and 1794*, Cyril Bruyn Andrews (Ed.), (Eyre and Spottiswoode, London: 1954).

11 William Gilpin, *Observations on the River Wye, and several parts of South Wales &c.* (London: 1782)

12 William Gilpin, Essay III, 'On the Art of Sketching Landscape, from *Three Essays: On Picturesque Beauty; on Picturesque Travel; and on Sketching Landscape* (London: 1791), p. 61.

13 The Claude Glass 'A pleasing and beautiful instrument, for viewing clouds, landscape, &c.; ...the Mirror condenses or diminishes the view into a true perspective effect, the instrument is invaluable to the artist, and is a very desirable companion for the tourist.' from a nineteenth-century French optical catalogue (Victoria & Albert Museum website)

14 Salvator Rosa (1615-1673), was the Italian painter principally admired in the eighteenth and nineteenth centuries for his wild landscapes and dramatic mountain scenery. Horace Walpole considered that the dramatic views of the Alps, seen on his first crossing into Italy (1739) were 'Precipices, mountains, torrents, wolves, rumblings – Salvator Rosa...' Many writers of Tours of Wales refer to his work such as Thomas Pennant: in his *Journey to Snowdon* (1782), p. 44:

> The whole scenery requires the pencil of a Salvator Rosa: and here our young artists would find a fit place to study the manner of that great painter of wild nature.

15 Elizabeth Wheeler Manwaring, *Italian Landscape in Eighteenth Century England*, (Oxford University Press, New York: 1925), p. 68.

16 William Gilpin, *Observations on several parts of the counties of Cambridge, Norfolk, Suffolk, and Essex. Also on several parts of North Wales; relative chiefly to Picturesque Beauty, in two Tours, the former made in the year 1769; the latter in the year 1773*, (London: 1809)

17 Peter Lord, *The Visual Culture of Wales: Imaging The Nation*, (University of Wales Press, Cardiff: 2000), p. 11.

18 Pugh, *Cambria Depicta*, Preface pp. iv-v.

19 Y Fachddreiniog is an early 19th-century house, ...and is a classic example of an early villa, linked to the Picturesque: it was specifically designed for its views, being only one room deep so that one could see across the lake from every room (although not actually either end of it): interestingly, it has an outside kitchen.

20 Richard Fenton, *A Historical Tour through Pembrokeshire*, (London: 1811; reprint 1903), p. i.

21 J.C. Loudon, *Calls in Hertfordshire, Bedfordshire, Berkshire, Surrey, Sussex and Middlesex, July-August 1829, The Gardener's Magazine; extract from In Search of English Gardens: The Travels of John Claudius Loudon and his wife Jane*, Ed. Priscilla Boniface (National Trust Classics: Century, p/b, 1990), p. 33.

22 J.C. Loudon, *The Gardener's Magazine*, (1835), p. 539.

23 J.C. Loudon, *Encyclopaedia of Gardening*, (London, Second Edition 1824), p. 1085.

The Coming of the Railway

1 *The Gardener's Magazine*, December 1837, p. 543.

2 'Thomas Cook and Tourist Travel', www.bristolreads.com/around the world.

3 Jack Simmons, 'Thomas Cook of Leicester', Leicestershire Archaeological and Historical Society, Vol. XLIX-3, pp. 24-25.

4 William Cathrall, *Wanderings in North Wales; A Road and Railway Guidebook* (London: 1851)

5 *A Handbook for Travellers in North Wales*, (John Murray, London: 1868), pp. xxv, xxvi.

6 Mr & Mrs S.C. Hall, *The Book of South Wales: The Wye and the Coast* (Arthur Hall, Virtue & Co., London: 1861), pp. 292, 470.

7 *Bradshaw's Descriptive Railway Hand-Book*, p. 49.

8 Britannia Park was never completed by Paxton, although some of its features were installed and planted such as the Lime Avenue and a cascade. Purchased by Richard Davies in 1867, it became part and parcel of Treborth House with a garden designed by Edward Milner in 1875.

9 *A Handbook for Travellers in North Wales*, p. xxvi.

10 *Blackwood's Edinburgh Magazine*, Volume 54, No. 334, August 1843.

THE SEVENTEENTH CENTURY
Chirk Castle

1 Family details from Emeritus Professor Arthur Herbert Dodd, M.A., 'MYDDELTON, of Gwaenynog, Denbigh, Chirk, and Ruthin (Denbs.), London, and Essex', Welsh Biography Online, www.llgc.org.uk.

2 Whittle, *The Historic Gardens of Wales*, p. 19.

3 Quoted in *Chirk Castle* (The National Trust, 2003), p. 28

4 Peter Lord, *Imaging the Nation*, p. 57.

5 The Sensitive Plant is *Mimosa pudica* from Central and South America. Its name, from the Latin, pudica = shy, bashful or shrinking, led to its being called the sensitive plant. A creeping herb grown for its curiosity value, its leaves fold in and droop when touched or shaken, re-opening minutes later. This should be the plant mentioned by Thomas Dineley as Robert Hooke (1635-1703), the English scientist famous for his early work with microscopes, was one of the first people to investigate the movement of the sensitive plant. *Mimosa pudica* was first formally described by Linnaeus in 1753.

6 Sir Richard Myddleton, 3rd Baronet, had only just inherited Chirk and his title from his brother who had died earlier in the year.

7 Dineley, *The Account of the Official Progress...Through Wales*, p. 313.

8 John Davies, 'William Emes in Wales', *Newsletter No. 8*, June 1995 (Welsh Historic Gardens Trust), p. 88.

9 Wyndham, *A Tour in Wales*, p. 175.

10 Quoted from the *Chirk Castle Accounts* by John Davies in 'William Emes in Wales', *Newsletter No. 8*, June 1995 (Welsh Historic Gardens Trust), p. 84.

11 Edward Hubbard, *The Buildings of Wales: Clwyd (Denbighshire & Flintshire)*, (Penguin Books: University of Wales Press, 2nd edition, 1994), p. 128.

12 Davies, 'William Emes in Wales', p. 88.

13 Byng, *The Torrington Diaries*, pp. 179-180.

14 Byng, *Rides Around Wales*, p. 435.

15 Richard Myddleton had died just before Sir Christopher Sykes paid his visit to Chirk. As he was unmarried the 'Lady' referred to must be his mother, Elizabeth Rushout, daughter of Sir John Rushout, 4th Baronet of Northwick Park, Worcestershire.

16 Sir Christopher Sykes, Bt., *Journal of a Tour in Wales 1796*, (NLW MS. 2258.C), ff. 73, 75, 76.

17 Warner, *A Walk through Wales, in August 1797*, p. 185.

18 Adrian Bristow (Ed.), *Dr Johnson & Mrs Thrale's Tour in North Wales 1774* (Bridge Books, Wrexham: 1995), p. 120.

19 Sir Richard Colt Hoare, *The Journeys of Sir Richard Colt Hoare through Wales and England 1793-1810*, M.W. Thompson (Ed.), (Alan Sutton, Gloucester: 1983), 1798: North Wales and Monmouthshire, p. 92.

20 Ibid., 1799: The Marches and North Wales, p. 113.

21 John Broster, *Circular Tour from Chester through North Wales* (London: 1802), p. 9.

22 Samuel Lewis, *A Topographical Dictionary of Wales* (London: 1832); this is unpaginated – see Vol. I under Chirk.

23 George Borrow, *Wild Wales* (John Murray, London: 1862 re-published by Bridge Books, Wrexham: 2009), pp. 247, 248, 252-253.

24 History does not relate what happened to the statue of Mars. The Farnese Hercules is an ancient statue, made in the early third century AD. The enlarged copy was made for the Baths of Caracalla in Rome, where the statue was discovered in 1546. It is now in the Museo Archeologico Nazionale in Naples. The heroically-scaled *Hercules* is one of the most famous sculptures of antiquity and copies were purchased by many young aristocrats who had made the Grand Tour to Italy like Sir Thomas Myddleton.

25 Reginald Blomfield and F. Inigo Thomas, *The Formal Garden in England* (Macmillan, London: 1892), pp. 232, 235. Reginald Blomfield (1856-1942) published this book with his fellow-architect Francis Inigo Thomas (1865-1950). They did the research together: Blomfield wrote the text and Inigo Thomas provided the drawings. After its publication they both received garden design commissions, sometimes working together, creating formal gardens for Tudor mansions.

26 *Chirk Castle*, (National Trust, 2003), p. 45.

Margam Abbey

1 John Newman, *The Buildings of Wales: Glamorgan* (Penguin Books/University of Wales Press, London: 1995), p. 422.

2 Dineley, *The Account of the Official Progress...*, pp. 313, 314.

3 George Lyttelton, 1st Lord Lyttelton, *An Account of a Journey into Wales* (London: 1781), Vol. 2, pp. 201-202.

4 With the failure of the direct Mansel line in 1744 the inheritance of the Margam and Penrice estates went sideways and, following the deaths of both the 3rd and 4th Lords Mansel, Margam was inherited by their sister, Mary Mansel. She married, in 1716, John Talbot of Lacock Abbey in Wiltshire. Their first son inherited Lacock Abbey and their second son, the Rev. Thomas Talbot (1719-1758) in time inherited Margam and Penrice hence the new name of Mansel Talbot. His son was Thomas Mansel Talbot.

5 Details from *An Inventory of the Ancient Monuments in Glamorgan, Volume 4, Part 1* (Royal Commission on the Ancient and Historical Monuments in Wales, Aberystwyth: 1981), pp. 325-327.

6 Quoted from Joanna Martin, *Henry and the Fairy Palace*, (National Library of Wales, Aberystwyth: 1992.), pp. 126-7.

7 John Byng, *A Tour into South Wales in August 1787*, (MS 3. 235, Volume I, ff. 76, Cardiff Central Library), ff. 77-78. Byng had discovered a stag housed in the Chapter House. He was not alone in caring passionately about the fate of the beautiful Chapter House. George Nicholson's *The Cambrian Traveller* (1808) noted that 'on the 17th of Jan. 1799, in consequence of the outer walls becoming defective, this elegant Gothic structure became a ruin.'

8 Colt Hoare, *The Journeys of...*, 1793: South Wales, p. 55.

9 Davies, 'William Emes in Wales', p. 90.

10 Sykes, *Journal of a Tour*, ff. 17-19.

11 The Rev. Richard Warner, *A Second Walk through Wales, in August and September 1798* (London: 1800), pp. 82-83, 86.

12 Colt Hoare, *The Journeys of...*, 1802: South Wales, p. 212.

13 Philip Miller's *Gardener's Dictionary* (5th edition: London: 1763) describes the Orange varieties commonly known in the eighteenth century. Listed under Aurantium they include the Bitter or Seville Orange (*Citrus aurantium*); the China Orange (*Citrus sinensis*); a Pomegranate orange does not appear and it is unclear whether this is the pomegranate itself or a form of orange; the curled leaf orange; the Dwarf or Nutmeg Orange [modern reference books do not

relate what this might be]; Lemons – called Limon by Miller who listed 9 varieties as 'the most remarkable found in English gardens'; Bergamot orange (*Citrus bergamia*); the Citron (*Citrus medica* – meaning 'from Media'), the oldest known form of citrus largely prized for its peel; the Shaddock (*Citrus grandis*), apparently so-called after the naval captain who introduced it to the West Indies.

14 Nicholson, *Cambrian Traveller's Companion* (1808), pp. 415-416.

15 Edward Donovan, *Descriptive excursions through South Wales and Monmouthshire: in the year 1804, and the four preceding summers* (London: 1805), p. 7.

16 Margaret Martineau, *A Journey from St Albans into North and South Wales*, (Hampshire Record Office, 83M93/21), pp. 44-45.

17 Benjamin Heath Malkin, *The Scenery, Antiquities, and Biography, of South Wales from materials collected during two excursions in the year 1803* (London: 1804), p. 611.

18 Groes suffered the fate of its predecessor when it too was swept away with the building of M4 in 1975.

19 Details from *Journal of Horticulture, Cottage Gardener*, Vol. XXV, August 1878, p. 131.

20 Esther Williams, unpublished tour of Wales, 1836, (MS1.521, Cardiff Central Library).

21 *Glamorgan* (Cadw: Welsh Historic Monuments/ICOMOS UK, Cardiff: 2000), p.III.

22 *Journal of Horticulture, Cottage Gardener*, Vol. XXV, August 1878, p. 110.

23 *Sequoiadendron giganteum* – the seed was first introduced to Britain in 1853.

24 *Journal of Horticulture*, Vol. XXV, pp. 129-31.

25 *The Gardeners' Chronicle*, November 12, 1881, pp. 622, 655.

26 *Journal of Horticulture*, Vol. 16, 1888, pp. 69, 70.

27 *The Gardeners' Chronicle*, February 3, 1894, p. 135.

28 This was the wedding on July 6 1893 of Prince George, Duke of York and Princess Mary of Teck, later King George V and Queen Mary. This gesture was repeated on the marriage of HRH The Prince of Wales to Lady Diana Spencer in 1981 when branches of orange blossom from Margam were attached to their carriage.

29 The first hydrangea called then *Hydrangea hortensis* rather than hortensia was first introduced to Britain from a Chinese garden by Sir Joseph Banks.

Powis Castle

1 Many Welsh aristocrats were secretly or, in some cases like the Herberts, openly, supporters of the Jacobite cause – Lord Bulkeley of Baron Hill, Sir Watkin Williams Wynn, 3rd Baronet, of Wynnstay and Sir John Philipps of Picton Castle were known to have Stuart sympathies. Sir Watkin founded the Circle of the White Rose, a clandestine Jacobite society.

2 The 1st Marquess had died in exile in France. His Welsh estates were forfeit to the Crown and William III gave them to his Dutch compatriot, William van Nassau van Zuylestien, later Lord Rochford. He spent little time at Powis and returned to the Netherlands in 1627. The 2nd Marquess was reinstated in 1722.

3 Stephen Lacey, *Powis Castle Garden* (1997), p. 3.

4 Family details from Burke's *Extinct and Dormant Baronetcies of England* (1844). Winde worked at Castle Bromwich for Sir John Bridgeman and his wife, Mary from 1685-c. 1704 giving advice usually by letter as he was busy elsewhere. Mary Bridgeman refers to him as 'cousin' in her letters to him asking for advice on Castle Bromwich and Winde offered practical suggestions on both layout and planting. A letter from Winde to Lady Bridgeman on 17 July 1704 starts 'I have lately received from my cosen Bridgeman (by yr Ladp commands) a bill ...'. There seems to have been quite a close relationship between the Bridgemans and Winde and this may account for Sir John's interest in the development at Powis Castle.

5 John Loveday, *Diary of a Tour in 1732 through parts of England, Wales, Ireland and Scotland* (Edinburgh: 1890), p. 16.

6 Oakley Park is just across the border in Shropshire.

7 Lyttelton, *An Account of a Journey into Wales*, pp. 555-56.

8 Byng, *Tour to North Wales*, 9 July-20 August 1794, Saturday July 3, p. 137-138.

9 Warner, *A Walk through Wales*, p. 67. The piece quoted is from Alexander *Pope's Epistle to Several Persons: Epistle IV* (1731).

10 The Rev. John Evans, (1768-1812), *A tour through part of North Wales, in the year 1798, and at other times : principally undertaken with a view to botanical researches in that Alpine country: interspersed with observations on its scenery, agriculture, manufactures, customs, history, and antiquities* (London: 1800), Letter 9 from Bangor, pp. viii.

11 Henry Skrine, *Two Successive Tours throughout the whole of Wales* (London: 1798), p. 246.

12 Colt Hoare, *The Journeys of...*, 1799: The Marches and North Wales, p. 112.

13 Colt Hoare's friend was the Rev. Frowd, who had the living at Bishop's Castle, just over the border in Shropshire.

14 Colt Hoare, *The Journeys of...*, p. 112.

15 J.C. Loudon, *An Encyclopaedia of Gardening* (London: 1824), p. 1086.

16 Edward Clive had inherited Powis from his uncle, the second Earl of Powis, known for his prodigal ways in London rather than in Wales. This had contributed the neglect and decay at Powis commented on by visitors at the end of the eighteenth century. He was created 1st Earl of Powis (of the third creation) in 1804 as a reward for services in India and acknowledging that his son was the heir to Powis.

17 Quoted in *Powys* (Cadw: ICOMOS Register, 1999), p. 222.

18 Thomas Roscoe, *Wanderings and Excursions in North Wales*, (London: 1836), p. 253.

19 Advertisement from *Annals & Antiquities of the Counties and County Families of Wales* by Thomas Nicholas (Longman, Green, Reader, and Co., 1872).

20 *The Gardeners' Chronicle ii*, 1879, p. 787.

21 *The Garden*, October 7, 1893, pp. 321, 322.

22 *The Gardeners' Chronicle v*, 1894, pp. 310-312.

23 Quoted by Christopher Rowell in *Powis Castle* (The National Trust, 1988), p. 44.

24 Helena Attlee, *The Gardens of Wales* (Frances Lincoln Ltd, London, 2009), p. 54.

Llanerch Park

1 Foulk Wynne, from a late seventeenth-century praise poem translated from the Welsh (NLW MS 263B) and quoted in Peter Lord, *Imaging the Nation*, p. 82.

2 John Loveday, *Diary of a tour in 1732*, pp. 69, 70.

3 Robert Plot, *The Natural History of Oxfordshire* (1677), p. 243.

The website www.polyolbion.org.uk (accessed 8.04.2014) gives a detailed history of the site and the archaeological work being undertaken to reveal the remains of the Enstone Marvels through the Hanwell Park Project.

4 Jinny Jenks, *A Tour in North Wales*, pp. 46-47.

5 Adrian Bristow (Ed.), *Dr Johnson & Mrs Thrale's Tour in North Wales 1774* (Bridge Books, Wrexham: 1995), p. 40.

6 Thomas Pennant, *Journey to Snowdon* (London: 1771), pp. 51-52.

7 Phillip Yorke, *The Royal Tribes of Wales* (Wrexham: 1799), p. 98.

8 The Rev. John Evans, *The Beauties of England and Wales* (London: 1812), p. 530.

9 Loudon, *An Encyclopaedia of Gardening*, p. 1085.

10 Thomas Nicholas, *Annals and Antiquities of the Counties and County Families of Wales*, (Longman, Green, Reader, and Co.,

London: 1872), p. 406.

11 Whittle, *The Historic Gardens of Wales*, p. 27.

Dynevor Park (Newton House)

1 Donald Moore, 'Dynevor Castle and Newton House', (*Archaeologia Cambrensis*, Journal of the Cambrian Archaeological Association, Vol. CXLIII, 1994), pp. 204-235.

2 Manners, *Journal of a Tour through North and South Wales*, pp. 106-107.

3 Dr Richard Pococke, *Travels through England*,(The Camden Society, London: 1888), Vol. 3, 1756, p. 195.

4 Letter from Lancelot Brown to George Rice, August 20th 1775.

5 Lancelot Brown, Facsimile of his Account Book, RHS Lindley Library, p. 126.

6 Quoted in Roger Turner, *Capability Brown and the Eighteenth-Century English Landscape* (Phillimore, Chichester, 2nd Edition 1999), p. 17.

7 Arthur Young, *Annals of Agriculture*. Suffolk-born Arthur Young (1741-1820) was one of the most important writers about and promoter of agricultural improvement. He travelled all over Britain, Ireland and France. He published the *Annals of Agriculture* between 1784 and 1809. He first visited Wales in 1776.

8 Mrs Mary Morgan, *A Tour to Milford Haven in the year 1791*, (London: 1795), pp. 366-368.

9 Colt Hoare, *Journal of a Tour in South Wales, Anno 1793* from The Journeys of, p. 39.

10 Dr George Lipscombe, *Journey into South Wales*, (London: 1802), pp. 193-95.

11 Malkin, *The Scenery, Antiquities and Biography of South Wales*, pp. 571, 573-74.

12 Richard Fenton, *A Historical Tour through Pembrokeshire* (London: 1811; reprinted 1903), p. 62. The poetry is quoted from *Poems by Mr Fenton* (London, 1790), Vol I, pp. 11-17, 'On Seeing Dynevor Park, The Seat of Lady Dynevor in May 1789'.

13 Roscoe, *Wanderings ... South Wales*, (London: 1837), p. 194.

14 Catherine Sinclair, *Hill and Valley, or, Wales and the Welsh* (London: 1839), pp. 252-5.

15 *Illustrated London News*, 15 January 1859.

16 Mr & Mrs S.C. Hall, *The Book of South Wales*, p. 368.

17 Gerald Morgan, *Dinefwr: A Phoenix in Wales* (Gomer Press, Ceredigion: 2014), p. 125.

Picton Castle

1 Dineley, *The Official Progress...*, pp. 278.

2 Sir Erasmus Philipps, *A Journal of my Travels into Holland, Germany &c. in 1719* (NLW, MS 23273A), ff. 176, 181, 183.

3 I am indebted to *The Families of Picton* (Picton Castle Trust, 2002) by Hero von Friesen and Thomas Lloyd for their clear account of the family and its succession over the centuries.

4 Sykes, ff. 35.

5 Mrs Mary Morgan, *A Tour to Milford Haven*, Letter XXIII, pp. 294-96.

6 Manners, *Journal of a Tour through North and South Wales*, pp. 163-168.

7 The Rev. J. Evans, *Letters written through a Tour of South Wales, in the year 1803* (London: 1804), p. 271.

8 Richard Fenton, *A Historical Tour through Pembrokeshire* (Dyfed County Council, 1994; reprint of 1811 edition first published in 1903), pp. 152-3.

9 Nicholson's *Cambrian Traveller*, quoting Fenton: p.188.

10 The Rev. T. Rees, *A Topographical and Historical Description of South Wales* (London: 1815), p. 785.

11 Hero von Friesen & Thomas Lloyd, *The Families of Picton*, p. 27.

12 Roscoe, *Wanderings in South Wales*, p. 167.

THE EIGHTEENTH CENTURY

1 Mark Girouard, *Life in the English Country House* (Yale University Press: 1978), p. 190.

2 Mrs Mary Morgan, *A Tour to Milford Haven*, Letter XXIII.

3 Richard Owen Cambridge, *The World*, (London, 1754).

4 Thomas Herring, *Letters...to William Duncombe from the year 1728 to 1757* (London: 1777), pp. 39-40. It is worth noting that Bishop Herring only visited his remote Welsh diocese during the summer months.

Wynnstay

1 Christine Gerrard, 'Lyttelton, George, first Baron Lyttelton (1709–1773)', *Oxford Dictionary of National Biography*, Oxford University Press: 2004; online ed., May 2009.

2 This is a reference to the house that had been enlarged for the 3rd Baronet by Francis Smith in the 1730s. He was the father of the 4th Sir Watkin Williams Wynn who employed Capability Brown.

3 Lyttelton, *An Account of a Journey into Wales*, p. 563.

George Lyttelton, 1st Lord Lyttelton (1709-1773) was a friend of Alexander Pope, and as the owner and creator of Hagley Park in Staffordshire, a lover of 'romantick landscapes'. The poet James Thomson was a frequent visitor to Hagley and revised his famous poem about landscape, *The Seasons*, there in the summer of 1743. Lyttelton's tour to Monmouthshire was written 'with the intention of attracting visitors to Wales which he regarded as under-visited. [p. i]

4 'A Pocket Book of Mapps of Demesne Land belonging to Sir Watkin Williams Wynn' (c. 1740) by Thomas Badeslade. This is privately owned and not available to reproduce. The photocopy listed in Clwyd Record Office (NTD/176) appears to have been mislaid in the reorganisation of the archives between the Ruthin and Hawarden Record Offices. I am immensely grateful to Elisabeth Whittle for the sight of her copy of the pages in question.

5 P.Q., 'Animadversions on the Journey into Wales', *The Gentleman's Magazine*, January 1768, p. 6. See also T.K., 'Account of a Journey through North Wales', *The Gentleman's Magazine*, December 1767, pp. 589-90, c.f. Griffiths, p. 8.

6 Pennant, *Tours in Wales,* (2nd ed.: 1810), Vol. I, 'Advertisement of the Author', p. viii.

7 Fiona Cowell, 'Richard Woods (? 1716-93): A Preliminary Account, part II', *Garden History* 15.1 (Garden History Society, 1987), pp. 29-31; *Richard Woods (1715-1793): Master of the Pleasure Garden* (The Boydell Press: 2009), pp. 241-242.

8 The Duchess of Argyll ordered '498 square tiles the same as made for Sir WWW', quoted in Paul Hernon, *Sir Watkin's Tours: Excursions to France, Italy and North Wales, 1768-71* (Bridge Books, Wrexham: 2013), p. 118. These tiles are now lost.

9 Wyndham, *A Gentleman's Tour*, p. 174.

10 Laura Mayer, *Capability Brown and the English Landscape Garden* (Shire Publications, Oxford: 2011), p. 41.

11 John Evans (1723-95) is best-known as a cartographer of Wales and his nine-sheet map of North Wales (1795) was dedicated to the 5th Sir Watkin Williams Wynn of Wynnstay.

12 Details from a reprint of a 1784 newspaper account of 'The Belan Water' reproduced, courtesy of Thomas Lloyd, in *The Bulletin*, (Welsh Historic Gardens Trust, Summer 1999).

13 Byng, *The Torrington Diaries*, p. 176.

14 Skrine, *Two Successive Tours throughout the whole of Wales*, Book II – Tour of North Wales, pp. 183-184.

15 Nicholson, *The Cambrian Traveller's guide*, pp. 549-550.

16 Sykes, ff, 72.

17 Edward Pugh, *Cambria Depicta*, p. 321. Pugh describes his work as being undertaken in 1813 and there is a publisher's note to the effect that Pugh died before publication in June 1816.

18 Ibid., p. 550.

19 Bowood, Wiltshire. Capability Brown designed the landscape here in 1762. The cascade referred to is probably Hamilton's Cascade installed some 15 years later.

20 The Rev. J Evans, *The Beauties of England & Wales: or, Original Delineations Topographical, Historical and Descriptive of each County: North Wales* (London: 1812), p. 581. *The asterisk refers to a footnote that describes how the trees referred to were moved into place in the eighteenth century:

21 William Bingley, *Excursions in North Wales: including Aberystwyth and the Devil's Bridge intended as guide for Tourists* (1839), p. 234.

22 Bernard Burke, *A Visitation of the Seats and Arms of the Noblemen and Gentlemen of Great Britain*, Vol. ii, p. 36.

23 The column was erected by his grandmother in memory of his father, the 4th Baronet.

24 Octavius Morgan, *Journal of a Tour through North Wales* in 1821, quoted from an article by Dai Morgan Evans published in *Archaeoligica Cambrensis*, Volume 160 (2011), and transcribed from an original MS lodged with the Society of Antiquaries, MS/680, p. 245. Octavius Morgan was travelling with his father, Sir Charles Morgan of Tredegar Park in South Wales, and his sister Angelena.

25 Loudon, *Encyclopaedia of Gardening* (1822), p. 1085.

26 *Leigh's Guide*, p. 289

27 Amelia Waddell (later Lady Jackson), *Diary of Amelia Waddell and her brother George Waddell (Junior) on a tour in Wales, May-Sep 1828*, (Royal Geographical Society, SSC/79 & GB 0402 LAJ), pp. 124-126.

28 Edward Hubbard, *The Buildings of Wales: Clwyd* (Penguin Books/University of Wales Press: 1986), p. 313.

29 Nicholas, *Annals & Antiquities ...*, p. 367.

30 Russell Davies, *Hope and Heartbreak: A Social History of Wales and the Welsh, 1776–1871* (University of Wales Press, Cardiff: 2005), p. 93.

31 Sykes, ff. 77.

32 Mark Girouard, *The Victorian Country House* (Yale University Press, New Haven and London: 1979), p. 318.

Plas Newydd, Anglesey

1 Henry, 7th Marquess of Anglesey, 'The Gardens at Plas Newydd', *Newsletter No. 8, June 1995* (Welsh Historic Gardens Trust), p. 83.

2 Lyttelton, *A Tour into Wales...*, (London: 1781), Vol. II, p. 560.

3 Pennant, *Tours in Wales* (1770), Vol. III, p. 18.

4 Mrs Thrale, *Dr Johnson & Mrs Thrale's Tour*, p. 112.

5 Byng, *A Tour in South Wales*, 1787, Monday July 12, p. 163.

6 Colt Hoare, *The Journeys of...*, 1797, p. 70-71.

7 Manners, *Journal of a Tour through North and South Wales*, pp. 311-312.

8 Graham Stuart Thomas, *Gardens of the National Trust*, p. 70.

9 Humphry Repton, *Plas Newydd in the Isle of Anglesea, North Wales, the seat of the Rt Honble the Earl of Uxbridge*, MS Red Book, 1799 (NLW. MS 2052. B), ff.1-2, 7, 9, 24, 25.

10 Colt Hoare, *The Journeys of...*, 1810: Caernarvonshire and Anglesey, p. 265.

11 Fenton, Anglesey 1810, p. 255.

12 Nicholson, *The Cambrian Traveller's Guide*, pp. 154-155.

13 Pückler-Muskau, *A Tour into England &c...*, Volume I, Letter III, pp. 97-99.

14 The Anglesey Column, designed by Thomas Harrison of Chester, was erected by public subscription in 1817 on land in Llanfair P.G. overlooking Plas Newydd. The bronze statue of the 1st Marquess by Matthew Noble was added in 1860.

15 Pückler-Muskau, *A Tour into England &c...*, Volume I, Letter III, pp. 97-99.

16 *Queen Victoria's Journals*, Lord Esher's typescripts, Vol. 1, p. 17, 23.

17 Louisa Stuart Costello, *The Falls, Lakes, and Mountains of North Wales*, pp. 80-81.

18 Margaret, Lady Willoughby de Broke (d. 1880) was the widow of the 8th Lord Willoughby de Broke and a member of a distinguished Welsh family, the Williams of Bodelwyddan Castle in Flintshire. Her husband died in 1852 and she had the beautiful 'Marble Church' built in his memory on the edge of the park of her childhood home. It would seem that she moved to Plas Newydd at some point around 1855.

19 *Journal of Horticulture*, September 25, 1873, p. 236, 237.

20 Colt Hoare, *The Journeys of...*, p. 265.

Baron Hill, Beaumaris, Anglesey

1 Mount Edgcumbe House in Cornwall, across the river Tamar from Plymouth has spectacular views to Plymouth Sound. Built (1547-1553) for the Edgcumbe family, it was the first house in England built to take advantage of a wonderful situation and views rather than as a defensive house built around a courtyard. The park and gardens are Grade I.

2 Loveday, *Diary of a Tour...*, p. 60.

3 Richard Pococke, *The Travels Through England...*, Volume I.

4 The paintings belong to a private collection and cannot be reproduced.

5 Dr Johnson, *Dr Johnson & Mrs Thrale's Tour*, p. 46.

6 Loudon, *An Encyclopaedia of Gardening*, p. 1085.

7 Colt Hoare, *The Journeys of...*, 1801: North Wales, p. 183.

8 The Castle was leased from the crown and then bought back by 7th Viscount.

9 William Watts, *The Seats of the Nobility and Gentry in a Collection of most interesting and Picturesque views* (London: 1779), Volume I, plate xi.

10 Owen, *Caernarvonshire*, p. 27.

11 Byng, *The Torrington Diaries*, pp. 166-267.

12 Byng, *A Tour to North Wales*, 25 June - 31 July 1784, (MS.3. 235, Vol. II, Cardiff Central Library), ff. 8-9.

13 Skrine, *Two Successive Tours*, pp. 205-206.

14 Colt Hoare, *The Journeys of*, p. 185.

15 Richard Fenton, *Tours in Wales* (1804-1813), from his MS Journals in the Cardiff Free Library, Ed. John Fisher, B.D. (Cambrian Archaeological Association, The Bedford Press, London: 1917), pp. 256, 268.

16 Colt Hoare, *The Journeys of, 1810: Caernarvonshire and Anglesey*, p. 267.

17 Broster, *Circular Tour*, p. 129.

18 Evans, *The Beauties of England & Wales*, p. 180.

19 Richard Llwyd, *Beaumaris Bay: A Poem: with notes, descriptive and explanatory; particulars of the Druids, founders of some of the fifteen tribes of North Wales, the ... from the bards* (J. Fletcher, 1800). This was the most celebrated poem by 'The Bard of Snowdon, Richard Llwyd' (1752-1835).

20 This court would have been for Royal or Real Tennis. Lawn Tennis was not patented until 1873.

21 Dr S. H. Spiker, *Travels through England, Wales, and Scotland in the Year 1816 by Dr S.H. Spiker, Librarian to His Majesty the King of Prussia, Dedicated to Friends of England, translated from the German*, (London: 1820, 2 vols.), Vol. II, p. 18. Dr Spiker, as Librarian to the King of Prussia (Frederick William III) was highly regarded as a writer in Germany. He visited England and Wales in 1815.

22 Nicholson, *The Cambrian Traveller's Guide*, p. 68.

23 Spiker, *Travels through England, &c.*, Vol. II, p. 19.

24 *The Journal of Horticulture*, Vol. 50, 1873, pp. 138, 139, 176.

25 *A Trip to the Suspension Bridge over the Menai Straits, to Caernarvon, the Lakes of Llanberis, Snowdon, Beddgelert, Capel Curig, Llanrwst, Conway and Beaumaris*, printed in the *Stockport Advertiser*, 21.7.1826, p. 62.

26 The present Sir Richard Williams-Bulkeley still owns the cucumber cutter belonging to his great-great grandfather.

27 *The Journal of Horticulture* (1873), p. 177.

28 Quoted by Penelope Hobhouse in *Plants in Garden History* (Pavilion Books, London, 1992), p. 250. Alfred de Rothschild lived at Halton in Buckinghamshire where his head gardener set out some 41,000 bedding plants – more than any duke.

29 Nicholas, *Annals & Antiquities...*, p. 6.

Penrhyn Castle and the Penrhyn Estate

1 John Summerson, *Georgian London* (1945), p. 65, quoted by John Martin Robinson in *The Wyatts: An Architectural Dynasty* (Oxford University Press: 1979).

2 This is the road praised by Edward Pugh in *Cambria Depicta*.

3 A.H. Dodd, *A History of Caernarvonshire* (Bridge Books, Wrexham: 1990), p. 232. By 1800 Richard Pennant, working with Benjamin Wyatt, was responsible for the planting of over 600,000 trees.

4 Quoted from *Conwy, Gwynedd & The Isle of Anglesey, Register of Landscapes, Parks and Gardens of Special Historic Interest in Wales* (Cadw:ICOMOS, Cardiff, 1998), p. 255.

5 Colt Hoare, *The Journeys of..., 1797: North and South-East Wales*, p. 71.

6 The Rev. J. Evans, *Tour through part of North Wales, in the year 1798* (London:1800), pp. 224, 236.

7 Nearly all the delightful additions to the Penrhyn Estate made in the 1780s and 1790s appear to have been designed by Benjamin Wyatt for Lady Penrhyn. All the travellers who noted Ogwen Bank and the ferme ornée, Pen isa'r Nant, attribute them to Lady Penrhyn. The Penrhyns were a childless couple and with Lord Penrhyn away pursuing his political and business interests it

would seem that Lady Penrhyn took the opportunity to indulge her imagination and occupy her time with the architectural delights that Wyatt created for her. She was known to adore small dogs – her carriage apparently always contained several who travelled with her everywhere. Pugh describes the 'large, handsome room' at Ogwen Bank which contained a beautifully ornamented chimney-piece with 'portraits of two favourite pug dogs and a terrier.' (*Cambria Depicta*, p. 105).

8 Anon, *Tour into South & North Wales, 1802* (MS. I. 497, Cardiff Central Library), ff. 35.

9 Fenton, *Caernarvonshire* (1810), p. 210-213.

10 Augustus Hare, *Memorials of a Quiet Life*, (London: 1872), p. 10.

11 Colt Hoare, *The Journeys of...*, 1810: Caernarvonshire and Anglesey, p. 258.

12 & 13 Pugh, *Cambria Depicta*, pp. 104-105.

14 Cathrall, *History of North Wales*, p. 101.

15 Roscoe, *Wanderings – North Wales*, p. 163.

16 Loudon, *An Encyclopaedia of Gardening*, p. 1085.

17 George Hay Dawkins' great-great grandfather was Giffard Pennant of Jamaica, Richard Pennant's grandfather. He had emigrated to Jamaica in 1658 establishing the sugar plantations that formed the basis of the Pennant fortune.

18 Cathrall, *History of North Wales*, p. 99.

19 Roscoe, *Wanderings – North Wales*, pp. 166-167.

20 *The Garden*, (London: 1854), p. 418.

21 *The Gardeners' Chronicle*, Vol. X, 9 November (London, 1878), p. 592.

22 *Fuchsia Riccartonii* was raised in 1830 by Mr Young, the head gardener at Riccarton in Scotland and is noted for its hardiness.

23 *The Gardeners' Chronicle*, 9 November 1878, p. 592.

24 *The Gardeners' Chronicle*, Vol. X, 17 October 1891 (London: 1891), pp. 454, 457.

25 *The Gardeners' Chronicle*, Vol. xiii, December 10 (London: 1892), p. 695.

26 *The Journal of Horticulture*, Vol. xxxi, August 8 (London: 1895), p. 131.

Stackpole Court

1 Joseph Addison, *The Spectator*, 1712.

2 The use of Sir John Campbell I and II is to distinguish them, one from another.

3 Marius and Sulla were two Roman Consuls c. 80 BC who began life as friends and ended it as bitter foes. They were responsible for Rome's first Civil War.

4 Mrs Mary Morgan, *A Tour to Milford Haven in the year 1791* (London, 1798), Letter L, October 7th, pp. 349 & 356.

5 Liz Pitman, *Pigsties and Paradise: Lady Diarists and the Tour of Wales* (Gwasg Carreg Gwalch, Llanrwst: 2009), p. 52.

6 Sir Christopher Sykes, *Journal of a Tour in Wales, 1796*, ff. 31.

7 Arabella Friesen, *Stackpole and the Cawdors: Evolution of a Landscape* (The National Trust), p. 21.

8 Manners, *Journal of a Tour of South and North Wales*, pp. 124-126. His stay and burgeoning friendship with the Cawdors was important to Lord John, at the time aged nineteen. Several years later he married Lady Elizabeth Howard, Lady Cawdor's younger sister.

9 Benjamin Heath Malkin, *The Scenery, Antiquities...of South Wales*, p. 530.

10 Richard Fenton, *An Historical Tour through Pembrokeshire*, pp. 229-30.

11 One link to Wales was that Lady Elizabeth's Mother, the Hon. Isabella Elizabeth Byng, was the niece of the peppery John Byng, the 5th Viscount Torrington.

12 Sir Jeffry Wyatville was born Jeffry Wyatt, the grandson of Benjamin Wyatt, Lord Penrhyn's agent at Penrhyn Castle. He designed parts of Windsor Castle, and carried out immense additions to Chatsworth. It is said he changed his name to Wyatville when a change of surname was suggested by George IV. John Martin Robinson, *The Wyatts, An Architectural Dynasty* (Oxford University Press, 1979), p. 120.

13 Arabella Friesen, *Stackpole and the Cawdors*, p. 15.

14 Samuel Lewis, *A Topographical Dictionary of Wales*, Vol. II, 1833, not paginated, see under 'Stackpole-Elidor'.

15 J.C. Loudon, *Arboretum et fruticetum Britannicum* (2nd Ed., London, 1854), p. 1237.

16 The Rev. Joseph Romilly, *Romilly's Visits to Wales, 1827-54: Extracts from the Diaries of the Reverend Joseph Romilly* (M.G.R. Morris, Ed.), (Gomer Press, 1998), South Wales Circuit, 1838, p. 75.

17 Thomas Roscoe, *Wanderings in South Wales including the Scenery of the River Wye* (London & Birmingham, 1837), pp. 155-157.

18 *A Handbook for Travellers in South Wales and its Borders, including the River Wye* (John Murray, London, 1860).

19 *The Gardeners' Chronicle*, Vol. XLV – 3rd Series January – June 1909, p. 218.

THE SEARCH FOR THE PICTURESQUE

1 Thomas Whateley, *Observations on Modern Gardening* (1770), pp. 106, 146.

2 Colt Hoare, *The Journeys of...*, Introduction, p. 14.

3 Skrine, *Two Successive Tours*, North Wales, p. 218.

4 Edmund Burke, *A Philosophical Enquiry into the Origin of Our Ideas of the Sublime and Beautiful* (London, 1759), p. 48.

5 William Gilpin, *Remarks on Forest Scenery* (London: 1791), Vol. I, p. 191.

6 Richard Payne Knight, *The Landscape; A Didactic Poem* (1794), quoted from John Dixon Hunt & Peter Willis, *The Genius of the Place*, (The MIT Press, Cambridge, Massachusetts: 1988), p. 345.

7 Cradock, Joseph, *An Account of some of the Most Romantic Parts of North Wales* (London: 1777), p. 50.

Piercefield

1 Ken Murphy & Elisabeth Whittle, 'Piercefield, Monmouthshire: The results of a new survey', *The Bulletin* No. 39 (Welsh Historic Gardens Trust, Summer 2005).

2 Whittle, *The Historic Gardens of Wales*, p. 40.

3 *The Works of Richard Owen Cambridge, including pieces never before published: An Account of his Life and Character by his son, George Owen Cambridge, M.A., Prebendery of Ely*, (1803), p. xxiii.

Richard Owen Cambridge (1717-1802) was a friend of Alexander Pope, Horace Walpole, Thomas Anson of Shugborough and George Lyttelton, amongst others. He was also a writer on gardens and landscape in *The Word* (1753-1756), the magazine edited by Edward Moore, a protégé of Lord Lyttelton. Deciding not to purchase Piercefield, he had an estate in Whitminster in Gloucestershire, as well as a villa in Twickenham. Cambridge was among the many people who supplied rocks and minerals, in his case 'Gold Clift', to line Alexander Pope's Grotto at Twickenham. He had a Grotto at his Gloucestershire home and is it is a pleasant thought to consider whether he inspired Valentine Morris's 'beautiful Grotto lined with Spar, and the slack of Iron and Copper.'

4 Pococke, *The Travels Through England ...*, Vol. 2, 1753, pp. 214-215.

5 Miss M's account of Piercefield in a letter to William Shenstone at The Leasowes: quoted in Stephen Bending, 'The Country House Landscape', *The Georgian Country House: Architecture, Landscape and Society* (Sutton Publishing, Stroud: 1998), Dana Arnold (ed.), p. 69.

6 Description of Piercefield from a MS written in November 1758 by the Rev. Mr Barford, Fellow of King's College, Cambridge, Cardiff Library Local Studies MS 2.727, ff. 12-18.

7 Anon., extract from a diary of 1759 sent by John Harris to Anne Rainsbury, Curator, Chepstow Museum, pp. 65-68.

8 *The Correspondence of Robert Dodsley 1733-1764*, Ed. James Tierney (Cambridge University Press, 1988), Oct. 12, 1759, pp. 224-226. In a P.S. to this letter Dodsley adds Spence's description of the 'Scenes and Views' at Piercefield running to 23 in all, including 'A Chinese bridge, a pretty confined Prospect'; A Mew for Pheasants, with Shrubberies of the finest foreign Shrubs; A Druid's Throne and Temple *in a Parterre*; the Cave where we dined...; A Chinese Semicircle; An octagon Temple, surrounded with *Chinese* rails.'

9 This was demolished c. 1800.

10 Nineteenth-century pencil drawings, not available to reproduce, in Chepstow Museum show charming rustic bridges built of branches lying across drops in the way Young describes.

11 Arthur Young, *A Six Weeks Tour*, Letter IV, pp. 164-179.

12 William Gilpin, *Observations on the river Wye* (1782), p. 40. These were based on his excursions there twelve years earlier.

13 Richard Sulivan (later Sir Richard Sulivan, 1st Bt.), *Observations made during a tour through parts of England, Scotland and Wales in a Series of Letters* (London: 1780), pp. 97, 98.

14 Murphy & Whittle, 'Piercefield, Monmouthshire'.

15 Ivor Waters, *Piercefield on the Banks of the Wye* (F.G. Comber, Chepstow, Gwent: 1975).

16 Young, *A Six Weeks Tour*, pp. 178-179.

17 Coxe, *An Historical Tour of Monmouthshire* (London: 1801), p. 393.

18 Attributed to Coxe by Ivor Waters in *Piercefield on the Banks of the Wye*.

19 Byng, *The Torrington Diaries*, Vol. I, ' A Tour to the West', pp. 29-30.

20 Ibid., 'A Tour in South Wales 1787', pp. 273-274.

21 The Rev. Stebbing Shaw, *A Tour to the West of England in 1788* (London: 1789), p. 10. The archaeological work done at Piercefield in 2005 supports this statement. Smith's widening and straightening of the paths is clearly visible. Apparently Morris's serpentine paths were much narrower than the later ones amended by Smith.

22 Soane had previously worked for George Smith in Durham.

23 Details quoted from the original Sale advertisement in the Soane Museum Library. The sale details reveal more of the gardens than the famous scenic walks stating that 'the Kitchen Garden is very productive, and contains about three acres. The Flower Gardens & Shrubberies are extensive.'

24 Charles Heath, *Historical and Descriptive Accounts of the Ancient and Present State of the Town and Castle of Chepstow, including The Pleasurable Regions of Persfield*, (6th Edition, Monmouth: 1813). The pages are not numbered. The Lion Lodge and its gates are now the entrance to Chepstow Racecourse.

25 G.W. Manby, *An Historic and Picturesque Guide from Clifton, through the counties of Monmouth, Glamorgan, and Brecknock: with representations of ruins, interesting antiquities, &.*, (Bristol: 1802), p. 270.

26 Quoted from Elisabeth Whittle, 'All these inchanting scenes: Piercefield in the Wye Valley', *Garden History* Vol. 24:1 (The Journal of the Garden History Society, Summer 1996), p. 151.

27 Ivor Waters, *About Chepstow* (The Newport & Monmouthshire Branch of the Historical Association & Chepstow Society, Chepstow: 1952), p. 73.

28 Manby, *An Historic and Picturesque Guide*, p. 3.

29 Mitchell, *The Wye Tour and Its Artists*, p. 85.

30 Sociables gained their name from the fact that they could easily accommodate an entire family for outings. They had a pair of folding hoods to protect passengers from the elements.

31 Nicholas Herbert, *Road Travel and Transport in Georgian Gloucestershire* (Ross-on-Wye: 2009) quoted in Mitchell, *The Wye Tour and Its Artists*, p. 85.

32 *The Diary of Joseph Farington*, edited by Kenneth Garlick & Angus Macintyre, (Yale University Press, New Haven & London: 1979), Vol. VI, April 1803-December 1804, pp. 2131-2132.

33 Charles Heath (1761-1831) was a Monmouth printer and a bookseller who published his first account of Piercefield in 1793: *A Descriptive Account of Piercefield and Chepstow*. Prince Pückler-Muskau describes buying a guide book from him in Monmouth (and mislaying his pocket book there). His books provided valuable information to succeeding writers about the Wye Valley and Monmouthshire [see wbo.llgc.org.uk accessed 26.07.2013]. He records that he conversed with Charles Howells (by then very old) who was 'employed in erecting the different Buildings and Seats in the Walks of Persfield, under Mr Morris's direction... He informed me that Mr Morris devoted a large portion of his time in superintending these monuments of his taste.'

34 Heath, quoted from *A Descriptive Account of Piercefield*, (1793).

35 *The Stranger's Illustrated Guide to Chepstow* (London, 1843)

36 J.T. Barber, *A Tour throughout South Wales and Monmouthshire* (London: 1803), p. 255. A footnote to the text indicates that Barber was visiting just as 'Col. Wood is about to dispose of this estate.'

37 Actually never knighted, Nathaniel Wells was an extraordinary character who triumphed over his mixed-race background. In 1818 he became Britain's first black High Sheriff for Monmouthshire. Highly respected locally, he was also a JP and a Deputy Lieutenant for the county.

38 *Travels through England, Wales, and Scotland in the Year 1816 by Dr S.H. Spiker, Librarian to His Majesty the King of Prussia, Dedicated to Friends of England, translated from the German*, (London: 1820, 2 vols.), Vol. 2, pp. 82-85 .

39 Pückler-Muskau, *A Tour in England, Ireland &c.*, Vol. 2, Letters X & XI, pp. 181, 192, 196. With his two wives (both clergymen's daughters) Nathaniel Wells produced 20 children.

40 Details from the 'A Description of the celebrated Piercefield Estate' to be sold through W. Smith, Son & Co., 8 Newgate Street, and 6 King Street, Seven Dials' c. 1837 in Soane Museum Library:

...the beautiful Park, profusely adorned with an uncommon Variety of the finest Timber, Groves, Clumps and single Trees, negligently scattered over, and feathered down to the finest Lawn. The Detached Offices and Kitchen Garden are situated at a proper distance from the House, and screened by Plantations; The Kitchen Garden and Melon Ground, are near three acres, inclosed by lofty Brick Walls, covered with the best Fruit Trees; and contain a large Hot House 81 Feet by 24 Feet, with Fireplaces; Gardener's Room and Tool Houses of the same length behind, and also an extensive Grapery and forcing House, and Tool Houses, in the Melon Ground.

41 Louisa Anne Twamley [Mrs Charles Meredith], *The Annual of British Landscape Scenery: An autumn ramble on the Wye* (London: 1839), Chapter III, p. 42.

42 Roscoe, *Wanderings and excursions in South Wales*; pp. 133-134.

43 Catherine Sinclair, *Hill and Valley or Wales and The Welsh* (Edinburgh: 1839), p. 312-13. Her tour began in Scotland in June 1833 so it can be supposed that this is the year in which she saw Piercefield.

44 *A Handbook for Travellers in South Wales and Its Borders, including the River Wye*, (John Murray, London: 1860), p. 47.

45 Mr & Mrs S.C. Hall, *The Book of South Wales*, p. 134. The Halls were travelling on the South Wales Railway from Gloucester to Milford Haven. Their book provided details of 'day-excursions that could be made from leading stations'. The opening of the Wye Valley Railway in 1876 between Chepstow and Monmouth brought even more tourists to the area.

46 Letter to the *Chepstow Weekly Advertiser*, September 14th 1861.

47 *A Handbook for Travellers in South Wales*, p. 48.

48 Coxe, *An Historical Tour in Monmouthshire*, p. 399.

Hafod

1 Malcolm Andrews, *The Search for the Picturesque* (Stanford University Press, California: 1989), p. 145.

2 William Gilpin, quoted from Bodl MS Eng. Misc d. 571, ff. 7, 23 April 1787 by Mavis Batey in 'The English Garden in Wales', *Garden History* Vol. 22:2, (Winter 1994).

3 Thomas Johnes, letter of 1793 quoted in the Introduction of the Bicentenary Edition of *An Attempt to Describe Hafod* (The Hafod Trust, Aberystwyth, 1996), p. 4.

4 Thomas Johnes, *The Letters of Thomas Johnes of Hafod* (Gomer Press, Llandysul: 1992), p. 101.

5 George Cumberland (1770-1845) was a connoisseur, artist, writer and poet. He was a lifelong friend of William Blake and it is thought that this was the connection that inspired him to commission Blake to produce the map of Hafod found in his great prose poem to Hafod, *An Attempt to Describe Hafod.*

6 George Cumberland, *An Attempt to Describe Hafod* (London: 1796), pp. 2-3, 11, 12, 23, 35.

7 *The Cambrian Directory, or, Cursory Descriptions of the Welsh Territories* (1801), p. 74.

8 Warner, *A Walk, through Wales, in August 1797*, pp. 66, 67.

9 Warner, *A Second Walk, through Wales*, pp. 147, 149, 150.

10 Colt Hoare, *The Journeys of..., 1796*: Mid-Wales, p. 63.

11 Sykes, *Journal of a Tour*, ff. 49.

12 Jennie Macve, 'The Picturesque Response to Devil's Bridge' in *Newsletter No. 8* (Welsh Historic Gardens Trust, June 1995), p. 5.

13 G. Sael (ed.), *A Collection of Welsh Tours and A Tour of the River Wye* (London: 1798) quoted by Jennie Macve in 'The Picturesque response to Devil's Bridge', *Newsletter No. 8* (Welsh Historic Gardens Trust, Summer 1995, p. 6.

14 Henry Thomas Payne (Archdeacon), Transcript of a *Journal of a Tour from Aberystwyth to Llanbedr*, c. 1815, (NLW Cwrtmawr 101C MS 101).

15 The Rev. James Plumptre, *A Narrative of a Pedestrian Journey through some parts of Yorkshire, Durham and Northumberland to the Highlands of Scotland and home by the Lakes and some parts of Wales in the summer of 1799*, Cambridge University Library, Add MSS, 5814-16 (3 vols) & Ian Ousby, *James Plumptre's Britain, The Journals of a Tourist in the 1790s* (London: 1992). Quoted in *Newsletter of the Friends of Hafod*, no 15, Summer 1997, pp. 11-17.

16 John Thomas Barber (1774-1841), *Tour throughout Wales and Monmouthshire* (1803).

17 George Lipscombe, *Journey into South Wales: through the counties of Oxford, Warwick, Worcester, Hereford, Salop, Stafford, Buckingham, and Hertford; in the year 1799*, (London: 1802), pp. 127, 128, 129, 129-131, 132, 135.

18 Richard Payne Knight, *The Landscape : A Didactic Poem in 3 books. Addressed to Uvedale Price, Esq.*, (London: 1795), p. 347.

19 Richard Fenton, *The Genius of Hafod* (written at Hafod, the seat of Thomas Johnes Esq in 1787 and meant as an inscription for a sequester'd seat there' from *Poems by Mr Fenton* (London 1790), Vol. II, p. 141.

20 Malkin, *The Scenery, Antiquities, and Biography of South Wales*, pp. 339, 347-8, 349, 361.

21 Quoted from a print in the possession of the author.

Francis, 5th Duke of Bedford (1765-1802) had a lifelong interest in agriculture. He had a model farm at Woburn and carried out new methods of farming and livestock breeding on his estates. He was greatly admired by Thomas Johnes who was himself an innovator of new farming practises and land improvement.

22 'Stuart's Athens' refers to James 'Athenian' Stuart (1713-88) the English architect, archaeologist, and painter who, with Nicholas Revett published *The Antiquities of Athens*, (London: 1762-1816) based on their expedition to Athens in 1761. The book was very influential in spreading the classical designs of Greek architecture.

23 Loudon, 'Gardens of Wales', *Encyclopaedia of Gardening*, p. 1085. His description is based on his visit to Hafod where he was responsible for designing new greenhouses. In *The Gardener's Magazine*, nearly 40 years later he wrote: 'Miss Johnes, the proprietress of Torquay [Woodbine Cottage], is sister to the late Colonel Johnes of Hafod in Cardiganshire, where we had the pleasure of passing a few days professionally, so long ago as 1805. Miss Johnes is upwards of ninety years of age, and in perfect health.

24 Borrow, *Wild Wales*, p. 392.

25 Colt Hoare, *The Journeys of..., 1810*, p. 143.

26 The various biographies of Thomas Johnes describe his home in Devon as a cottage, but he took his dreams with him to Dawlish and Langstone Cliff Cottage was a *cottage ornée* surrounded by nearly 20 acres of grounds.

27 Nicholson, *The Cambrian Traveller's Guide*, pp. 274, 275, 509.

28 The Rev. Joseph Romilly, *Tour of Wales 1837*, The Rev. M.G.R. Morris (Ed.), (Gomer, Llandysul: 1998), p. 57.

29 *Wandering and Excursions in South Wales*, pp. 20-22.

30 *Handbook of South Wales*, pp. 116-117.

31 John R.E. Borron, 'The Waddinghams of Hafod', *Ceredigion*

(Journal of the Ceredigion Antiquarian Society, Volume XI, No. 4, 1992), pp. 388, 393.

32 T.H. Williams, *Picturesque Excursions in Devonshire and Cornwall* (London: 1804), 'A Tour to North of Devon', p. 1.

Plas Tan y Bwlch

1 The Vale of Tempe was a valley in Greece, sacred to Apollo, and the phrase has been used by poets down the years to refer to a wooded valley of great beauty.

2 Pennant, *A Journey to Snowdon*, pp. 44, 128.

3 Wyndham, *A Tour through Monmouthshire and Wales*, p. 132.

4 Joseph Cradock, *An Account of some of the Most Romantic Parts of North Wales*, (London: 1777), p. 34.

5 Byng, 'Tour into North Wales, 1793' from *Rides Round Britain*, p. 450.

6 William Oakeley, *Transactions of The Society*, instituted in London for the Encouragement of Arts, Manufacture and Commerce, (London, 1798), pp. 186-187, 198.

7 Gwyndaf Hughes in *House on A Hill: A History of Plas Tan y Bwlch & the Maentwrog Valley* (Friends of Plas Tan y Bwlch: 1989), p. 14.

8 Sykes, *Journal of A Tour in Wales*, ff. 56.

9 Warner, *A Walk through Wales*, pp. 117-118.

10 The Rev. John Skinner, *Tour in South Wales*, 1800, unpublished MS. 2258c, Cardiff Central Library, quoted in Auston, 'The Gardens of Plas Tan y Bwlch (*Gerddi*, Vol. II: No. I, 1998-1999), p. 35.

11 Broster, *Circular Tour*, pp. 72-73.

12 Pugh, *Cambria Depicta*, p. 168.

13 Quoted in *A Genealogical and Heraldic History of the Commoners of Great Britain & Ireland*, James Burke (London, 1836), Vol.I, p. 251.

14 Colt Hoare, *The Journals of*, p. 68.

15 Barber, J.T., *A Tour throughout South Wales and Monmouthshire, Comprehending A General Survey of the Picturesque Scenery, Remains of Antiquity, Historical Events, Peculiar Manners, and Commercial Situations of That Interesting Portion of the British Empire*, (1st edition, J. Nichols & Son, London, 1803).

16 Pückler-Muskau, *A Tour in England &c.*, Vol. I, Letter III, pp. 123-124.

17 The Ffestiniog Railway Company sent the slate down to the sea in railway carriages moved entirely by gravity. The horses needed to haul the empty trucks back were carried in special wagons on the downwards journey. The railway did not use a steam engine until 1863 and the first passenger train was introduced in 1865. The first halt on the Tan y Bwlch estate was at Hafod y Llyn, but this was replaced in 1872 with the little station of Tan y Bwlch. There is an early photograph of W.E. and Mary Oakeley sitting on the platform of 'their' station.

18 Roscoe, *Wanderings... in North Wales*, p. 213.

This would place the planting of the rhododendrons between c. 1800-1815 which is early for the introduction of rhododendrons to Britain in any quantity. China did not really open up for European explorers and plant collectors until after 1860. Louisa Kenyon's description of 'fine, scarlet rhododendrons' indicate that these might well be *Rhododendron arboreum*, only introduced into Britain in 1810. Tan y Bwlch was evidently in the vanguard of introducing rhododendrons at this time.

19 Kenyon, Louisa Charlotte, *Journal of tour to North Wales*, 1839, (Shropshire Records and Archive Centre, 549/286).

20 Louisa Stuart Costello, *The Falls, Lakes and Mountains of North Wales*, p. 158.

21 The Hon. Mary Russell's (1830-1914) father was a connection of the Duke of Bedford. She succeeded her mother as Baroness de Clifford in her own right in 1874.

22 Probate Register for 1879.

23 William Edward Oakeley, letter from Tan y Bwlch, July 14th 1868 (Meirionydd Archives, Z/DV/4/III)

24 Nicholas, *Annals & Antiquities of the Counties and County Families of Wales*, p. 706.

25 John Roberts, Letter to William Edward Oakeley, February 1909, (Meirionydd Archives Z/DV/3/665)

26 Jenny Uglow, *A Little History of British Gardening* (Pimlico, London: 2005), p. 182.

27 The Gardens, Tan y Bwlch Wage Books, 1885 & 1886, (Meirionydd Archives, DV/3/457)

28 *Journal of Horticulture*, March 15, 1888, pp. 218-221.
The Parma violets referred to were very popular and, in the case of *viola odorata* 'Comte de Brazza' - named for the Italian who had introduced them from Naples in 1883. It is white, double and ruffled, sweetly scented; 'Marie Louise' - named for Marie Louise of Hapsburg-Lorraine, Duchess of Parma - is a deep violet-blue double; Odoratissima is a single dark blue violet.

29 Garden Statement of Accounts, 1889 (Meirionydd Archives DV/3/470)

30 *Tamworth Gazette*, February 1903.

Plas Newydd, Llangollen

1 This was originally Pen-y-Maes, Llangollen, a small cottage, with kitchen, sitting-room, and two bed-rooms; the Ladies took a lease of this cottage, and added to it from time to time, having changed its name to Plas Newydd.

2 Quoted in Patrick Taylor, *The Oxford Companion to the Garden* (Oxford University Press: 2006), p. 440.

3 *The Poems of Ossian*, supposedly gathered together and translated from the Gaelic by James Macpherson from 1760-1763 evoked a 'strange Celtic past' and had a remarkable effect on their audience, 'being read, reprinted and translated into Italian, German, French, Polish, Russian, Danish, Spanish, Dutch, Bohemian and Hungarian.' Fiona Stafford, Introduction, p. xv, *The Poems of Ossian and Related Works*, (Howard Gaskill, Ed.), (Edinburgh University Press: 1996).

4 Manwaring, *Italian Landscape in Eighteenth Century England*, p. 68.

5 Quoted by Elizabeth Mavor in *The Ladies of Llangollen: A Study in Romantic Friendship* (Penguin Books, London: 1973), p. 64.

6 This line is quoted from Sonnet LV in *Rime* (1530) by Pietro Bembo (1470-1547), Italian scholar, poet and later Cardinal. The hanging up of poetic quotes and verses about their gardens reflected the Ladies' admiration for William Shenstone at The Leasowes.

7 Anna Seward, *Letters of Anna Seward written between the years between 1784 and 1807 in six volumes* (Edinburgh: 1811), Vol. 4, Letter XX, Sept. 7, 1795, pp. 98-109; Letter XLIII, 1796, pp. 208-214.

8 Skrine, *Two Successive Tours*, p. 241.

9 *The Cambrian Directory*, p. 150.

10 William Gerard Walmesley, *Journal of a Pedestrian Tour made in north Wales during the month of June, 1819 by William Gerard Walmesley and William Latham*, (London Metropolitan Archives, CLC/521/MS00477), pp. 104-105. Accessed via Ladiesofllangollen.wordpress.com

11 The papers of the Ladies of Llangollen are held in the National Library of Wales, Aberystwyth.

12 The Rev. James Plumptre, from Ousby, *James Plumptre's Britain: The Journal of a Tourist in the 1790s*, pp. 80-88.

13 Loudon, *An Encyclopaedia of Gardening*, p. 1085.

14 Pückler-Muskau, *A Tour in England &c.*, Vol. 1, Letter 1, pp. 20-21.

15 Extracted from the Sale Particulars of 1832.

16 Roscoe, *Wanderings in North Wales*, pp. 39-40.

17 Costello, *The Falls, Lakes and Mountains of North Wales*, p. 21.

Bodnant Hall

1 Jones, Ieuan Gwynedd, *Mid-Victorian Wales: The Observers and the Observed* (University of Wales Press, Cardiff: 1992), p. 142.

2 *Bradshaw's Descriptive Railway Hand-Book*.

3 Messenger & Co. Ltd were famous for their conservatories, hot houses and heating apparatus and designed many such in Wales including Miss Talbot's glasshouses at Margam Castle in 1890 and 1891; a Fernery for Picton Castle in 1890 and a Vinery for the Waddinghams at Hafod.

4 *The Gardeners' Chronicle*, (London, February 16, 1884), p. 207.

5 Michael McLaren, *The History of the Conservatory and the Fernery at Bodnant*, (private publication, 1991), Appendix D, Pulham Correspondence, p. 204.

6 *The Garden*, Vol. XXIV, Christmas 1888, (London, 1888), p. 551.

7 *The Gardeners' Chronicle* (London, September 17, 1892), p. 331-32.

ENVOI

1 Loudon, *Encyclopaedia of Gardening, Book I, Private British Gardens*, p. 1047.

2 Quoted from *The Cambrian Companion*, p. 199.

GARDENS GAZETTEER

1 Stephen Anderton, *Discovering Welsh Gardens* (Graffeg, Cardiff: 2009), p.171.

2 Graham Stuart Thomas, *Gardens of the National Trust* (Weidenfeld & Nicholson, London: 1979), pp. 195-196.

3 C.C. Green, *The Vale of Rheidol Light Railway* (Wild Swan, Didcot: 1986), p. 51.

4 John R.E. Borron, 'The Waddinghams of Hafod' in *Ceredigion* (Journal of the Ceredigion Antiquarian Society, 1992), pp. 398.

5 Quoted from the display exhibition at Plas Newydd, Llangollen, 2014.

6 Phil Clayton, 'Powis Castle Garden', *The Garden*, August 2014, p. 34.

7 Powys (Cadw: ICOMOS Register, 1999), p. 222.

BIBLIOGRAPHY

All of the books quoted from are listed in the Notes to each section. What follows is a list of general books that I have found of great assistance in preparing this book and that might be of interest to my readers.

Anderton, Stephen, *Discovering Welsh Gardens: 20 of the liveliest gardens selected and explored by Stephen Anderton and photographed by Charles Hawes* (Graffeg, Cardiff, 2009)

Andrews, Malcolm, *The Search for the Picturesque: Landscape Aesthetics and Tourism in Britain 1760-1800* (Stanford University Press, California, 1989)

Attlee, Helena, *The Gardens of Wales* (Frances Lincoln, London, 2009)

Batey, Mavis & Lambert, David, *The English Garden Tour: A View into the Past* (John Murray, London, 1990)

Bending, Stephen, *The Georgian Country House: Architecture, Landscape and Society* (Sutton Publishing, Stroud, 1998)

Brewer, John, *The Pleasures of the Imagination: English Culture in the Eighteenth Century* (Harper Collins, London, 1997)

Brown, Jane, *The Omnipotent Magician: Lancelot 'Capability' Brown 1716-1783* (Chatto & Windus, London, 2011)

Brown, Jane, *The Pursuit of Paradise: A Social History of Gardens and Gardening* (Harper Collins, London, 1999)

Daniels, Stephen, *Humphry Repton: Landscape and the Geography of Georgian England* (Yale University Press, New Haven & London, 1999)

Davies, Russell, *Hope and Heartbreak: A Social History of Wales and the Welsh, 1776–1871* (University of Wales Press, Cardiff, 2005)

Desmond, Ray, *Bibliography of British Gardens* (St. Paul's Bibliographies, Winchester, 1984)

Dixon Hunt, John & Willis Peter (Eds.), *The Genius of the Place: The English Landscape Garden 1620-1820* (The MIT Press, Cambridge, Massachusetts & London, 1988)

Dodd, A.H., *A History of Caernarvonshire* (Bridge Books, Wrexham: 1990)

Gard, Robin (Ed.), *The Observant Traveller: Diaries of Travel in England, Wales and Scotland in the County Archive Offices of England and Wales,* (Association of County Archivists, HMSO, London, 1989)

Girouard, Mark, *Life in the English Country House* (Yale University Press, New Haven & London, 1978)

Girouard, Mark, *The Victorian Country House* (Yale University Press, New Haven and London, 1979)

Griffiths, Eric, *Philip Yorke (1743-1804), Squire of Erthig* (Bridge Books, Wrexham, 1995)

Hadfield, Miles, *A History of British Gardening* (John Murray, London, 3rd edition, 1979)

Harris, John, *The Artist and the Country House: A history of country house and view painting in Britain 1540-1870* (Sotheby Parke Bennet, London, 1979)

Hernon, Paul, *Sir Watkin's Tours: Excursions to France, Italy and North Wales, 1768-71* (Bridge Books, Wrexham, 2013)

Inglis-Jones, Elisabeth, *Peacocks in Paradise: The Story of a House – its owners and the Elysium they established there, in the mountains of Wales, in the 18th century* (Faber & Faber, London, 2nd edition, 1960)

Jacques, David, *Georgian Gardens: The Reign of Nature* (B.T. Batsford Ltd, London, 1983)

Lloyd, Thomas, *The Lost Houses of Wales: A Survey of Country Houses in Wales demolished since c. 1900* (SAVE Britain's Heritage, London, 1989, revised edition)

Lord, Peter, *The Visual Culture of Wales: Industrial Society* (University of Wales Press, Cardiff, 1998

Lord, Peter, *The Visual Culture of Wales: Imaging the Nation* (University of Wales Press, Cardiff, 2000)

Mavor, Elizabeth, *The Ladies of Llangollen: A Study in Romantic Friendship* (Michael Joseph, London, 1971; Penguin Books, London, 1973)

Moir, Esther, *The Discovery of Britain: The English Tourists 1540-1840* (Routledge & Kegan Paul, London, 1964)

Moore, Donald (Ed.), *Wales in the Eighteenth Century* (Christopher Davies, Swansea, 1976)

Mowl, Timothy, *Gentlemen Gardeners: The Men Who Created the English Landscape Garden* (The History Press, Stroud, 2010)

Ousby, Ian, *The Englishman's England: Taste, Travel and the Rise of Tourism* (Pimlico, 2002)

Palmer, Caroline with David, Penny & Laidlaw, Ros, *Historic Parks & Gardens in Ceredigion* (Welsh Historic Gardens Trust: Ceredigion, 2004)

Parker, Mike, *Mapping the Roads: Building Modern Britain* (AA Publishing, Basingstoke, 2013)

Pavord, Anna, *Landskipping:* (Bloomsbury, London, 2016)

Register of Landscapes, Parks and Gardens of Special Historic Interest in Wales:

Part I: Parks & Gardens:

Carmarthenshire, Ceredigion and Pembrokeshire: (Cadw: Welsh Historic Monuments ICOMOS UK, Cardiff, 2002)

Clwyd (Cadw: Welsh Historic Monuments ICOMOS UK, Cardiff, 1995)

Conwy, Gwynedd & The Isle of Anglesey (Cadw: Welsh Historic Monuments ICOMOS UK, Cardiff, 1998)

Glamorgan (Cadw: Welsh Historic Monuments ICOMOS UK, Cardiff, 2000)

Gwent (Cadw: Welsh Historic Monuments ICOMOS UK, Cardiff, 1994)

Powys (Cadw: Welsh Historic Monuments ICOMOS UK, Cardiff, 1999)

Robinson, Dr John Martin, *The Wyatts: An Architectural Dynasty* (Oxford University Press, 1979)

Robinson, Dr John Martin, *James Wyatt: Architect to George III* (Yale University Press, New Haven & London, 2012)

Strong, Sir Roy, *The Artist & the Garden* (Yale University Press, New Haven & London, 2000)

Strong, Sir Roy, *The Renaissance Garden in England* (Thames & Hudson, London, 1979)

Stroud, Dorothy, *Capability Brown* (Country Life Publishing, London, revised ed. 1957)

Stuart Thomas, Graham, *Gardens of the National Trust* (Weidenfeld & Nicholson, London, 1979)

Taylor, Patrick (Ed.), *The Oxford Companion to the Garden* (Oxford University Press, 2006)

The Buildings of Wales:

Carmarthenshire and Ceredigion, Thomas Lloyd, Julian Orbach, Robert Scourfield (Yale University Press, New Haven & London, 2006)

Clwyd (Denbighshire and Flintshire), Edward Hubbard, (Penguin Books: University of Wales Press, 1986)

Glamorgan: Mid Glamorgan, South Glamorgan and West Glamorgan, John Newman (Penguin Books: University of Wales Press, 1995)

Gwynedd, Richard Haslam, Julian Orbach, & Adam Voelker (Yale University Press, New Haven & London, 2009)

Gwent/Monmouthshire, John Newman (Penguin Books: University of Wales Press, 2000)

Pembrokeshire, Thomas Lloyd, Julian Orbach and Robert Scourfield (Yale University Press, New Haven & London, 2004)

Powys: Montgomeryshire, Radnorshire and Breconshire, Richard Haslam & Robert Scourfield, (Yale University Press, New Haven & London, 2013)

Thomas, Hilary (Ed.), *Historic Gardens of the Vale of Glamorgan*, (Welsh Historic Gardens Trust: South & Mid-Glamorgan, 2007)

Tinniswood, Anthony, *The Polite Tourist: A History of Country House Visiting* (The National Trust, London, 1998)

Uglow, Jenny *A Little History of British Gardening* (Chatto & Windus, London, 2004 & p/b edition, Pimlico, 2005)

Watkins, Charles & Cowell, Ben, *Uvedale Price (1747-1829): Decoding the Picturesque* (Boydell Press, Woodbridge, Suffolk, 2012)

Whittle, Elisabeth, *The Historic Gardens of Wales* (Cadw: Welsh Historic Monuments, Cardiff, 1989)

Wilson, Francesca M., *Strange Island: Britain through Foreign Eyes 1305-1940* (Longman Green and Co., London, New York, Toronto, 1955)

INDEX